PHOTOSHOP
LIGHTROOM 2 ADVENTURE

Mastering Adobe's next-generation tool for digital photographers

Iceland

Tasmania

PHOTOSHOP
LIGHTROOM 2 ADVENTURE

Mastering Adobe's next-generation tool for digital photographers

Mikkel Aaland

O'REILLY®

BEIJING • CAMBRIDGE • FARNHAM • KÖLN • SEBASTOPOL • TAIPEI • TOKYO

Photoshop Lightroom 2 Adventure BY MIKKEL AALAND

Editor: **Colleen Wheeler**

Production Editor: **Christine Meredith**

Technical Editor: **Doug Nelson**

Copyeditor: **Felicity O'Meara**

Cover Design: **Jan Davis**

Cover Photos: **Mikkel Aaland** (Main image), **Philip Andrews, Ian Wallace**

Interior Design: **Michael Kavish**

Graphic Production: **Ron Bilodeau, David Van Ness**

Published by O'Reilly Media, Inc., 1005 Gravenstein Highway North, Sebastopol, CA 95472.

O'Reilly books may be purchased for educational, business, or sales promotional use. Online editions are also available for most titles (*safari.oreilly.com*). For more information, contact our corporate/institutional sales department: 800.998.9938 or *corporate@oreilly.com*.

Visible Earth image on page ii provided courtesy of NASA (*http://visibleearth.nasa.gov/*).

Print History: September 2008
ISBN: 9780596521011

[F]
Printed in Canada.

To Paul Persons,
who made every day an adventure

Acknowledgments

The Tasmania Adventure stands on the shoulders of the success of the first Adobe Lightroom Adventure to Iceland. Iceland began as an act of faith from my publisher O'Reilly (Steve Weiss, Mark Brokering, Laurie Petrycki) and Adobe (Jennifer Stern, George Jardine). Tasmania and this book were another huge challenge and couldn't have been done without the support of many people. Tourism Tasmania's Daryl Hudson became our angel, and I can truly say the Tasmania Adventure would never have happened without his help. Adobe's Frederick V. Johnson made another leap of faith and supported us again, O'Reilly's Dan Brodnitz became a "can-doer" and cleared many roadblocks, and Peter Krogh—I love you Peter!—was a rock and so supportive and unwavering. Tourism Tasmania's Joshua Iles made it all seem so easy—everyone on the team wanted to take him home when we were done. My associate director, Megumi L. Inouye, took many of the details off my plate.

Thanks to the people behind our sponsors: Melissa Rose, Dina Louie, Tammy Haldeman, Qantas; Dan Steinhardt, Epson; Maris Berzins, Charles Mauzey, Josh Weltman, Digital Railroad; Sam Marsh, Sharon Hustwit, Lowepro; Lou Schmidt, Hoodman; Satohiro Ozawa, Masahiro Shioji, Hiroshi Fuji, Sawako Tanaka, Sanyo; and Craig Strong, Lensbabies. Thanks to Joe Shemesh, Stormfront Productions, for producing the video of the Adventure. The people behind Tourism Tasmania were absolutely fantastic to work with. I've already thanked Daryl Hudson; others include Paula Wriedt, Felicia Mariani, Ruth Dowty, Karen Fraser, Karren Wissling, Susie De Carteret, Sandra Leach, Jennifer Fitzpatrick, Kerry Lorimer, Liza-Jane Sowden, Adam Pike, and Jan Ross. And from Tasmania Parks and Wildlife Service: Matt Taylor, Steve Johnson, Shaun Brooks, and Ben Clark. Special thanks to Liz Dombrovskis, the widow of Tasmania's greatest landscape photographer Peter Dombrovskis, and to Geoff Lea for introducing his work to the team at our opening ceremony.

The Adobe support, as usual, was awesome. I already thanked Frederick V. Johnson. Thanks to these other Adobe people: Johnny Loiacono, Kevin Connor, Tom Hogarty, Mark Cokes, Chitra Mittha, John Nack, Addy Roff, Eric Chan, Thomas Knoll, Troy Gaul, Kevin Tieskoetter, Donna Powell, Mala Sharma, Muneo Tochiya, Kelly Castro, Jeff Van de Walker, Andrew Rahn, Eric Scouten, Dan Tuff, Ton Frederick, and Julianne Kost. I would also like to especially thank O'Reilly's Derrick Story, Suzanne Caballero, Laura Painter (Laura, you rock!), Dennis Fitzgerald, Corina Lange, Sara Peyton, Ron Bilodeau, Inken Kiupel, and Betsy Waliszewski. The Adventure would not have been an adventure without the team who made the trip. They are listed in the Adventure Team section that follows. My thanks and appreciation goes to all of them (and to the original Iceland team as well).

Thanks, as always, to my agent at Studio B, Neil Salkind, and David Rogelberg. Other thanks go to Harris Fogel, Fred Shippey, Arjan van Bruggen, Luis Delgado, Tom Mogensen, Jill Waterman, Monica Suder, Bill and Sue Rabe, Leonard Koren, Rudy Burger, David Cohen, Stephan Obermueller, Tim Grey, Ethan Salwen, Lynn Ferrin, John Flynn, Bruce Yelaska, Cheryl Parker, Dave Drum, Mike Pasini, Alexis Gerard, and Michael Reichmann; William Pekala and Michael Rubin, Nikon; Manuelita Rangel and Deke McClelland; and Mike Aikins and Karen Maleby, Tourism Australia. Thanks to everyone who provided ground support while we were in Tasmania, including the wonderful people at the Henry Jones Art Hotel and Rob Penicot and Simon Stubbs and many many more. The Tasmanians are some of the kindest, friendliest people I've ever met. Big thanks to Doug Nelson, for his awesome technical editing; Lightroom 2 prerelease beta testers, especially Sean McCormack; Jan Davis for designing another great cover; and Russell Brown for once again referring us to Jan, and much more.

And finally, I want to thank Mark Hamburg for creating Lightroom; my O'Reilly editor, Colleen Wheeler, who is smart, committed, and an author's dream; Leo Laporte for his foreword and friendship; and my wife, Rebecca, and my daughters, Miranda and Ana, who make everything worthwhile.

Mikkel Aaland—2008

Contents

Foreword

by Leo Laporte

If Mikkel Aaland ever asks you to join him on an adventure, say yes. That's what happened to me. Mikkel is an old friend, a regular contributor to my radio and television shows, and an inspirational photographer. We ran into each other at Macworld Expo in San Francisco this year. I was showing him snapshots of my trip down the Nile when he popped the question.

"How would you like to go to Tasmania this spring?"

At the time I wasn't particularly clear as to where, or even what, Tasmania was, but I said yes. Definitely yes.

As I would soon learn, Taz is a beautiful island off Australia's southeast coast, one of the last unspoiled places. Mikkel was planning to take 18 of the world's best photographers there as guests of the Tasmanian Tourist Bureau. These talented artists would spend the day shooting the island, then return each evening to share their photos and stories with one another, and use a prerelease version of Adobe's new Lightroom 2 to bring their Tasmanian visions to vibrant life. I was to follow along as a "special media guest."

Watching great photographers plan their shots, wait for the perfect light, then capture an image was an education. Hearing them talk about what they do and why and how they do it was an inspiration. Watching them use a computer to turn their raw images into breathtaking works of art was a revelation.

I saw this magic happen day after day, night after night, for 10 days and nights and it never got old. This book is the result of these long days and nights. In these pages you'll see a beautiful land populated with amazing wildlife and spirited, generous people. In that respect, this book is a gorgeous photographic document. It's also something more: A practical guide to a program no photographer should be without, Adobe Lightroom 2.

Can a computer program help you be a better photographer? That's a controversial question, to be sure. As a technology evangelist, I live, breathe, and sleep gadgets and gizmos, but even I was skeptical about the role of technology in the art of photography until I spent some time with the pros whose work fills this book. For them, digital tools like Adobe Lightroom 2 help make their pictures not only more beautiful, but also more true to their original vision. In the hands of an amateur like me, Lightroom can make an imperfect picture something to be proud of. In the hands of these pros, Lightroom took already excellent pictures and made them works of art.

Did Ansel Adams need a computer or Adobe Lightroom? Never. Would he have embraced them? Absolutely. Just as the darkroom and enlarger helped Adams print the magic he saw in life onto paper, so today's great photographers use digital technology to make their pictures more true to the original, or in some cases to create entirely new works of art. Lightroom can take your photography to a new level, and in this book you'll learn how from Mikkel and his company of talented visual artists.

This is an adventure you'll be glad you said yes to.

Introduction

Adobe Lightroom is a revolutionary, all-in-one imaging application. It was created from the ground up for serious photographers who'd rather spend most of their time shooting and not all day sitting in front of a computer. Lightroom makes it easy to import, edit, organize, process, and share digital images in an integrated work environment. Because Lightroom is nondestructive and doesn't alter a single pixel of the original image file—be it RAW, JPEG, or TIFF—it is lightning fast. You'll be amazed at how quickly you can change white balance, optimize exposure, create a slide show or a web gallery, or prepare 1 or 100 images for print.

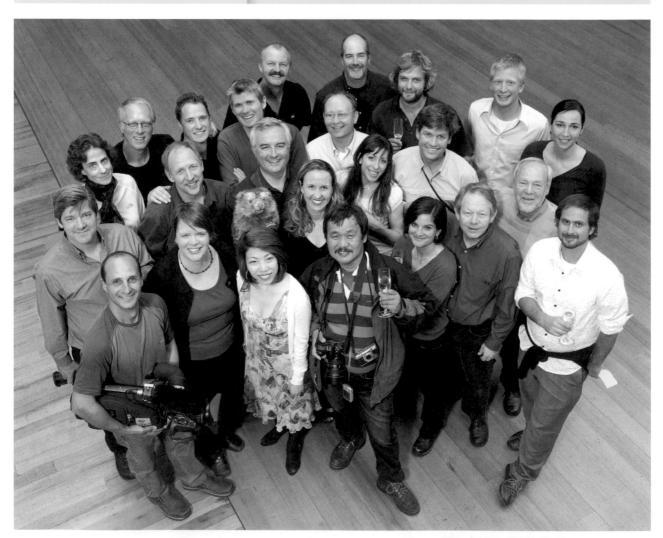

Adventure Team Photo by Simone Müller

Who Should Read This Book?

Anyone using Lightroom, be they an amateur photographer or a professional, should find this book useful. I've done my best to explain in easy-to-follow text, complemented with hundreds of illustrations, how to get the most out of this amazing application. I've also included numerous double-page photo spreads throughout the book, which I hope you'll enjoy and find inspiring as well.

Written for Lightroom 2

This book is written for Lightroom 2, the latest version of the software. Lightroom 2 is a significant upgrade from Lightroom 1. The many new features include localized adjustments, a graduated filter, a new library filter, and more-efficient folder organization. The print module now includes the very useful print packages and the ability to print to JPEG. There is now second-display support. Many other small improvements also contribute in a large way to make the entire Lightroom experience more pleasurable.

Because Adobe is constantly updating and improving the software, I suggest that you regularly check adobe.com for updates.

About the Adobe Lightroom Tasmania Adventure

Both the title for this book and most of the content grew out of the Adobe Lightroom Tasmania Adventure, a unique collaboration between 18 professional photographers and 5 Adobe Lightroom team members. The Adventure took place at the beginning of April 2008 in Tasmania.

The Tasmania Adventure follows the very successful Iceland Adventure, which occurred in 2006. You will occasionally see references to the Iceland Adventure in this book, and I've incorporated some of the Iceland experiences into this book as well. The idea for the Adventure started when I envisioned a small group of serious professional photographers sequestered with several of the Adobe professionals involved with creating Lightroom in an adventurous and visually exciting location to road-test Lightroom. I couldn't think of a better way to see if Adobe was on track to making a product that truly met the needs of us photographers. I approached Adobe and they agreed to sponsor the ambitious project. (Other sponsors are listed at the end of the Introduction.)

And road test the product we did! At the end of a long day of shooting, we all gathered in workrooms, fired up our computers, and got to work. We liked a lot of what we saw, and we learned a lot about the product. We also found things lacking, and things that didn't work the way we wanted. Because we were working with beta versions of Lightroom, it was very satisfying to express our concerns to the Adobe people on the Adventure and have a fix, sometimes by the next day. I'm happy to say that many of our suggestions have been realized in the final release product.

The fact is, everyone got something out of the project. The photographers were unpaid, but they got a trip and the experience of a lifetime. Adobe got real-time feedback. And me...well...I got the chance to write the book you are holding.

Platform Differences

For the most part, Lightroom is the same for the Mac and PC platforms. There are some minor cosmetic differences between the platforms, and a few more-significant ones, which I have noted throughout the book. For example, PC users who have Photoshop Elements loaded will find it easy to import libraries from Element's Organizer, which is not an option for Mac users. When keyboard commands differ between platforms I've included both. For example, to select all images I write: +Shift+A (Ctrl + Shift+A), with the Mac command first, followed by the PC command in parentheses. For the sake of simplicity, I only say "right-click" and don't include the keyboard command for the Mac (ctrl+click), which is necessary for single-button mouse users. (Most Mac users are now using multibutton mice, so I hope this omission isn't too big of a deal.)

For More Information

You can address comments and questions concerning this book to the publisher:

O'Reilly Media, Inc.
1005 Gravenstein Highway North
Sebastopol, CA 95472
(800) 998-9938 (in the United States or Canada)
(707) 829-0515 (international or local)
(707) 829-0104 (fax)

We'll list errata, examples, and any additional information at:

http://www.oreilly.com/catalog/9780596521011

To comment or ask technical questions about this book, send email to:

bookquestions@oreilly.com

You can also find more information by going to the O'Reilly general Digital Media site:

digitalmedia.oreilly.com

Also, check out the O'Reilly Inside Lightroom site, where I join other Lightroom users in a daily blog:

digitalmedia.oreilly.com/lightroom

I'm such a big fan of Lightroom and want to do everything I can to make your experience with the application as rewarding as possible. Feel free to email me at *mikkel@cyberbohemia.com* with any suggestions or questions you have and I'll do my best to answer. Or check out my personal website:

www.shooting-digital.com

Let another Adventure begin!

Mikkel Aaland
San Francisco, 2008

Sponsoring Partners

Adobe Systems, Inc. (*www.adobe.com*)

Tourism Tasmania (*www.discovertasmania.com*)

O'Reilly (*www.oreilly.com*)

Gold Premier Sponsors

Digital Railroad (*www.digitalrailroad.net*)

Qantas (*www.qantas.com*)

Epson (*www.epson.com*)

Silver Sponsors

Lowepro (*www.lowepro.com*)

Friends

Sanyo (*www.sanyo.com*)

Lensbaby (*www.lensbaby.com*)

Hoodman (*www.hoodmanusa.com*)

Stormfront Productions (*www.storm-front.com.au*)

The Tasmania Adventure Team

It wouldn't have been an adventure without these intrepid contributors. They've been generous with letting me use their beautiful photographs throughout this book.

Masaaki Aihara is a Japanese photographer who has made Tasmania his second home. His work can be seen at *www.aihara-australia.ecnet.jp*.

Philip Andrews is an Australian author, publisher, and photographer. His work can be seen at *http://web.mac.com/philip_andrews/Philip_Andrews/Home.html*.

Marcus Bell is an Australian photographer named by BBC Television as one of the top 10 wedding photographers in the world. See his work at *http://www.marcusbell.com*.

Mark Cokes is Adobe's Pacific Marketing Manager and an avid photographer. He can be contacted at *mcokes@adobe.com*.

Charles Cramer is an American landscape photographer who teaches regularly at Ansel Adams Gallery workshops. His work can be seen at *www.charlescramer.com*.

Bruce Dale is a former National Geographic staff photographer and a legend in his own time. His work can be seen at *www.brucedale.com*.

Angela Drury is an American fine art photographer. Her work can be seen at *www.angeladrury.com*.

Peter Eastway is an Australian landscape photographer and publisher, and an inspirational teacher and lecturer. His work can be seen at *www.petereastway.com*.

Robert Edwards is an Australian commercial photographer and an active leader in the photographic community. His work can be seen at *www.photographer.com.au*.

Katrin Eismann is an author, photographer, and cofounder and chair of the Masters in Digital Photography department at the School of Visual Arts in New York City. Her work can be seen at *www.katrineismann.com*.

Melissa Gaul is a member of the original Lightroom engineering team, based in Minnesota. She is also an accomplished photographer. Follow her blog at *http://hyvetyrant.typepad.com/talks/*.

Catherine Hall is an American photographer who lectures and exhibits widely. More of her work can be seen at *www.catherinehall.net*.

B. Winston Hendrickson is the senior director of engineering for Adobe's professional digital imaging products, including Lightroom and Photoshop. His photography work can be found at *bwinston.smugmug.com*.

Maki Kawakita is a Japanese-American photographer based in New York. More of her amazing work can be found at *www.makiphoto.com*.

Jackie King is a British photographer whose images range from hyperrealistic to avant-garde abstraction. View more of her work at *www.jackieking.com*.

Peter Krogh is both an award-winning photographer and the author of the definitive work on digital asset management. His work can be seen at *www.peterkrogh.com*.

Leo Laporte was the Adventure's special media guest. He is a popular radio, TV, and web personality as well as an avid photographer. His work can be found at *www.leoville.com*.

Darran Leal is an Australian photographer and author, and workshop leader. His work can be seen at *www.wildvisions.com.au/*.

Simone Müller is a German photographer who specializes in shooting stock. She can be contacted at *simo04@gmx.de*.

Jeff Pflueger is an editorial photographer specializing in adventure themes. He is also the creator of the Adventure's site, *www.xyzadventures.com*. His photographic work can be seen at *http://jeffpflueger.com*.

Joe Shemesh is a Tasmanian videographer and still photographer who runs Stormfront Productions, the company that produced the Adventure video. See his work at *www.storm-front.com.au*.

Bill Stotzner is a member of the Adobe Lightroom team. He is also a graduate of Rochester Institute of Technology and an avid underwater photographer. He can be contacted at *stotzner@adobe.com*.

Ian Wallace is a Tasmanian photographer who photographs just about everything (as you can see here). And does a great job! His work can be seen at *www.ianwallace.com*.

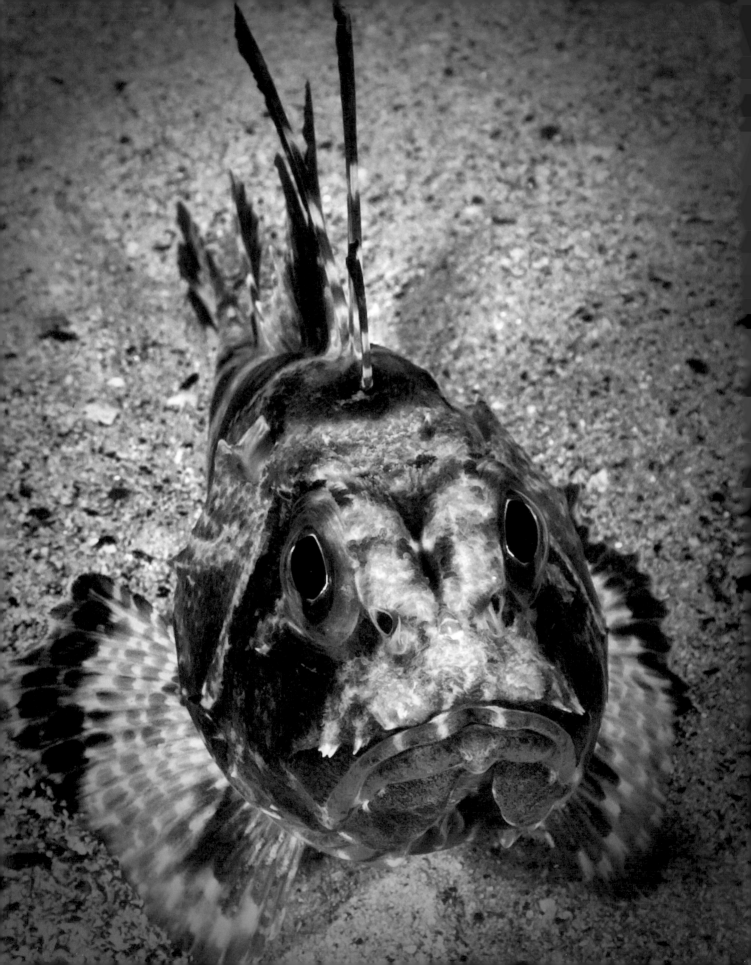

CHAPTER ONE

The Lightroom Workspace Revealed

Adobe Photoshop Lightroom is designed to streamline the process of importing, edting, processing, and sharing your digital images. Many photographers find the controls and menus extremely intuitive and quickly grasp the underlying logic behind the modular design. Although much can be discovered by simply experimenting on your own, there is a lot to the program that doesn't immediately meet the eye. In this chapter, I take you on a short Lightroom test drive, point out what is new in Lightroom 2, and give you a general overview of this groundbreaking application.

Chapter Contents

1

Lightroom Modules

Lightroom is based on a modular system. The Lightroom modules are Library, Develop, Slideshow, Print, and Web. Let's start by taking a general look at each of these modules. In later chapters, I'll explain in detail how to use them in a coordinated way.

The modules are listed in the upper-right corner of the workspace in the Module Picker, as shown in Figure 1-1. They should appear as shown here when you open the application, but depending on the size of your screen and how you've customized the work area, they may be hidden. Clicking on the name in the Module Picker takes you to that particular module.

> NOTE *When you open Lightroom for the first time, you won't see any images. You must first import your photos into Lightroom, which is the subject of Chapter 2.*

You can set the Module Picker to remain visible (or hidden) by choosing Window→Panels→Show Module Picker from the menu bar, as shown in Figure 1-2.

If the modules are hidden, they can be revealed at any time by clicking on the triangle icon at the top middle of the screen, as shown in Figure 1-3.

> TIP *To quickly get back to the Library module from other modules, simply use the G key (the shortcut for Library Grid). Use D to take you to the Develop module.*

Figure 1-1

Figure 1-2

Figure 1-3

NOTE *There is some functionality crossover between modules. For example, you can perform basic image processing in the Library module, and you can import from within the Develop module (although you'll end up back in the Library module). In general, however, each module provides a workspace designed for a specific set of tasks.*

You can enter a module by clicking on the name of the module in the Module Picker or by using one of the following keyboard commands:

- Library +Opt+1 (Ctrl+Alt+1)
- Develop +Opt+2 (Ctrl+Alt+2)
- Slideshow +Opt+3 (Ctrl+Alt+3)
- Print +Opt+4 (Ctrl +Alt+4)
- Web +Opt+5 (Ctrl+Alt+5)

Library Module

In the Library module, shown in Figure 1-4, you can import, export, organize, search, sort, rate, and tag your images with keywords. You can also apply simple image processing to any number of selected images, or, if you prefer, you can apply a custom preset created in the Develop module to an entire batch of selected images. Lightroom 2 also offers improved folders and files management via the Folders pane, about which I go into more detail in Chapter 3.

Develop Module

The Develop module, shown in Figure 1-5, is where you'll find some of the most powerful features of Lightroom. Not only does the Develop module provide an outstanding RAW converter, but also, all the controls work equally well on JPEG or TIFF images. (Of course, RAW files provide the most flexibility and often the best quality.) Everything you do to your image here is nondestructive. When you export a file, the original is left intact, and Lightroom creates a copy that reflects your edits. No pixels are changed in the original image, even when you use Lightroom 2's new localized correction controls.

Figure 1-4

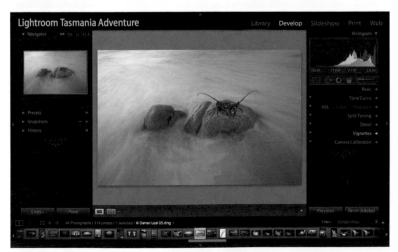

Figure 1-5

Slideshow Module

After you organize your images in the Library and process them in the Develop module, you can use the Slideshow module to make a simple—yet effective—slide show, as shown in Figure 1-6. Personalize each slide with a custom identity plate, add text based on EXIF data, or add custom text to your liking. You can also add sound or convert your slide show into the PDF format for offline viewing. Lightroom 2 offers an export to JPEG option so you can quickly take sequenced images into another application and make a slide show there. (Chapter 10 is devoted to working with the Slideshow module.)

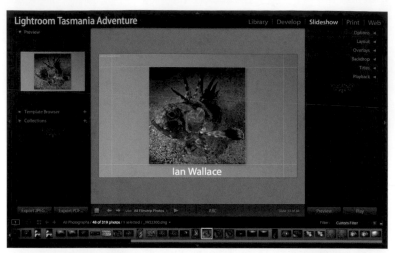

Figure 1-6

Print Module

The Print module shown in Figure 1-7, like the rest of Lightroom, is equally suited for processing single or multiple images. It's set up to print some of the more popular sizes and print configurations (such as contact sheets), which you can also easily customize. Lightroom 2's Print module also includes easy-to-use print packages and a more controllable alignment grid. In version 2 you can also "print" page layouts to JPEGs, and print sharpening has also been improved.

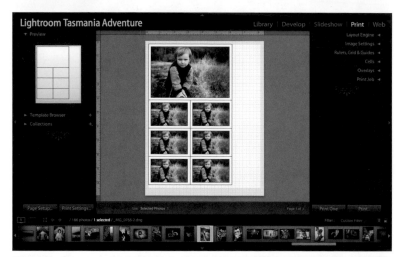

Figure 1-7

Web Module

The Web module creates both HTML- and Flash-based web galleries quickly and easily, as shown in Figure 1-8. Several presets are available, but you can also easily create your own. You can add text-based or image metadata or simply type in your own. (Chapter 11 is devoted to the Web module.)

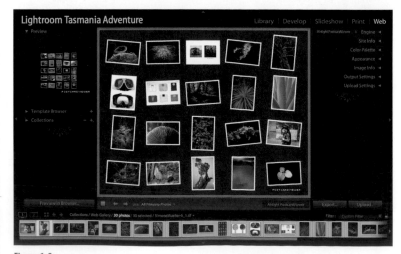

Figure 1-8

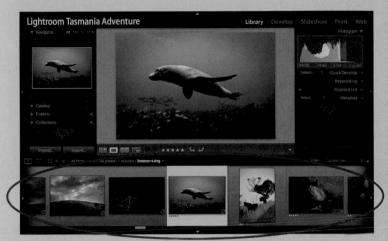

Figure 1-9

Figure 1-10

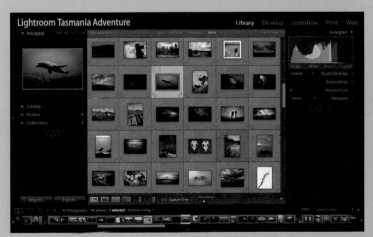

Figure 1-11

The Filmstrip

The filmstrip, located at the bottom of the Lightroom workspace, is the common denominator between the modules. The filmstrip contains thumbnail versions of all the images displayed in the main window of the Library module, and these images can be rearranged directly from the filmstrip, affecting the Slideshow, Print, and Web sequencing. The filmstrip can vary in size. Here in Figure 1-9, for example, it is about as large as it can get relative to the entire interface.

To change the size of the filmstrip, place your cursor on the line between the filmstrip and the main work area; it turns into the shape shown in Figure 1-10. Then drag to change the size of the filmstrip.

You can't make the filmstrip larger or smaller than the examples shown here in Figure 1-11, and you cannot position the filmstrip anywhere but on the bottom of the window.

You can control what information (ratings, and so on) appears on the thumbnails in the filmstrip and other filmstrip functionality in Lightroom's Preferences, under the Interface tab.

(Continued)

You can use the menu command Window→Panels→Show Filmstrip to turn the filmstrip off, as shown in Figure 1-12. You can also turn off the filmstrip by clicking on the small triangle at the bottom of the window. Another click on the same triangle will make the filmstrip reappear.

If you're in the Library's Grid view, with thumbnails visible in the main window for easy selection, the filmstrip may seem redundant. However, in just about any other Library viewing mode, or in any other module, the filmstrip is quite handy. You can quickly find individual images or select multiple images without going back into the Grid view in the Library module.

To scroll through the filmstrip, simply click on the arrows at either end, circled in Figure 1-13. You can also use the scroll bar (circled) at the bottom of the filmstrip to move from left to right and review hidden thumbnails. You can also use the arrow keys on your keyboard to scroll from image to image in the filmstrip.

To select an image from the filmstrip, simply click on the desired thumbnail. A selected thumbnail is outlined like the one circled in Figure 1-14. To select multiple images sequentially in the filmstrip, choose the first image, hold the Shift key, and then click on the final image in the sequence; this also selects the images between the selected thumbnails. For noncontiguous selection or to deselect a single thumbnail, use ⌘+click (Ctrl+click).

Figure 1-12

Figure 1-13

Figure 1-14

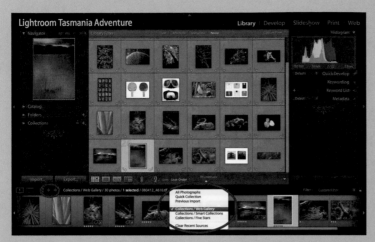

Figure 1-15

Figure 1-16

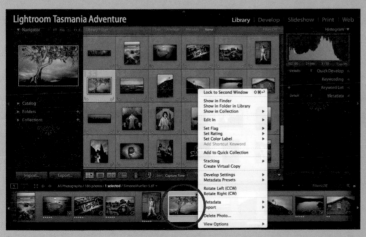

Figure 1-17

You can use the navigator arrows on the left side of the filmstrip (circled in Figure 1-15) to toggle between current and formerly used modules. Click on the grid icon to the left of these arrows and you are taken to the Library Grid mode, regardless of which module you are currently in. Click on the Second Window icon to open a second viewing window. (I cover the Second Window option, which is new to Lightroom 2, in Chapter 3.) You can even switch between collections, or follow "bread crumbs" to previously selected images without going back to the Library module, by using the pop-up menu, which is circled on the right. Click on the arrow next to the file name to reveal the pop-up menu.

Viewing filters, shown circled in Figure 1-16, can also be applied directly from the filmstrip (circled). Viewing filters are covered in Chapter 3.

If you right-click any thumbnail in the filmstrip, you get the contextual menu shown in Figure 1-17. This menu contains many commonly used commands such as Develop Settings, Rotate, and Create Virtual Copies. It also includes filmstrip view options.

In the appropriate chapters of the book, I go into more detail on using the filmstrip while working in different modules.

Peter Eastway

Peter Eastway is one of Australia's most renowned landscape photographers. He is also the publisher of several photo magazines. Peter helped kick off the Tasmanian adventure with an inspiring opening-night slide show of his work at the Hobart Art Museum Hotel. Peter calls this shot, taken from Mount Wellington and looking north, "Peninsula Storm." He literally had to drop from his mountaintop vantage below the clouds to get this early morning shot of the sun rising through storm clouds crossing the Tasman Peninsula.

Organizing the Lightroom Workspace

The Lightroom workspace is extremely malleable. You can easily enlarge or shrink the various windows to suit your viewing and working preferences, whether you are on a laptop in the field or using your large display in the studio.

Let's start with the obvious and then move on to more hidden ways of organizing the Lightroom workspace. Everything here applies to all the modules.

The Obvious

If you are like me, when you see certain icons you naturally want to click on them to see what they do.

See the triangle-shaped icons on the side panels and top and bottom in Figure 1-18? (I circled them in red.) This is a quick way to get extra real estate.

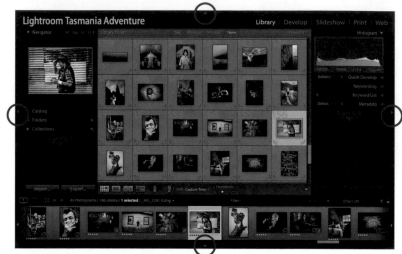

Figure 1-18

I positioned my mouse and clicked on them one at a time. Now I have a screen, shown in Figure 1-19, that displays only my preview images without any extra clutter. To reveal the side panels and the filmstrip and menu bar, simply click on the triangle again. (Rolling your cursor over the triangle while any of the panels are hidden temporarily reveals them. They disappear when the cursor is moved away.)

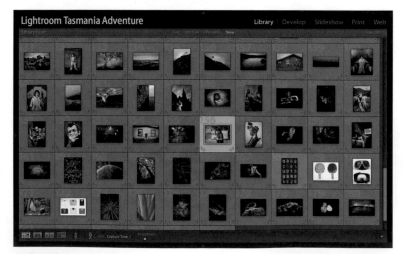

Figure 1-19

Figure 1-20

You can also resize the entire Lightroom window to fill a specific area on your screen by placing your cursor on the bottom right of the window, then dragging the window to the desired size, as shown in Figure 1-20.

Menu commands

Menu commands are another obvious way of controlling the look of your Lightroom work area. Under the Window menu you have several options. The Mac menu (at left in Figure 1-21) is slightly different from the Windows version (at right in Figure 1-21).

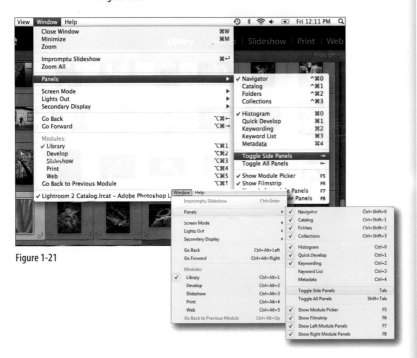

Figure 1-21

Screen mode options

You can change screen modes directly from the menu bar (Window→ Screen Mode), as shown in Figure 1-22. However, learning to use the keystroke F to toggle between screen modes will make your workflow much more efficient. Again, the menu looks slightly different on Mac (left) and Windows (right).

Figure 1-22

Normal (or Standard) Screen Mode

When you set your screen mode to Normal, your screen looks like the one shown in Figure 1-23. The menu bar is visible at the top, and all the panels and the module picker are visible as well. Of course, you can further customize the screen mode by hiding the panels or module picker by clicking on the small side triangles as described previously. (For this example, I've gone from thumbnail view or Grid View to single image view or Loupe View. These are specific viewing options within the Library module, which I'll discuss in more detail in Chapter 3.)

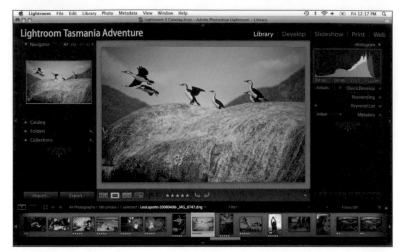

Figure 1-23

Full Screen with Menu

Setting your screen mode to Full Screen with Menu makes your screen look like the one shown in Figure 1-24. The screen looks similar to the Normal screen; however, it fills your display screen and you don't have screen resize capabilities.

Figure 1-24

Full Screen

With Full Screen the menu bar is gone, unless you roll your mouse over it. Side panels and filmstrip remain as shown in Figure 1-25 unless you choose to hide them.

Figure 1-25

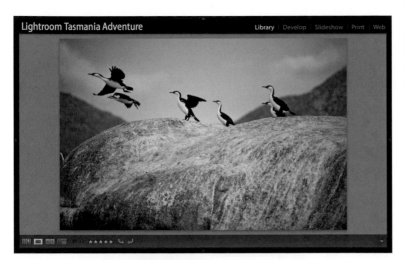

Figure 1-26

Figure 1-27

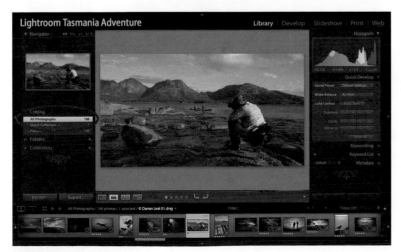

Figure 1-28

Full Screen and Hide Panels

This mode maximizes the image viewing area, yet maintains some of the viewing and sorting tools as shown in Figure 1-26.

Not So Obvious

Lightroom provides a couple of not-so-obvious commands that help you organize and frame your work area more efficiently.

For example, by default, all the panes in all the side panels (circled in Figure 1-27) open sequentially and remain open when you click on them.

If you hold the Opt/Alt key while clicking on any side panel pane (like the one circled in Figure 1-28), only that pane opens, in the so-called Solo mode. To return to the default behavior, hold the Opt/Alt key and click on the pane again. This behavior is on a panel-by-panel basis.

You can also control the behavior of the panes by right-clicking anywhere on the pane header (except on the triangle).

The contextual menu shown in Figure 1-29 appears. If you select Solo Mode, you duplicate the behavior described previously (the same effect as when you hold the Opt/Alt key while clicking on the pane). You can also hide individual panes by deselecting the check mark next to their name. (You can't, however, rearrange the panel order.) The choices are applied on a panel-by-panel basis.

You can swap, customize, or remove the panel end mark at the bottom of the left or right panel. Right-click the bottom of a panel to bring up a contextual menu, as shown in Figure 1-30. (Custom panel end marks are PNG files placed in the Panel End Marks folder. The file is available in the Panel End Mark contextual menu when it is in the Panel End Marks folder.)

> TIP *Photoshop users are probably familiar with using the Tab key to hide tool palettes. Selecting the Tab key in Lightroom hides (or reveals) the side panels and is a quick way to maximize the image viewing area. Shift-Tab hides the top and bottom panels as well.*

Setting Interface Preferences

Lightroom interface preferences can also be used to customize the look and feel of the workspace. Select Preferences (under the Lightroom menu on a Mac, under the Edit Menu on Windows) and click on the Interface tab. Here, as shown in Figure 1-31, you can find choices for many things, including the look of the panel end mark, Lights Out levels, background colors and texture, and filmstrip view options.

Figure 1-29

Figure 1-30

Figure 1-31

Lights On Lights Out

This falls in the category of way cool, especially for those who like to toggle between working on their images and viewing (or showing off) their images without distraction. Figure 1-32 shows the viewing area with Lights On, the default setting. All the panels and filmstrip are clearly visible.

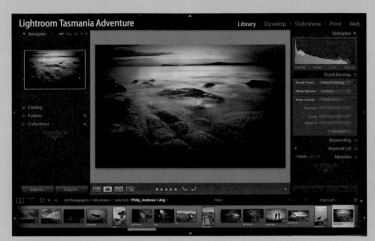

Figure 1-32

Figure 1-33

Figure 1-33 shows the viewing area with Lights Dim selected. The panels and filmstrip are still visible, albeit dimmed.

Figure 1-34

Figure 1-34 shows the work area with Lights Out. Now the image is easily viewable with no distractions.

To control the Lights Out feature, you can use the menu control Window→Lights Out. It's far easier, however, just to press the L key and toggle between states. In Preferences, under the Interface tab, you can set Dim Level and/or Screen Color. This affects the entire desktop, even on multiple monitors.

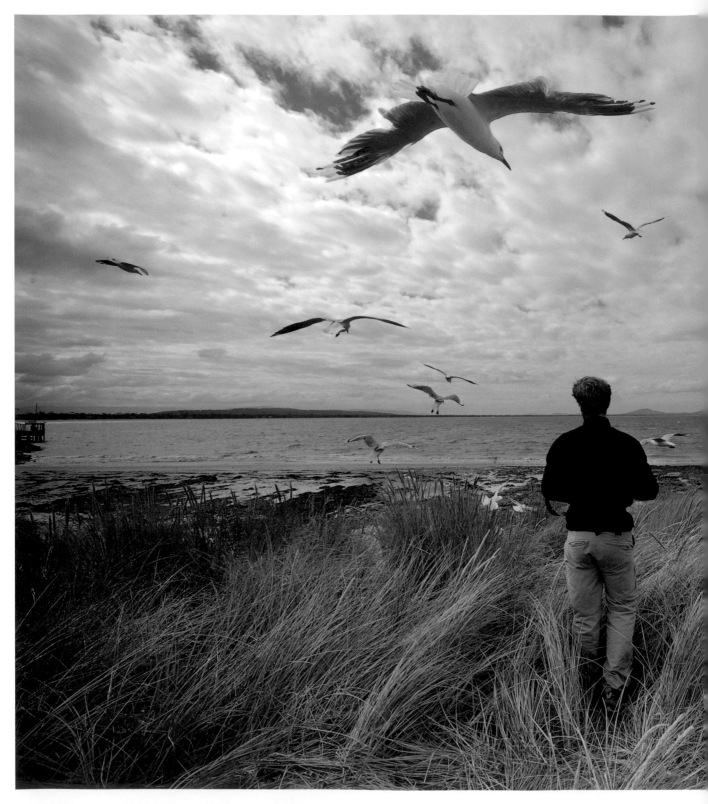

Mikkel Aaland

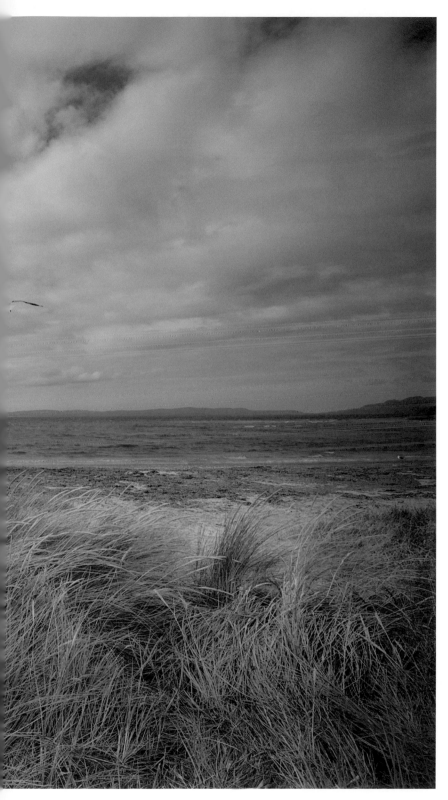

One of the disadvantages of organizing the Adobe Adventure is that I don't get enough time to shoot. However, here is one shot I took in Tasmania that I particularly like. It really was an accident. Jeff Pfleuger and I were eating our sack lunches on the Swansea waterfront, overlooking Great Oyster Bay, on the Tasmanian east coast, and I purposely threw bread at a few birds to attract enough of them to make a good photograph. Jeff, seeing what I was up to, jumped up with *his* camera and stepped in front of me, ruining, I thought, my shot. Well, of course, the shot with Jeff turned out to be the best of the lot.

I look at the photo now, and I'm struck with the title that Diane Byrne from the Events Tasmania office gave it when she saw it at our benefit auction. She titled it "The Island of Inspiration," and she got it right. It truly was a few weeks of inspiration, and although I'm always happy be home with my wife and two daughters, I am already scheming ways to go back, and bring them with me.

Creating Identity Plates

You can personalize the Lightroom environment by creating identity plates that appear throughout the application for a nice aesthetic touch. They also have very practical purposes —they can be used to identify Slideshows, Web Galleries, and Prints. Here's how to set up an identity plate of your own.

First, select Lightroom→Identity Plate Setup (Mac) or Edit→Identity Plate Setup (Windows). This brings up the dialog box shown in Figure 1-35. If you select "Use a styled text identity plate" (circled), you can type your name or descriptor in the text field. Choose a font, font style, and size from the pop-up menus below. Change the color by clicking on the color swatch next to the type size and selecting a color.

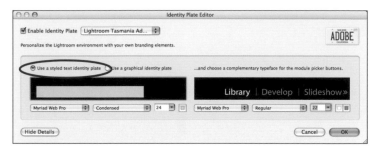

Figure 1-35

If you select Enable Identity Plate at the top of the dialog box, your work appears in the upper-left corner of the Lightroom workspace (circled in Figure 1-36) and you can view the effects of your type and color choices.

Figure 1-36

If you select "Use a graphical identity plate" (circled in Figure 1-37) you can import a premade graphic by dragging it from your desktop to the box or navigating to the file by selecting Locate File. The graphic can be a JPG, GIF, PNG, or TIFF file, but no larger than 60 pixels high. Keep in mind that the graphical identity plate may be adequate for screen viewing but too low a resolution for printed output.

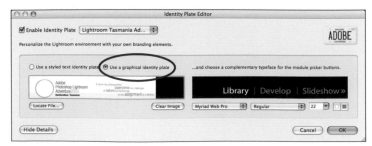

Figure 1-37

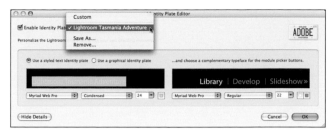

Figure 1-38

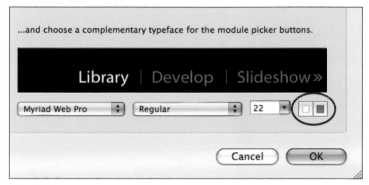

Figure 1-39

Create Multiple Identity Plates

You can create as many identity plates as you want, but only one can be used at a time. To do this, choose Save As from the Enable Identity Plate menu, and give your identity plate a name. When you next select the pop-up menu, the new name will appear, as shown in Figure 1-38.

Customize Module Picker Buttons

In the Identity Plate Editor you can also customize the font, size, and color of the Module Picker buttons to create a complementary typeface to go with your personalized one.

The first color picker box to the right of the font size sets the color of the current selected module, and the second box sets the color for unselected modules (circled in Figure 1-39).

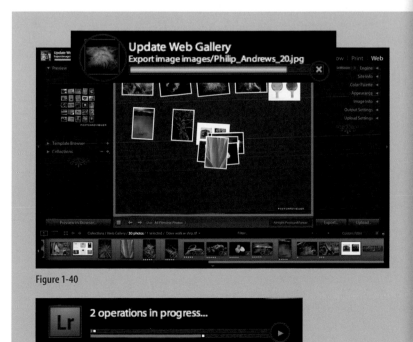

Figure 1-40

Figure 1-41

Reading the Progress Bar

Lightroom can process many tasks simultaneously. For example, you can export a batch of DNGs and build a Flash web gallery at the same time. Keep track of the progress of each operation with Lightroom's Progress bar, found at the top-left corner of the Lightroom display window and shown in Figure 1-40. A small thumbnail (circled) indicates which image the operation is currently working on. Cancel an operation by clicking on the X (circled). When two or more operations are in progress, click on the arrow (circled in Figure 1-41) and toggle between the status indicator of each operation.

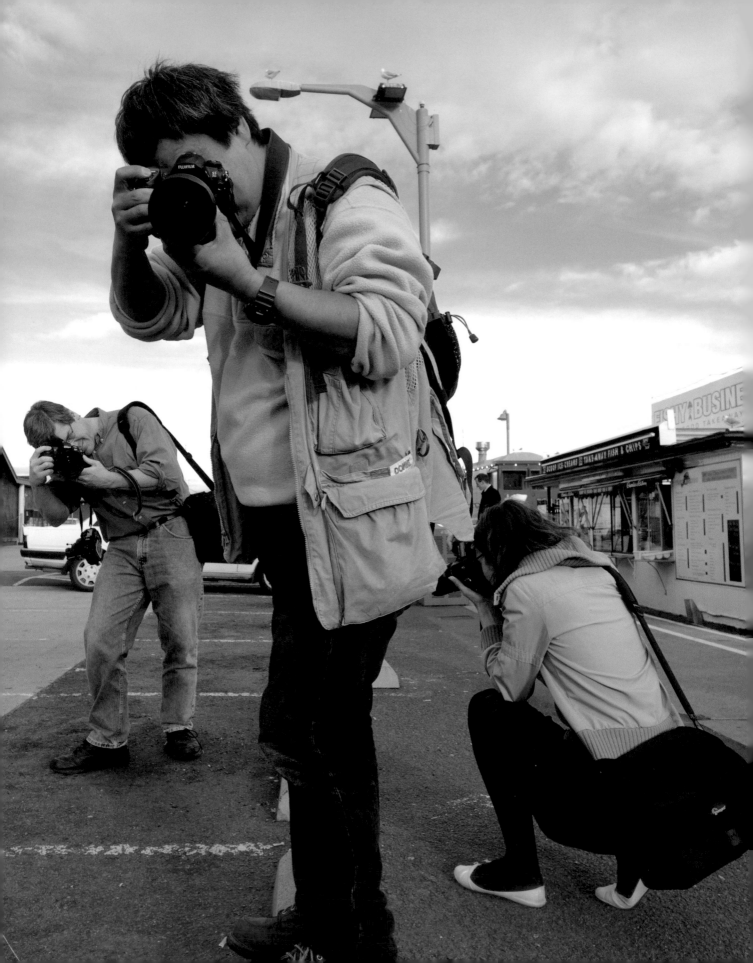

Importing Images into Lightroom

You don't *open* image files in Lightroom like you do in Photoshop, or *browse* to image files as you do with Adobe Bridge. You must first *import* images into Lightroom, either directly from your digital camera, or from your hard drive or other storage device. On import, Lightroom creates an image preview and a link between the preview and the original image file. When you work on your image in Lightroom, the program keeps a record of any changes in a database catalog and never touches a pixel in your original image. But I'm getting ahead of myself. Let's first see how to import images into Lightroom.

Chapter Contents

Importing Images

There are several ways to import your images into Lightroom. There are also several things you can do on import that will make your job easier when you are ready to organize, edit, rate, and process your images in Lightroom. Let's start the process.

Use the Import Button

The most obvious way to start the Import process is by clicking the Import button at the bottom of the left panel in the Library module, circled in Figure 2-1.

Of course, if you don't see the button, just click on the triangle to the left of the workspace to reveal the side panel, or press the Tab key. After you select Import, you'll be prompted to navigate to the folder/files or Lightroom catalog that you want to import.

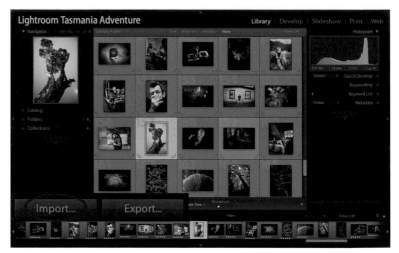

Figure 2-1

Use the Keyboard or Menu Command

Several Import commands can also be found under the File menu, as shown in Figure 2-2. (Windows and Mac menus are slightly different.) You can also start the import process for files or a catalog with the keyboard shortcut +Shift+I (Ctrl+Shift+I). This command is available in all the modules; however, regardless of which module you are in, Lightroom switches to the Library module for import.

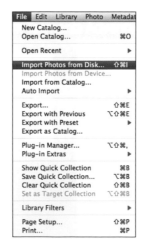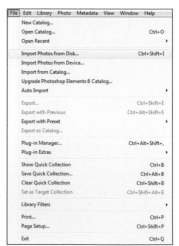

Figure 2-2

Use the Drag and Drop Method

You can drag and drop images from your finder or explorer (or an application like Adobe Bridge) directly into Lightroom by dragging the images onto the Lightroom application icon, as shown in Figure 2-3. This launches Lightroom and brings up the Import Photos dialog box. You can also drag an image into the display

Figure 2-3

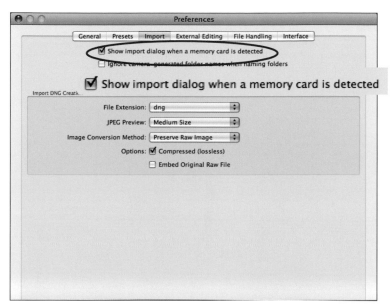

Figure 2-4

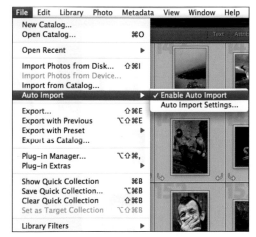

Figure 2-5

NOTE *You can choose the type of sound (or no sound) to alert you when import (or export) is complete. To do this:*

1. *Open the Preferences→General tab.*
2. *Select the desired alert (or None) from the pop-up menu.*
3. *Typically you would select different sounds for import and export so you can differentiate between the two.*

window of the Library module and the import begins.

Import Automatically from Card or Camera

In Lightroom's Preferences/Import tab, "Show import dialog when a memory card is detected" is selected by default as shown in Figure 2-4. This means that when Lightroom is running, import starts automatically when you insert a memory card or hook up a digital camera to your computer. To disable this autoimport "feature":

1. Open Preferences (Lightroom→Preferences on Mac, File→Preferences in Windows).

2. Under the Import tab, deselect "Show import dialog when a memory card is detected." When a card is detected, Lightroom won't do anything, but you can still manually import from a card via File→Import Photos from Device, or by clicking on Import in the left panel.

Auto Import from Watched Folder

If you select File→Auto Import→Enable Auto Import, as shown in Figure 2-5, you can drag and drop files or folders of images into a specially created location, for example, on your desktop, and import occurs automatically. (See the last section of this chapter for specifics on setting this option.)

Import from Catalog

You can specifically import images from another Lightroom catalog by selecting File→Import from Catalog from the menu bar. I get more into creating and using catalogs in the next chapter.

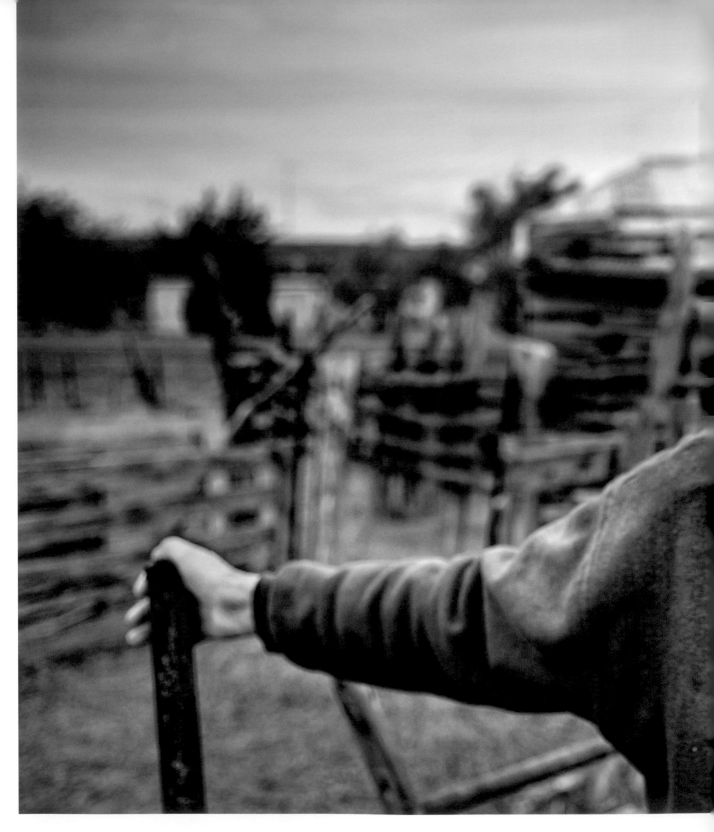

Catherine Hall

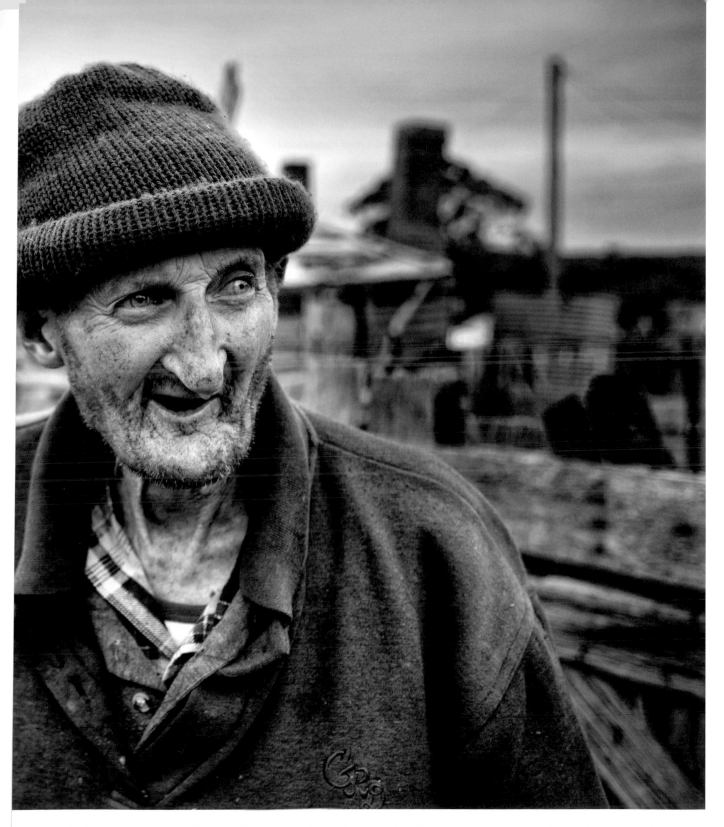

Catherine made it clear from the beginning of the adventure that she wanted to photograph people in Tasmania, not landscapes. She hit the ground running and quickly filled her Lightroom Library with heartwarming portraits such as the one shown here, "Ted." Ted is an 80-year-old sheep farmer who lives on the outskirts of Cranbrook, on the eastern shore of Tasmania. Catherine and Angela Drury discovered him on one of their outings and spent several hours photographing and visiting him, much to his delight. "He flirted and laughed a lot," explains Catherine, "and told us about all the women whose heart he broke when he told them he had no plans on getting married, ever."

import" is that it seriously slows the import process, especially if your image files are large.

Move photos to new location and add to catalog This option (circled in Figure 2-13) is similar to the previous one, but it actually moves the original file and places it in a predetermined location on your hard drive. Because it isn't copying the file, only moving it, the process doesn't take as much time as the previous choice. Be aware that if you're using this option with a card reader or your digital camera as source, Lightroom deletes the files from the card or camera after moving them.

Copy photos as Digital Negative (DNG) and add to catalog This choice, as shown in Figure 2-14, turns your original RAW files into DNGs and places the DNG files in a predetermined folder on your hard drive. The original files are left in their original location. (DNG stands for Digital Negative, a standardized, openly documented RAW file format championed by Adobe.) You can also convert a TIFF or JPEG file into a DNG. (Important DNG creation preferences are found under Lightroom's Preferences/Import tab.)

Initial Previews

Determine the way Lightroom generates image previews with the Initial Previews pop-up menu. You have four choices, as shown in Figure 2-15. Minimal means that Lightroom generates previews in the most efficient way, often using preexisting preview files generated by your digital camera. The next choice is Embedded & Sidecar, which, depending on what

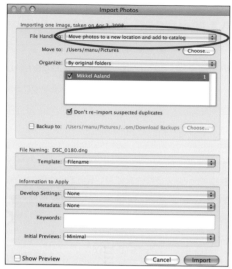

Figure 2-13

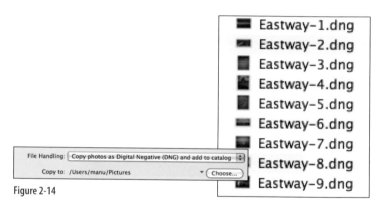

Figure 2-14

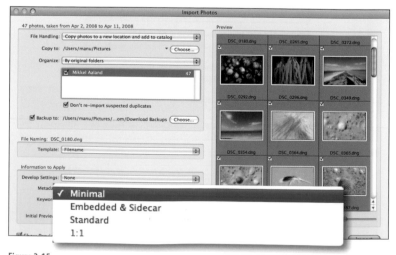

Figure 2-15

Figure 2-16

Figure 2-17

data is associated with your image files, can result in quickly viewable previews with higher quality than those generated by the Minimal setting. (Regardless of what you choose, Lightroom eventually generates an appropriate-size preview when you select and work on the image.) Select Standard and Lightroom generates a 1440-pixel preview by default or a user-set size determined in preferences (See below). Select 1:1 and Lightroom generates a preview the same size as the original file. Both the Standard and 1:1 options can considerably increase the import time but save you time when you enlarge or work on a file.

Setting preview image sizes in Catalog Settings

Let's briefly leave the Import Dialog box to discuss the preview preference choices, found in the Catalog Settings dialog box under the File Handling Tab. (Select Lightroom→Catalog Settings for Mac, Edit→Catalog Settings for Windows, or, in Lightroom's Preferences/General tab, select Go to Catalog Settings.) Here you can set the size of the standard preview, as shown in Figure 2-16. Obviously, the larger the preview, the slower the import. You can also set the preview quality to High, Medium, or Low, which can be important if hard drive space is an issue. All these settings apply on a catalog-by-catalog basis.

Manually building previews

As shown in Figure 2-17, after import, you can instruct Lightroom to build or render standard-size or 1:1 previews in the Library module, by selecting Library→Previews from the menu bar. Depending on how many images are selected, this may take some time. (1:1 previews are used in the Develop module

File Format Support

Lightroom supports the following file formats: JPEG, TIFF, PSD, RAW, and DNG. At this time, Lightroom doesn't support any video format. Although Lightroom supports the PSD file format (it better!), if your PSD file contains layers, only a flattened composite appears in the Lightroom viewing window. Individual layers are not accessible in Lightroom, although the original file with layers is kept intact. If you shoot JPEG plus RAW, Lightroom offers you the choice of importing only the RAW file or both of the file formats. (Make the choice in Lightroom's Preferences/Import dialog box by selecting or deselecting "Treat JPEG files next to raw files as separate photos.")

As you may already know, there is no such thing as a single RAW file format. Every camera manufacturer has its own, and it varies between models. In order to support the latest RAW formats, Lightroom engineers are kept busy updating the application. This means that you have to keep busy as well, checking the Adobe site frequently to see if updates are available. You can set a Lightroom preference to check automatically for you. To do this:

1. Open Lightroom preferences (Lightroom→Preferences on a Mac, Edit→Preferences in Windows).

2. In the General tab, select Automatically check for updates (circled in Figure 2-18).

You can also go to the Help menu and direct Lightroom to check for updates, as shown in Figure 2-19.

NOTE *At this time Lightroom supports photos up to 60,000 pixels in length or width.*

Figure 2-18

Figure 2-19

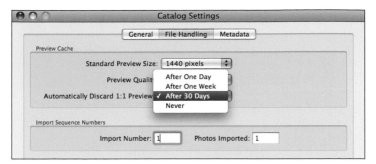

Figure 2-20

Figure 2-21

and are generated automatically when you select and work on an image there. Prerendering 1:1 previews may save you a little time in the Develop module, but it isn't necessary.)

Discarding previews

Because 1:1 previews are essentially full-resolution versions of your image, they can take up a lot of storage space. You only really need these 1:1 previews when you process an image or print in draft mode or show a slide show, so you may find it useful to purge your system from time to time. You can do this manually by selecting Library→Previews→Discard 1:1 Previews, or you can set up a Catalog Settings preference, as shown in Figure 2-20, so the 1:1 previews are automatically purged at an interval set by you.

Renaming Files on Import

OK, now back to the Import Photos dialog box. You can rename files on import, but in order to do so, you must first choose "Copy Photos to a new location and add to catalog" or "Move Photos to a new location and add to catalog" or "Copy Photos as Digital Negative (DNG) and add to catalog" from the File Handling pop-up menu (circled in Figure 2-21). With these choices, the renaming features are enabled (shown circled). If you select "Add photos to catalog without moving" the renaming features are not enabled.

As you can see in Figure 2-22, digital cameras generate unique file names, but you'll probably want to customize these file names on import to make them more useful and to lessen the chance of inadvertently overwriting them at a later date. Most digital cameras are capable of

Figure 2-22

generating eight-character file names. If you set your camera to generate sequential numbers and don't reset every time you erase files from card memory, you're off to a good start. However, what happens if you shoot with multiple cameras by the same manufacturer? The chances of creating image files with the same name goes up, and so does the chance that you'll overwrite one file with another.

To avoid this potentially disastrous situation, you can create a unique file name the first time you touch your image file and never change it. (Derivatives, of course, get their own unique file name later.) A good time to do this is when you import images into Lightroom.

Creating custom file names

Although several presets are available in the Filename Template Editor pop-up menu shown in Figure 2-23, I prefer to create a custom file-naming nomenclature recommended by my fellow Adventurer and digital asset management expert, Peter Krogh.

To do this:

1. Select Edit... (circled in Figure 2-23) from the Filename pop-up menu.

2. The Filename Template Editor appears, as shown in Figure 2-24. Empty the field window with the Delete key. Then, in the field window (circled) type in your name, followed by an underscore. Use the Delete key to correct any errors.

3. Find Date (YYYYMMDD) in the Sequence and Date subsection and click Insert. (You can choose how the year, month, and day are displayed. I prefer the YYYYMMDD format.)

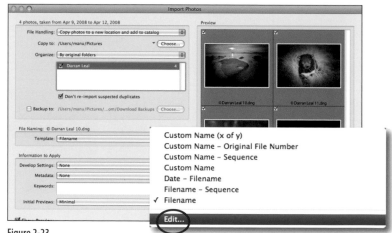

Figure 2-23

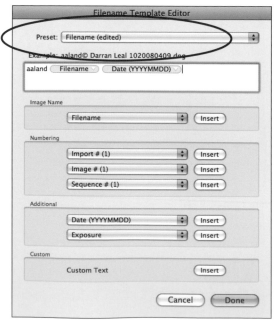

Figure 2-24

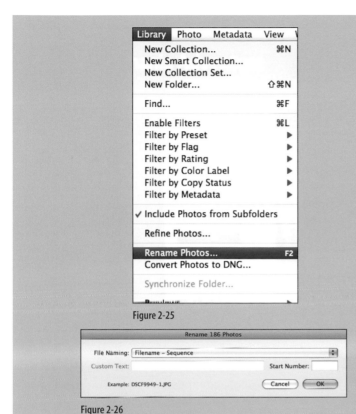

Figure 2-25

Figure 2-26

✓ Filename (edited)

Custom Name (x of y)
Custom Name – Original File Number
Custom Name – Sequence
Custom Name
Date – Filename
Filename – Sequence
Filename

Save Current Settings as New Preset...
Update Preset "Filename"

Figure 2-27

Rename After Import

You can always rename your files after im-
port in the Library module. After selecting
the images you wish to rename:

1. Select Library→Rename Photo... from the
 menu bar, as shown in Figure 2-25.

2. In the resulting dialog box, select your
 new naming protocol from the File
 Naming pop-up menu, or type in custom
 text in the Custom Text field, shown in
 Figure 2-26. An example of the new file
 name will appear at the bottom of the
 dialog box.

3. Bring up the Filename Template Editor
 by selecting Edit from the File Naming
 pop-up menu. Here you can create a new
 file name template based on numerous
 criteria. See previous page for more on
 this.

 The actual date will be derived from
 camera EXIF data. Type an underscore
 after the Date field.

4. Find Filename under the Image Name
 subsection and click Insert. Again,
 the actual file name is derived from
 camera EXIF data.

As you build and customize the file name,
an example appears above the field
window. When you are finished, select
Save Current Settings as New Preset from
the Preset pop-up menu, as shown in
Figure 2-27. Name the preset and then
click Done. Next time you select the
pop-up Template menu, the new preset
will appear as a renaming option.

Proper Punctuation

To create file names that are readable by all systems, you should follow certain universal rules. For example:

- Avoid all punctuation except underscores, dashes, and a single period prior to the file extension. You can set a Lightroom preference to automatically correct file names with unacceptable punctuation. Do this in the Lightroom Preferences in the File Handling tab, shown in Figure 2-28.

- Use no more than 31 characters.

- Every file name should have a 3-letter extension preceded by a period.

Applying Other Information on Import

Let's go back again to the Import Photos dialog box, shown in Figure 2-29. Here you can apply a custom develop setting and create and apply a custom metadata preset on import. You can also, if you want, apply a set of keywords on import that can be used later for sorting, editing, and filtering your images (circled).

Develop options on import

Lightroom ships with several develop presets, as shown in Figure 2-30. In later chapters, I show you how to create your own custom develop presets, which also show up in the Import window, as mine appear here. Remember, even if you apply these presets to your images, Lightroom doesn't touch the original image file. It just applies the preset to the previews. You can change the settings at any time with no loss in image quality.

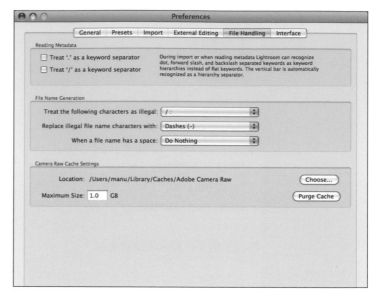

Figure 2-28

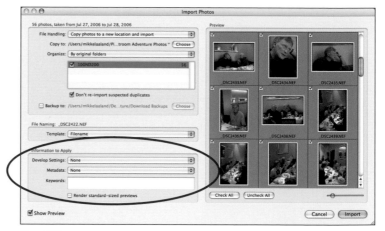

Figure 2-29

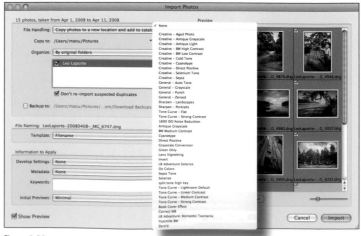

Figure 2-30

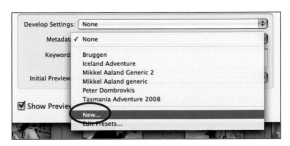

Figure 2-31

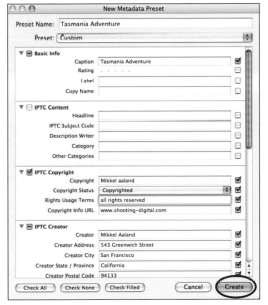

Figure 2-32

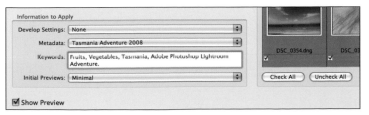

Figure 2-33

Metadata presets for import

I find the metadata preset on import feature one of the most useful of all. Instead of applying my name, copyright notice, and contact information on an image-by-image basis, I can do it all at once on import. You can create as many presets as you want. With Lightroom 2, you can also include keywords in a metadata preset. To do this:

1. Select New from the pop-up menu (circled in Figure 2-31).

2. In the resulting New Metadata Preset dialog box (Figure 2-32), fill in the appropriate IPTC data fields and Keywords entry box, name your new preset, and select Create.

3. Next time you open Lightroom and select Import, your new preset will appear in the metadata pop-up menu. (To prevent unwanted metadata presets from appearing in this menu, see "Deleting Metadata Presets" below.)

Editing metadata presets

To edit existing presets, select Edit Presets from the metadata pop-up menu. Use the resulting Edit Metadata Presets dialog box to make your changes, then select Done.

Add keywords on import

You can also add keywords that describe the content of your images on import on a one-time basis, which is useful for shoots that contain common themes or content, as shown in Figure 2-33. Keep in mind that for many images you'll want to add content-specific keywords on an image-by-image basis, something you can do more effectively in the Lightroom Library module (see Chapter 3).

Deleting metadata presets

In Lightroom 2, to delete unwanted or unused metadata presets you select Delete preset "[preset name]" from the Metadata Presets dialog box metadata pop-up window, as shown in Figure 2-34. (In earlier versions of LR the only way to delete a preset is to go to the Metadata Presets folder and trash the preset file directly from your desktop.)

Import Based on Camera Serial Number or ISO

You can set your Lightroom preferences to automatically apply a custom develop default setting on import based on a camera's serial number. If you shoot with multiple digital cameras and want to apply your own customized default RAW conversion to each one automatically, this option is very useful.

You can also set your preferences to apply a different default based on a specific ISO. Higher ISO settings typically result in more electronic noise, and you may want to create a default setting that automatically applies noise reduction.

To do either, start in the Develop module and use the Develop module controls as desired. (Chapter 4 goes into detail about using the Develop module.) Then:

1. Open Lightroom's Preferences, and in the Presets tab check the "Make defaults specific to camera serial number" check box, as shown in Figure 2-35. You can also select "Make defaults specific to camera ISO setting."

2. In the Develop module, select Develop→Set Default Settings from the menu bar. This brings up the Set Default Develop Settings dialog box

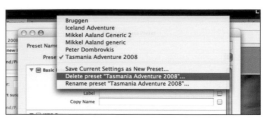

Figure 2-34

NOTE *Mac users can import their entire iPhoto library into Lightroom. Do this by finding the iPhoto Library on your desktop (usually found under Pictures). Right-click on the iPhoto Library on your desktop and in the pop-up menu select "Show Package Contents". Drag and drop the folder containing the images you wish to import on to the Lightroom icon in the dock or on to the application icon on the desktop. When the Lightroom Import Photos dialog appears, import as described earlier in this chapter.*

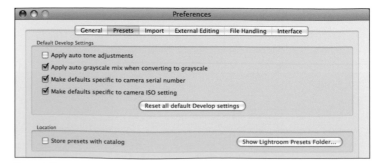

Figure 2-35

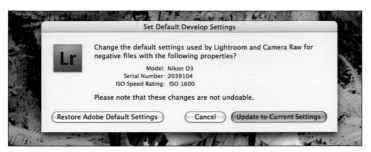

Figure 2-36

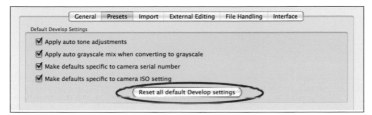

Figure 2-37

shown in Figure 2-36. Choose to either establish the current settings as the default or to restore the Adobe defaults. Now, on import, when Lightroom encounters either a specified camera model or a specified ISO setting, it will automatically apply the customized default.

In Preferences/Presets you can also restore all the Adobe defaults and discard the customized settings files (circled in Figure 2-37).

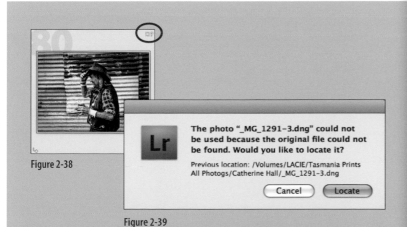

Figure 2-38

Figure 2-39

Figure 2-40

Finding Missing Files

Missing files can occur when you are not connected to the external source that contains your files, or if you move your files to another directory. If Lightroom can't locate a file, you get a warning question-mark icon (circled in Figure 2-38) in the thumbnail frame. What should you do? Start by clicking on the question mark, bringing up the screen shown in Figure 2-39. Select Locate and navigate to your files in the directory. Use the directories search function to help. If you are missing multiple files from one location, select Find Nearby Missing Photos from the directory dialog box, and Lightroom will automatically link to the others. You can also locate missing files on a folder-by-folder basis by right-clicking on a folder with a ? in the Folders pane and selecting Find Missing Folder, as shown in Figure 2-40.

Angela Drury

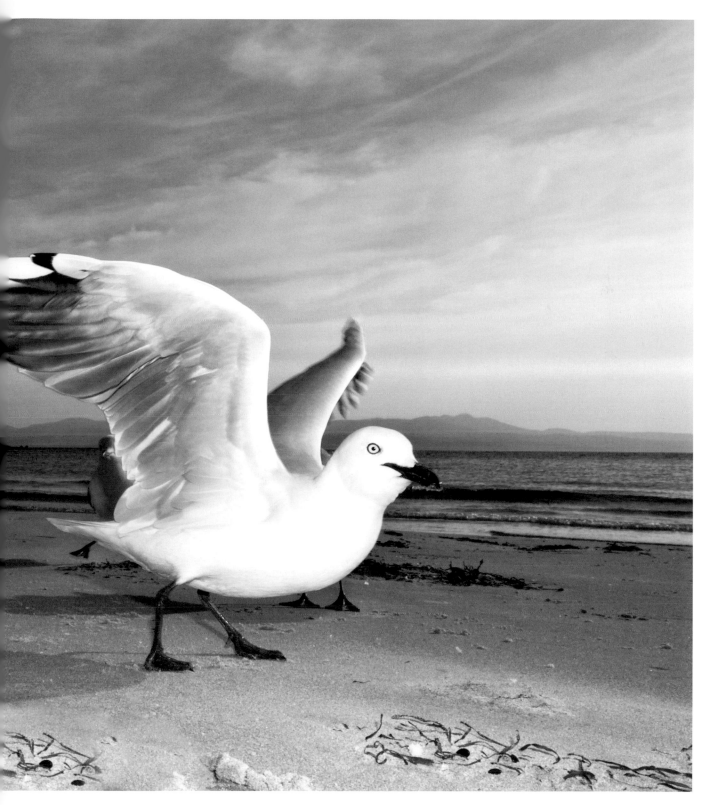

Angela Drury is the Adobe person responsible for many of the Lightroom Develop presets and also a great photographer. She shot this photo on a beach on Maria Island on the east coast of Tasmania, not far from the town of Bicheno where the Adventure team lodged. The island has a storied past as a convict colony and is now a nature park, complete with a wild herd of kangaroos, and is accessible only by boat. Angela took this shot lying on her stomach, using her Nikon D300's pop-up flash to add fill to the late afternoon light.

Creating and Using Watched Folders

By enabling Lightroom's auto import feature from the menu bar, you can automatically import photos into the Lightroom Library module using a designated watched folder. Let's see how to set up and use this feature.

Start by selecting Auto Import from the file menu, as shown in Figure 2-41. Then:

1. Choose File→Auto Import→Auto Import Settings.

2. In the Auto Import Settings dialog box, set the following, as outlined in Figure 2-42:

Figure 2-41

Watched Folder Select Choose, and, in the resulting Auto Import Settings dialog box, select an existing folder (it must be empty) or make a new folder and give it a name, such as "Lightroom Imports."

Destination Select Choose and create or choose a folder where you want the images from the previously described folder to end up. If you don't do anything, Lightroom automatically names the folder Auto Imported Photos and places the managed images in the Pictures folder (Mac OS X, Windows Vista), or the My Pictures folder (Windows XP).

File Naming Here, you can specify the file name protocol, as described earlier.

Figure 2-42

Information Here you can select Develop Settings presets or Metadata presets and add keywords, as shown in Figure 2-43. Choose carefully. Your choices will apply to all images placed in the Watched Folder.

When you are finished with the Auto Import Settings, click OK. The next time you are ready to import a single image or a folder full of images, simply drag and drop the file into the watched folder and the import will start automatically. No dialog box will appear, but the status bar at the top left of the Library module will give you an indication of the progress.

Figure 2-43

Tethering a Digital Camera

You can tether a digital camera directly to your computer and view images in near real-time in Lightroom, as shown in Figure 2-44. You'll need a supported digital camera (not all are) with separate capture software. You won't be able to control your camera or release the camera shutter via Lightroom; that's for the camera software to do. But you can create a nearly seamless workflow of capture, import and edit, and display. To do this:

1. Set up your camera's capture software and attach your camera.

2. Create a watched folder. (See previous section for details.)

3. Point your capture software to the Lightroom watched folder. That's it. Now when you shoot, your files are automatically sent to Lightroom and are ready for editing and viewing.

Figure 2-44

Using the Library Module

The next stop after importing images into Lightroom is the Library module, where you do your editing, rating, and sorting. It's also where you can add appropriate keywords and other metadata, as well as perform some basic image processing on one or multiple images at the same time. You'll be amazed at how easy it is to select, zoom in, and examine images for sharpness and content, as well as compare images in a side-by-side view. No longer will the thought of dealing with hundreds of images seem daunting. It might even seem like an adventure!

Chapter Contents

PHOTO CREDIT: Robert Edwards

The Library Module Revealed

At first glance, Lightroom's Library module has similarities to Adobe Bridge and other image browsers. Scalable previews in the viewing area can be easily sorted, edited, and have keywords and ratings applied. But, as you will see, there is much more to Lightroom's Library module.

The Library module consists of the view control panel on the left, the activity control panel on the right, the main viewing window in the middle, and the Library filter above the viewing window, as shown in Figure 3-1. The Library filter, new to Lightroom 2, replaces the Metadata Browser in Lightroom 1 and can be revealed and hidden with the \ keystroke. The left and right panels contain panes with specific functions. Near the bottom of the window are the toolbar and filmstrip. As explained in Chapter 1, the panels, toolbar, and filmstrip can easily be hidden or, in some cases, resized, maximizing the viewing area.

Let's take a quick look at the basic components of the Library module, see what they do, and then get into specific Library module-related tasks.

The Left Panel (View Controls)

The left panel consists of the Navigator and other panes through which you can control and refine what is displayed in the main viewing window.

Navigator pane

The Navigator pane displays the current active selection, as shown in Figure 3-2. While several images can be *selected* at once, only one image is considered *active*. (See "Selecting Thumbnails in Grid View

Figure 3-1

Figure 3-2

Lightroom Catalogs

Lightroom saves its image database as a *catalog*. You can create multiple catalogs, but only one catalog can be open at a time. Catalogs can be created (or integrated with each other) as a backup strategy or as a way of sharing all or parts of a catalog of images between, for example, an in-the-field laptop and a desktop unit, or between users of the same computer.

You can create a new catalog while Lightroom is running by selecting File→New Catalog from the menu, or, on startup of the application hold the Option (Alt) key and select Create New Catalog from the Select Catalog dialog box, as shown in Figure 3-3. Name the catalog whatever you want but be sure to keep, or add if necessary, the .lrcat extension.

You can also import selected images as a catalog (File→Export as Catalog). Collections or folders located in the left panel can also be exported as a catalog (right-click on the folder or collection name and select Export this Folder as a Catalog... from the contextual menu, as shown in Figure 3-4).

To open an existing catalog, go to File→Open Catalog or File→Open Recent. Choose a catalog, and Lightroom will relaunch and open with the new catalog (after making sure that's what you want to do). You can also hold the Option (Ctrl) key while launching Lightroom and choose a catalog from the Select Catalog dialog box. This dialog box opens automatically if you set your Lightroom preferences as shown in Figure 3-5.

NOTE *It's possible to import and integrate one catalog (or part of a catalog) with another catalog. To do this, select File→Import from Catalog and navigate to a catalog. After you select open, the Import from Lightroom catalog dialog box appears, where you can further refine your import options.*

Figure 3-3

Figure 3-4

Figure 3-5

and Filmstrip," later in this chapter.) Clicking on the image in the Navigator pane immediately takes you from the thumbnail (or Grid) view in the main viewing area into the single-image Loupe view, where different magnification levels can be quickly applied. (Press the G key to return to the Grid view.) Clicking and holding on the image in the Navigator temporarily puts you in Loupe view. Releasing the mouse puts you back in Grid view.

Figure 3-6

Quick Collections

You may notice in the Catalog pane (shown in Figure 3-6), under All Photographs, the category Quick Collection. I'm often asked what this means. Think of a quick collection as a temporary holding area during an edit session. Select a thumbnail and use the B key to place the image in the quick collection. Type B again to remove it. Quick collections can be saved and renamed and then included as a permanent collection category. (File→Save Quick Collection), as shown in Figure 3-7. To empty a quick collection, select File→Clear Quick Collection. To display the contents of a quick collection, click on Quick Collection in the Library pane or use the menu command File→Show Quick Collection. If you have set your Library module View Options (View→ View Options) to Include Quick Collection Markers, a shaded dot (circled in Figure 3- 8) appears on mouseover in the thumbnail, designating its inclusion. Clicking this dot removes the image from the quick collection. Click it again to add it back to the quick collection.

Figure 3-7

Figure 3-8

Figure 3-9

Figure 3-10

Figure 3-11

Catalog pane

In the Catalog pane, shown in Figure 3-9, you see at least three categories. (If you have duplicate images, or a previous export, at least three other categories appear.) Click on any of the categories and the appropriate thumbnails are displayed in the main viewing window.

- All Photographs is a total accounting of all the images in your active catalog.

- Quick Collection shows the number of images you've placed in the quick collection. (See previous sidebar.) Right-clicking brings up a contextual menu. A plus sign indicates this is a target collection. (Later, under "Collections," I'll show you how you can make any permanent collection from the Collections pane a target collection, with quick collection properties and controls.)

- Previous Import includes only the images from the last import.

- Previous Export as… includes images last exported as a new catalog.

- Already in Catalog appears when you have duplicate files in your catalog. You can erase them by right-clicking on the pane and selecting Remove this Temporary Collection, as shown in Figure 3-10.

Folders pane

The Folders pane displays a folder/data hierarchy based initially on your import settings. The number to the right of the folder name tells you how many files are in that folder. Click on the folder name, and the corresponding thumbnails appear in the main display window, as shown in Figure 3-11.

Lightroom 2 provides several ways to manage your original files and folders directly from within Lightroom. It also provides useful information about the status of the original data and storage media capacity. Right-clicking on a drive pane header, for example, brings up the contextual menu shown in Figure 3-12. Here you can set various criteria ranging from Disk Space to Photo Count to None, which determine what shows on the right side of the drive pane header.

Folders that are online and available are signified in green icons, as circled in Figure 3-13. A red icon means that the media is full, locked, or in the case of a CD, not changeable. A gray icon means that the media is offline. Orange, or variation, means a volume is dangerously full.

You can move and change the folder order—and even rename folders in the Folders pane—but do this knowing that Lightroom must actually change and/ or move the original folders on your hard drive. And then it only moves the cataloged image files, and nothing else.

To rename a folder, right-click on the name and choose Rename from the pop-up menu, as shown in Figure 3-14. Then type in the new name. Lightroom automatically changes the name of the original folder on your disk as well. If the folder is missing, there is a ? mark. Right-click on the folder name and then select Find Missing Folder from the contextual menu, as shown in Figure 3-15.

To move a folder, drag it to a new location. You can drag it onto another folder to create a subfolder. A triangle next to the folder name indicates that there is a subfolder. You can have subfolders within subfolders. Use the contextual menu to

Figure 3-12

Figure 3-13

Figure 3-14

Figure 3-15

Figure 3-16

Figure 3-17

Figure 3-18

Figure 3-19

delete unwanted folders. When you move a folder to a new location, Lightroom needs to move the original folder as well, and you get the dialog box shown in Figure 3-16.

If you try to move a folder whose original folder is located on one disk to another separate disk, you'll get the dialog box shown in Figure 3-17, warning you that this move will take a while and cannot be undone.

Right-click on a folder name, and a contextual menu, such as the one shown in Figure 3-18, appears. Most of the choices are self-explanatory, except perhaps Synchronize Folder, which can be a very useful option if you want to keep your Lightroom catalog up to date with any new images you may have added to a folder on your hard drive. Select this option, and the dialog box shown in Figure 3-19 appears. New photos are detected and noted, and you have the option of whether or not to show the import dialog box on import.

NOTE *When you are viewing thumbnails in the Grid mode, you can determine which folder contains a specific image by right-clicking on the image part of the thumbnail (not the edge) and choosing Show in Folder in Library from the contextual menu. You can do this also from the Metadata pane by clicking on the arrow in the Folder field.*

Robert Edwards

Robert used a Lensbaby mounted on a NIkon D200 body to make this selective focus shot of the infamous Port Arthur prison, an hour's drive from Hobart. In the mid-nineteenth century the prison housed "criminals" sent from England, ostensibly for misconduct. However, because stealing a loaf of bread was considered a crime, it's probably safe to say that the policy was in reality a clever way to populate Van Dieman's Land, as it was then known.

Collections pane

Collections are just what the name implies: collections of images based on particular criteria determined by you. Smart collections, which are new to Lightroom 2, are collections based on metadata criteria also chosen by you. Images that meet those criteria are automatically added to the collection. You can't physically add or take away images from a smart collection, but you can drag and drop images from a smart collection into a collection.

When you first start up Lightroom, there are several default preset smart collections in the Collections pane, as shown in Figure 3-20. You can create as many collections or smart collections as you want, and an image can reside in multiple collections. To create a new collection, click on the plus sign (circled in Figure 3-20) and type in a name, or right-click on an existing collection and choose Create Collection from the contextual menu. You get a dialog box like the one shown in Figure 3-21. You can include all the selected images in the Library module grid, or later manually add images by dragging and dropping them from the grid to the collection folder.

To create a smart collection, click on the plus sign in the Collections pane and select Create Smart Collection from the contextual menu. A dialog box like the one shown in Figure 3-22 appears. Here you can pick various metadata criteria and various AND/OR-like conditions. You can create quite complex criteria based on ISO, lens type, camera model, ratings, and so on. Create new criteria fields by clicking on the small plus sign to the right of a field, circled in Figure 3-22, and

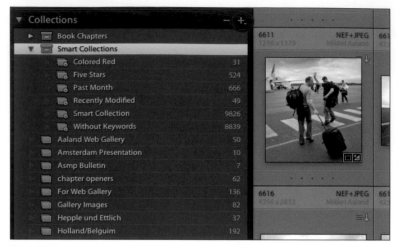

Figure 3-20

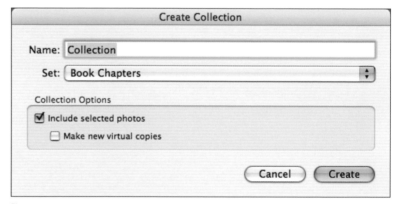

Figure 3-21

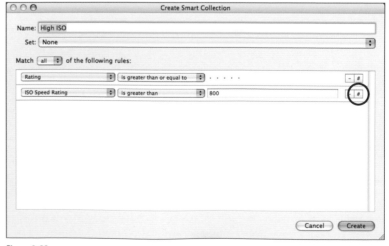

Figure 3-22

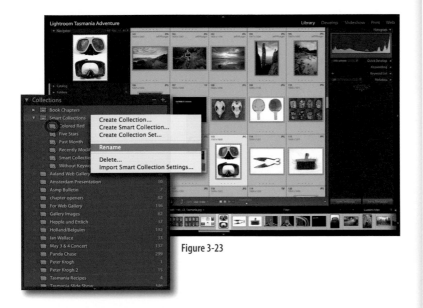

Figure 3-23

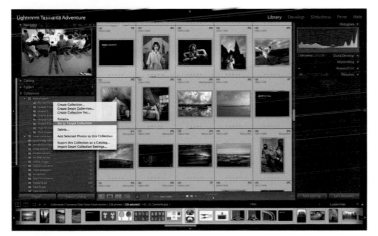

Figure 3-24

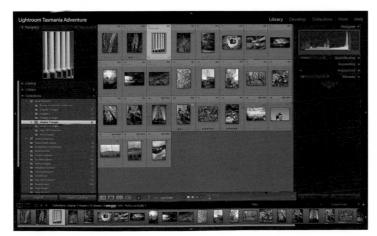

Figure 3-25

remove fields by clicking on the minus sign. A smart collection is signified by a star burst in the lower-right corner of the collection icon, as circled in Figure 3-23. Change the name of a collection or smart collection at any time by right-clicking on the name and choosing Rename from the pop-up menu, as shown in Figure 3-23.

You can also move collections around and create collection sets. Right-click on the collection name and select Create Collection Set. Name your collection set in the resulting dialog box. Collection sets can reside within other collection sets as sub-collection sets. The easiest way to place a collection into a collection set is to drag it onto the collection set icon, which has a dash through it, and then release. To make a collection a target collection, choose that option after right-clicking on the collection name, as shown in Figure 3-24. Only one collection can be designated as a target destination, and this folder essentially becomes the new quick collection. Now when you select a thumbnail in the grid mode and press the B key, or click on the dot in the upper right of the thumbnail image, the image automatically goes into the target collection, and not the Quick Collection folder under the Catalog pane.

When you click on a collection name, the main display window shows only the images in that specified collection, as shown in Figure 3-25. (Deleting an image with the delete key removes it only from the collection, not from your catalog.) You can create a new Lightroom catalog based on a specific collection or smart collection by using the Export this Collection as a Catalog command from the contextual menu.

What the Thumbnails Reveal

You can set Lightroom to reveal a lot of useful data at a glance directly from the thumbnails in Grid view. By default, Lightroom has Show Extras selected. If you don't want thumbnails to display extra information, select View→Grid View Style and deselect Show Extras, shown in Figure 3-26.

You can also press the J key to cycle through view styles.

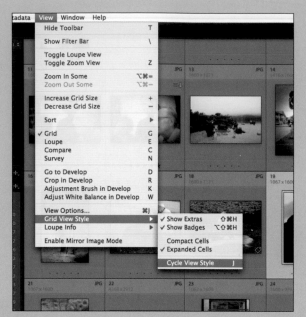

Figure 3-26

To determine exactly what information is displayed on the thumbnails, start by selecting View→View Options from the file menu. Or, right-click on a thumbnail and select View Options from the contextual menu. If you select Show Grid Extras and Expanded Cells, the frame of the thumbnails is larger, and you can display more information on it than you can with compact cells.

As you can see in Figure 3-27, you have a lot of choices for what to include, ranging from Quick Collection Markers to File Name to Cropped Dimensions. You can view in real time the effect of your choices on the viewable thumbnails, both in the main viewing area and in the filmstrip. The thumbnails in the filmstrip are affected only by the choices in Lightroom's Preferences, under the Interface tab.

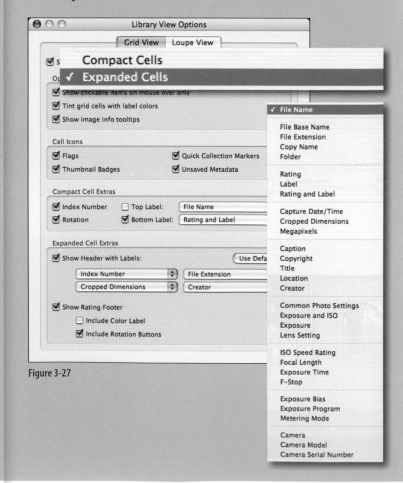

Figure 3-27

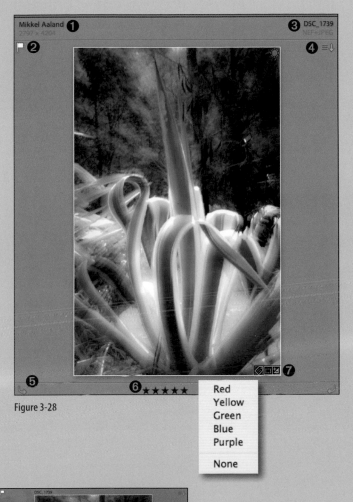

Figure 3-28

Red
Yellow
Green
Blue
Purple

None

Figure 3-29

Take, for example, the expanded cells thumbnail shown here in Figure 3-28. It shows just a sampling of extra data.

❶ Shows copyright and cropped image dimension in pixels.

❷ Shows pick flags.

❸ Shows the file name and extension.

❹ Indicates metadata has been changed.

❺ Shows left and right rotation icons. (If "Show clickable items on mouse over only" is selected in View Options, these only appear when the cursor rolls over the thumbnail.)

❻ Shows the star rating and color Labels. You can add or subtract stars directly from the thumbnail or by tapping an appropriate numerical key. Click on the Color Label icon to bring up a list of colors.

❼ Shows thumbnail badges representing, from left to right, metadata, cropping, and develop changes. Click on an icon and you're taken to the appropriate module or panel.

A compact cell thumbnail (at left in Figure 3-29) displays a slightly more limited number of extras, without the same amount of room around the edges as the expanded cell view (at right in Figure 3-29).

Remember, you can change the size of the thumbnails with the slider in the toolbar (T). If you make the thumbnails too small, the data described here will barely be visible.

The Library Filter

At the top of the display area in Lightroom 2 is the Library Filter, shown in Figure 3-30, which replaces the Find and Metadata Browser panes of earlier versions. The Library Filter is hidden or revealed by selecting the \ key, or via the View menu (View→Show Filter Bar).

The Library Filter is a sophisticated search feature that allows you to search for single or multiple images using different criteria based on text, attribute, or metadata. With search criteria selected, only images that meet the criteria are displayed in the display window. You can search your entire catalog, or select a specific folder or collection to search. Users of previous versions of Lightroom may find the Library Filter daunting and wonder why precious space in the preview window is used for this new feature, shown in Figure 3-31. However, I can assure you that after the initial disorientation, you'll find the Library filter very useful and well thought out.

Text

Click on Text from the Library Filter (circled in Figure 3-32) and you can search for images based on any text associated with an image. You can narrow the search with the pop-up menus, also shown circled in Figure 3-32.

Attribute

Select Attribute (circled in Figure 3-33) from the Library Filter and you can filter by Flags, Ratings, or Color. Next to Copy Status (circled, right) you can also choose to filter by Master Photos or Virtual Copies (of the master photo).

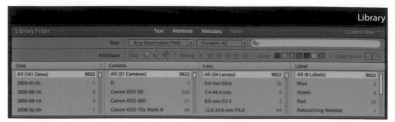

Figure 3-30

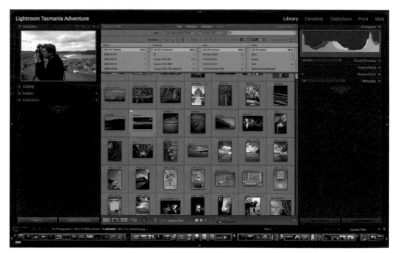

Figure 3-31

Figure 3-32

Figure 3-33

Figure 3-34

Figure 3-35

Figure 3-36

Metadata

Select Metadata, as shown circled in Figure 3-34, and you can search for images by data automatically supplied by your camera's EXIF data or other metadata embedded in an image file or keywords. You can search using a single metadata criterion or several, using AND or OR search criteria. (See Note on this page.) Add more column fields by clicking on the pop-up menu shown in Figure 3-35 and selecting Add Column. The pop-up menu, shown in Figure 3-35, right, is where you make your choices. You could, if you want, find all the images with an assigned ISO of 1600 (first field), *and* all images in your collection shot with a particular camera (second field), *and* by lens (third field). The possibilities are nearly endless.

None

Select None to deselect all search criteria.

Save as preset

In the pop-up menu shown in Figure 3-36 you can select setting presets, or create a search preset with settings of your own.

The Right Panel

Moving over to the right panel (sometimes called the activity panel), we find the Histogram, Quick Develop, Keywording, Keyword List, and Metadata panes. At the bottom of the panel are controls for synchronizing settings and metadata between images. If an image is offline, the right panel is grayed out.

Histogram pane

At the top of the right panel is the Histogram pane, shown in Figure 3-37. Here you see a graphical representation of the color and tonal values contained in the active image. This histogram, unlike the one found in the Develop module, isn't interactive; it is for information only. Just as useful, in my opinion, is an at-a-glance accounting of camera data as ISO, focal length, f-stop, and shutter speed (circled in Figure 3-37).

Quick Develop pane

Under the histogram is the Quick Develop pane, shown in Figure 3-38. Here you can apply some common image corrections to single or multiple images. You can also apply presets (created in the Develop module) and even apply proportional cropping. I'll go into more detail on using Quick Develop later in this chapter.

Keywording pane

With the Library module's Keywording pane, shown in Figure 3-39, not only can you view which keywords are associated with any image, you can also add and edit keywords and even create as many keyword sets as you like. (A few premade keyword sets, including Outdoor Photography, Portrait Photography, and Wedding Photography, are included with

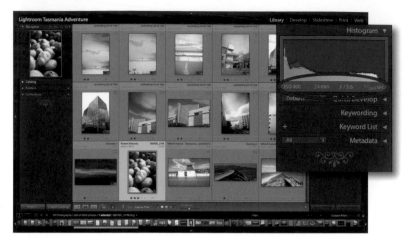

Figure 3-37

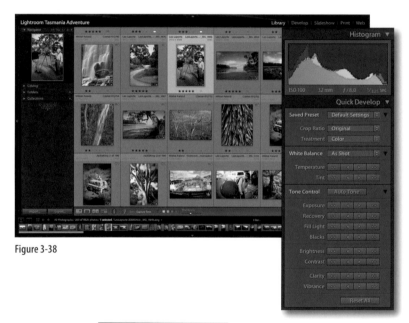

Figure 3-38

Figure 3-39

Figure 3-40

Figure 3-41

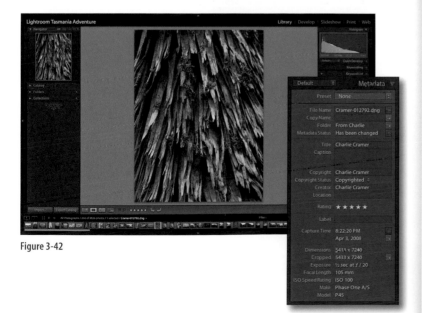

Figure 3-42

Lightroom.) Keyword suggestions, new to Lightroom 2, help you select appropriate keywords based on existing keywords and other keywords applied to other images captured within a similar time frame. I'll go into more details on creating and applying keywords later in this chapter.

Keyword List pane

The Keyword List pane, shown in Figure 3-40, also new to Lightroom 2, adds another way to manage, add, and search keywords. Keyword List is roughly equivalent to the old Keyword Tags pane in earlier versions of Lightroom.

Any keyword associated with an image appears under the Keyword List. The numbers to the right tell you how many images in your catalog include that particular keyword (circled in Figure 3-41). Click on the arrow—visible on mouseover—to the far right of the keyword (circled) and the corresponding images are displayed in the display window. Keywords can be grouped hierarchically by dragging and dropping one keyword onto another. To expand and view a grouping, click on the triangle to the left (circled).

Dragging a keyword from the Keyword List pane to an active image in the display area applies that keyword to that image; or click on the box to the left of the word (circled). Right-click on a keyword to bring up more options from the contextual menu. (More on keywords later in this chapter.)

Metadata pane

Cameras generate metadata that is incorporated into an image file. In the Metadata pane, shown in Figure 3-42, you can view this so-called EXIF data and even

correct some of it, such as the capture date and time. You can also add metadata of your own using standard IPTC fields, and you can create presets, which include keywords, that will appear in the pop-up menu in the upper left of the Metadata pane or in the Import dialog box when you import images. I get into this and more later in the chapter.

Sync Settings and Sync Metadata buttons

At the bottom of the right panel are the Sync Settings and Sync Metadata buttons, shown in Figure 3-43, which are active when more than one image is selected. These controls are used when you want to synchronize a batch of images using the same develop settings or same metadata. I go into this in more detail later.

Toolbar Menu Strip

The toolbar, found at the bottom of the viewing area, is where you'll find several useful, not so easily classified, tools and mode-changing controls, as shown in Figure 3-44.

Why does my toolbar look different from yours? Well, if you're in the Grid view and click on the inverted triangle on the far right of the toolbar, you get the list shown in Figure 3-45. (In the Loupe view, the list is slightly different.) Only the checked items will be displayed on the toolbar. You can selectively check and uncheck this list to customize the toolbar. Let's go over the icons, starting from the far left.

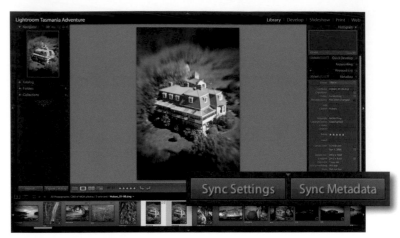

Figure 3-43

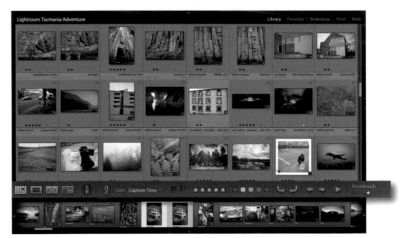

Figure 3-44

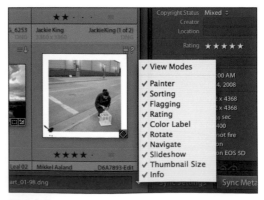

Figure 3-45

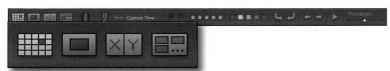

Figure 3-46

Figure 3-47

Figure 3-48

Figure 3-49

Figure 3-50

Figure 3-51

Figure 3-52

Figure 3-46 These icons represent the view options: Grid, Loupe, Compare, and Survey. Click to select.

Figure 3-47 This is the Painter, used for spraying specific keywords, labels, ratings, flags, settings, rotation, and metadata on single or selected images. Presets can be sprayed on as well. (It's not available in the Loupe view.)

Figure 3-48 This is where you set the sort order for the Grid view and filmstrip. You have several choices, ranging from Capture Time to Aspect Ratio.

Figure 3-49 Here are the rating options. You can rate by star, flag as pick, flag as rejected, and color.

Figure 3-50 The arrows change the orientation of images from clockwise to counterclockwise. Batch rotate is possible with multiple selections.

Figure 3-51 Click this triangle to start an impromptu slide show of the selected images. (The look and feel of the slide show is determined in the Slideshow module, covered in Chapter 10.)

Figure 3-52 Here is the slider that controls the size of the thumbnails in the Grid view. (The Loupe view has a Zoom slider control.)

Not shown is the info panel, which contains the file name of the selected image.

NOTE *Critical keyboard command alert! Use the T key to toggle the toolbar menu strip off and on.*

Menu Commands

Lightroom gives you many ways to do the same thing. The menu commands, for example, often duplicate controls found in the panels or in the toolbar. However, a few menu commands don't have an icon or display equivalent. For example, the all important stacking function is done via the Photo→Stacking menu, as shown in Figure 3-53. (It can also be done via the contextual menu; see below.) Enable Mirror Image Mode, which reverses all the images in the viewing area, is done via the View menu. I'll be sure and note these commands in the appropriate sections.

Figure 3-53

Contextual Menu

You can also bring up a contextual menu, such as the one shown in Figure 3-54, that contains many of the critical commands by right-clicking anywhere on the thumbnail in the Grid view or filmstrip, or on the image in any of the other views.

Figure 3-54

Keywords are especially useful as your catalog grows and you need ways to find individual images or groups of similar images. Keywords, which can become part of your image file when you export, also make it easier for others to find your images. Not surprisingly, there are many ways to create and add keywords.

Applying Keywords in the Library Module

NOTE *To import a set of keywords you've created in another application, such as Adobe Bridge, select Metadata→Import Keywords. To export keywords created in Lightroom for use in another application, select Metadata→Export Keywords.*

Keywords are words or phrases that describe or are related to the content of an image. Images can be tagged with keywords that then become associated with that image file. Keywords can be applied to a single image or to a batch of selected images. Here are a few ways to use Lightroom to edit, create, and apply keywords.

Use the Keywording Pane

Figure 3-55

When you select a thumbnail in the Library module Grid view, if it has any keywords attached to it, they show up in the Keywording pane under Keyword Tags, as shown in Figure 3-55. If you select multiple images, all the keywords associated with all the images appear. An asterisk next to a word indicates that the keyword is applied to only some of the images. Select Enter Keywords from the Keyword Tags pop-up menu to add or edit keywords directly in the text field. If you add text via the text field box, you need to add a comma after each word. If you enter a word in the text field under the box, you only need to hit the Return key. Selecting Keywords & Containing Keywords from the pop-up menu displays both the parent and child tags of a hierarchical keyword set. (Using hierarchical keyword sets can be very useful but is not widely supported by other applications at this time. I suggest sticking with "flat" keywording for now, at least for most of you.) Selecting Will

NOTE *Keywords are stored in Lightroom's database. To ensure that keywords are embedded into exported JPEG, TIFF, DNG, or PSD files, do not select Minimize Embedded Metadata in the Export dialog box. To ensure that keywords are attached to proprietary RAW files in an XMP sidecar file, select "Automatically write changes into XMP" from the Metadata tab in the Catalog Settings dialog box (Lightroom→Catalog Settings).*

Export shows you which keywords will export with the image file. (Select which keywords to export by right-clicking on the keyword in the Keyword List pane, and choosing Edit Keyword Tag from the contextual menu.) Add new words based on keyword suggestions and a keyword set that includes Recent Keywords and several other choices via the pop-up menu. Click on the appropriate word, and the word, along with a comma, is added to the Keyword Tags text field.

Apply Keywords with the Painter

The Painter, found in the Library module toolbar (circled in Figure 3-56), is a handy way of adding keywords (and other information) to a single thumbnail or a group of selected thumbnails. Simply click on the Painter spray can icon (it will disappear) and choose a criterion from the pop-menu (it appears when you click next to the word Paint in the toolbar, as shown in Figure 3-57). If you select Keywords, for example, a type field box appears where you can type in a word or phrase. Place your cursor, which becomes a spray can or eraser icon (circled in Figure 3-57, right), over a thumbnail and click to add the keyword or keywords. Clicking on the thumbnail again removes the phrase or word, or whatever you sprayed on with the Painter. Place the Painter back in its dock by pressing the ESC key.

Drag and Drop Keywords

Finally, add keywords by selecting the word in the Keyword List pane and dragging and dropping the word onto a thumbnail or a selection of thumbnails. A plus sign will appear over the thumbnail with the keyword (circled in Figure 3-58).

NOTE *Create your own keyword set preset by choosing Save Current Settings as New Preset from the Keyword Set pop-up menu. You can also edit or delete sets from this menu. When you hit Return, the new words are added to the image database.*

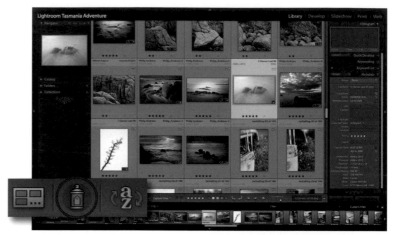

Figure 3-56

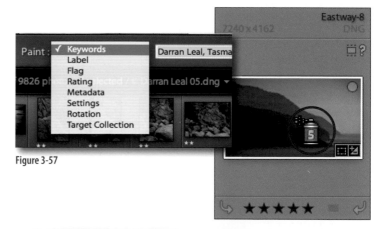

Figure 3-57

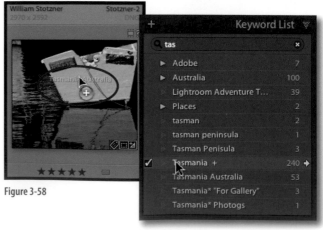

Figure 3-58

Metadata is all the "extra" data associated with an image file. Keywords, which were discussed in the previous section, are metadata. EXIF metadata is mostly fixed, camera-provided information. IPTC metadata is data that you enter into set categories. The gateway to viewing and working with metadata is Lightroom's Metadata pane.

Using the Metadata Pane

With Lightroom's Metadata pane, you can view as much metadata as you want (except keywords, which are listed in the Keywording pane). Click on the up and down arrows at the top of the pane to see your choices (circled in Figure 3-59). If you choose All, the metadata list will be quite long and you'll have to scroll through it, unless, of course, you have a mega-large monitor. (It's even too long for me to show on this page!) The default view, which is shown here, is much more manageable.

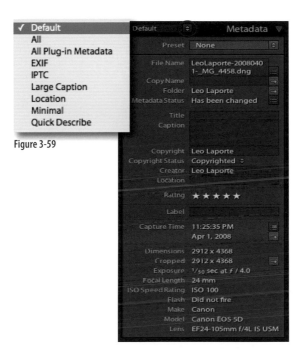

Figure 3-59

Figure 3-60

Figure 3-61

Figure 3-62

Adding and Changing Metadata

Let's work our way down the Default view and see what can and can't be done.

File name To change the file name, select the box to the right of the field (circled in Figure 3-60). This brings up the Rename Photos dialog box shown in Figure 3-61. Choose custom text field from the File Naming pop-up menu and type in the new name. You can also choose from one of the presets or select Edit, which brings up the Filename Template Editor, which allows you to further customize a file name. Any changes you make are also made to the original file.

Copy name If this is a copy, clicking on the arrow shown in Figure 3-62 brings you to the original.

Folder If you click on the arrow next to this field, shown in Figure 3-63, you are taken to the Folders pane in the left panel, and the folder containing the selected image is highlighted.

Metadata Status If there is a discrepancy between the information in the Lightroom database and the original file, you can resolve it by clicking on the resolve conflict icon.

Figure 3-63

Title, Caption, Copyright, Creator, Location Titles, captions, copyright ownership, creator, and location, shown in Figure 3-64, can be read, added, or edited in their text fields. Copyright Status is selected from the pop-up menu.

Figure 3-64

Rating and Label Click on an appropriate number of stars, as shown in Figure 3-65. Type in the name of a label. For example: Red, Yellow, Green, Blue, or Purple. Or more easily, just select a label from the toolbar, or from the menu bar, select Photo→Set Color Label.

Figure 3-65

Capture Time You can change the capture time to compensate for an improper time and date. (When was the last time you changed your camera date and time to accommodate daylight savings time or a different time zone?) To do this, click on the icon above the arrow to the right of the date time field (circled in Figure 3-66). This brings up the Edit Capture Time dialog box, shown in Figure 3-67, in which you can set the correct time and date. (Clicking on the Capture Time arrow selects other images with the same capture time.)

Figure 3-66

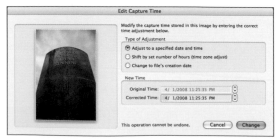

Figure 3-67

Figure 3-68

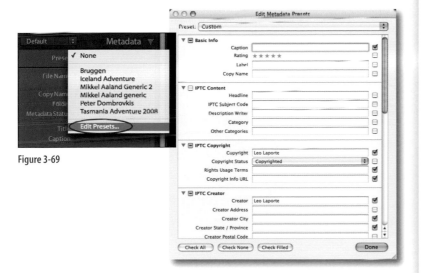

Figure 3-69

Dimensions, Cropped, Exposure, Focal Length, ISO Speed Rating, Flash, Make, Model, Lens None of these can be changed, but click on the arrow to the right of Cropped, shown in Figure 3-68, and you're taken to the Develop module Crop Overlay tool. (Lens won't appear with non-SLR cameras.)

(The other fields in the other views are pretty much self-explanatory. The All Plug-in Metadata view is only relevant if you have plug-ins such as SmugMug or Zenfolio loaded.)

Create and Save Metadata Presets

You can save your metadata entries, including keywords, as a preset. Click on the up and down arrows to the right of the word Preset. Select Edit Presets from the pop-up menu (circled in Figure 3-69). Edit, delete, or check your data in the Edit Metadata Preset dialog box. Select Save Current Settings as New Preset from the Preset pop-up menu. Name your preset and select Done. Next time, the preset will be available in the Preset pop-up menu. It will also be available when you import images from the Import dialog box.

Batch Apply Metadata

If you want to globally apply similar metadata to a batch of images, select the images. Type the information into the Metadata pane that you want to include, knowing that some EXIF fields can't be changed. That's all. All the selected images now have these common metadata entries.

TIP *Selectively sync metadata from one master image file (the active image) to a group of selected images by clicking the Sync Metadata button at the bottom of the right panel. In the resulting dialog box, check the boxes you want synchronized and then click Synchronize. (The Sync Settings button, next to the Sync Metadata button, is for synchronizing Develop module settings, which I explain at the end of this chapter.)*

Selecting Thumbnails in the Grid View and Filmstrip

There's more to selecting a thumbnail than just placing your cursor over it and clicking. Where you place your cursor and which keys you press make a difference. Let me show you what I mean. Here, in the Library module Grid mode, I placed my cursor over the first thumbnail on the left and clicked. It is now active, as signified by the lighter shade of gray frame shown in Figure 3-70. (Photos by Bill Stotzner.)

Here, in Figure 3-71, I held the key (Ctrl key in Windows), placed my cursor over the thumbnail to the far right, and clicked. Both thumbnails are now selected, but not the ones between. Only the thumbnail to the far left is active, as signified by an even lighter shade of gray frame. (Now we have three shades of gray.)

Here, in Figure 3-72, I held the Shift key, placed my cursor over the thumbnail to the far right, and clicked. Now all the thumbnails between the one to the far left (originally selected) and the far right are selected. Again, only the thumbnail to the far left is active, as signified by the lightest shade of gray frame.

- Selected means that the image will be included in any slideshow or print. You can also apply any preset to a group of selected images.

- Active means that this is the photo the other selected photos synchronize to. (More on this later in the chapter.)

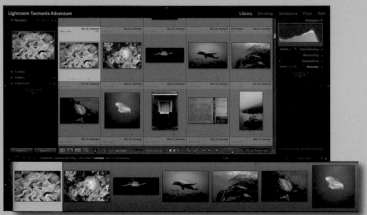

Figure 3-70

Figure 3-71

Figure 3-72

NOTE If you are viewing All Photographs from the Catalog pane, you cannot, I repeat, cannot physically rearrange thumbnails within the main viewing area. You can, however, *sort* images via the toolbar, which I get into later in the chapter.

Figure 3-73

Figure 3-74

Figure 3-75

Figure 3-76

To deselect just one thumbnail when multiple thumbnails are selected, hold the key (Ctrl key) and click on the thumbnail. To deselect all the thumbnails except one, simply click outside the image area, on the frame of the one you want to remain selected, as shown in Figure 3-73. If you click on the image area, this makes that thumbnail active, while keeping the others selected as well.

You also need to position your cursor correctly if you want to move a thumbnail to a collection or folder, or to another position in the main viewing area. Here I placed my cursor outside the image area (circled in Figure 3-74), on the frame, and clicked and dragged. The thumbnail doesn't move. (If you are in the expanded view, a menu pops up when you click outside the image area.)

Here, shown in Figure 3-75, I placed my cursor over the image area (not the frame) and dragged. You can see a tiny version of the thumbnail move with my cursor. I can move this thumbnail (or thumbnails, if I have multiple selections) to another location, or place it in any folder or collection in the left panel. (This won't work if you are in the Catalog/All Photographs view.)

Selecting thumbnails in the filmstrip, as shown in Figure 3-76, is similar to selecting thumbnails in the Grid mode. What happens when you select images in the filmstrip is dependent on which viewing mode (Grid, Loupe, Compare, or Survey) you are in. I note the difference in the appropriate sections.

Editing a Day's Shoot

In this section I use Lightroom to edit a day's shoot down to two specific groups of images: one group of "keepers" destined for a slideshow and/or print, and another group ready to email to some of the subjects in the shoot. The shoot occurred on beautiful Burney Island, a short ferry-ride from Hobart, Tasmania.

First, I import the images from a wonderful day of exploring with fellow Adventure team member Peter Eastway. (Importing is covered in Chapter 2.)

The images are displayed here in the Library module's Grid view, as seen in Figure 3-77. Notice how I optimize the main viewing area of Lightroom by closing the right panel and collapsing the filmstrip. I'm working on a laptop, and screen space is limited. I keep the toolbar visible. (The T key toggles it on and off.) I'll bring back the filmstrip later, in the Loupe view and when I filter my images.

Figure 3-77

Setting Thumbnail Size

I can control the size of the thumbnails in the Grid view with the Thumbnails slider, found in the toolbar. At this point, as shown in Figure 3-78, I keep the thumbnails relatively small so I can view as many of them as I can at once. But they're not so small (circled) that I can't view the extras, such as rotation buttons and color labels.

Figure 3-78

Sort Order

I want to view the images sequentially, as they were shot, so I set the sort order to Capture Time from the toolbar dropdown, shown in Figure 3-79. I could have also set the sort order to File Name. My camera is set to create sequential file names, so the effect is the same.

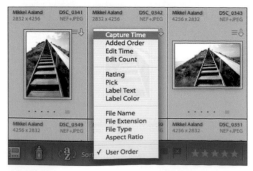

Figure 3-79

NOTE *Many digital cameras add orientation information to the EXIF data, and Lightroom reads this and orients the shots correctly. If your thumbnail isn't shown in the proper orientation, you can use the rotate command to get it right. Simply click on the rotate icon in the toolbar, right-click on an image or thumbnail and use the contextual menu, or, depending on your Grid view option settings, rotate directly from the thumbnail. You can also use the Paint tool in the toolbar set to Rotation.*

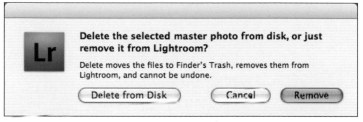

Figure 3-80

Figure 3-81

Figure 3-82

Deleting Images While in Grid View

To properly view and edit my images, I'll use Lightroom's single-image Loupe view. But before I go to that view, I often do a quick scan in the Grid view for duds. I don't like making decisions based on thumbnails, so I'm looking for *obvious* duds, like completely black or white frames. To delete, just hit the Delete key. You'll get the dialog box shown in Figure 3-80, where you decide how serious you really are about "permanently" deleting a photo. Selecting Remove just deletes the Lightroom reference to the file, while Delete from Disk places the actual original file in the Trash or Recycle Bin.

Loupe View

OK, on to the Loupe view, shown in Figure 3-81, where you can examine an image at different magnifications. It's called the Loupe view after a specially made magnifying glass often used in traditional photography. There are several ways to get into Loupe view: Hit the E key, double-click on the thumbnail in Grid view, or just click on the image in the Navigator. You can also click on the Loupe view icon in the toolbar (circled). You can even use the clumsiest method of all: View→Loupe. I mostly use E, which stands for easy! When I'm in the Loupe view, I usually reveal and enlarge the filmstrip so I can see my other images at a glance.

Setting magnification levels

Next, I'm going to set magnification levels in the navigation pane. I'll start by setting my magnification level to Fit by clicking on that word (circled in Figure 3-82). The white border around the preview indicates that the entire image will be visible in the viewing window.

Here, in Figure 3-83, I set the Navigator to 1:1 (circled), which is good for checking image sharpness. Note where the white frame is now. I can move the frame around to different locations, and when I hit the Space bar or click, my cursor will snap to this spot on any selected image.

You can also choose higher magnifications if you want. Click on the triangle to the right, and a pop-up menu (Figure 3-83, insert) gives you magnification choices.

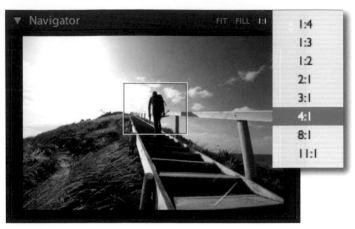

Figure 3-83

Customizing the Loupe view

You can customize what is displayed in the Loupe view in the Library View Options, shown in Figure 3-84. (View→View Options/Loupe View tab)

In Figure 3-84 you can see that I set the options to display Creator, Date/Time, and Exposure and ISO. I selected "Show briefly when photo changes," so the data only stays over my image for a few seconds. You can set up two info displays with different information and toggle between them with the I key.

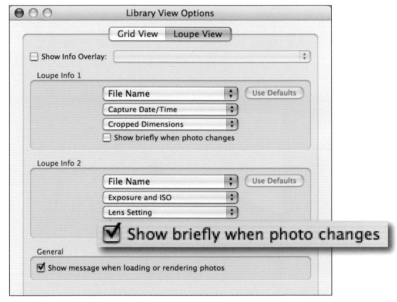

Figure 3-84

Moving between images

Move to the next image by simply hitting the right arrow key on your keyboard or the navigation arrows that can be set to display in the toolbar (circled in Figure 3-85). If you want to skip over images, scroll to the desired image in the filmstrip and select it there. You can also go back into the Grid view and select the image there, before returning to the Loupe view. (Remember: G takes you to Grid view, and E takes you to Loupe.)

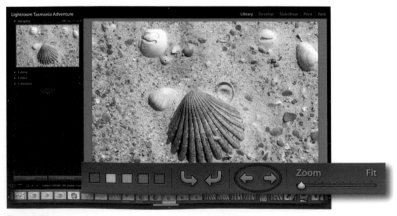

Figure 3-85

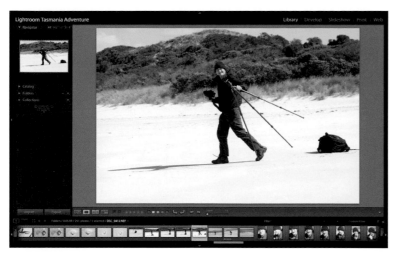

Figure 3-86

Figure 3-87

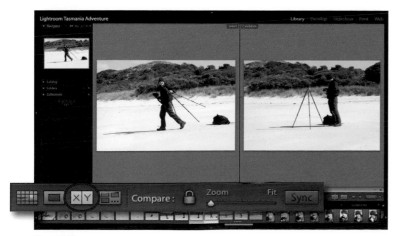

Figure 3-88

Zooming in Loupe view

Next, I want to zoom in and check for lack of sharpness or other technical flaws. This part is fun! As I wrote earlier, magnification levels are set in the Navigator. In this case, I'll start with Fit, as shown in Figure 3-86.

Then, I set my Navigator level to 1:1, which is shown in Figure 3-87. (2:1 also works for me at this stage.) Lightroom remembers the last level used, and when I press the Space bar, click on the image in the display window, or use the Z key, zooooommmm—I go right to the previous magnification. Hit the Space bar (or other zoom shortcut) and zooooommmm, again. A magnification will hold as you cycle through other images until you press the Space bar, click on the image, or select Z again. (As I mentioned earlier, you can move the white frame in the Navigator tab to view another portion of your image.)

If you think this is cool, next I am going to show you one of the coolest Lightroom features of all: the Compare view.

Compare View

I love the Compare view. Here's how to get to it. Have at least two images selected, either in the Grid view or in the filmstrip. (If you have only one image selected, Lightroom will autoselect the next one.) Then, select the compare icon in the toolbar (circled on Figure 3-88), or press the C key. You should see something like what is shown in Figure 3-88.

Magnify in tandem

If I click on either image in the main viewing area or hit the space bar, both images magnify to 1:1. I can set other zoom levels with the Zoom slider, as shown in Figure 3-89.

If I click the lock icon to unlock it, I can magnify the selected image only, as shown in Figure 3-90. With the hand tool that automatically appears when I zoom in, I can locate specific parts of the image and, for example, check for focus directly in the main viewing window. If locked, the images move together. Clicking Sync (circled) in the toolbar (or right-clicking on the images in the main viewing area and selecting Sync Focus from the contextual menu) puts both images into the same relative position, regardless of whether they are locked together.

Select versus Candidate

See the words Select and Candidate at the top of the main viewing window in Figure 3-91? The Select image remains visible while you use the keyboard arrow keys (or the arrows in the toolbar) to select new candidate images for comparison. (You can also select new candidates directly from the filmstrip.) To make a select image a candidate, click either the Swap or Make Select icons from the right side of the toolbar, as shown in Figure 3-92. You can also right-click on either image and use the contextual menu to swap images.

Rating in Compare view

At the bottom of each image in the Compare view, as shown in Figure 3-93, are rating controls. You can use these to apply stars, colored labels, or picks on the fly.

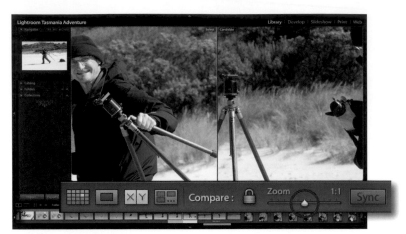

Figure 3-89

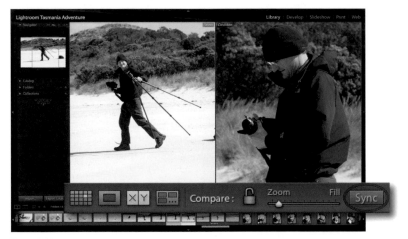

Figure 3-90

Figure 3-91

Figure 3-92

Figure 3-93

Figure 3-94

Survey View: Compare More than Two

You don't need to restrict yourself to comparing only two images at a time. You can compare as many as reasonably fill the main viewing area. Back in the Grid view, select the images that you want to compare, as shown in Figure 3-94.

Figure 3-95

Now select the Survey icon from the toolbar (circled in Figure 3-95). Depending on how many images you selected, you'll see something like this. (At some point, selecting too many images for the Survey view becomes counterproductive. The images become so small that you might as well go back to viewing them in the Grid view.)

You can't change the magnification levels in the Survey view. (If you try, you are brought back to the Loupe view). But you can easily reduce the number of images in the main viewing area by clicking on the X that appears on mouseover in the lower-right corner of each image, shown in Figure 3-96. You can also apply ratings from the main display window, toolbar, or contextual menu to the selected image, which is the one with the white border. To select another image, just click on it.

Figure 3-96

OK, let's not forget we are on a mission, not just looking at pretty pictures. We must make decisions! Which brings us to rating, flagging, and assigning values.

Applying Stars, Flags, and Colors

There are three distinctly different ways to rate or tag images in Lightroom: stars, flags, and colors, as shown in Figure 3-97. Rating controls are located in the toolbar, or, depending on how you set your view preferences, you can apply stars directly from the thumbnails. You can also set the Painter tool from its pop-up menu to spray labels, flags, or rating on single or selected thumbnails. There are several useful key commands, as well:

- Stars Typing a number from 0 to 5 assigns that many stars.

- Flags Each option has a keystroke:

 P is a "pick"

 U is "unflagged"

 X is a "reject"

- Colors All but purple have a keystroke:

 6 is red

 7 is yellow

 8 is green

 9 is blue

To delete a color, simply type the key command again. You can stick to one rating method or use a combination of all three. (If you have used Adobe Bridge, stars and colors should be very familiar.)

For this example, I use two methods. I assign a blue color to the images I'm planning to email to friends, as shown in Figure 3-98. I assign a five-star rating to my keepers, the ones I want for a slide show, web gallery, and to print as shown in Figure 3-99. (I won't use picks for this example.)

Why don't I just create a collection for each category and place my choices

Figure 3-97

Figure 3-98

NOTE Note the blue outline in the thumbnail in Figure 3-98. I set my View Options preferences to show color labels. (View→ View Options).

Figure 3-99

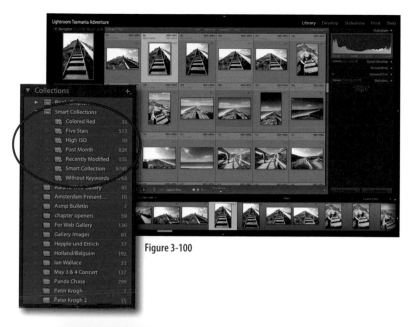

Figure 3-100

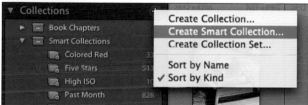

Figure 3-101

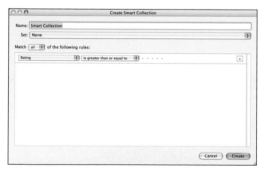

Figure 3-102

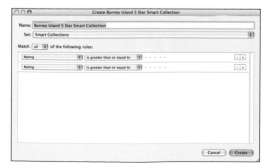

Figure 3-103

there? Good question. It's a lot easier to use a keyboard command or a click to assign a rating or label than it is to drag and drop a thumbnail into a collection. And as you will see, with Lightroom 2's smart collections it's easy to set up an automated workflow based on labels and ratings. Why not just filter my picks based on ratings and labels and avoid collections altogether? Theoretically, all the ratings live with the image until you remove them, but I tend to use ratings and labels as a temporary, on-the-fly solution and don't rely on them for a permanent organizing strategy. It's just too easy to inadvertently change a rating or label, or to forget the rationale for using it in the first place.

Smart Collections

Lightroom ships with several preset smart collections, as shown in Figure 3-100, but I will create two custom smart collections that apply only to the images I shot on Burney Island.

1. In the Collections pane, click on the plus sign. This brings up the pop-up menu shown in Figure 3-101.

2. Select Create Smart Collection. This brings up the dialog box shown in Figure 3-102. I name my first smart collection Burney Island 5 Star and select Smart Collections with the Set pop-up menu.

3. Set Match to All. Then, click on the plus sign to the right of the first criteria field. Now I have two criteria fields, as shown in Figure 3-103.

4. From the first criteria pop-up menu I select Folder, then "contains", then I type in the name of the folder. If I don't

include this criterion, the smart folder might contain images other than the ones I shot at Burney Island.

5. From the second criteria field I select Rating and "is", in the adjacent pop-up menu select "is", and then, finally, click on the stars so that five are selected, as shown in Figure 3-104.

6. Select Create. All my five-star picks from the grid are now automatically added to the Smart Folder named Burney Island 5 Star.

To take me back to all my Burney Island thumbnails, and not just to the ones in the new smart folder, I select the Go Back arrow at the far left of the filmstrip, as circled in Figure 3-105.

Next I create a smart folder for the color-labeled images that I want to email to friends. I repeat the earlier steps, but now I name my smart collection Burney Island Blue Label. (I could also name it For Email. Whatever.) As I did before, I create a new criteria field for Capture Time. For the second criteria field, instead of Rating I select Color Label from the pop-up menu, then "is", then "blue". Select Create, and now all the blue-labeled images go automatically into the smart collection called Burney Island Blue Label, as as shown in Figure 106.

I'm done, at least for now.

NOTE *If there were some overlap between my selections, it wouldn't matter. Images can reside in multiple smart collections and collections.*

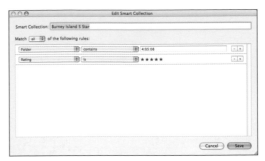

Figure 3-104

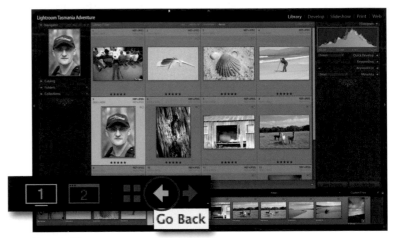

Figure 3-105

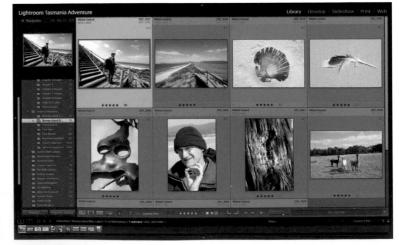

Figure 3-106

You can create multiple versions of the same image—say, one in black and white, the other with a radical crop—and have all the versions available in a stack or in a collection. Because Lightroom saves only a set of processing instructions, very little extra space is taken on your hard drive. Let's see how to do it.

Using Virtual Copies to Create Multiple Versions

Figure 3-107

Figure 3-108

Figure 3-109

Figure 3-110

First we need to create a virtual copy. Do this by selecting the image you want to work on. Now, place your cursor over the thumbnail or image. (Do this in the Grid or Loupe view.) Right-click and bring up the contextual menu, as shown in Figure 3-107.

Select Create Virtual Copy from the pop-up menu. You can create as many virtual copies as you want. I'm going to create three copies. Your copies will be adjacent to each other, and copies are indicated by a turned-page icon in the lower-left corner (circled in Figure 3-108). Double-click on this turned-page icon, and you return to the original image, regardless of where it is.

In my example, I cropped one version into the Develop module to give it a panorama aspect ratio. In another, I converted it to black and white. In yet another I enhanced the color values, as shown in Figure 3-109. You can stack the images or create collections with different names and drag and drop individual versions into the appropriate collection. You can have the same image in as many collections as you want. You can also add different keywords or other metadata to each virtual copy. Use the Library Filter to display only virtual copies. (Click on the word "Attribute" in the Library Filter, then click on the turned-page icon to the right next to Copy Status, shown circled in Figure 3-110.)

Creating and Using Stacks

Stacks are another useful way to organize your images. Imagine a traditional light table (if you can!) and remember how you could set one slide on top of another, creating a relational stack. Well, that's pretty much what you do with Lightroom stacks.

Start in the Grid view by selecting All Photos from the Catalog pane or a folder from the Folders pane. You can't stack from within a collection from the Collections pane or between different folders. Next, select a group of related images that you want to stack together, as shown in Figure 3-111. (To select multiple sequential images, click on a thumbnail, hold the Shift key, and click on the last thumbnail in the sequence. All the thumbnails between are also selected.) Next, right-click on one of the selected thumbnails. Be sure to click on the image area, not the outer frame. This brings up the menu shown in Figure 3-112. You can get the same options by selecting Photo→Stacking from the menu bar.

Now your selected images are collapsed into one, and the visible image displays a number in the upper-left corner indicating the number of stacked images (circled in Figure 3-113). Change the order of images in a stack by dragging and dropping thumbnails from the grid, via the Stacking menu or the following keyboard commands:

- Shift + [Move up in stack

- Shift +] Move down in stack

- Shift + S Move to top of stack

Remove images from a stack via the Photo menu, or by right-clicking on a thumbnail and choosing Remove from Stack from the contextual menu.

Figure 3-111

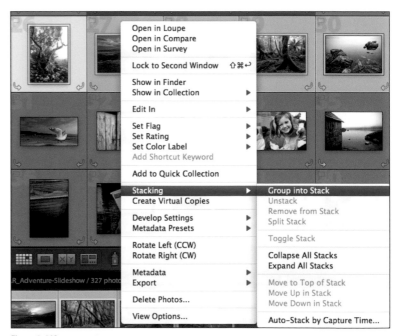

Figure 3-112

Figure 3-113

Figure 3-114

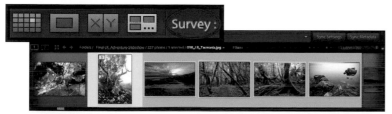

Figure 3-115

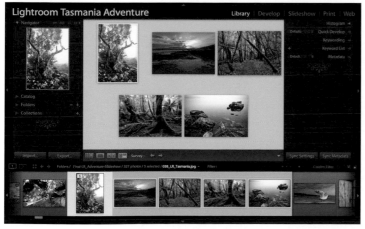

Figure 3-116

Working with Stacks

To expand a stack, right-click to bring up the contextual menu and select Expand Stack, or simply click on the stack icon in the top thumbnail. You also can choose to Expand All Stacks if you have multiple stacks and you want to view all the contents. Numbers in the upper-left corner of the thumbnail indicate the grouping order (circled in Figure 3-114). Your collapsed stack now looks like this in the filmstrip (circled, top in Figure 3-115). Select the stack in the filmstrip and double-click it, and you see the top image in the Loupe view. Click on the stack thumbnail in the filmstrip, and the stack expands, as shown here (circled), and you can use your arrow keys to select and view the other images in the Loupe view one by one.

You can also select the Survey view (circled in Figure 3-116) and, when you expand the stack in the filmstrip, all the images will appear in the main viewing window, as shown in Figure 3-117. (Obviously, the larger the stack, the smaller the images will be in the main viewing window.) To split a stack, first expand it, then click on one of the middle thumbnails and select Split from the contextual menu. This makes two stacks: one including all to the left, and one containing the selected image and all to the right.

Unstacking Stacks

To unstack a stack, go to the contextual menu and select Unstack. The images now appear as distinct thumbnails, as they were before stacking.

Figure 3-117

NOTE *Auto-Stack by Capture Time is also an option via the contextual menu or the Photo→Stacking menu. This feature is especially useful if you want to automatically stack sequenced photos that are destined for a panorama.*

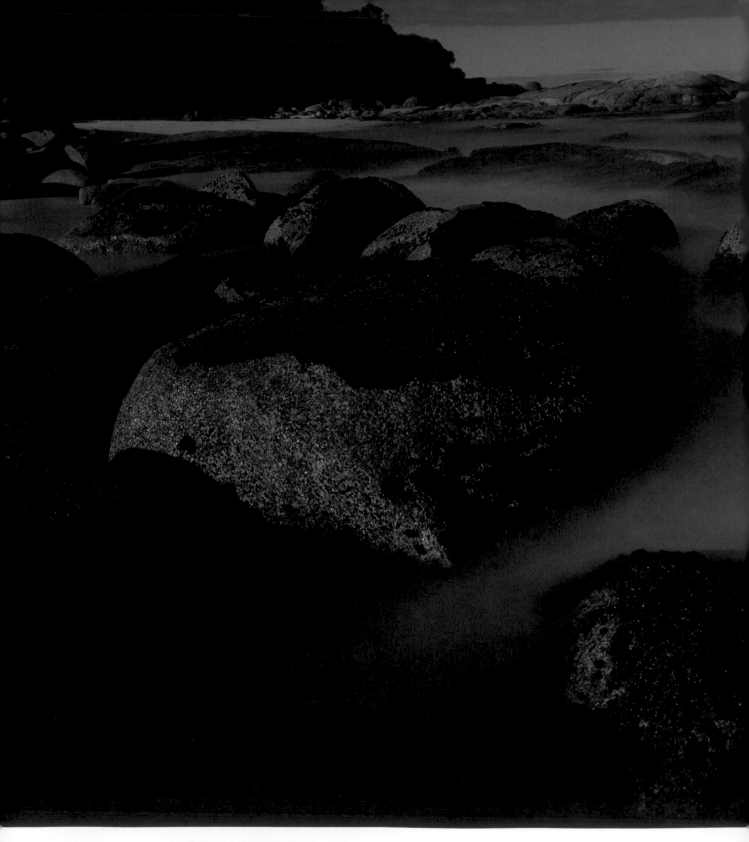

Masaaki Aihara

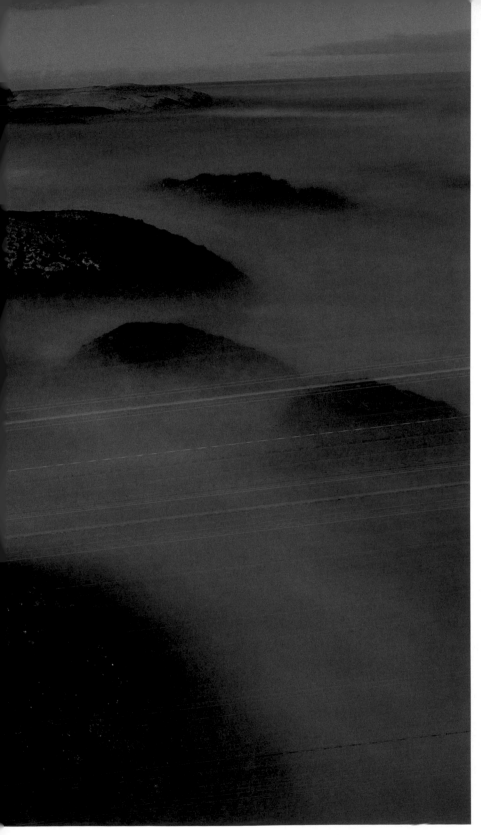

Japanese photographer Masaaki (or Masa, as we call him) has adopted Tasmania as his second home. Last year he spent more time in the Tasmanian wilderness than he did in Japan. He is well known to the Tasmanians, who call him one of their own.

I love Masa's photos of Tasmanian nature, and his commentary, which is written both in Japanese and English, is especially entertaining. Masa had a show at the Cradle Mountain Lodge, where we were staying, and one of his photo captions went something like this: "When I took this photo I was very cold, and drunk."

This photo, taken with a 30-second exposure, was made in the middle of the night on the Tasmanian east coast. I'm pretty sure Masa was cold, but sober.

Using Quick Develop

The Library module contains streamlined image processing capabilities via Quick Develop. Quick Develop is especially handy if you want to apply a simple white balance correction or a relative exposure bump to a large group of selected images.

You'll find the Quick Develop tools under Histogram in the right side panel of the Library module. To expand any pane, click on the arrow key (circled, top, Figure 3-118). To reveal the Crop Ratio and Treatment choices, you need to click on the up and down arrows (circled, bottom, Figure 3-118). When you apply Quick Develop settings, the image previews update accordingly, regardless of which viewing mode you are in. The image in the Navigator window also updates to reflect your adjustments.

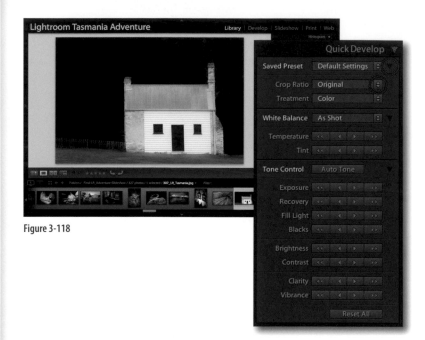

Figure 3-118

Applying Saved Presets

Several presets ship with Lightroom that apply settings ranging from Aged Photo conversion to Zero'd to your selected images, as shown in Figure 3-119.

You can also make your own presets in the Develop module, which appear in the Saved Preset pop-up menu as well. (I get into creating Develop module presets in subsequent chapters.)

To apply a preset to one image, select that image and choose the appropriate preset. To apply a preset to a batch of images, select all the images you want in the display window and then choose the appropriate preset. Pressing ⌘+Z (Ctrl+Z) reverts to the previous setting. Clicking the Reset All button at the bottom right of the Quick Develop pane takes you back to the original camera settings.

Figure 3-119

NOTE *To reset individual Quick Develop Settings, click on their label which turns white on mouse over.*

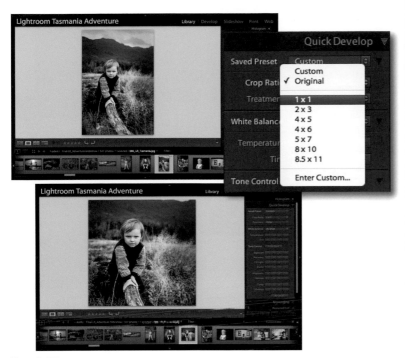

Figure 3-120

Crop ratio

The crop command in Quick Develop doesn't crop to a user-defined area, but applies a preset aspect ratio or a ratio of your choice, as shown in Figure 3-120. It's useful when you have a batch of images that you want to fit to a specific proportion, such as a standard-size commercial print. (If you want to improve composition or eliminate unwanted parts, I suggest that you use the Develop module's Crop Overlay tool, covered in Chapter 4.)

Treatment: Color or Grayscale

Under Treatment, you can choose between Color and Grayscale, as shown in Figure 3-121. Tweak the conversion using other Quick Develop exposure controls. However, you won't have the fine tuning (Grayscale Mix controls) of the Develop module to really make a special black and white conversion (see Chapter 5).

> NOTE *You can convert to grayscale at any time in the Library module by selecting an image and pressing the V key, which toggles between black and white and color.*

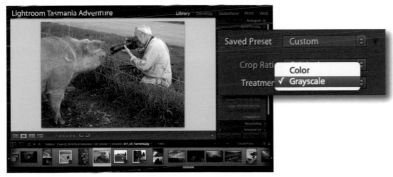

Figure 3-121

White Balance

White Balance settings, shown in Figure 3-122, can be changed here. You can leave the setting to reflect the camera setting (As Shot) or choose Auto or a range of other options. Your selected image immediately changes to reflect your choice. White balance controls affect JPEG and TIFF images, although they are much more effective on RAW files. You can fine-tune your white balance settings with the Temp and Tint controls.

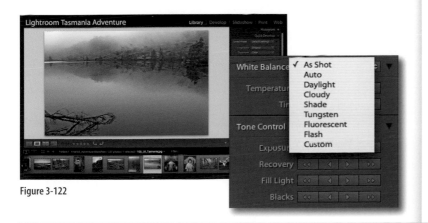

Figure 3-122

Tone Controls

Clicking on the Auto Tone button can be a quick way to improve an image. Auto Tone works by automatically adjusting tonal and color values, and for some images it does a good job. For others, it's a disaster. The only way to find out is to try.

Under the Auto Tone button, there's a range of useful tone controls. A positive clarity value adjustment, shown in Figure 3-123, for example, gives a nice punch to an image that is especially evident when you go to print. A negative clarity value will diffuse an image. You need to click on the arrow (circled in Figure 3-124) to reveal all the choices. The effect of these controls on your images mirror those found in the Develop module, on which I go into more detail in the following chapters. The primary difference is in the way they are applied via the > and >> buttons. Again, the > button is for minor adjustments and the >> is for more coarse adjustments.

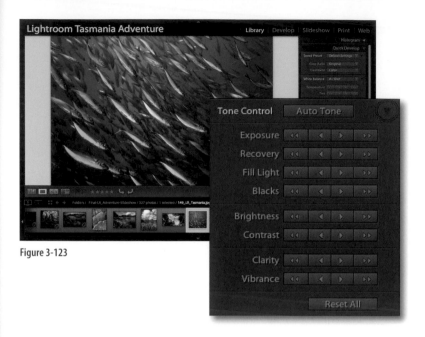

Figure 3-123

TIP *Hold the Option/Alt key, and the Clarity and Vibrance controls change into Sharpening and Saturation.*

Quick Develop for Multiple Images

The ability to easily and quickly apply a particular look or tonal correction to a batch of images is one of the really cool things about Lightroom that set it apart from the previous generation of image processing software. To do this:

1. Select the images you want to work on in the image viewing area, as shown in Figure 3-125. Pressing +A (Ctrl+A) selects all. Using +D (Ctrl+D) deselects all. The histogram reflects values of the active image only.

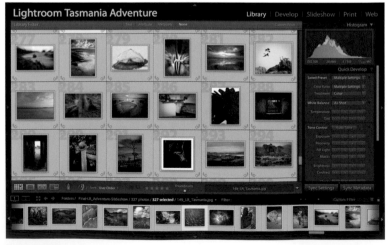

Figure 3-124

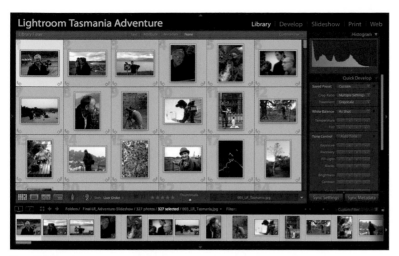

Figure 3-125

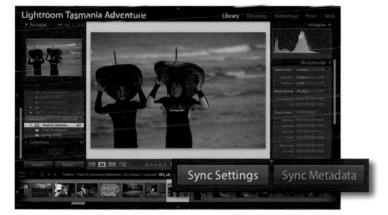

Figure 3-126

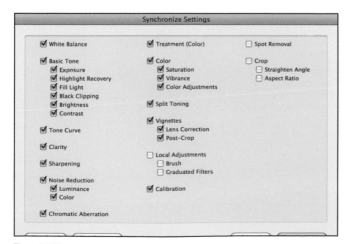

Figure 3-127

2. Select the appropriate white balance or tone controls. (In this example, I selected grayscale.) The changes are visible in all the selected thumbnails, as shown in Figure 3-125. Use Reset All to revert back to your original camera settings.

When you select multiple images and work with the Quick Develop pane in the Library module, remember that you are applying relative changes to each image. For example, if you start with one image that is overexposed 1 stop, say, and another is 1.5 stops over, if you increase the Exposure value, the starting point for the first image is 1 stop over and the starting point for the other is 1.5. (This may seem totally logical to you, but as you will see, when you apply previous settings to one or more images in the Develop module, you are applying exactly the same settings in a nonrelative way, which may or may not be effective.)

Sync Settings

What if you want to apply some but not all of the settings from one Image to a batch of images? Then you use the Sync Settings option at the bottom of the right-hand panel, shown in Figure 3-126.

Make your corrections to the active image. Then select one or more other images. Click on Sync Settings. When the Synchronize Settings dialog box appears, choose only the settings you wish to apply to the other images and then select Synchronize when you are done, as shown in Figure 3-127.

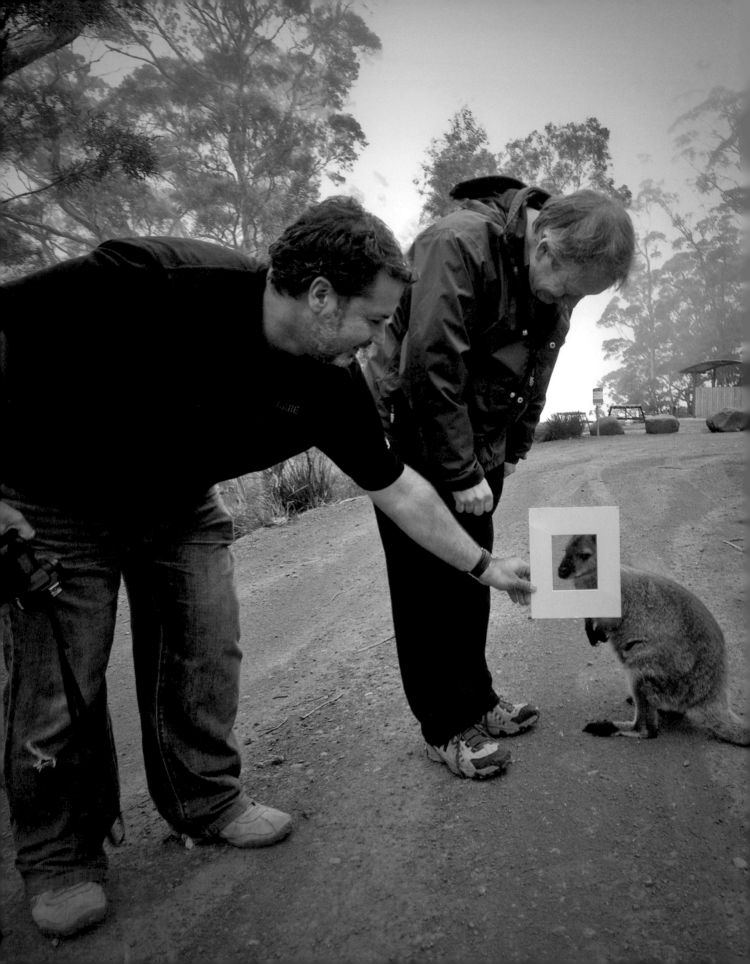

The Develop Module

The Develop module is where the heavy image processing occurs. Here you'll find sophisticated, yet easy to use, tone and color developing controls, which in Lightroom 2 can also be applied locally to specific parts of your image. You'll also find cropping, straightening, and basic retouching tools for removing or altering unwanted image defects. With all these tools at your fingertips, you can create a look that is uniquely yours and save it as a preset, ready to apply to other images. This chapter introduces this powerful module and goes into detail on using its view modes, retouching options, and cropping tools. In subsequent chapters, I provide more details on mastering the Develop module's tonal and color capabilities and creating useful presets based on the work of both Iceland and Tasmania Adventure team members.

Chapter Contents

PHOTO CREDIT: Peter Krogh

The Develop Module Revealed

Let's start with an overview of the Develop module tools. Then, later in the chapter, I'll get more specific on how you can use the tools to get the most out of your digital images. Like the Library module, the Develop module is divided into five main parts.

The view control panel is on the left, the adjustment control panel is on the right, and the main display window is in the middle, as shown in Figure 4-1. The panels are divided into panes with specific functions. Near the bottom of the window are the toolbar and filmstrip. As you learned in Chapter 1, the left and right panels, toolbar, and filmstrip can easily be hidden by clicking on the triangle icon, maximizing the viewing area. Let's take an expanded look at the basic components of the Develop module and see what they do.

Figure 4-1

TIP *Regardless of which Lightroom module you are in, press the D key and you're taken to the Develop module. Pressing the G key always takes you back to the Library's Grid view.*

The Navigator Pane

This should look familiar by now. The Navigator displays the current active selection, as shown in Figure 4-2. Not only is this pane useful for at-a-glance reference, but it is also where you set the magnification level for the zoom controls (circled, left). (For more on the magnification controls, see Chapter 3.) A white frame (circled, right) shows the area of magnification; by clicking on and moving the frame, you reposition the image in the main viewing area as well.

Figure 4-2

Figure 4-3

Figure 4-4

Figure 4-5

Changing Navigator window size

You can make the Navigator window (and entire left panel) larger by placing your cursor over the right edge and dragging (circled in Figure 4-3). This doesn't affect the size of vertical images, but you get a lot more real estate to display horizontal images when you enlarge the panel. The figure on the left is collapsed, and the figure on the right is expanded as far as the panel will go.

Previewing in the Navigator pane

Want to see something really cool? Open the Presets pane and wave your cursor over the presets (circled, left in Figure 4-4). The image in the Navigator window immediately changes to reflect the settings.

The Navigator can also show you in real time your cropped photo (right), before you even apply the crop! (I describe how to apply a crop overlay later in this chapter.)

Presets Pane

Lightroom ships with several presets, listed in the Presets pane, as shown in Figure 4-5. As I just noted, if you pass your cursor over your preset of choice, you can observe the effect in the Navigator window. If you like what you see, just click on the preset name and it is applied to the image in the main display window. The presets shown here are organized in folders; for example, Lightroom Presets and User Presets. You can create more folders by selecting Develop→New Preset Folder from the menu bar. You can also create custom presets, and later in the chapter I show you how.

Snapshots Pane

The Snapshots pane, shown in Figure 4-6, is analogous to Photoshop's History palette snapshot. You can "freeze" a moment in your work and save all your settings in a snapshot, which can be retrieved at a later date. You can save as many snapshots as you like. Click on the snapshot name and the saved settings apply. The keyboard shortcut +Z (Ctrl+Z) undoes the effect of the snapshot. (Future versions of Adobe Camera Raw, I'm told, will actually read Lightroom snapshots. This will be a great way to bring multiple versions of the same image into ACR.) Snapshots apply only to the image you are working on. Even if you clear the history, your snapshots remain. To create a snapshot, click on the plus sign. To remove one, select it and then click on the minus sign. Naming is done by clicking on the text and typing.

> TIP *Make the side panels go away or reappear at any time by hitting the Tab key. Hit the L key repeatedly to cycle between lights on, dim, and off.*

History Pane

Every adjustment you make in the Develop module is recorded in the History pane, shown in Figure 4-7. You can step backward either sequentially or in jumps by placing your cursor over the state and clicking. You can view various states in the Navigator window by just passing your cursor over them. History states are saved automatically and are available when you relaunch the application or reselect an image. There is no limit to the number of history states recorded. To clear the History tab, select Clear.

Figure 4-6

> NOTE *When metadata is saved to file, Develop history is not included. Flags, virtual copies, collection membership, stacks, Develop module panel switches, and image pan positions are also not saved in the XMP.*

Figure 4-7

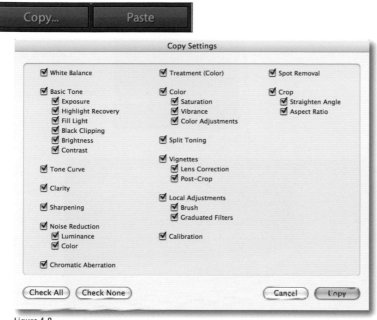

Figure 4-8

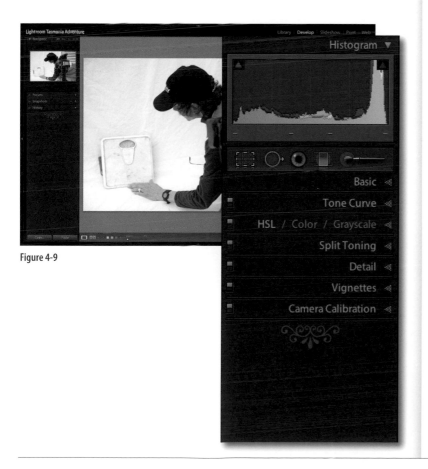

Figure 4-9

Copy and Paste

Copy and Paste buttons are another way to transfer adjustments from one image to another. When you click Copy, you get the Copy Settings box, shown in Figure 4-8, where you can select which settings you want to transfer. Then, with one or multiple images selected in the filmstrip, select Paste and your selected settings apply to the selected images.

Image Adjustment Panel

Anyone familiar with the controls found in Adobe Camera Raw (ACR) should feel right at home here with Lightroom's Develop module adjustment panel, shown in Figure 4-9.

The Histogram pane at the top of the panel gives you a real-time readout of the tone and color distribution of the active image. This histogram is interactive, meaning you can actually make tonal adjustments directly from it. Basic camera data, if available, is placed conveniently under the histogram, and over- and underexposure warning controls are at the top left and right of the histogram as well. (Right-click on the histogram to customize the display.)

In Lightroom 2 the new tool strip is found directly under the histogram. It contains the crop overlay tool, a red-eye correction tool, a spot removal tool for getting rid of unwanted dust or other artifacts, and importantly, the new local adjustment tools, including a Graduated filter and an Adjustment brush. Below the tool strip, the image adjustment panel is roughly divided into four color and tone controls followed by Detail (sharpening and noise reduction), Vignettes, and Camera Calibration. With the exception of the

Basic pane, adjustments made in a pane can be turned on and off with the switch icon on the left (circled in Figure 4-10). I provide much more detail on using these controls later in the chapter.

Previous/Sync and Reset Buttons

At the bottom of the image-adjustment panel are the Previous and Reset buttons shown in Figure 4-11. When you have more than one thumbnail selected in the filmstrip, the word Sync appears instead of Previous, as shown in Figure 4-12. Choose Previous when you want to apply the settings of the previous image to the current image and bypass the Synchronize Settings dialog box. Choose Sync when you have a lot of images you want to apply specific settings to. When you click Sync, the Synchronize Settings dialog box appears, where you can choose which settings you want to apply from the primary selected image. Use the Reset button to return your image to the default settings. Holding the Option/Alt key changes Reset to Set Default, which, if clicked, makes the current settings the new default. (Option/Alt turns Sync to Auto Sync, which when clicked bypasses the Synchronize Settings dialog box.)

The Develop Toolbar

The Develop toolbar in Lightroom 2 contains the Loupe and Before/After view icons, as shown in Figure 4-13. The crop overlay tool, red-eye correction tool, and spot removal tools have been moved to the tool strip found under the histogram. You can set the toolbar with the pop-up menu (circled) to display tools for Flagging, Rating, Color Label, Navigate, Slideshow, and Zoom. The toolbar looks different depending on how you set your options. The toolbar, as noted in

Figure 4-10

Figure 4-11

Figure 4-12

Figure 4-13

Figure 4-14

Figure 4-15

Figure 4-16

Chapter 1, can be customized or made to disappear altogether. The T key toggles it on and off.

Filmstrip in the Develop Module

Images selected in the Library module show up in the Develop module filmstrip shown in Figure 4-14. The icons to the far left control the primary and secondary monitors. Clicking on the adjacent icon (circled) takes you back to the Library module grid view. The arrow icons take you back and forth between previously visited modules. Navigate to other image collections directly from within the Develop module by clicking on the arrow to the right of the Folders path (circled) and navigating from the pop-up menu. To the far right of the filmstrip are the filter controls (which we explored in detail in Chapter 3). Here you set filter criteria and turn filtering on or off with the switch icon (circled in Figure 4-15).

Contextual Menu Commands

Right-click on an image in the main viewing window to access a range of useful commands (top, Figure 4-16). Right-click on a pane header in one of the side panels to get viewing options that vary from panel to panel (middle, Figure 4-16). I find the Solo mode particularly useful. Right-click in the filmstrip on a thumbnail to access another set of commands (bottom, Figure 4-16). Right-click on a Snapshot or History state to change the before settings and more.

NOTE *Many of the commands discussed here are duplicated in the menu bar under Develop, Photo, Settings, and View.*

Develop View Options

If you thought the viewing modes in the Library module were useful, wait until you get up to speed with the ones in the Develop module. Not only can you view your images with the standard Loupe single-image mode, but the Compare mode is simply awesome.

Loupe View

The most commonly used view is the Loupe view, shown with a Peter Krogh image in Figure 4-17, which displays a single image that is easily magnified via the Navigator pane, a click of the mouse, or the Zoom slider in the toolbar. When you enter the Develop module, you're taken to the previously used view mode. Select the Loupe view icon from the toolbar (circled) or use the D key to bring you to the Loupe view. (In the Library module, pressing E took you to the Loupe view.) Control informational overlays via the Develop View Options dialog box. (View→View Options). The I key cycles the Info display.

Compare View

The Compare view icon is found in the toolbar, adjacent to the Loupe icon (circled in Figure 4-18). If you click on the triangle you see a pop-up menu that shows you comparison choices. (If the toolbar isn't visible, press the T key to reveal it.) You can select the compare view of choice from the pop-up menu or by clicking on the compare icon, which cycles through the various options as well. Farther to the right in the toolbar, when Compare is selected, are the Before & After controls, where you can choose to copy or swap settings between before and after versions. Figure 4-19 shows you the Before/After Left/Right view without magnification.

Figure 4-17

Figure 4-18

Figure 4-19

Figure 4-20

Figure 4-21

Figure 4-22

Figure 4-23

Figure 4-20 shows you the Before/After Left/Right view with magnification. Note that both images zoom to the same magnification. You can also use the hand tool, which appears automatically if your image is magnified in this view, or the Navigator, to move within both image areas simultaneously and analogously.

Figure 4-21 shows you the Before/After Left/Right Split view with magnification. I find this view especially useful for checking color changes and the effect of noise reduction settings.

> NOTE *Selecting the \ key in the Library module reveals the Library filter. Selecting the \ key in the Develop module reveals the Before view. Select \ again to reveal the After view.*

Figure 4-22 shows you the Before/After Top/Bottom view.

Figure 4-23 shows you the Before/After Top/Bottom Split view.

> TIP *Right-click on either the Before or After view to bring up a contextual menu with options to apply a snapshot or develop preset directly to the image, and much more.*

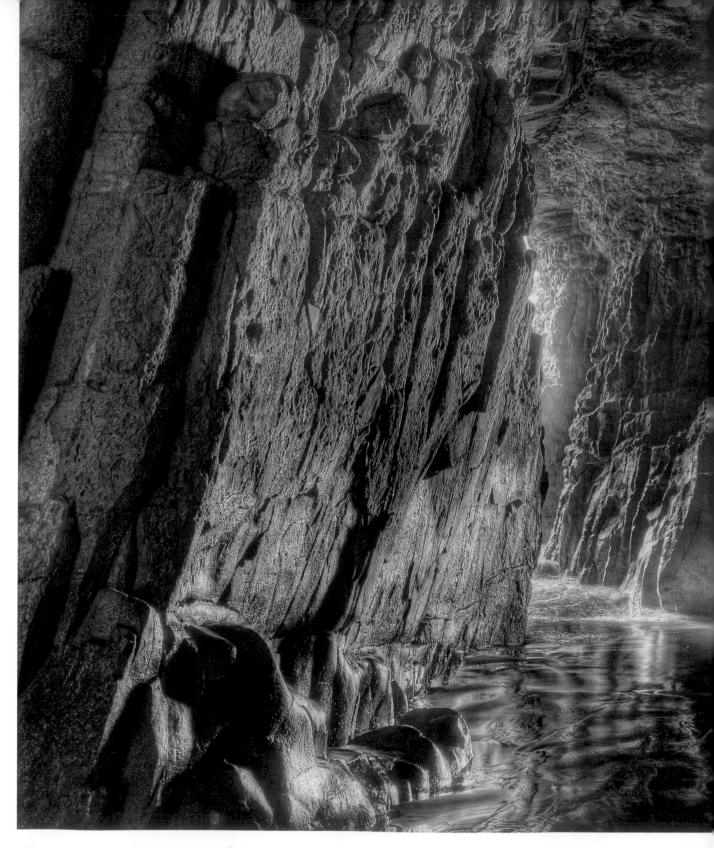

Peter Krogh

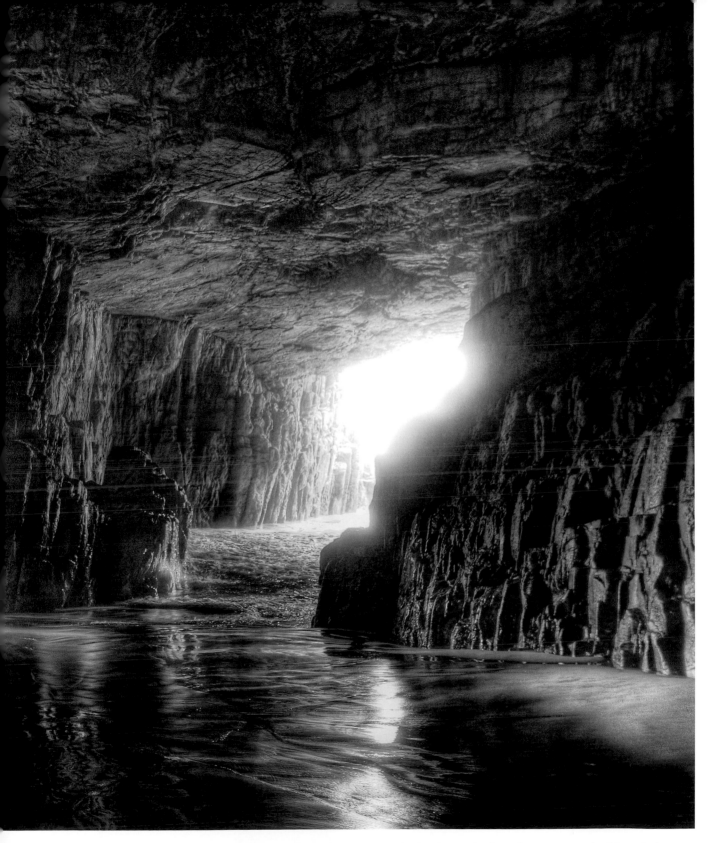

This is an amazing shot of Tasmania's famous Remarkable Cave, which is located a few kilometers south of Port Arthur. Its remarkableness comes from the fact that it has two openings. Peter Krogh shot five frames, each with a different exposure, and stitched the images together using a combination of Lightroom and Photoshop to create this single image. Peter Eastway accompanied Peter Krogh on his early morning trek to the cave.

Cropping in the Develop Module

Cropping in the Develop module can be used to improve an image by isolating critical content, sizing an image to a specific aspect ratio, or straightening an off-axis horizon line. Of course, like everything else in Lightroom, cropping is completely changeable at any time.

In Lightroom 2 the crop overlay tool is located in the tool strip, under the histogram. Click on the crop overlay icon (circled in Figure 4-24) or type R, and you are ready to go. There are several ways to use the Lightroom Develop module's crop overlay tool. You can set the crop area and then drag the image around within the stationary crop marks. You can also use the crop overlay tool (like the familiar Photoshop crop tool) to frame the crop area exactly where you want it. (The Photoshop crop tool actually crops away pixels, while Lightroom creates a nondestructive overlay.)

Figure 4-24

Standard Crop with Maintained Aspect Ratio

Here, I select the crop overlay icon and the crop handles appear on the perimeter of the image, as shown in Figure 4-25. The lock icon is locked (circled), which keeps the current aspect ratio regardless of crop size.

Figure 4-25

Grab the handles and shrink the window as shown in Figure 4-26. If you want, you can place your cursor inside the bounding box and move the image around until you have it positioned exactly as you want it. (If you place your cursor outside the bounding box, you can rotate the image.)

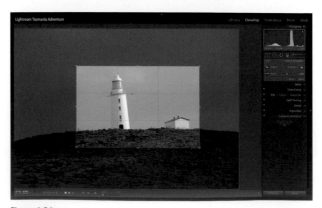

Figure 4-26

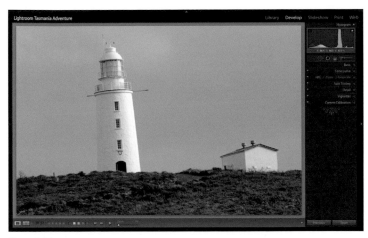

Figure 4-27

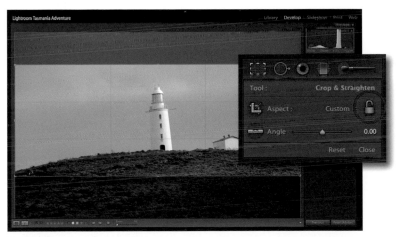

Figure 4-28

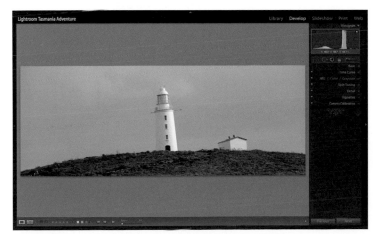

Figure 4-29

When you hit Return/Enter, your cropped image appears and you are out of the crop overlay mode, as shown in Figure 4-27. To return to the crop overlay mode, simply click on the crop icon in the tool strip again or press the R key.

> NOTE *If you are in the crop overlay mode and you right-click, you get a contextual menu. Useful commands include Reset Crop, Constrain Aspect Ratio, Crop to Same Aspect Ratio, and Transform options such as Rotate and Flip.*

Standard Crop with Unrestricted Aspect Ratio

In this example, I unlocked the aspect ratio (circled in Figure 4-28) by clicking on the lock icon in the tool drawer.

Now you can move the bounding box into any aspect ratio you want. I use this feature to create a panorama, as shown in Figure 4-29.

Using a Crop Preset

You can use a preset crop ratio as well, like you can in the Library module. When you click on the triangle next to Original, the pop-up menu is shown, as seen in Figure 4-30.

If you select Enter Custom, you can set your own aspect ratio that will appear in the menu next time you use it. It will also appear as a choice in the Library module crop tool for every image. Here, I've created a preset for the popular 16:9 aspect ratio (circled).

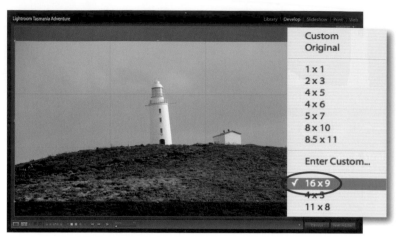

Figure 4-30

Crop Directly on Image

If you select the crop frame tool icon in the tool drawer, you can use the familiar crop to the image technique (as done in Photoshop). The tool disappears from the tool drawer and appears after you make your crop selection, as circled in Figure 4-31.

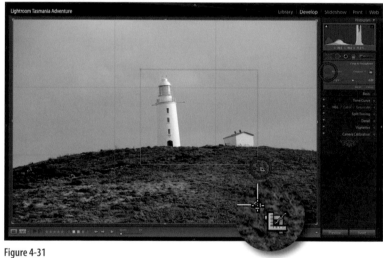

Figure 4-31

Now you can drag a crop exactly where you want it. You can use the handles on the edges (just like in Photoshop) to shrink or enlarge the window. You can also place your cursor inside the box (it turns into a hand icon, circled) and move the image within the crop, as shown in Figure 4-32.

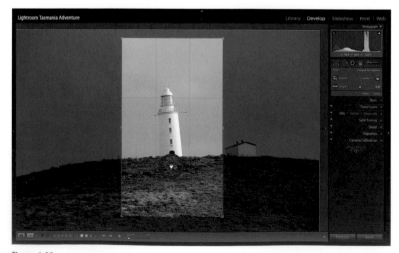

Figure 4-32

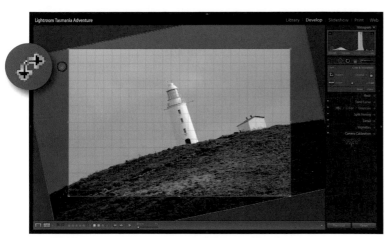

Figure 4-33

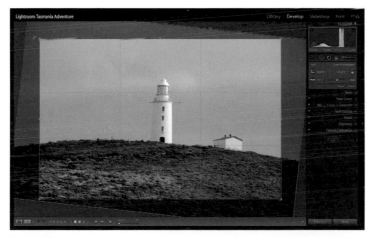

Figure 4-34

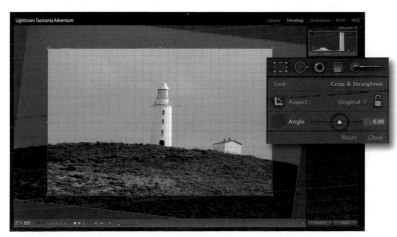

Figure 4-35

Straightening a Crooked Horizon

There are several ways to straighten a crooked horizon line (or lighthouse!). You can use a grid and line the horizon up visually, or use the straighten tool.

Using a grid with the crop overlay tool

With the crop overlay tool, simply place your cursor outside the image area (it turns into a curved arrow, circled) and click, as shown in Figure 4-33.

If your View→Tool Overlay setting is set to Always Show or Auto Show, a grid appears over the image. Now when you move your cursor, the image rotates and you can line up the horizon to the straight gridline, as shown in Figure 4-34. Press the Return key when you are done.

> TIP *Grid guidelines are useful for helping straighten a crooked horizon, but Lightroom offers several other useful guide overlays under View→ Crop Guide Overlay in the menu bar. You can cycle through the various options (including Thirds, Diagonal, Triangle, Golden Ratio, and Golden Spiral) by pressing the O key. Turn guide overlays on and off by pressing +Shift+H (Ctrl+Shift+H).*

Another way to do this is to use the Angle slider in the tool drawer, shown circled in Figure 4-35. When you click on the slider, the grid automatically appears and you can slide the slider back and forth until you get a horizon line that lines up with a straight gridline.

Using the straighten tool

Finally, as if there weren't enough ways to do the same thing, you can use the straighten tool, which shows up in the crop overlay tool drawer. When you click on the straighten tool icon in the tool drawer, the icon disappears, but appears in the image where you place your cursor, as shown in Figure 4-36.

Click on a starting point, then drag along the line you want to straighten. When you release your mouse, the image automatically aligns, as shown in Figure 4-37.

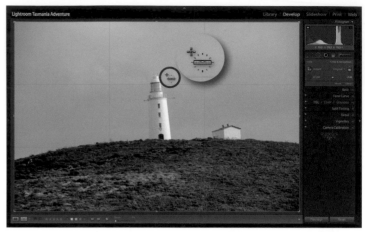

Figure 4-36

NOTE *Any crop you make in Lightroom is completely redoable. Nothing has been added or taken away from the original image. However, when you export your image as a JPEG, TIFF, or PSD file, the actual crop is applied. If you export to a DNG file, the crop remains redoable in Lightroom and Adobe Camera Raw. It may or may not be recognizable by another application.*

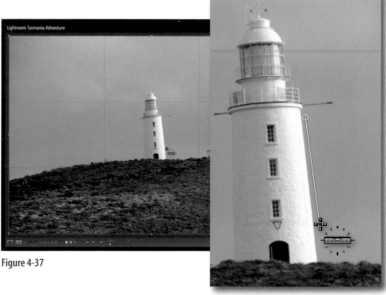

Figure 4-37

Crop Indicated with Thumbnail Icon

If an image has been cropped or straightened, a crop icon appears in both the filmstrip and the Library grid mode thumbnail, as shown in Figure 4-38. If you click on the crop icon from the Library grid mode or the filmstrip, you're taken directly to the Develop mode with the crop overlay tool selected.

Figure 4-38

Lightroom doesn't have anywhere near the retouching capabilities of its parent, Photoshop, but it's very competent in simple, common tasks, such as removing artifacts caused by dust on a sensor or removing red eye. Like everything else about Lightroom, the tools are nondestructive and always redoable.

Retouching Tools in the Develop Module

The Develop module retouching tools are located in the tool strip below the histogram (circled in Figure 4-39). These tools can also be selected from the View menu.

Using the Red-Eye Correction Tool

Let's start with the red-eye correction tool, which is very easy to use:

1. Select the tool from the tool strip by clicking on the eye icon. The dark pupil icon becomes red when you have it selected.

2. Place the pattern over the red eye, with the crosshair positioned in the pupil, as shown in Figure 4-40. If the pattern is too large or too small, click and drag from the center of the eye until it is slightly larger than the eye. Release your cursor, and the red should disappear.

3. Fine-tune the red-eye removal with the Pupil Size and Darken sliders in the tool drawer, shown in Figure 4-41. The Pupil Size slider increases or decreases the size of the pupil (left). The Darken slider affects the opacity of the pupil (right).

4. Repeat this process as many times as necessary on other eyes. Select Reset from the tool drawer to start over. Once you are finished with the red-eye correction tool, select Close or select another tool. The red eye icon now returns to black.

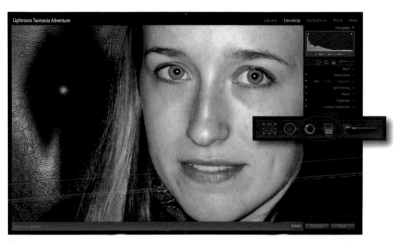

Figure 4-39

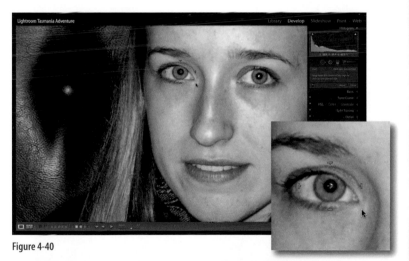

Figure 4-40

Figure 4-41

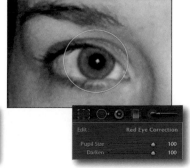

Using the Spot Removal Tools

A common problem with digital cameras is sensor dust, which can appear in the same spot on all images. Often the resulting spot is not noticeable unless it appears in an area like the sky. This is what occurred with one of my adventure shots. As you can see in Figure 4-42, the spot is very conspicuous, and detracts from an otherwise beautiful image. Here is what to do to remove spots like this.

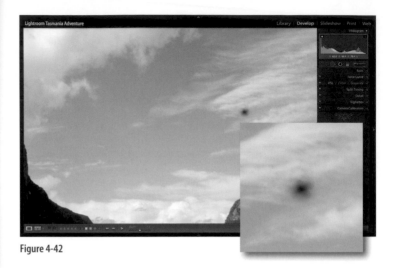

Figure 4-42

1. Select the spot removal tool from the tool strip. Click on the word Heal in the tool drawer. The healing tool works in a similar fashion as its Photoshop counterpart: it blends the target and source. (Lightroom's clone tool, on the other hand, takes a copy of the source area and pastes it over the target area and blends the edges.)

2. Place your cursor over the sensor dust spot. Adjust the spot size with the slider until it is about 25 percent larger than the dust spot, as shown in Figure 4-43. Other ways to enlarge or shrink the spot size are by Control/Ctrl-dragging or by using the bracket keys or the mouse wheel.

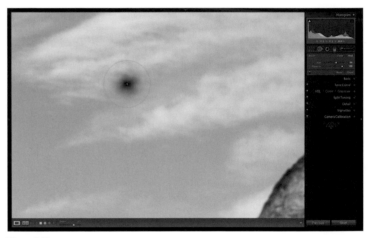

Figure 4-43

3. Click, and Lightroom automatically chooses an adjacent blending source, as shown in Figure 4-44. If you're not satisfied with the results, drag the source circle around until a satisfactory degree of healing occurs in the target area. If you move the source circle from its default location, it becomes fixed when copied and pasted to another image. The default source becomes relative when applied to another image.

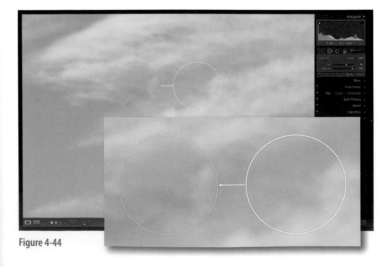

Figure 4-44

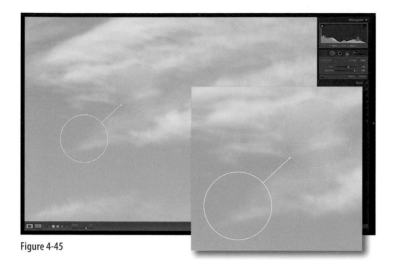

Figure 4-45

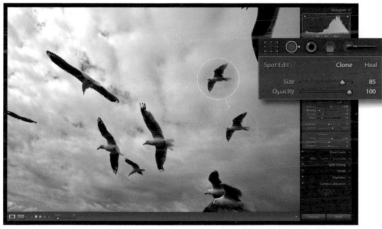

Figure 4-46

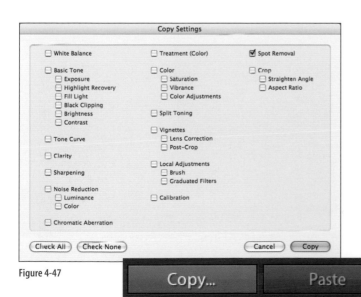

Figure 4-47

The entire procedure can be repeated as many times as necessary on the same image until all the spots are removed. At any time, you can go back and relocate either the target or source, as shown in Figure 4-45. Toggling the H key hides and reveals your selections. Delete unwanted selections by placing your cursor over the circle, clicking, and using the delete key. Use the Reset button in the tool drawer to remove all the selections. Click on the clone/heal icon when you are done, or press the N key. You can go back to the image at any time and resume using the tool.

Figure 4-46 is an example using the clone tool, and as you can see, the effect is quite different from that of the healing tool. Even so, everything I said about using the healing tool applies to the clone tool.

Apply clone/heal tools to multiple images

You can create a copy of your settings from one image and then apply them to multiple images. Repeat what we did earlier, and use the clone or heal tool to get rid of an offending spot. If possible, use Lighroom's default selection and don't move the source circle. Now, in the left panel, click Copy. This brings up the dialog box shown in Figure 4-47. Deselect all and select only Spot Removal. In the filmstrip, select as many of the images you wish to fix. Now click Paste from the panel. Done. If you didn't move the source circle, Lightroom will pick an appropriate new source. If you moved it, the source is fixed, which may or may not give good results.

NOTE *At this time, you cannot create a preset to do this.*

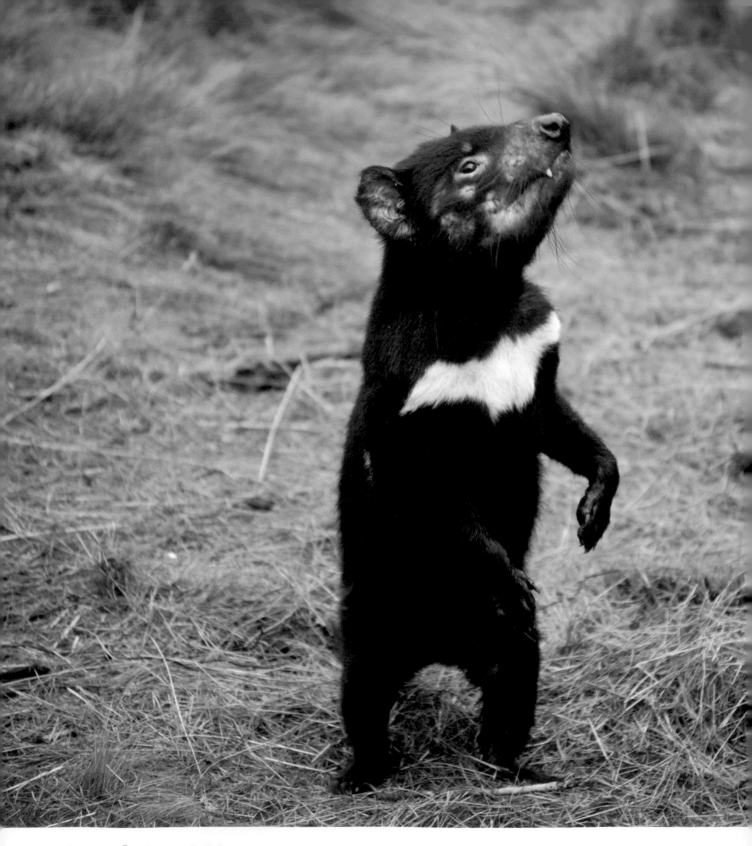

Jackie King

Tasmania is probably best known for the Tasmanian devil, which Jackie King captured here. The devil, as it is fondly called, is a carnivorous marsupial native only to Tasmania. It is an endangered species. On our last night in Tasmania, Tourism Tasmania organized a farewell reception. At the reception, every photographer donated images from the Adventure, and we auctioned off scores of archival prints made using an Epson Stylus Pro 3800 printer. I'm happy to report that we raised over $7,000 for the Save the Tasmanian Devil campaign (www.tassiedevil.com.au).

Graduated Filter

New to Lightroom 2 is the Graduated filter, which, as the name implies, allows you to set tonal adjustments gradually across a specific area of your image. In this section I show you how it works. You can also see the Graduated filter used in a recipe in Chapter 8.

In Figure 4-48 you can see a problem that is easily corrected using the Graduated filter. The sky is much brighter than the foreground. Global tonal changes just don't cut it—there is just too much difference in tonal values. Instead, I'm going to use the Graduated filter.

The Graduated filter is located in the tool strip, under the histogram, as shown circled in Figure 4-48. The options appear in the tool drawer when the Graduated tool is selected. (Keyboard command is M). Note that when you first select the tool, the mask mode is set to New. When you apply the mask, the mode is set to Edit.

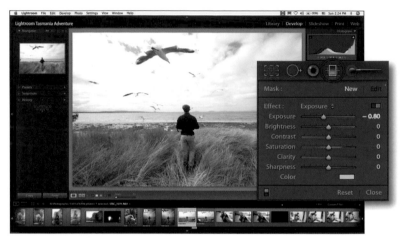

Figure 4-48

Click on the switch icon (circled in Figure 4-49a) and you switch from button mode (Figure 4-49a) to slider mode (Figure 4-49b). Button mode gives you control of only one effect at a time, selected from the Effect pop-up menu or by clicking on the plus sign, and controlled by the Amount slider. With slider control you can select multiple settings and apply them all at once. (You can also select from the Effect pop-up menu.) I prefer the slider mode and I use it in this example.

I start by moving the Exposure slider left, to –3. It's not critical that you get the settings right—you can always go back and change them later, in edit mode.

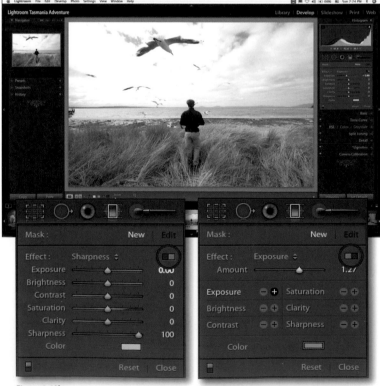

Figure 4-49b Figure 4-49a

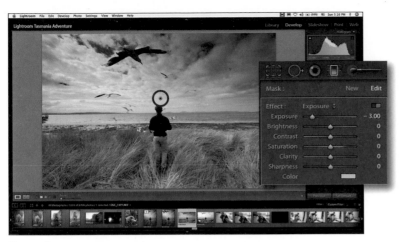

Figure 4-50

Figure 4-51

Figure 4-52

Next I'll hold the Shift key, which constrains the Graduated filter to a right angle, and drag from the top down until I get the sky the way I want it. The results are shown in Figure 4-50.

A Graduated filter pin appears at the center of the effect (circled). Three white guides represent the center, low, and high ranges of the filter effect. (You can only see two here; one is hidden at the top.) I am not worried that the bird is now too dark; I'll correct it later, using an adjustment brush. When I release my mouse button, the Graduated filter mask is ready to be edited.

Editing a Graduated Filter Mask

If it is not selected already, select the Graduated filter pin by locating it in the preview window, then clicking on it. A black dot signifies that the mask is now active and ready to be edited, as shown in Figure 4-51. Press the H key once to show the selected pin. Press H again to hide all pins, and press H a third time to show all pins. Now the word Edit should be highlighted in the tool drawer. If you have made multiple Graduated filter masks, which I'll do shortly, you can edit only one mask at a time.

Change the position of the filter by first waving your cursor over the lines in the preview window. When a hand icon appears, as shown circled in Figure 4-52, it means that you can grab either of the two outer lines and drag them toward the edge of the photo to expand the range of the gradient effect, or drag them to the center of the photo to contract the range. When clicked, the cursor becomes a closed fist.

If your cursor becomes a curved, double-pointing arrow, as shown circled in Figure 4-53, it means that you can drag and rotate the direction of the filter's effect.

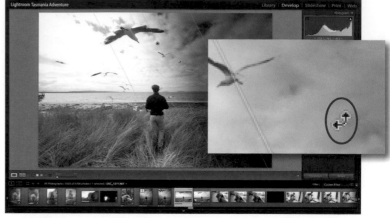

Figure 4-53

If your cursor becomes a cross or a plus sign, as shown circled in Figure 4-54, that means that when you click, you create a new graduated filter, which is now active.

To erase a filter, make sure that it's active (black dot in the middle) and use the Delete key. Erase all your filters by selecting Reset from the bottom of the tool strip drawer. When you are finished, use the Esc key or select Close, also from the bottom of the tool strip drawer.

Figure 4-54

Variations on the Graduated Filter

In Figure 4-55, I apply a second Graduated filter to the foreground, using a green tint. I also boosted saturation and clarity settings just to show you how, in the Slider mode, you can select and apply multiple effects to a Graduated filter.

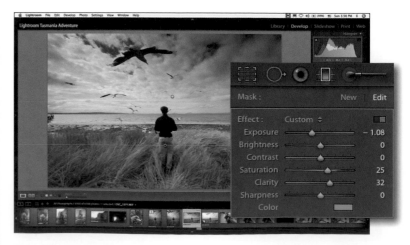

Figure 4-55

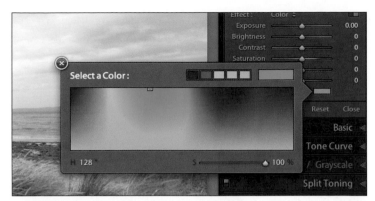

Figure 4-56

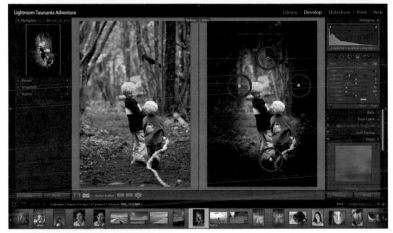

Figure 4-57

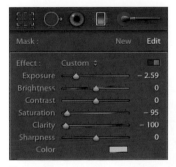

Figure 4-58

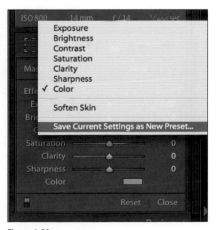

Figure 4-59

I selected the green tint by clicking on the color swatch at the bottom of the tool strip drawer and picking from the color spectrum pop-up, shown in Figure 4-56.

WARNING *By now you should have seen how easy it is to use this new Graduated filter, but I've only scratched the surface of its potential. It's easy to spend all day in front of the computer using this tool. So beware! There are photos out there that need to be taken.*

Creating Custom Vignettes with Control

In Figure 4-57, I created a sort of super vignette using four Graduated filters with a variety of effect settings. I circled the four pins so you can see what I mean. You can also see my settings in Figure 4-58, which included negative exposure, saturation, and clarity values.

Creating Custom Presets

If you create a Graduated filter effect that you like, it is very useful to create a custom preset that makes it easy to apply to other images. Simply select Save Current Settings as New Preset from the Effect pop-up menu shown in Figure 4-59. Name your preset, and the next time you select the Effect pop-up menu it will be there ready to use.

Adjustment Brush

Lightroom 2 boasts another amazing new feature, the Adjustment brush. No longer are you restricted to global adjustments—now you can select one or more areas of an image and individually adjust tonal values and sharpness and even add tints selectively. Let's see how the new brush works.

I'm gong to use Lightroom's new Adjustment brush to finish up what I started with the Graduated filter in the previous section, and then I'll show you some more amazing things you can do with this brush. The Graduated filter, remember, gave me a wonderful sky but darkened the bird. To fix it, I do the following:

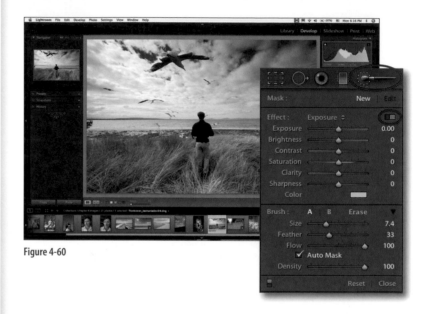

Figure 4-60

1. Click on the Adjustment brush tool icon in the tool strip, circled in Figure 4-60. This opens the tool drawer with a set of options, also shown in Figure 4-60. The Adjustment brush tool has two work modes, just like the Graduated filter: button and slider. They are selected by clicking on the switch circled in Figure 4-60. (As I wrote earlier, the button mode gives you control of only one effect at a time, selected from the effect pop-up menu or by clicking on the plus sign, and controlled by the Amount slider. With slider control you can select multiple settings and apply them all at once. You can also select from the Effect pop-up menu.) I prefer the slider mode and I use it again in this example.

2. Select Exposure from the Effect pop-up menu, as shown in Figure 4-61, left. By default, the exposure is set to the last used setting, as shown in Figure 4-61, right. I could, of course, type in any value I want, or use the

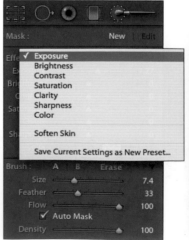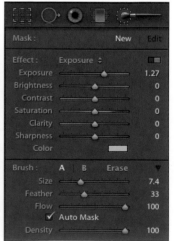

Figure 4-61

Figure 4-62

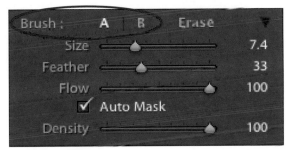

Figure 4-63

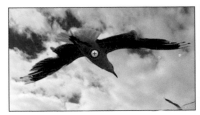

Figure 4-64

Figure 4-65

slider to select a value. At this point I don't need to be exact; I can go back later and change the exposure (or any effect) in edit mode.

3. Place my cursor over the bird and adjust the brush size, as circled in Figure 4-62. I can use either my bracket keys or my mouse wheel to enlarge or shrink my brush, or the Brush Size slider at the bottom of the tool strip drawer. I ended up with a 4.0-size brush, and I set feather to 13, flow to 100, and density to 100. Here's what the different brush controls and settings do:

Brush lets you customize two brushes, A and B, with completely different settings. Toggle between them with the / key or simply select them in the tool strip drawer, as shown circled in Figure 4-63. Your brush settings will stick until you reset them.

Size controls the size of the brush.

Feather Larger values create a soft-edge transition between the brushed area and adjacent pixels. Lower values create a harder edge. (Move the Feather slider and observe the brush in the viewing window. You'll see the transition areas, represented by concentric circles, narrow or widen, as shown in Figure 4-64, left and right.)

Flow controls how fast the brush acts. Select low values, and the brush effects appear very slowly as you brush, as shown in Figure 4-65, left. Higher values make the effects visible more quickly, as in Figure 4-65, right.

Density controls transparency of the mask. Select a lower value and the mask is less transparent, and therefore the effect you are brushing on is less obvious. Select a higher value and the mask is more transparent, so the effect is more obvious.

Auto Mask finds edge differences and restricts the effect of the brush to one side of the edge or the other. (Auto Mask is a no-brainer for an image like mine where the bird's wing is uneven and hard to trace manually.)

4. OK, now I'm ready to paint the higher exposure value over the bird. As you can see in Figure 4-66, I've done a good job. But to really see the effect of the brush, I place my cursor over the pin, and as you see in Figure 4-67, a red mask appears, showing me clearly where my brush strokes start and end. If you prefer you can have the colored mask appear even when you are painting with the brush. Press the O key. Each time you press the key, it will cycle mask views.

> NOTE *Critical keyboard command alert! Change the color of the mask from red to white to black to green by holding the Shift key and repeatedly pressing the O key.*

Creating a New Adjustment Mask

There are other areas of this image that need localized adjustments as well. For example, the top of the person's head, shown in Figure 4-68, needs to be slightly lighter. (That would be Jeff Pflueger in the picture.)

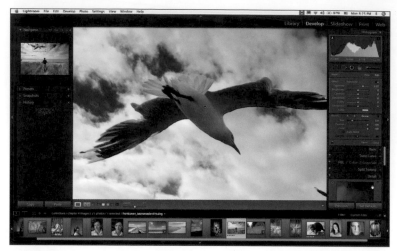

Figure 4-66

Figure 4-67

Figure 4-68

Figure 4-69

Figure 4-70

Figure 4-71

I could keep painting with the same Adjustment brush I used on the bird. Brush strokes need not be contiguous. However, since I want separate control over each area, I create another mask and use another Adjustment brush. When I first released the mouse after brushing the adjustment on the bird, an adjustment pin appeared and in the tool drawer the Mask mode changed to Edit. I need to create a new mask, so I select New. Now I place my brush over the new location, as shown in circled in Figure 4-69, with just a slight adjustment to the brush size. Once again the auto mask setting works wonderfully, and as I brush with my cursor only the hair is lightened up nicely, as shown in Figure 4-70. (For the final version of this image, the one you see on the cover of this book, I used a third adjustment mask, a much larger one, to apply a slightly darker exposure value and positive saturation and clarity values. I also used the spot removal brush to get rid of the bird near Jeff's right ear.)

Editing an Adjustment

When you've finished brushing, and you release your mouse, you are in the Adjustment brush edit mode. You can change any or all of your previous effect settings, or add new effects. You can also change the behavior of your brush or brushes to paint the new effects. (For example, if you select a lower density value you can effectively reduce an effect incrementally, with much control.) To delete masked areas, select the Erase as a Brush option from the tool drawer, or hold the Option key and the plus sign inside your brush turns into a minus sign, as shown in Figure 4-71.

Brush away the areas you want to delete. To delete a mask entirely, be sure the mask pin is selected (black dot in the center) then select the delete key. (Select and deselect pins by clicking on them. Only one can be selected at a time.) To remove all the masks (pins) select Reset from the bottom of the tool drawer. Selecting Close takes you out of the Adjustment brush, as does selecting the K key. The K key also selects the brush.

Soften Skin

There are several presets available in the Effect pop-up window, including ones for Exposure, Brightness, Contrast, Sharpness, and so on. I suspect the Soften Skin preset will be very popular. Basically all it does is apply a negative clarity effect, but with great results, as shown in the before and after view shown in Figure 4-72. In this example I also applied some brightening to the teeth using a separate adjustment brush with an increased exposure setting.

Change Eye Color

Applying localized tints has infinite possibilities. Let me show you just one by changing the color of the eyes, as shown in Figure 4-73. I applied two adjustment masks, one to each eye, and selected a different color from the color pop-up window that appears when you click on the color swatch next to the word Color, shown in Figure 4-74. If I really wanted to do a smash-up job I could also create another adjustment mask and paint in a higher exposure value to brighten the white part of the eyes as well. But then, I'm going to stop here. I really don't want this to become like Photoshop where I spend all my time fiddling with the image.

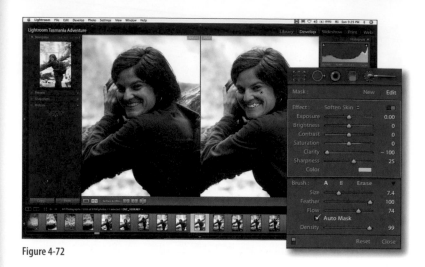

Figure 4-72

NOTE *Create custom presets by selecting Save Current Settings as New Preset from the Effects pop-up menu and type in a name.*

As with the graduated filter, I've only scratched the surface of the potential of this amazing new feature. Have fun!

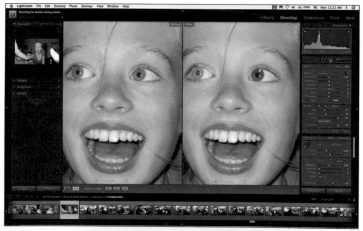

Figure 4-73

Figure 4-74

Lightroom's sharpening sliders, which are found in the Develop module's Detail pane, offer sophisticated control. With just a basic understanding of what each slider does, you can produce images with crisp, clearly defined edge detail without introducing distracting noise or artifacts to other areas of your image.

Sharpening the Way You Like It

Lightroom's Develop module has four sliders that control image sharpening, as shown in Figure 4-75. For many, the control offered by these sliders is welcome. For others, using the sliders to achieve optimal sharpening may seem daunting. For those of you who don't want to spend a lot of time sharpening your images, I want to reassure you Lightroom's default settings are pretty darn good, especially if you are working with RAW files. There are also some out-of-the box sharpening presets that may be all you need.

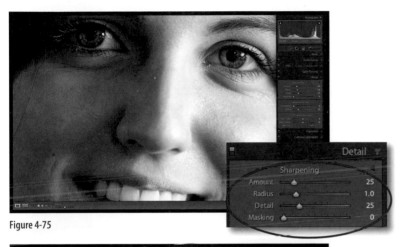

Figure 4-75

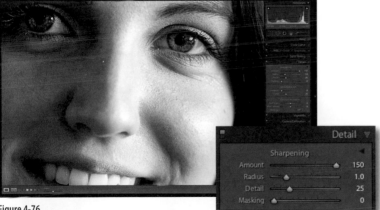

Figure 4-76

Sharpening Fundamentals

Fundamentally, image sharpening is really just an exaggeration of contrast along edges, places where light and dark pixels meet. Lightroom's Amount slider controls the intensity of the edge contrast; the Radius slider controls how wide the edge is; the Details slider determines exactly what is an edge, and the Masking slider gives you more control over where the effects of the first three sliders occur. Let me show you what I mean.

Amount slider

The Amount slider controls the amount of contrast along the edges of an image on a scale from 1 to 150. In Figure 4-76, I bumped the amount to 150 and kept the other default sharpening settings. In Figure 4-77, I set the slider to 0. You can

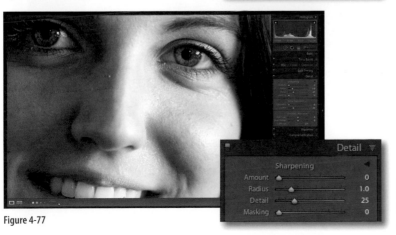

Figure 4-77

see here the extremes. For RAW files, the default amount setting is 25, a relative number based on the characteristics of your digital camera (see sidebar on the next page). For other files, such as JPEGs and TIFFs, the Amount is set to 0, which means no extra sharpening is applied until you move the slider.

Radius slider

The Radius slider controls how wide the edge is in values from .5 to 3.0. The greater the radius value, the larger the edge and the more obvious the sharpening. If you go too far with the radius setting, you'll get an unpleasant halo effect. Again, the best way for me to illustrate this is by example. I boost the radius to 3 (maximum) and the amount to 150 (maximum) so you can clearly see what is going on in this before and after shot in Figure 4-78.

An even better way to show what this slider does is to hold the Alt/Option key and then click on the slider. Figure 4-79 shows a radius setting of 0.5 (minimum), and, as you can see, a faint outline appears and few pixels are affected. Figure 4-80 shows a radius setting of 3 (maximum), and now you can clearly see the pixels outlined that will be affected when I move the Amount slider.

For all types of image files, the default radius setting is 1.0, and this is a good starting point. With JPEG and TIFF and other non-RAW files, you have to move the Amount slider before you notice any sharpening.

Detail slider

This slider works in a similar fashion to the Radius slider, but instead of working on a wide range of pixel values, it works

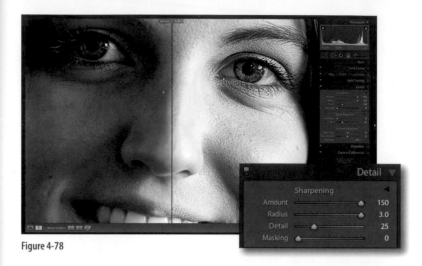

Figure 4-78

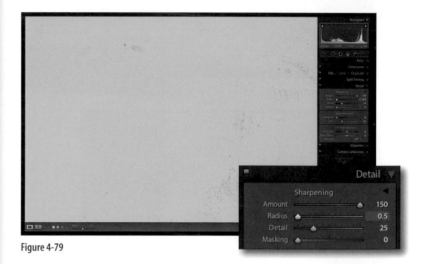

Figure 4-79

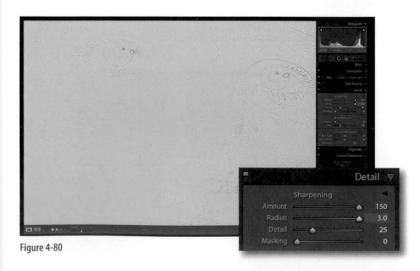

Figure 4-80

Figure 4-81

Photo by Marcus Bell

What's with the Number 25?

If you are working with a RAW file in Lightroom, you'll notice that the sharpening amount is set to 25, regardless of which digital camera you use. Why this number, and what does it mean? See Figure 4-81. (If you are working on a JPEG or TIFF, the sharpening amount's default is set to 0.) It helps to understand how Lightroom processes RAW files. Every RAW file is subject to a demosaicing algorithm that includes purposeful blurring. This blurring helps prevent color fringing by slightly blending adjacent pixels. Every digital camera model requires a different amount of blurring. The exact amount depends on many factors, including the size and characteristics of the camera sensor. Smaller sensors with many pixels typically produce a lot of noise and require more blurring during the RAW conversion in order to prevent the halo effect.

Lightroom uses information that is specific to a particular camera model to process a RAW file and determine how much blurring to apply. Since it knows how much blurring has been applied, it also knows how much sharpening is needed to compensate for that blurring. The number 25 represents the optimal sharpening strength for a particular camera. For example, a 25 value for a RAW file produced by a camera with a relatively small sensor represents more sharpening than, say, 25 for a RAW file produced by a camera with a larger sensor.

on very fine detail. A setting of 100 (maximum) defines everything as an edge and increases contrast between all pixels equally. Lower values decrease the range and therefore the effect. Again, looking at the extreme setting is helpful. Figure 4-82 shows a before and after view with a detail setting of 100.

Holding the Option (Alt) key while moving the Detail slider clearly outlines which areas are affected at this setting, as shown in Figure 4-83.

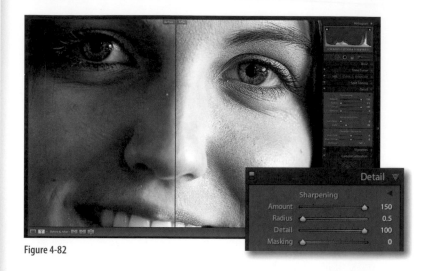

Figure 4-82

NOTE *Lightroom 2 is also capable of selective sharpening via the local adjustment tools. I covered these tools earlier in the chapter. With the local adjustment Sharpen slider you get basic local sharpen control, albeit without the powerful options found under the Detail pane.*

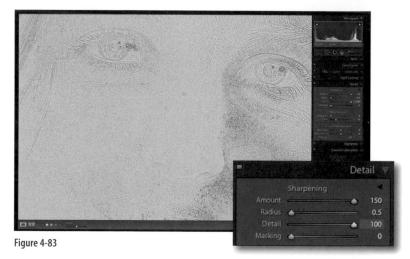

Figure 4-83

Masking slider

The Masking slider does just that: creates a mask that controls where sharpening is applied. This control is especially useful when you are working with portraits or other images that contain large areas of continuous tones that you want to remain smooth and unaffected by increases in contrast.

Again, let's see how it works by example. Here, in Figure 4-84, I set the Amount, Radius, and Detail sliders to their maximum. In other words, I've totally oversharpened the image.

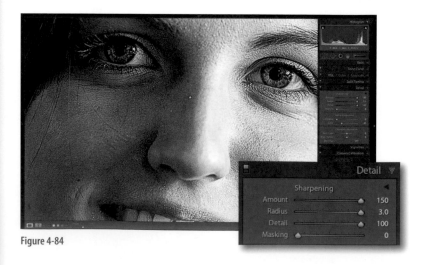

Figure 4-84

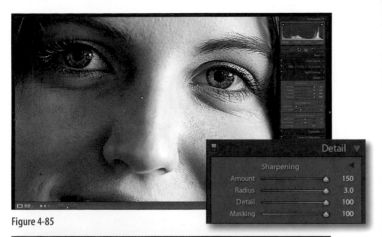

Figure 4-85

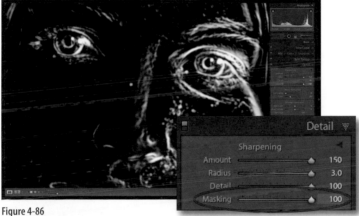

Figure 4-86

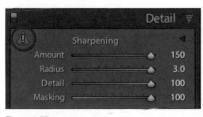

Figure 4-87

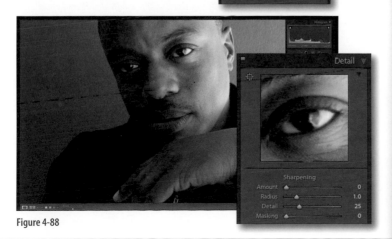

Figure 4-88

Next, I'll move the Masking slider to its maximum. You can see in Figure 4-85 how the sharpening (or contrast enhancement) is not as apparent in the skin tones. Holding the Option/Alt key while clicking on the Masking slider reveals the actual mask as shown in Figure 4-86. The black areas are the areas that are masked, or blocked.

Sharpening Strategy

Just about every image will benefit from some sharpening. The default settings may be a good place to start, but if you are willing to take the time, you can certainly do better. Knowing that every image demands different settings, here is a general strategy to follow:

1. Make your color and tonal adjustments first. (These are detailed in subsequent chapters.)

2. Select the Detail pane. You can turn sharpening off and on by clicking the switch icon to the left (circled).

3. Select the triangle at the top right of the Detail pane window, circled in Figure 4-87, right. This opens and closes a preview window with a part of your image magnified to 100%. If you don't open the preview window and if your image isn't enlarged at least 1:1 (100%), a warning icon appears (circled in Figure 4-87, left). Click on this icon and Lightroom automatically enlarges the image in the preview window. Now pick an area that contains both detail and continuous tone (like an eye, hair, or tree branch against blue sky).

4. If you are working on a RAW file, the sharpening amount setting is always 25 by default. In Figure 4-88 you'll see I find it useful to start by sliding the

slider to 0 and then examining the image to establish a baseline for my next adjustments. Keep in mind that the effect of a 0 sharpening setting varies from camera to camera. With some digital cameras, the effect is barely noticeable. With others, it appears extremely noticeable.

5. Next, move the Amount slider to 150, which, usually, is way off, as you can see in Figure 4-89. Again, I go to the extreme to visually establish a range.

6. Through trial and error and going to extremes I come up with reasonable radius and detail settings. I look for a balance between sharpness of the edges, with no noticeable noise added to the continuous tone areas. You can mitigate noise in the continuous tone areas with the Masking slider. Hold the Alt (Option) key when using the Radius, Detail, and Masking sliders. You'll get a better idea of what parts of the image are being affected, as shown in Figure 4-90 and Figure 4-91.

7. The amount of sharpening depends on the final output. If you are sharpening for screen, sharpen until it looks right. If you are sharpening for print, you will probably want to oversharpen to compensate for paper/ink absorption. (Print-specific sharpening is a whole topic into itself. There are many variables to consider, including printer characteristics, print size, ink, paper, viewing distance, and so on.)

8. Finally, don't worry about getting it perfect (whatever that may be). Lightroom uses a completely nondestructive process, and you can go back at any time and start over.

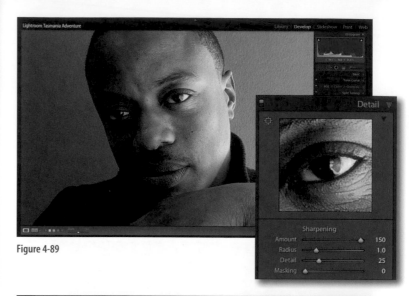

Figure 4-89

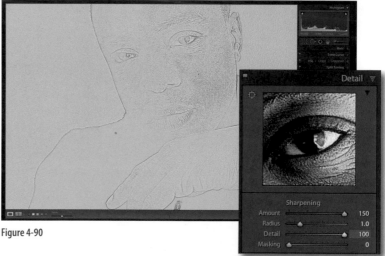

Figure 4-90

Figure 4-91

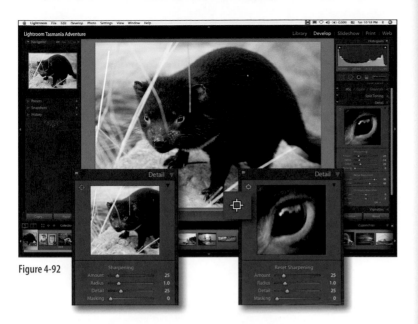

Figure 4-92

Using the 1:1 Preview Window

Click on the triangle under Lightroom 2's Details pane and a 1:1 preview box opens, as shown in Figure 4-92. Clicking on the image enlarges an area to 100 percent view, or 1:1, as shown in Figure 4-92, right. Place your cursor over the 1:1 preview window, and you can click and move the field of view. If you click on the icon in the upper-left corner of the preview box, the 1:1 preview tool, the 1:1 preview window, and your cursor become synced to the image in the large display area. Wherever you place your cursor in the large display window, that part of the image will be enlarged in the 1:1 preview box. Click in the display area, or on the 1:1 preview tool, and the views become uncoupled.

Figure 4-93

Resetting Sharpening

Hold the Option/Alt key and the words Sharpen, Noise Reduction, and Chromatic Aberration turn into reset buttons, as shown in Figure 4-93. Click on them to reset the sliders to their default settings.

Additional Sharpening Control

You'll find additional sharpening control in the Lightroom Print module, which I cover in Chapter 11, and in the Export dialog box, which I cover in Chapter 9.

Noise Reduction

With varying degrees, all digital cameras produce electronic noise, extraneous pixels sprinkled throughout an image. Higher ISO, underexposure, long exposure, and oversharpening can increase this effect. Lightroom's noise reduction feature can easily reduce the effect of electronic noise, while maintaining image detail.

Lightroom's Noise Reduction controls are found under the Detail pane, as shown in Figure 4-94.

NOTE *Noise isn't necessarily bad. It can give an image dimension and authenticity. But, think twice before applying noise reduction to your image.*

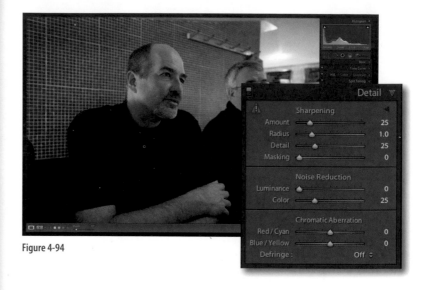

Figure 4-94

Examine Image First

Noise isn't always apparent when you examine an image at low magnification. Use Lightroom's magnifying tools to enlarge your image after applying tone and color controls (but before applying additional sharpening), and the noise will become apparent, as shown in Figure 4-95.

Pay particular attention to areas of continuous tone and shadow areas. Note the makeup of the noise. Does it look like a colored patchwork quilt? Or is the noise speckled and monochromatic?

Some images actually contain a combination of chromatic (color) and luminance (monochromatic) noise. Getting a handle on the type of noise will help determine which Lightroom control —Luminance, Color, or both—will be most effective.

Figure 4-95

Figure 4-96

Figure 4-97

Figure 4-98

Noise Reduction Procedure

To begin the process of noise reduction, follow these steps:

1. Select the Detail pane, as shown in Figure 4-96. If you are working on a RAW file, you'll notice the default color setting is 25, while luminance is set to 0. Unlike the sharpness amount setting number, 25, which is a relative value based on the type of camera you used, the color setting is an absolute value. This value is applied generically, which may or may not be right for your camera or image, but it's almost always a good starting point.

2. Enlarge your image preview to at least 1:1 (100%), preferably higher. (Clicking on the [!] icon, if present, will automatically enlarge your image.)

3. Start by sliding the Color slider to the left, down to 0, as shown in Figure 4-97. Next, move the slider incrementally to the right, increasing the value. This affects the chromatic (color) noise and leaves details found in the luminance (brightness) channel alone for the most part. If you go too far with the color setting, you won't lose detail per se, but you'll compromise color accuracy.

4. If increasing the color value doesn't do the trick, set it to zero and use the Luminance slider. Go easy and increase the value incrementally. When working on the luminance channel, you can quickly compromise image detail, as shown in Figure 4-98.

5. Sometimes, a combination of luminance and color settings produces the best result. You'll have to experiment to get the correct combination, because the correct values vary from image to image, as shown in Figure 4-99. Remember, the trick is to reduce noise without losing too much image detail.

Making a noise reduction preset

When you find an optimal setting for your camera, at a frequently used ISO, you can save those specific settings and apply them to other similar images. To do this:

1. Select the plus sign in the Presets tab.

2. In the New Develop Preset dialog window, select Check None (this unchecks all). Then check Noise Reduction, as shown in Figure 4-100.

3. Name your setting and click Create.

The preset will now show up in the Presets pane in a User Preset folder of choice, shown in Figure 4-101, as well as in the Import dialog box, many contextual menus, and in the Library module's Quick Develop pane preset pop-up menu. If you are applying a preset from the filmstrip, hold the Control key (or right-click) and click on one of the selected thumbnails. Be sure to click on the image area of the thumbnail, not the edges.

NOTE *If you find Lightroom's noise reduction controls don't take you far enough, open Photoshop and use its more powerful, and feature-laden, Reduce Noise filter instead.*

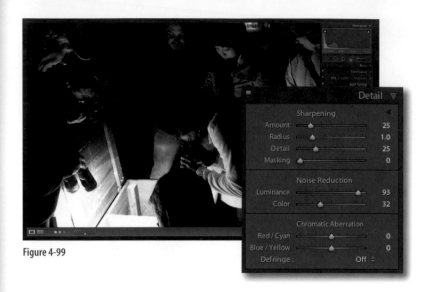

Figure 4-99

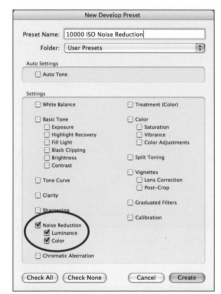

Figure 4-100

Figure 4-101

In the Details pane provides controls for fixing chromatic aberrations. These are the same controls found in Adobe Camera Raw and can also be mimicked using Photoshop's Reduce Noise and Lens Correction filters. (In previous versions of Lightroom, Chromatic Aberrations was found under the Lens Corrections pane, which does not exist in LR2.)

Fixing Chromatic Aberrations

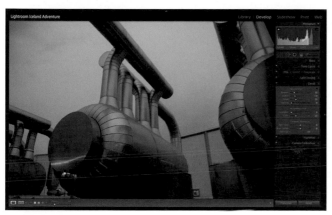

Figure 4-102

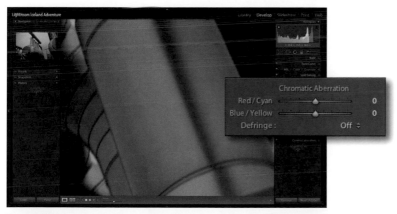

Figure 4-103

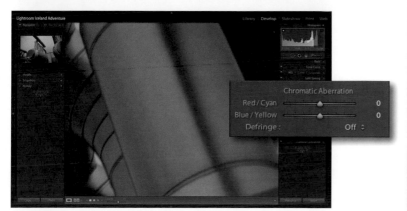

Figure 4-104

Chromatic aberrations (CA) show up as anomalous color shifts, mostly on the outer perimeter of an image, in areas with distinct edge transitions. The fringing is sometimes there because when light passes through glass, different color wavelengths are separated and shifted in focus ever so slightly. They are mostly evident when wide-angle lenses are used, but can appear with longer lenses as well. The image in Figure 4-102 is of a huge Icelandic power plant taken during the first Adventure in Iceland. Although the chromatic aberrations are not visible at first glance, as shown in Figure 4-103, magnification shows some annoying anomalies on the edges, as shown in Figure 4-104. This is how to reduce CA:

1. Magnify the image to at least 100 percent to identify the color fringing.

2. Select the Details pane. Make sure the pane switch icon is in the up position. (An [!] icon appears if you are below 100 percent magnification. Click on the icon to automatically resize.)

3. Select the appropriate slider. For this image, it took moving the Red/Cyan slider to −30 to get it right. (See the sidebar on page 130 to learn exactly what each slider does.)

4. If neither of these sliders does the trick, try one of the two Defringe settings (Highlight Edges or All Edges) and see if that helps.

Understanding How CA Controls Work

It's very useful to understand how the CA controls actually work. They don't simply look for edges and remove or desaturate colors. If you move the control sliders radically one way or another, you will notice a subtle distortion of your image, growing in intensity from the center of the image out to the edges. In fact, the distortion is limited to select colors that are actually expanding or shrinking (that is, distorting) based on your settings. For example, if you choose to fix Red/Cyan fringing, then either the red or cyan colors will be affected, as shown in Figure 4-105. If you chose to fix Blue/Yellow fringing, only those colors will be affected, as shown in Figure 4-106.

(The Defringe options—Highlight Edges and All Edges—slightly desaturate edges, which can help in some cases, but may also result in thin gray lines.)

The key point is that there are important practical implications. First, don't crop your image, apply CA controls, and expect good results. The color distortions are based on a lens model; the moment you crop, you've changed that model. Second, don't expect this to work on other aberrations such as a dead pixel or a highlight blooming that appears in the dead center of an image. The effect is more powerful on the edges of your images, and it diminishes as you move closer to the center. Finally, the results you get will vary depending on the lens you use.

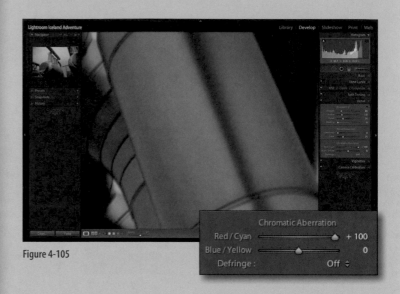

Figure 4-105

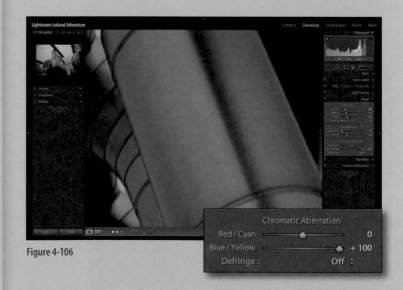

Figure 4-106

The Vignettes pane controls can be used for lens corrections or for creative effects that add emphasis and depth to your image. New controls include post-crop support, as well as control over the vignettes shape (to a point), and edge feather. It's still one of the easiest and effective controls Lightroom has to offer.

Lightroom Vignettes Pane

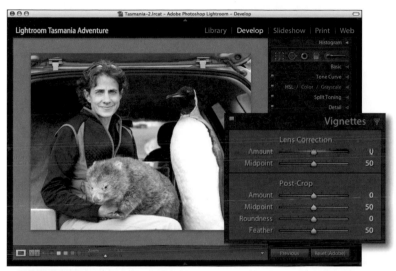

Figure 4-107

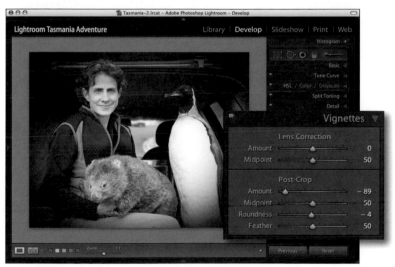

Figure 4-108

Vignetting (darkening at the corners of the frame) can be caused by a mismatched filter/lens hood or a lens (for example, using a filter on an ultra-wide-angle lens). It can also be caused by using wide-angle lenses not optimized for digital capture (that is, not optimized for even brightness across the fame).

To add or diminish a vignette:

1. Select the Vignettes pane, as shown in Figure 4-107. If you are working with a cropped image, use the sliders found under Post-Crop. If your image hasn't been cropped, you can use either the Lens Correction or Post-Crop slider.

2. Adjust the Amount slider to the left or right. The edges darken or lighten from a central radial point. In this case, I actually darken the edges of the image to bring more attention to Katrin Eismann and her well behaved pets, as shown in Figure 4-108.

3. Use the Midpoint slider to expand or decrease the range of the effect. You cannot, however, create multiple interest points. Adding a vignetting effect is therefore most effective when your image contains a single point of interest that you want to emphasize.

4. Under Post-Crop, you can control the shape of the vignette from oval to round with the Roundness slider. Control the edge with the Feather slider, from hard to soft.

Develop Great-Looking Photos

The road to a great digital photo starts the moment you frame the shot and press the shutter release. Using Lightroom's Develop module, you can do a lot to bring out the best tonal qualities of that image and much more. In the preceding chapter I introduced many features of the Develop module. In this chapter, I'll show you specific ways to evaluate your image to make sure it is adjusted correctly. I'll show you both how to determine the correct white balance and how to distribute tonal values based on a combination of technical and subjective criteria. In subsequent chapters, I'll focus on other aspects of the Develop module: color-related issues, localized corrections, black and white conversion, and special effects.

Chapter Contents

Evaluating Tonal Distribution and Color

Adjusting White Balance

Basic Tone Controls

Tone Curve for Advanced Control

PHOTO CREDIT: Charlie Cramer

Histogram Options

Right-click anywhere on the histogram and you'll get the contextual menu shown in Figure 5-4. Here you can control the visibility of tools and information that appears along with the histogram.

Figure 5-4

Hold Option (Alt) Key and Move Exposure Slider

You can get even more information about exactly which colors are clipped by holding the Option (Alt) key while moving the Exposure (circled in Figure 5-5), Recovery, and Black sliders in the Basic panel.

If you hold the Option/Alt key while moving the Exposure and Recovery sliders, the image turns black, and clipped areas appear white.

Red, green, or blue color areas indicate clipping in one of those color channels. If more than one color channel is clipped, your preview will be indicated with cyan, magenta, or yellow.

Do this with the Black slider (circled in Figure 5-6), and the image turns white and clipped areas appear black.

> NOTE *The histogram in Lightroom's Library module also displays 8-bit RGB values of your selected image, albeit without the interactive features of the histogram in the Develop module.*

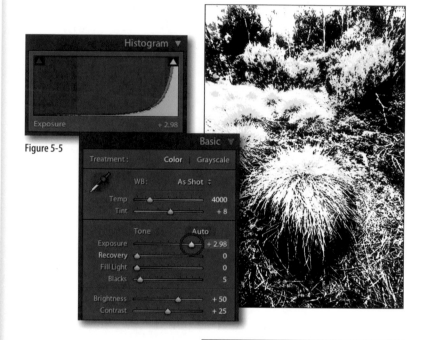

Figure 5-5

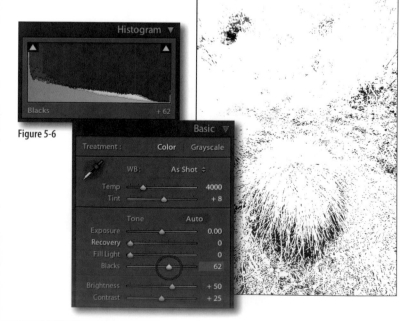

Figure 5-6

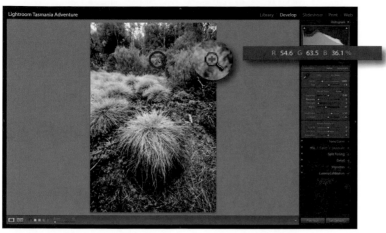

Figure 5-7

Color Samples

Place your cursor over a color in the preview window, and the corresponding RGB color percentage values appear under the Histogram pane, replacing the camera EXIF data, as shown in Figure 5-7. Color information is particularly useful if you have included a quantifiable color target in your image, or if you can find an area of your image that should be close to neutral. In that case, you can determine color cast by comparing the RGB percentage values. The closer they are to each other, the closer you are to a neutral color.

Figure 5-8

Monitor Calibration

If a monitor is too contrasty, too bright, or if the colors are off, there is no way to predict what an image will look like when it is printed. A monitor can be calibrated using software alone, but hardware calibration is more accurate.

For around a hundred dollars, you can buy a product that attaches to your monitor and physically measures the colors and brightness, creating a color profile that can be used to produce consistent results.

Shown in Figure 5-8 is the i1 Display 2, which costs around $200 (*www.xrite.com*). Software calibration comes with Mac OS X. It's called the Display Calibrator Assistant, found in the Utilities folder. (Windows users will need to rely on third-party solutions.)

The Tasmanian Adventure featured photographers from Germany, England, Japan, Australia, and North America— and flying everyone in from around the world at the same time was a logistic challenge. Fortunately, one of our main sponsors was Qantas Airlines, which got us all there and back safely, and—for those of us lucky enough to be upgraded to business class—in style. I took this shot of Leo Laporte on the way down from San Francisco to Sydney, sleeping like a baby.

Mikkel Aaland

Adjusting White Balance

Under simple lighting conditions, most digital cameras do a remarkably good job of setting an accurate white balance and making colors appear as you expect them to. When the white balance is off, don't fret. Lightroom can help you get it right, especially if you shot RAW.

There are a few ways to adjust white balance in Lightroom's Develop module, as shown in Figure 5-9. You can do this via the Basic pane and these features:

- Presets

- White balance selector tool

- Temp and Tint adjustment sliders

The goal is to use one of these methods to produce a pleasing balance of colors, yielding white whites and neutral midtones. (Of course, correct white balance can be subjective as well. Some images warrant warmer tones, and other images call for cooler ones.)

Generally, establishing a correct white balance should be done before adjusting other tonal distribution and color settings. That's why Adobe placed the white balance (WB) tools at the top of the Basic pane, where image adjustments are made. After you make all your other tonal adjustments, it's advisable to go back and fine-tune your white balance settings.

White Balance Presets

If you are working with a RAW file, clicking on the two arrows next to As Shot in the Basic pane brings up the WB pop-up menu, shown on the left in Figure 5-10. If you are working with a non-RAW file such as a TIFF or JPEG, your choices are those shown on the right.

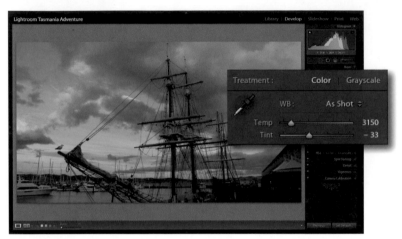

Figure 5-9

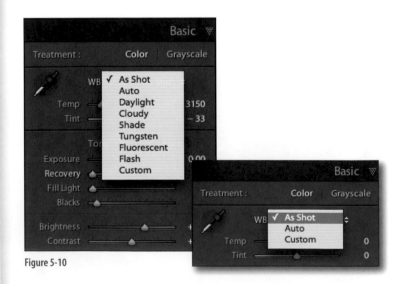

Figure 5-10

Figure 5-11

The Auto White Balance setting is also available through the menu by choosing Settings→Auto White Balance, using the keyboard shortcut +Shift+U (Ctrl+Shift+U), or the contextual menu displayed by right-clicking on the image preview, as shown in Figure 5-11.

As Shot is the default setting in the Basic pane WB pop-up menu. Lightroom will apply the white balance setting that was recorded at the time of exposure. In my experience, when lighting conditions are simple—that is, the light is provided by a single light source—I am generally happy with the As Shot preset both for RAW and for JPEG files.

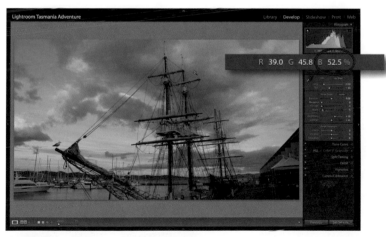

Figure 5-12

I hope I'm not the only one who has set the white balance incorrectly on his camera, as I have done here with the image shown in Figure 5-12, taken at the harbor in Hobart, Tasmania. In this case there is a strong blueish cast, which is confirmed by placing my cursor over a "neutral" area of the image and noting the dominance of blue in RGB percentage values displayed under the histogram (circled).

> TIP *I often press the L key while checking white balance and evaluate my image against a Lights Dim or Lights Out view mode.*

Other white balance presets

If you are not satisfied with the As Shot setting, you can try the other settings from the pop-up menu. Start with Auto, where Lightroom reads the image data and automatically attempts to adjust the white balance. Auto often works fine, as it does in this case, even though Auto gives our example image a slightly reddish cast, as shown in Figure 5-13.

Select the other presets and observe the changes in your image. Shown in Figures 5-14 through 5-17 are the effects of various presets on my sample image. As you can see, none of the presets do the trick of producing a neutral gray.

TIP *On the earlier Iceland Adventure, many photographers used an ExpoDisc digital white balance filter like one shown here to create a custom white balance setting. (Expoimaging was a sponsor of that Adventure.) You can achieve a custom white balance setting with a simple gray card, but I find the results achieved with the ExpoDisc to be far superior. It's available for about $75 at camera stores and online at* www. expoimaging.net.

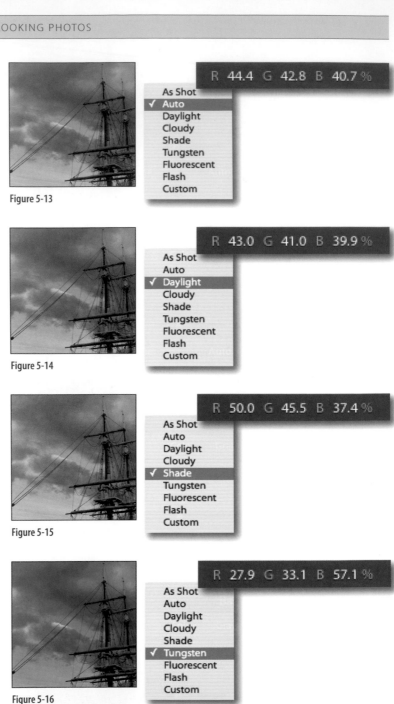

Figure 5-13

Figure 5-14

Figure 5-15

Figure 5-16

Figure 5-17

Figure 5-18

Figure 5-19

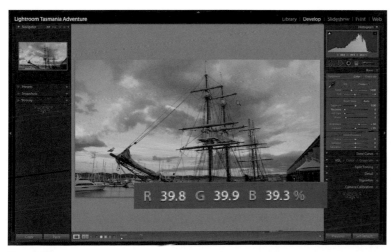

Figure 5-20

The White Balance Selector

The white balance tool (circled in Figure 5-18) attempts to make the color exactly neutral. The changes are reflected in the Temperature and Tint sliders. You'll also notice a change in the histogram. Sometimes this produces a satisfactory result, sometimes it doesn't.

Using the white balance tool

The white balance tool—accessed by clicking the eyedropper icon at the top of the Basic pane, under the View menu (View→White Balance Selector), or by hitting the W key—is very easy to use.

Simply select the tool and move your cursor over an area of your image that should be neutral gray. A 25-pixel enlargement (circled in Figure 5-19) shows you exactly where you are sampling.

View the white balance changes in the Navigator window in real time as you move the tool around. When you are satisfied, click, and the new setting is applied.

Evaluating white balance results

I suggest using the color sampler on a should-be-neutral area of your image and evaluating the results with the color sampler, or viewing your image in the Lights Out view mode. To undo the effect, use the History panel or type ⌘+Z (Ctrl+Z).

Using the white balance tool, I was able to obtain the correct white balance, as confirmed when I placed my cursor over a neutral area of the image and saw the near-identical RGB values shown in Figure 5-20. If you are not satisfied, select the tool again, either by clicking on its icon or pressing the W key, and try again.

Temperature and Tint Controls

Below the WB pop-up menu are two sliders—Temperature and Tint—that can be used to fine-tune the white balance or produce creative effects.

Move the Temperature slider to the left, and colors appear bluish (become cooler), as shown in Figure 5-21.

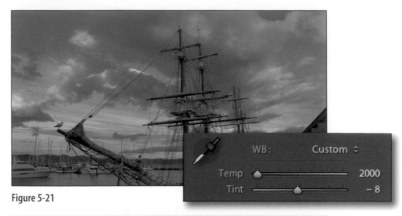

Figure 5-21

Move the Temperature slider to the right, and the colors appear more yellowish (warmer), as shown in Figure 5-22.

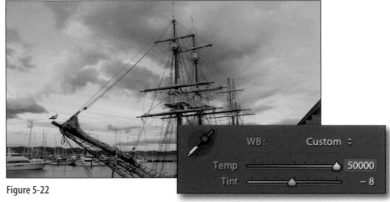

Figure 5-22

Move the Tint slider to the left (negative values), and you tint your image greenish, as shown in Figure 5-23.

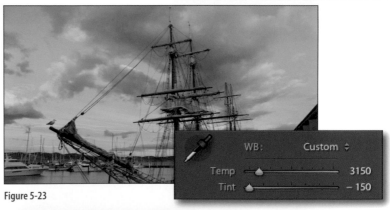

Figure 5-23

Move the Tint slider to the right (positive values), and you tint it a magentalike tone, as shown in Figure 5-24.

Moving either slider changes the white balance pop-up menu setting to Custom. Double-clicking on the slider triangle resets the slider setting to its default setting, as does double-clicking on the slider name. (This holds true for all sliders in Lightroom.)

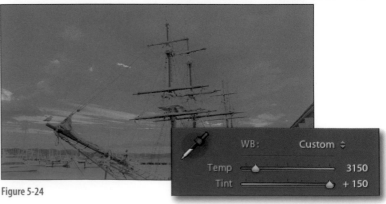

Figure 5-24

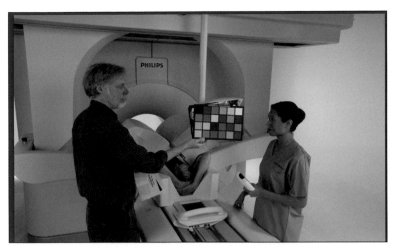

Figure 5-25

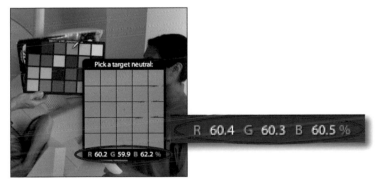

Figure 5-26

Determining White Balance from a Target

Including a quantifiable target in your shot will help determine if your white balance is perfectly correct. I find it very useful to include an X-Rite ColorChecker in a shot whenever lighting or shooting conditions are relatively stable, as shown in Figure 5-25. (This example isn't from the Iceland or Tasmania Adventure, but from a shoot I did for Philips Medical Systems.) A common, less expensive, 18 percent gray card also works fine, but I like the added bonus of the reference colors. Then I simply select and position my white balance tool over the target (in this example, a neutral square). If my white balance is in the ballpark, the R, G, and B values at the bottom of the 25-pixel enlargement (circled at left in Figure 5-26) should be close, but not necessarily the same. I then click on the target, and the RGB values that are now displayed in the Info window of the toolbar (circled at right in Figure 5-26) become nearly exactly the same, or neutral. Changes in the white balance are reflected in the image and histogram.

To selectively apply this white balance setting to other images, one at a time, click Copy on the bottom of the left panel. This brings up the Copy Settings dialog box shown in Figure 5-27. Check only the White Balance check box and then click Copy. Then, select another image taken under the same lighting conditions from the filmstrip and click Paste, at the bottom of the left panel. To apply the same white balance setting to multiple images, you can make a preset (described in Chapter 6) or, with your white-balance-fixed image active, make a selection in the filmstrip and then click on the Sync button in the right panel.

Copy Settings

- ☑ White Balance
- ☐ Treatment (Color)
- ☐ Spot Removal

- ☐ Basic Tone
 - ☐ Exposure
 - ☐ Highlight Recovery
 - ☐ Fill Light
 - ☐ Black Clipping
 - ☐ Brightness
 - ☐ Contrast
- ☐ Color
 - ☐ Saturation
 - ☐ Vibrance
 - ☐ Color Adjustments
- ☐ Crop
 - ☐ Straighten Angle
 - ☐ Aspect Ratio

- ☐ Tone Curve
- ☐ Split Toning

- ☐ Clarity
- ☐ Vignettes
 - ☐ Lens Correction
 - ☐ Post-Crop

- ☐ Sharpening
- ☐ Local Adjustments
 - ☐ Brush
 - ☐ Graduated Filters

- ☐ Noise Reduction
 - ☐ Luminance
 - ☐ Color
- ☐ Calibration

- ☐ Chromatic Aberration

(Check All) (Check None) (Cancel) (Copy)

Figure 5-27

Basic Tone Controls

Every digital image contains a range of tonal values, distributed over a range of light and dark tonal values. Often, even with properly exposed images, you'll want to redistribute these tonal values to meet aesthetic or quantifiable criteria. Lightroom gives you several ways to do this.

Lightroom's processing tools are organized systematically, providing a rough order to follow as you work on your image. After you have determined the proper Lightroom white balance, it's time to start working on the tonal values found under the Basic tone pane or directly in the histogram itself, as shown in Figure 5-28.

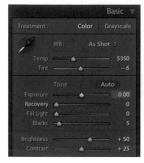
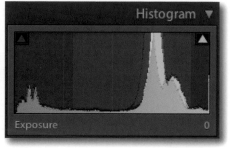

Figure 5-28

Auto Tone

A good place to start is with Auto. When you click on the Auto button (circled in Figure 5-29), Lightroom creates a made-to-order tone map based on the individual characteristics of a particular image. It does not affect the Clarity, Saturation, or Vibrance controls. Auto often produces satisfactory results, but not always.

For example, in the image shown in Figure 5-30, Auto successfully darkened the light blue wall around the subject, but it darkened the subject too much at the same time. I often keep the Auto setting, even if it's not perfect, and fine-tune the results with other tonal controls. I'll show you how I used fill light to get this image just right. If Auto is way off, use the keyboard shortcut ⌘+Z (Ctrl+Z) or step backward in the History tab. If you select Reset at the bottom of the Develop right panel, you'll go back to the original camera settings, which may or may not be what you want.

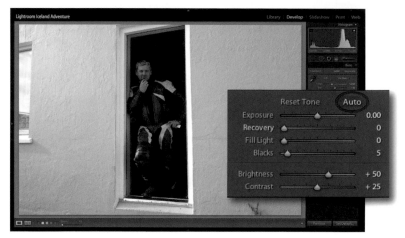

Figure 5-29

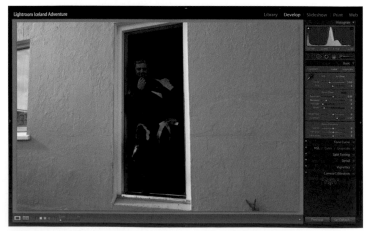

Figure 5-30

Figure 5-31

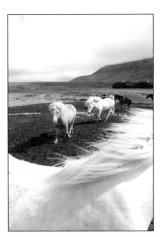

Figure 5-32

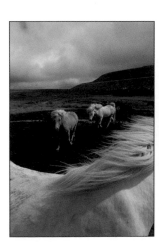

Figure 5-33

Exposure Slider

If Auto doesn't give you the tonal distribution you want, try using the Exposure slider. Take, for example, the image shown in Figure 5-31. As you can see from the corresponding histogram, the tonal values are shifted to the right, toward the highlights, and there is clipping (loss of detail) of these values.

If I move the Exposure slider to the right (positive values), the image brightens but there is even more clipping (loss of detail) in the highlights, as shown in Figure 5-32. Even though I can recover some of the highlight detail using the Recovery slider—more on this later—increasing the exposure was obviously the wrong way to go with this image.

NOTE *Exposure values—which can be typed directly into the numerical field with a + or − prefix—are roughly equivalent to f-stops. From an exposure point of view, an adjustment of +1.00 is similar to increasing a camera's aperture one stop. Similarly, an adjustment of −1.00 is similar to reducing the aperture one stop.*

If I move the slider to the left (negative values) the image darkens and detail is revealed in the highlights, as shown in Figure 5-33. Now I have a relatively good distribution of tonal values. However, to finish this image, I use the Brightness slider. As you will see later, the Brightness slider works primarily on the midtones.

Recovery

The image shown in Figure 5-34 is a perfect candidate for the Recovery slider, which comes after the Exposure slider. (If you work directly from the histogram, Recovery is found by moving your cursor to the right side of the histogram.)

In the image shown here, the sky is lacking detail, as revealed by the red highlight warning on the image and the vertical line on the far right side of the histogram.

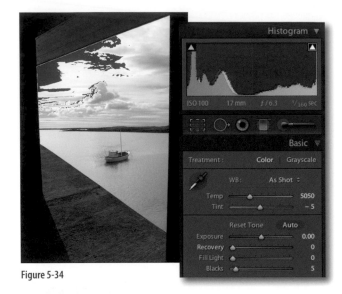

Figure 5-34

The intent of the Recovery slider is to recover details in the highlight areas that might otherwise be missing. It does this by looking individually at the red, green, and blue channels, finding data in one channel, and then reconstructing the data across the three channels. It has the effect of darkening the highlights slightly without affecting the darker areas.

As you can see by the diminished clipping in Figure 5-35, it's particularly effective on the image shown here, bringing out details in the clouds and leaving the rest of the image alone.

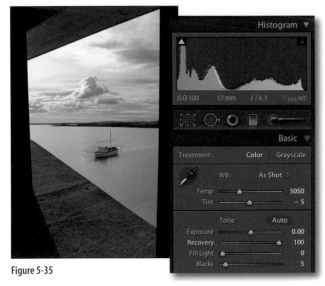

Figure 5-35

Fill Light

The Fill Light slider opens up the shadow areas without affecting the highlights (up to a point). I used fill light to finish up the image used in a previous example. Notice how the biker and the doorway shown in Figure 5-36, which were previously too dark after using Auto, are now plainly visible. (Care should be taken when using the Fill Light slider not to push it too far, as shadow noise is often enhanced as well.)

Figure 5-36

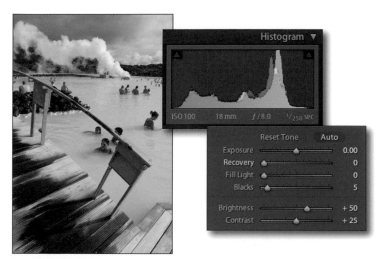

Figure 5-37

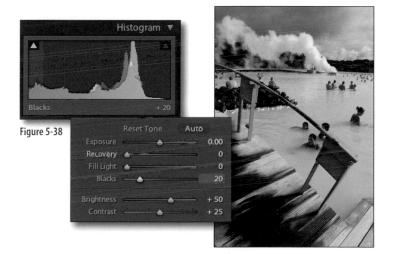

Figure 5-38

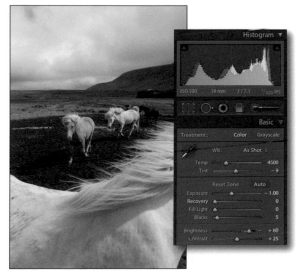

Figure 5-39

Blacks

I use the Blacks slider a lot. It darkens the darkest parts of an image (setting a black clipping point), while mostly leaving the rest of the image alone. It effectively produces the opposite effect of Recovery. I used the Blacks slider on this image, shown in Figure 5-37, which, at first glance of the preview and its histogram, looked fine.

But moving the Blacks slider just a little to the right (to 20) gave the image an appearance of more depth. I find many of my images benefit from a slight increase in the Blacks slider, as shown in Figure 5-38.

> NOTE *You can create an Auto Black user preset. Check out Peter Krogh's cool recipe for doing this in Chapter 8.*

Brightness

The Brightness slider is similar to the Exposure slider, but it redistributes the tonal values in an adjustment weighted toward the midtone values. While a positive Exposure setting may clip the highlights—moving the Brightness slider to the right doesn't result in highlight clipping—it compresses the highlights and opens up the midtone and shadow areas. Conversely, moving the slider to the left darkens an image by compressing the shadow areas and opening up the highlights. I used the Brightness slider as shown here in Figure 5-39 to give a final touch to the image I had previously adjusted using the Exposure slider.

Contrast

This slider results in either increased or decreased contrast, while avoiding clipping on the ends of the tonal scale. (You can observe this by watching the histogram as you move the slider.) In Figures 5-40 through 5-42, the first image has no contrast adjustment, the second shows the effect of sliding the Contrast slider to the left, and the third shows the effect when the Contrast slider is set to the extreme right. (The photo was taken in Tasmania by Masaaki Aihara.)

Resetting Tones

If you want to reset only the tonal changes to their original settings, go to the Basic pane and double-click on the word Tone, found to the left of the Auto button. This won't affect any changes made to the presence sliders, which include Clarity, Vibrance, and Saturation.

Presence Sliders

The final Basic pane controls are grouped under the name Presence and include Clarity, Vibrance, and Saturation. Because these sliders generally relate to color issues, I go into detail on when and how to use them in the next chapter, Color-Tuned Photos.

> TIP *Use Lightroom's compare mode to view before and after versions of your image. Select the Compare icon in the toolbar or select View→Before/After from the menu bar. Pressing the Y key cycles you between the Loupe and Compare view modes.*

Figure 5-40

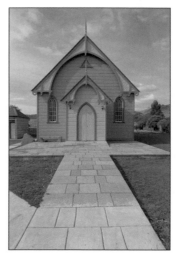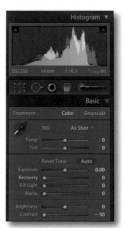

Figure 5-41

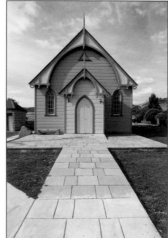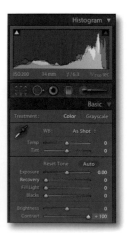

Figure 5-42

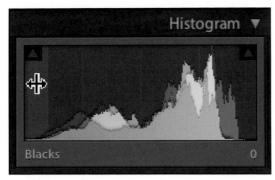

Figure 5-43

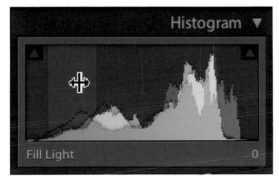

Figure 5-44

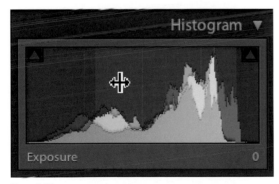

Figure 5-45

Figure 5-46

Adjusting Tone Directly from the Histogram

If you prefer, you can make your Basic tone settings directly from the histogram. Place your cursor over the histogram and drag to the left or right. Where you initially place the cursor determines which tone setting is affected.

Moving from the left side of the histogram to the right, you access these controls:

- Figure 5-43 Blacks
- Figure 5-44 Fill Light
- Figure 5-45 Exposure
- Figure 5-46 Recovery

As you move your cursor, you will see the relevant Tone slider move as well.

I often work directly from the histogram when I'm working outside the Basic tone pane—for example, when I'm in the Split Toning pane. It saves me from needing to scroll up the right panel, because I always keep the Histogram pane visible.

Basic Tone Step-by-Step Summary

Start by using Auto. Then, if necessary, fine-tune the Auto effect with any of the other tonal sliders. If Auto is completely off, start with the Exposure slider. Then, if necessary, the Recovery and/or Fill Light sliders, then the Blacks slider. Finish off with the Brightness and/or Contrast sliders. (Further fine-tuning can be done using the Tone Curve, detailed in the following section.)

Be sure not to rely only on the preview window. Use the histogram or under/over warnings to evaluate the effects of your tonal changes.

Tone Curve for Advanced Control

After performing your major tonal corrections in the Basic pane, fine-tune your work with the Lightroom Tone Curve. I suspect you'll really enjoy working directly off the image preview with the breakthrough Target Adjustment tool.

I really like Lightroom's tone curve graph, shown in Figure 5-47. Admittedly, you don't have as much control with Lightroom's tone curve as you do with Photoshop's curves feature, but it's hard to mess up, which I appreciate. It's kind of like using training wheels—without giving up too much control.

Just as with Photoshop's curves, the horizontal axis represents the original intensity values of the pixels, and the vertical axis represent the new tonal values.

Instead of placing a multitude of points on the curve and dragging the curve to a desired position, with Lightroom's tone curve you basically work with four set points: highlights, lights, darks, and shadows. You can control these values directly from the curve with your cursor or up and down keys, with the sliders, or directly from the image preview using the Target Adjust tool. There are also preset point curve settings: Medium Contrast (default), Linear, and Strong.

NOTE *As explained in Chapter 4, Lightroom 2 now features localized tonal control, with the ability to pinpoint precise areas of any image that need special treatment without affecting other areas. I show you more ways to work with the localized tools in Chapter 8.*

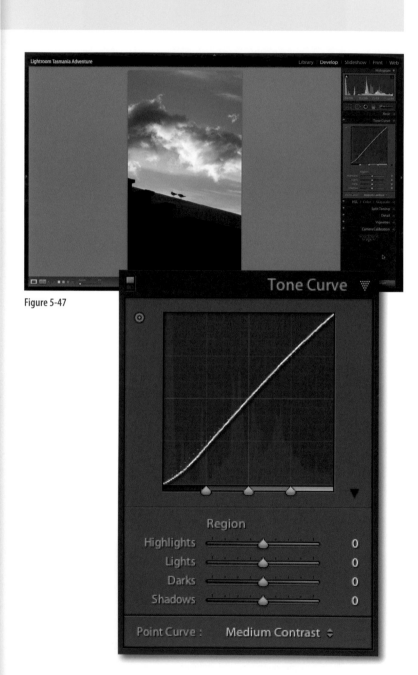

Figure 5-47

Figure 5-48

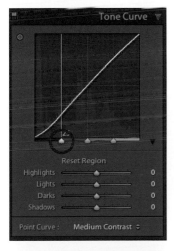
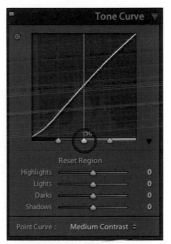

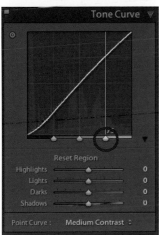
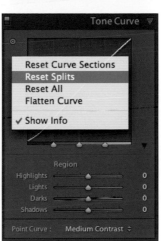

Figure 5-49

Curve on Training Wheels

No matter how much you try, you won't mess up too badly using the tone curve. Try this. Click anywhere on the graph. You'll see a bubble form around it, as shown in Figure 5-48. Now drag any part of the curve up or down. (Up lightens the image; down darkens it.) You won't be able to move beyond the constraints of the bubble, beyond which would either clip the highlights (up) or shadow areas (down). If you are feeling ambitious and want to "get under the hood," you can create presets that defy these restraints. (See the sidebar "Under the Hood" at the end of this chapter.)

Split Point Sliders

Further control is found with the split points, three triangles at the bottom of the curve graph as shown circled in Figure 5-49. Drag the triangles horizontally left or right to control the width of the given tonal range. To reset the split point sliders, right-click on the graph and select Reset Splits from the contextual menu shown at the bottom right of Figure 5-49. Double-clicking on a triangle resets that specific region.

NOTE *Charlie Cramer shows how he uses Lightroom's tone curve to enhance foggy or otherwise low-contrast images in Chapter 8.*

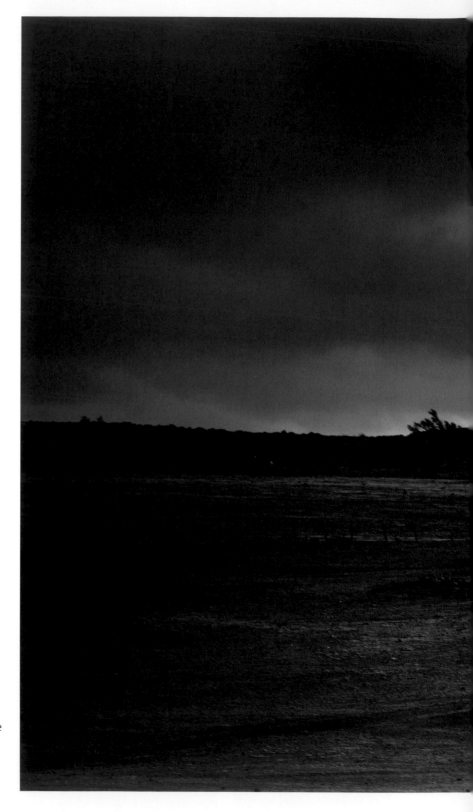

Marcus Bell is an Australian photographer named by the BBC as one of the world's top ten wedding photographers. I love the way he turned his camera toward landscapes when he joined us in Tasmania. There is something very special and unique about Marcus's outdoor shots. I see his portrait eye picking singular objects in nature like this gnarled old tree on the west coast of Tasmania, imbuing them with human character.

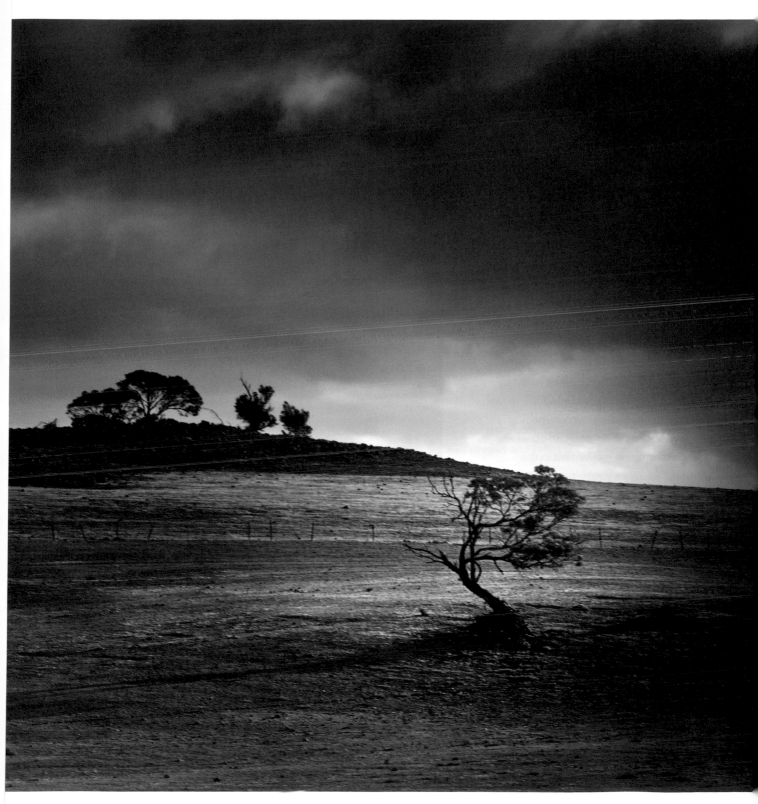

Marcus Bell

Under the Hood: Curves Control

As I mentioned earlier in the chapter, you can't physically drag the Curve graph over or under the perimeter of the bubble, as shown in Figure 5-56. If you could, it would result in highlight or shadow clipping.

This is great until you want to create a curve that replicates, say, a solarizing effect.

So, here is a workaround:

1. Open the Develop Presets folder on your desktop. You can find the Develop Presets folder by selecting Lightroom→Preferences→Presets →Show Lightroom Presets Folder from the menu bar, shown circled in Figure 5-57. (For Windows, Lightroom preferences are found under the Edit menu.)

2. Mac users, make a duplicate of the preset called *Tone Curve–Medium Contrast. lrtemplate*. Open the duplicate in a text editor such as TextEdit, shown in Figure 5-58. Window users, open *Tone Curve–Medium Contrast.lrtemplate* using Notepad, or a similar text editor application, and immediately do Save As, renaming the preset "LR Adventure Solarize" or whatever descriptive name you want, and save it in the Develop Presets/User Presets folder. Make sure it ends up with the *.lrtemplate* extension.

Figure 5-56

Figure 5-57

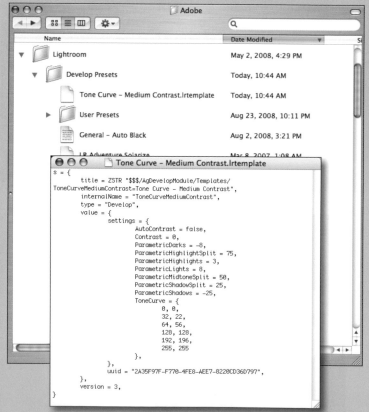

Figure 5-58

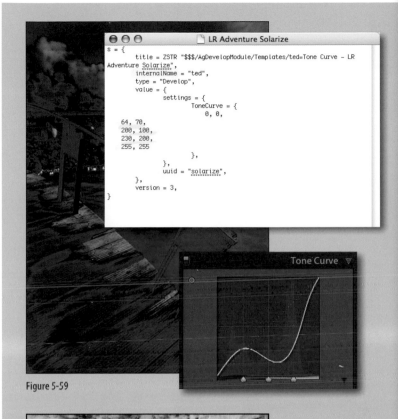

Figure 5-59

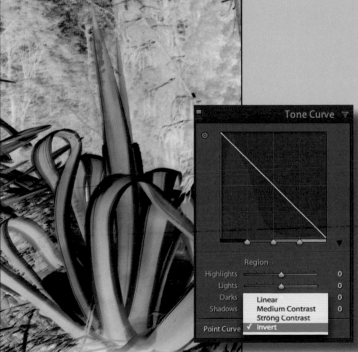

Figure 5-60

3. Replace the original text with the text and *ToneCurve x,y* coordinates you see here in Figure 5-59. It doesn't matter what "internalName" or "uuid" you use, as long as the names are unique. Also note that the "internalName" can be anything, but must match the name found in the title line.

4. Mac users, save and name your file (for example, "LR Adventure Solarize") and place it in the Develop Presets/User Presets folder. Make sure it ends up with the *.lrtemplate* extension.

5. If you duplicate what you see here in your open duplicate file, you'll end with a modified graph that will produce the effect shown.

6. Next time you fire up Lightroom, the new presets will appear in the Presets pane under User Presets.

If you don't want to do the coding yourself, just send me an email, and I'll send you the free presets (*mikkel@cyberbohemia.com*). Or go to *http://inside-lightroom.com*, where you can find lots of free presets. (In chapter 8 I show you another under-the-hood trick with Peter Krogh's Auto Black recipe.)

In my previous Lightroom Adventure book I gave instructions on how to create an inverted graph that produced a negativelike image. Well, there is no longer a need for those instructions. In Lightroom 2, in the Tone Curve pane under the Point Curve options, you can now choose Invert to produce the effect shown in Figure 5-60.

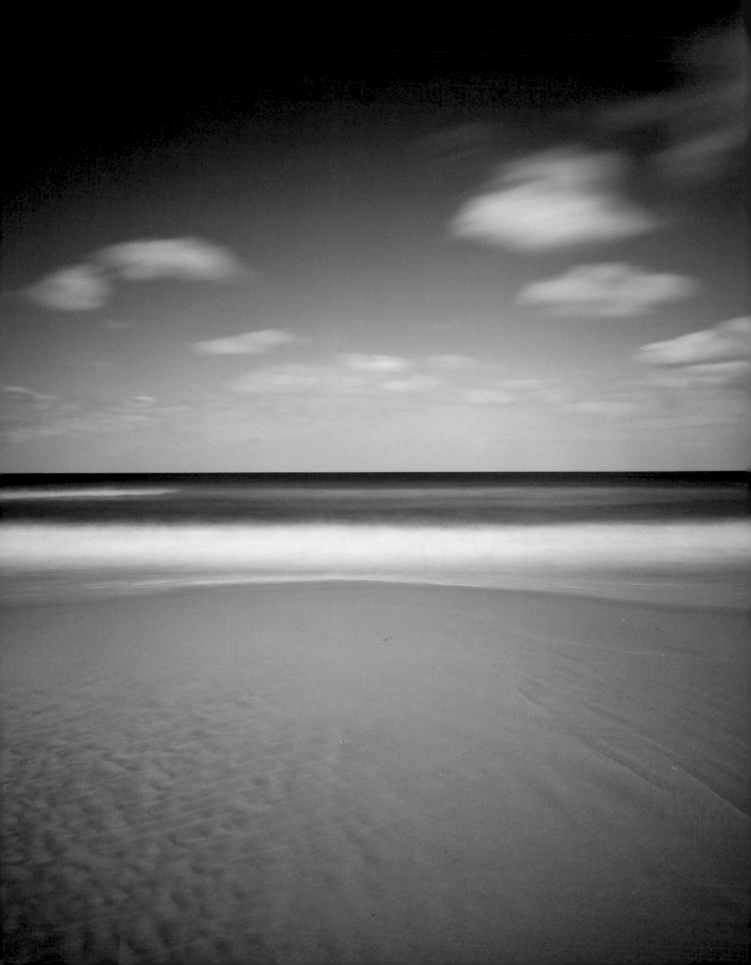

Color-Tuned Photos

Adjusting colors in Lightroom is a snap. With Lightroom's Develop module, you get sliders that help you make global color adjustments, or you can place your cursor directly over any color in your image and alter only that color with a click and a simple up or down movement. Imagine supersaturating a red apple or changing a soft orange sweater to bright pink without any special knowledge of color science. All this is possible with Lightroom's color controls, and this chapter shows you how. I also show you how to use Lightroom's Split Toning pane for subtle control over color in highlight and shadow areas, and I demonstrate how to create a custom camera profile as well.

Chapter Contents

Controlling Vibrance and Saturation

In the previous chapter, you learned how to use white balance controls to globally fine-tune the color cast of an image. Now I'll show you how to use the Vibrance and Saturation sliders to adjust color. Both controls, found in the Basic pane under Presence, increase or decrease color intensity, but in very different ways.

Vibrance Versus Saturation

Vibrance is especially useful when you are working on images that contain areas of primary colors you want to saturate or desaturate, while leaving areas of secondary shades—such as skin tones— alone. Saturation globally increases or decreases color intensity. As you will see, each slider has its appropriate use.

Look at the before and after shots shown in Figure 6-1. For Catherine Hall's shot of a Tasmanian beauty, I left the Vibrance slider alone and increased the color Saturation to a value of +66. Note the increased saturation in the green fern, which I wanted. However, also note the unpleasant shift in skin tones, which I didn't want.

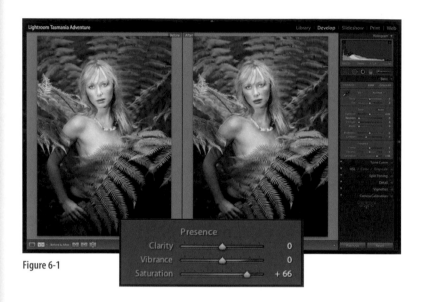

Figure 6-1

Now I reset the Saturation slider to 0, and instead use the Vibrance slider. In the after shot shown in Figure 6-2 the green fern is more vivid; however, even though the skin tones are warmer, they are still very pleasant.

> NOTE *Vibrance and Saturation (along with a control called Clarity) are grouped in a category called Presence. I describe how to use Clarity (to give your colors pop or diffusion) in the next section.*

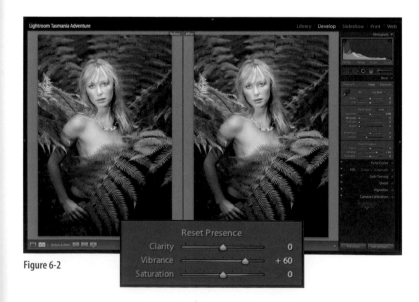

Figure 6-2

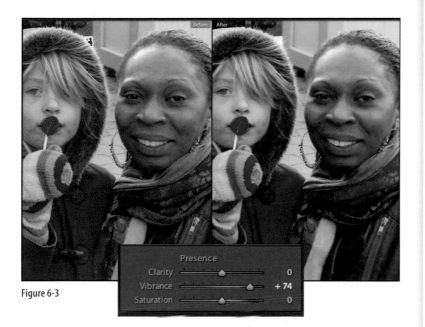

Figure 6-3

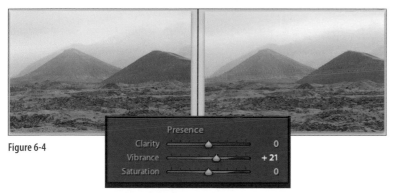

Figure 6-4

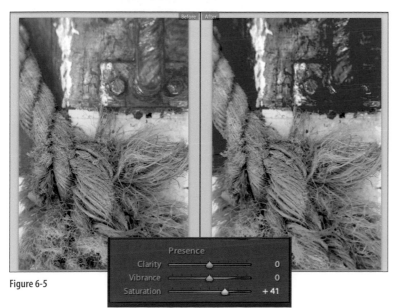

Figure 6-5

Using Vibrance

I find the Vibrance slider very useful when I work with portraits. Because skin tones are not primary colors, the Vibrance slider leaves most skin tones alone, regardless of color, as shown in Figure 6-3.

> TIP *Reset the Vibrance and Saturation (and Clarity) sliders to their default settings by holding the Option (Alt) key so the title changes to Reset Presence. Click on those words and the sliders are reset. Double-click on a slider's triangle indicator (circled) to reset that specific slider.*

But the Vibrance slider isn't only for portraits—you can use it for other types of images as well. In Figure 6-4, for example, increasing the Vibrance nicely enhanced the mossy foreground of the image, while leaving the burnt umber mounds in the background alone.

Using Saturation

The Saturation slider works globally on all the colors of an image. This can be desirable, especially with images like the one shown here in Before/After view in Figure 6-5. When I used Vibrance on Richard Morgenstein's image from the first Adventure in Iceland, it left the turquoise (or tertiary-colored) rope alone, which wasn't what I wanted. Saturation, however, boosted all the colors, as you can see. (Some photographers routinely apply a slight saturation boost to all their images in order to mimic the look of the venerable Fuji Velvia film, which was sometimes referred to as "Disneychrome.")

Adding Clarity

One of the easiest ways to add a punch to your images is with Lightroom's Clarity slider, found in the Develop module's Basic pane. Used in a small dose, like a sprinkle of salt, it acts like a secret sauce and makes the colors in your images pop. Negative Clarity values produce an opposite, and often pleasing effect.

Power Photoshop users have long known the value of using the Unsharp Mask filter to apply local contrast enhancement. By setting the filter Amount to 20%, Radius to 50, and Threshold to 0, for example, hazy photos become clear, dull images shine, and the appearance of depth is enhanced, as shown in my shot of a Tasmanian devil in Figure 6-6.

The technique works by selectively applying an increase in contrast to areas of detail while leaving areas of little detail relatively alone. This prevents a loss of detail in shadow and highlight areas and gives an image more clarity or punch.

Lightroom's Clarity

Lightroom has incorporated the fundamentals of this technique into the Clarity slider, found in the Develop module's Basic pane in the Presence section, as shown in Figure 6-7. There is just one control that affects the intensity of the effect, and everything else is done in the background. Clarity works well on many types of images, as long as the amount is not overdone. Even though the effect may appear subtle on a monitor, when you go to print, it will probably seem more pronounced.

Clarity overdone

Let me show you what I mean about using this slider judiciously. In this example, another shot by Catherine Hall,

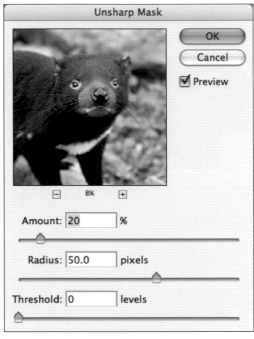

Figure 6-6

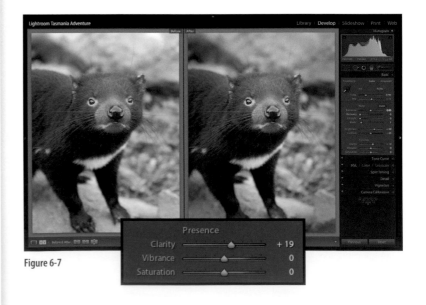

Figure 6-7

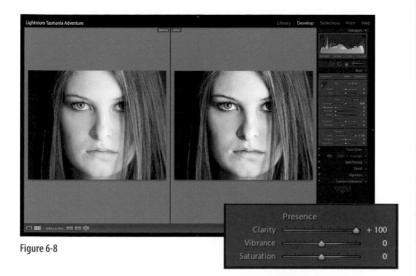

Figure 6-8

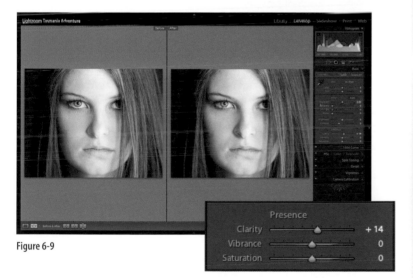

Figure 6-9

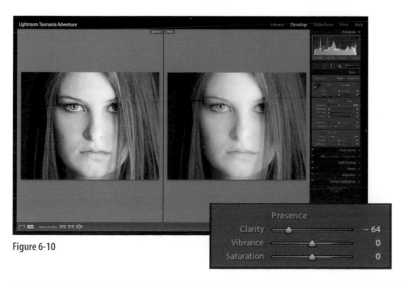

Figure 6-10

I cranked up the Clarity setting to 100, as shown in Figure 6-8. I also enlarged the image by 200% and included the before and after versions so that you can see the effect better. Look at the harsh transitions between details in the face and you can see what I mean when I say that Clarity applies local contrast enhancement. In this case, the higher values don't improve the image.

Clarity just right

In the next example, shown in Figure 6-9, I applied a Clarity setting of 14, which nicely intensifies the eyes and gives the overall image a nice punch. If you look closely, you'll see that the skin tones are still smooth.

Which Images Work Best?

Clarity should be used discriminatingly. I've found Clarity to be especially useful on low-contrast images caused by shooting through a dirty window or by shooting with an inherently low-contrast lens. Images with lens flare also make good candidates for Clarity.

Even though I urge you to use caution when using high Clarity positive values on close-up portraits, in Lightroom 2, high negative Clarity values can be used to give skin tones a soft, diffuse glow, as shown in Figure 6-10. In Chapter 8 I show you a recipe that takes advantage of negative Clarity values and gives landscapes a romantic, impressionistic look.

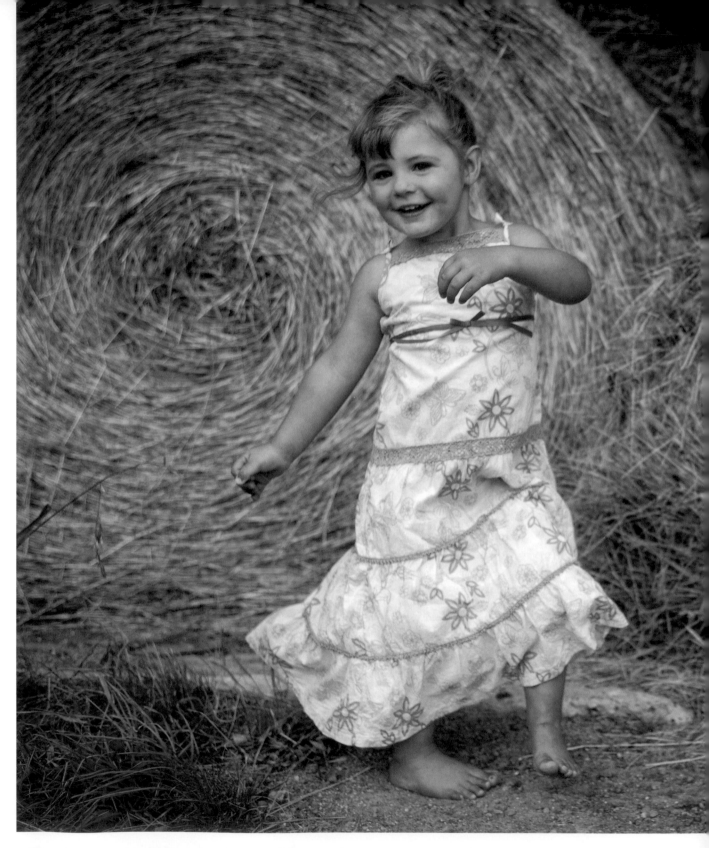

Catherine Hall

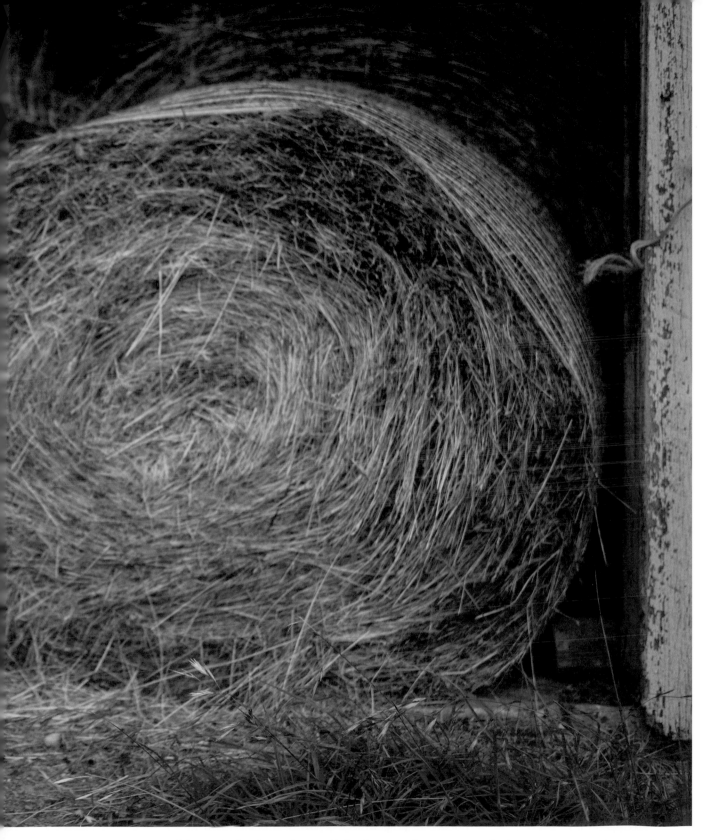

This is another wonderful people shot by Catherine Hall, taken on a farm just outside the eastern Tasmania coastal town of Bicheno. The girl, Montana Marshall, was extremely warm and friendly and hugged Catherine when she drove up and got out of the car. "She was adorable," remembers Catherine, "but a little reserved until she got in front of the hay barrels when she began twirling happily in front of me."

The HSL/Color/ Grayscale Pane

Lightroom's HSL/Color/Grayscale pane is where you get incredible color control. HSL stands for hue, saturation, and luminance, and Lightroom uses a method of defining and working with color based on these three values. Many people find working with color this way intuitive, easy, and fun.

The HSL/Color Controls

Let's take the HSL/Color/Grayscale pane apart. Right away you see three choices that are selected by clicking on their respective names: HSL, Color, and Grayscale, as shown in Figure 6-11. HSL and Color produce similar results, they just get you there in different ways. (I cover Grayscale in Chapter 7.)

Figure 6-11

HSL basics

If you click on HSL in the pane, you get the choices shown in Figure 6-12.

Hue sliders change the specified color. For example, change only the reds in your image to another color by sliding the Red slider left or right.

Saturation changes the color vividness or purity of the specified color. You can desaturate a specific color, say green, by sliding the Green slider to the left. You can saturate, say, only the reds in your images by sliding the Red slider to the right.

Figure 6-12

Luminance changes the brightness of a specified color.

(If you select All, then Hue, Saturation, and Luminance for all individual color ranges will all be visible in the panel. If you are working on a small screen, you need to scroll in the pane to see them all.)

Figure 6-13

Figure 6-14

Figure 6-15

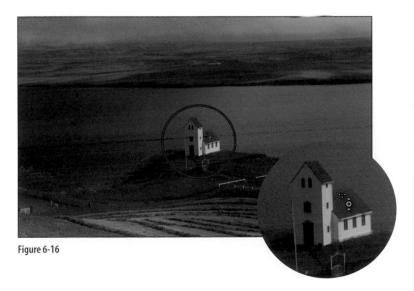

Figure 6-16

Color

If you select Color (circled in Figure 6-13) from the pane, you get the choices shown here. In this case, start by picking the color you want to work on, and then adjust the hue, saturation, and luminance for that specific color. Again, you have the choice of selecting All.

Targeted Adjustment Tool

In the HSL mode (but not the Color mode), click on the targeted adjustment Tool (TAT) in the upper left of the pane, as shown in Figure 6-14. Place your cursor over a color in the image preview that you want to adjust. Drag up and down or use the up and down arrow keys to make the global adjustment.

Turn off color adjustments

At any time you can turn off the effects of your HSL/Color/Grayscale pane adjustments. Just click on the switch icon shown circled in Figure 6-15.

Rooftop Example

Let's walk through some specific examples of how to use the HSL/Color/Grayscale pane, starting with changing the color of the top of this church that I photographed during the Iceland adventure (circled in Figure 6-16) and then changing the saturation and luminance values. I use the targeted adjustment tool (TAT), because I absolutely love the control I get with it. Of course, if you prefer, you can use the individual sliders instead. (In that case, the challenge is to match the targeted colors with the appropriate sliders, which isn't always easy.)

Changing hue

To change the color of the roof, I simply select the TAT and place my cursor over the color I want to change. Then I click and hold the mouse button while I move the cursor up and down, stopping when I get a desired color change. As you move the TAT, changes in individual colors are reflected in the sliders of the HSL, pane as shown in Figure 6-17. (Most areas contain a mix of colors, so more than one slider often moves.) You can, as I said earlier, control the colors directly from the sliders in the HSL pane, but this requires knowing in advance the colors you want to change. Remember that these are global changes, and in the case of this particular example, any orange or reds elsewhere in the image will change as well.

Changing saturation

To change the saturation of the colors in the roof, I click on Saturation in the HSL pane. Once again, I place the TAT directly on the red roof. You can see that in the HSL pane, the Red and Orange sliders move to reflect the changes caused by dragging the TAT in an upward motion, as shown in Figure 6-18.

Changing luminance

To change the luminance, I click on Luminance in the HSL pane and drag the TAT in a downward motion. In Figure 6-19 you can see the changes in the Red and Orange sliders as these colors darken. Any other reds and oranges in the image darken as well.

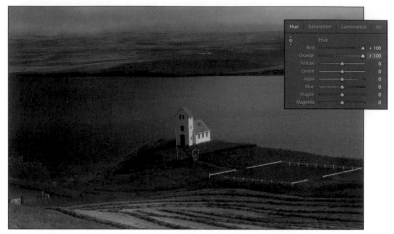

Figure 6-17

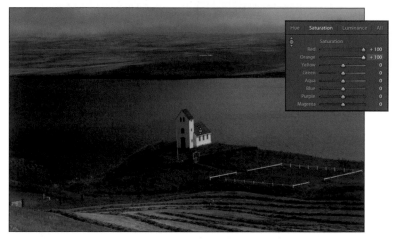

Figure 6-18

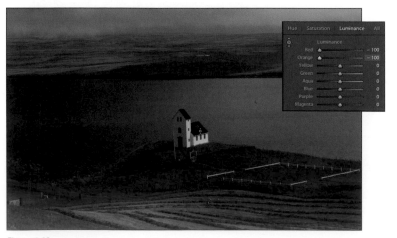

Figure 6-19

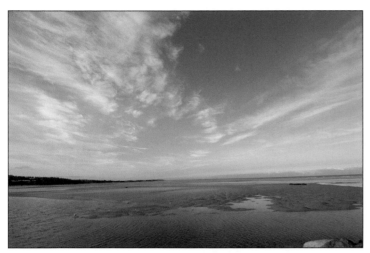

Figure 6-20

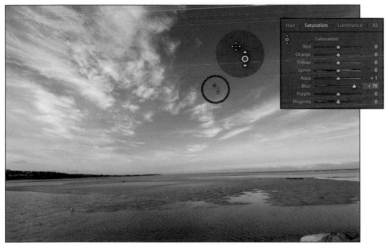

Figure 6-21

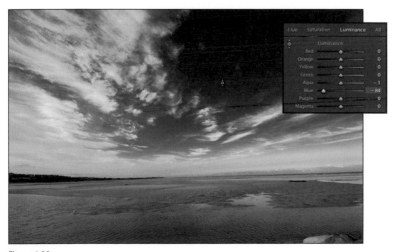

Figure 6-22

Create a Dramatic-Looking Sky

Here is an example using a combination of saturation and luminance controls. Again, I'm going to use Lightroom's TAT to turn this ordinary-looking Tasmanian sky, shown in Figure 6-20, into a more dramatic one.

I start by selecting Saturation in the HSL pane. (Make sure that you have selected the TAT by clicking on its icon in the HSL tab.) Then I place the TAT over the blue sky (circled in Figure 6-21). Dragging the TAT in an upward motion produces a richer cobalt blue.

Next, I click on Luminance in the HSL pane. Again, I place the TAT over the blue sky and drag it in a downward motion. This darkens my rich blue sky and gives it even more distinction from the white clouds, as shown in Figure 6-22.

> NOTE *Look at the toolbar on the left after you select the TAT. You'll see the words Target Group and text that reflects which HSL mode you are in. You can change modes from the pop-up menu next to this text. Clicking on Done to the right in the toolbar deselects the TAT.*

A Tanned Beach Look

I'm going to use the HSL color pane to give Australian photographer Peter Eastway a more outdoorsy look. I do this by making a subtle shift in the facial tones of this image without affecting the background colors. You will see a slight shift in the red in the hat, because some of the color values in the face are also present there.

The before image is shown here in Figure 6-23.

Figure 6-23

The after image is shown in Figure 6-24, along with the HSL pane showing the movement in the Orange and Red color sliders.

Again, I used the TAT, placing it directly on the face and dragging it in an upward motion to achieve this suntan look.

> TIP *You can quickly get to the HSL/ Color/Grayscale pane from another Develop module pane with the keyboard shortcut +3 (Ctrl+3).*

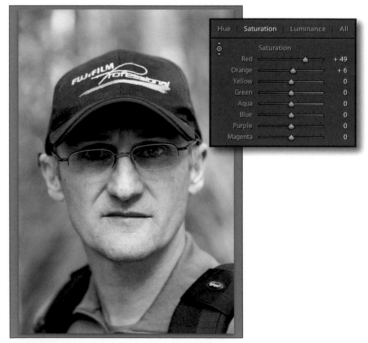

Figure 6-24

Figure 6-25

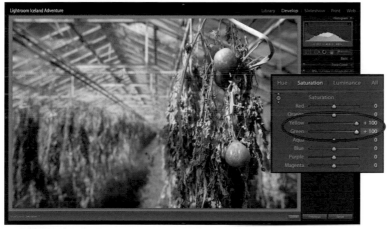

Figure 6-26

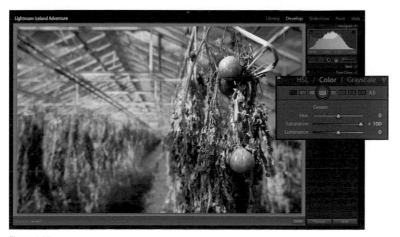

Figure 6-27

Using Color-Specific Control

The TAT selects a range of colors appearing under your cursor. Sometimes it's preferable to target a specific single color, and that's when the color control comes in handy.

This photo of an greenhouse shot during the Iceland adventure by Richard Morgenstein, shown in Figure 6-25, serves as a good example to illustrate what I mean.

If I place the TAT over the green row and crank up the saturation, both greens and yellows are targeted, and I get a boost in saturation in areas I don't want (circled in Figure 6-26). For example, there's an increase in the yellow saturation of the foreground plant.

Using the Color mode, I select the Green color swatch (circled in Figure 6-27) and boost only the saturation of that color. Now only greens are affected, and I get the look I want, which is close to the original with an increase only in the greens.

The Split Toning Pane

The Split Toning pane is often referred to as a black and white tone control tool or a special effects tool, as you'll see in the next chapter. But it can also be used to subtly tweak color in just the highlight or shadow areas and create a more pleasing image. Let's see how.

Figure 6-28 shows John Isaac's shot of Adobe's Russell Brown being attacked by a roll of killer toilet paper during the Iceland adventure. If you examine the roll closely with Lightroom's color sampler, you see that it contains a lot of blue. (Place your cursor over the area you want to measure. A RGB percentage readout appears in the toolbar.) This cast is a result of the blue sky reflecting back to us via the white wrapping. (Color shifts like this are common in snow shots as well.) If you try to remove the blue via HSL controls, all the blues in the image are affected—not a good idea. However, if you just work on the blues found in the highlights or bright areas of the image, you're in business. And that is what you can do with Lightroom's Split Toning pane.

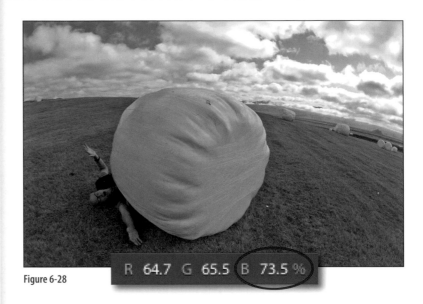

Figure 6-28

Split Toning to Remove Cast in Highlight

The Split Toning pane gives you specific control over highlight and shadow areas. I find it useful to use Lightroom's Compare view (shown in Figure 6-29) to observe subtle changes when I use the split toning controls. Click on the Compare icon found in the toolbar. Lightroom 2 gives you two ways to control the highlight and shadow color casts. For the first method, just click on the color swatch circled in Figure 6-30. This brings up a color swatch where you choose a color with the color picker and control the saturation of the chosen color via the slider. Your image changes in real time as you use the controls. Create color

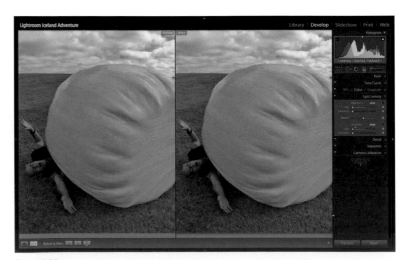

Figure 6-29

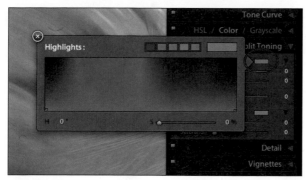

Figure 6-30

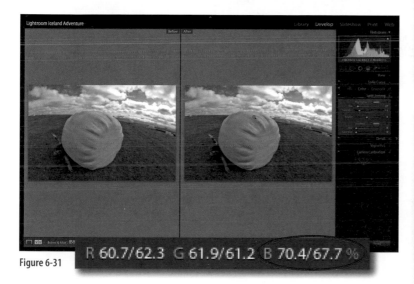

Figure 6-31

R 60.7/62.3 G 61.9/61.2 B 70.4/67.7 %

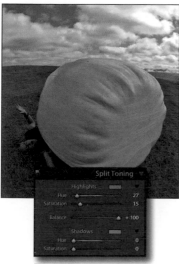

Figure 6-32

presets by clicking and holding the color picker over one of the five color swatches at the top of the color picker window. You can also use the Hue and Saturation sliders. The first thing you notice is that moving the Hue slider when saturation is set to 0 doesn't affect the image at all unless you Option-click (Alt-click) on the slider at the same time, or bump up the Saturation slider value. Option-clicking (Alt-clicking) produces a preview of the tint as if the Saturation slider were set to 100%.

Here, I use the Hue slider and watch the effect while I move the sliders. I initially rely on visual inspection. At the point at which I think I'm close to removing the tint, I stop moving the slider and place my cursor over a part of the image I want to sample, observing the RGB values displayed under the histogram. Figure 6-31 shows the Compare view, where I can see before and after color values. A hue setting of 27 combined with a saturation setting of 15 lowered my blue value enough to remove the blue tint from the hay bale highlights. The rest of the image with the exception of the clouds—which are also highlights— remains untouched.

NOTE *I could refine the way the split toning controls work with the balance control. Moving the Balance slider to +100 spreads the effects of the highlight settings into the shadow and midtone areas, as shown in Figure 6-32. Moving the slider to −100 effectively removes the effect entirely. For this example, using the Balance slider wasn't necessary, but when you use both the highlight and shadow controls, the Balance slider gives you relative control over each (see Chapter 7).*

Ian Wallace

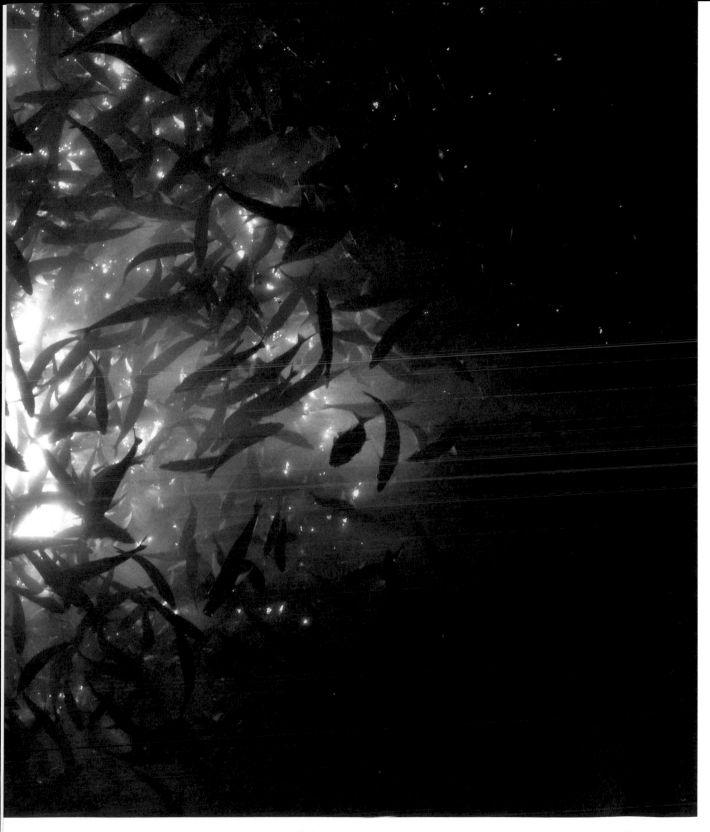

Ian Wallace lives and works in Tasmania, and like most Tasmanians we met, he loves the outdoors. He and Bill Stotzner spent much of the adventure scuba diving the temperate southern waters of Tasmania's east coast. This image was taken at Bicheno during a walk-in dive from the breakwater. Without warning, a huge school of fish surrounded Ian for about 5 minutes. By shooting from below the school, toward the surface (and the sun), he was able to create a silhouette accentuating the density of the mass of fish. This shot was one of four images that resulted in Ian's winning the 2008 EPSON AIPP Tasmanian Professional Photographer of the Year award.

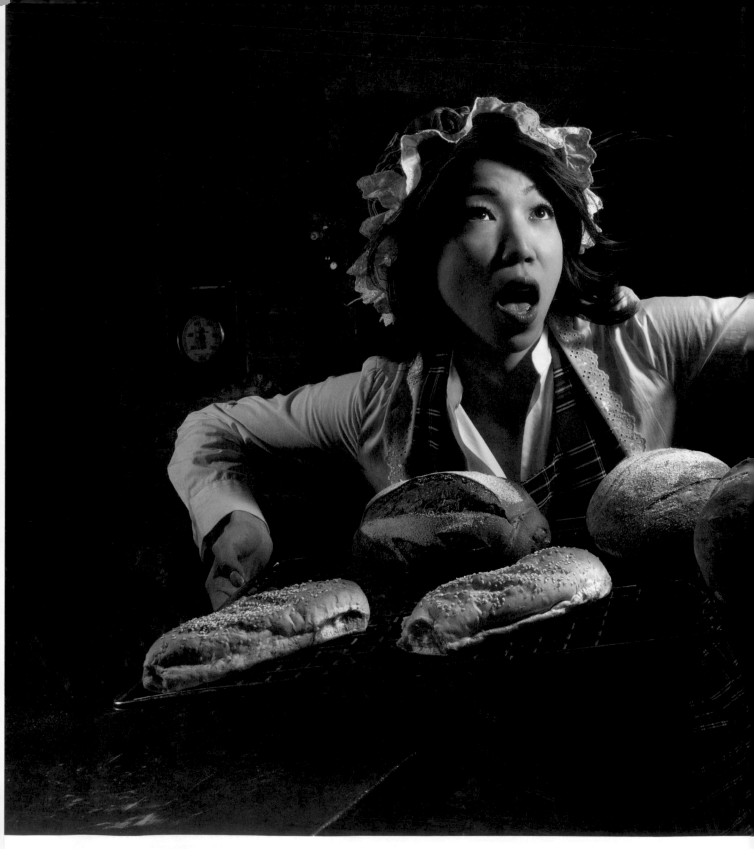

Maki Kawakita

This is another Makirama, a self portrait of the photographer Maki Kawakita. Here Maki is reenacting a scene from the famous Japanese 1980s animated film *Kiki's Delivery Service*. The main character of the film, Kiki, is a young witch-in-training who lives at the village bakery. Maki's photo was shot in the same bakery in the historic village of Ross in the Tasmania midlands that the film's director, Hayao Miyazaki, modeled his film's bakery after. The film is very popular in the United States but even more popular in Japan, and every year Japanese fans flock to Tasmania to make a pilgrimage to Ross and the bakery.

"Kiki's story," explains Maki, "really fit the mental stage I was going through at the time, and I could relate to Kiki who stays positive throughout all her trials, and who's eager to learn new things every day to become a mature witch."

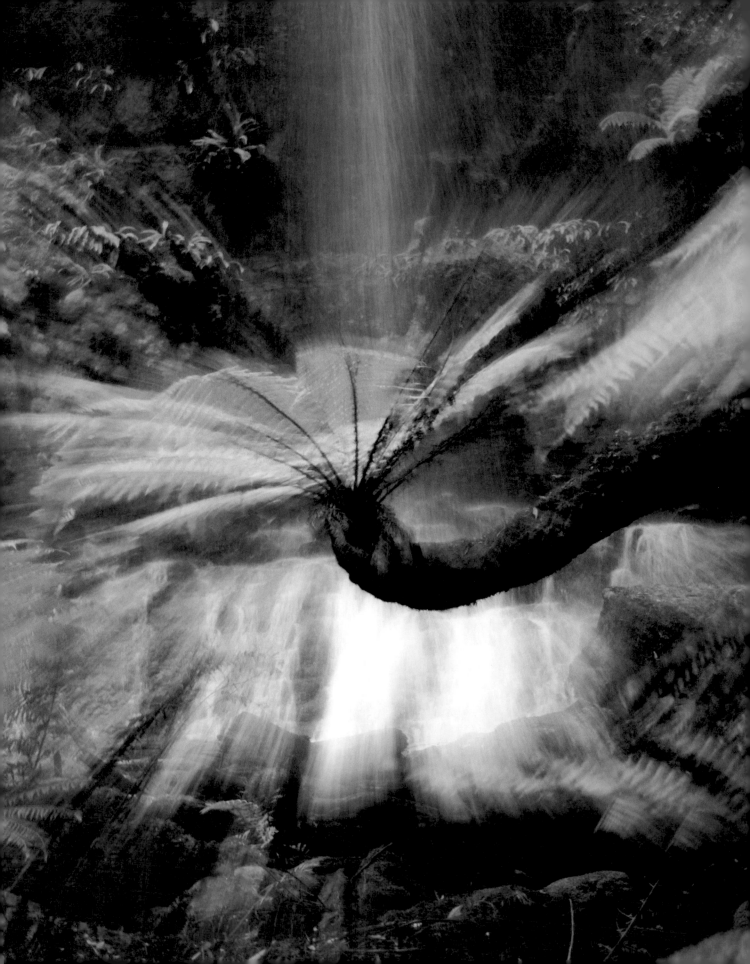

Black and White and Special Effects

Some images were made to be seen in black and white, and Lightroom makes it possible to not only quickly convert a color image to grayscale, but to control the conversion of individual colors as well. The results are roughly equivalent to using different color filters with panchromatic black and white film. You can produce dramatic skies or brilliant foliage and much more. It's up to you. Pushing the boundaries with special effects are also a slider away in Lightroom's Develop module, as you will learn in this chapter.

Chapter Contents

When to Convert to Black and White

Not all color images warrant conversion to black and white. A converted color image can be just plain boring if there is neither good composition nor compelling content. It can also suffer if it is not converted properly. Let's see what works in black and white, what doesn't, and why.

Some images work equally well in color or black and white. Take the wonderful portrait of two Tasmanian men by Marcus Bell, shown both in color and black and white in Figure 7-1. (I've included larger before and after versions on the next pages.) As a color image, Bell's shot is quite successful. The color adds information that contributes to the overall impression of the men as hard-workng, down-to-the earth types. When converted properly to black and white using Lightroom's grayscale controls, the photo is still quite good. In some ways, in my opinion, it's even better. Without the color of the cloths and background, the men's faces—and expressions—are more fully realized.

Figure 7-1

Doesn't Work

And then there are shots like the one shown in Figure 7-2 by Iceland adventurer John Isaac, which are substantially better in color. When converted to black and white, this shot becomes relatively mundane. The color is what holds the image together. There is little in the way of dramatic lighting or striking composition, and this becomes apparent when the color is removed.

Figure 7-2

Figure 7-3

Figure 7-4

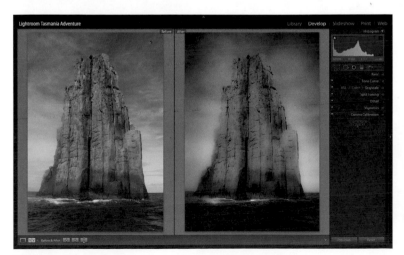

Figure 7-5

Works, but with Work

A bad conversion from color to black and white can also result in a boring image. Take the Maggie Hallahan shot of Icelandic wool shown in Figure 7-3. I converted it to black and white by simply clicking on Grayscale in Lightroom's Develop module, Basic pane. While this method works fine for some images, in this case, all the tones seem alike and the image is quite flat. (I have Lightroom's presets preferences set to "Apply auto grayscale mix when converting to grayscale". More on this later in the chapter.)

In this next example, shown in Figure 7-4, I used Lightroom's Develop module grayscale mix controls on Maggie's image. By controlling the way certain colors convert to grayscale, I ended with an image worth looking at. (I get into the details of how I did this later in the chapter.)

Simply Better in Black and White

And then there are images that are simply better in black and white. The shot in Figure 7-5, which I took in Tasmania, is a good example of what I am talking about. (I've included larger versions of these on subsequent pages.) In this case, the color doesn't add much, if anything, to the image. Take the color away and the image becomes much more dramatic and mysterious and, I think, better.

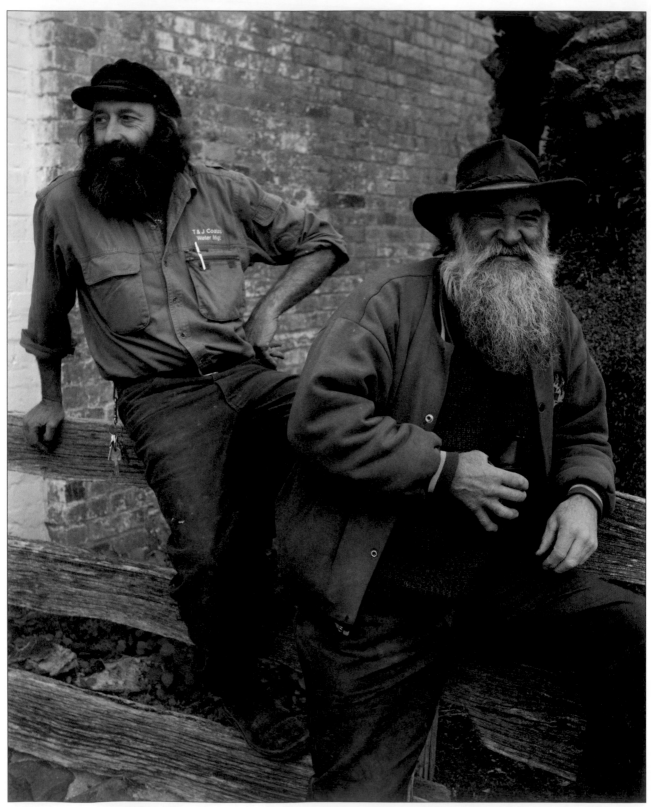

Marcus Bell's portrait works well in color...

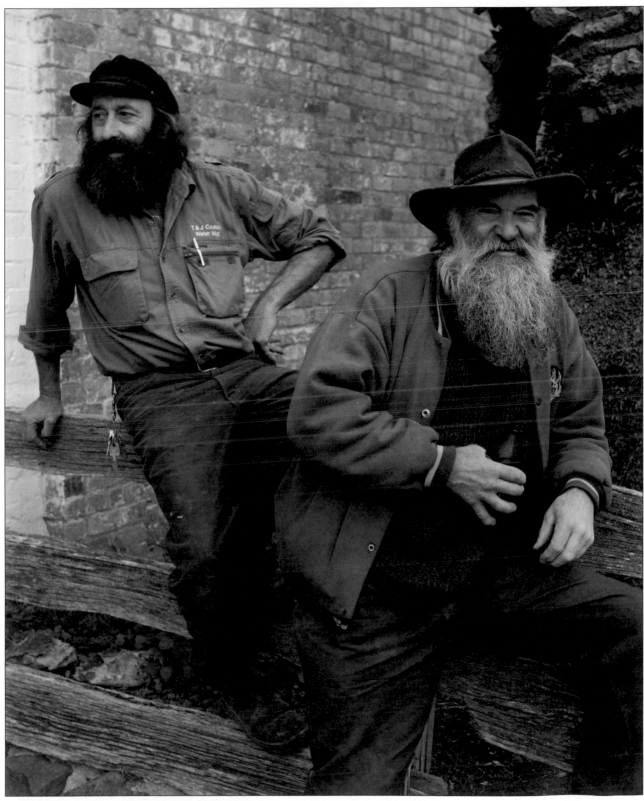

...and works equally well in black and white.

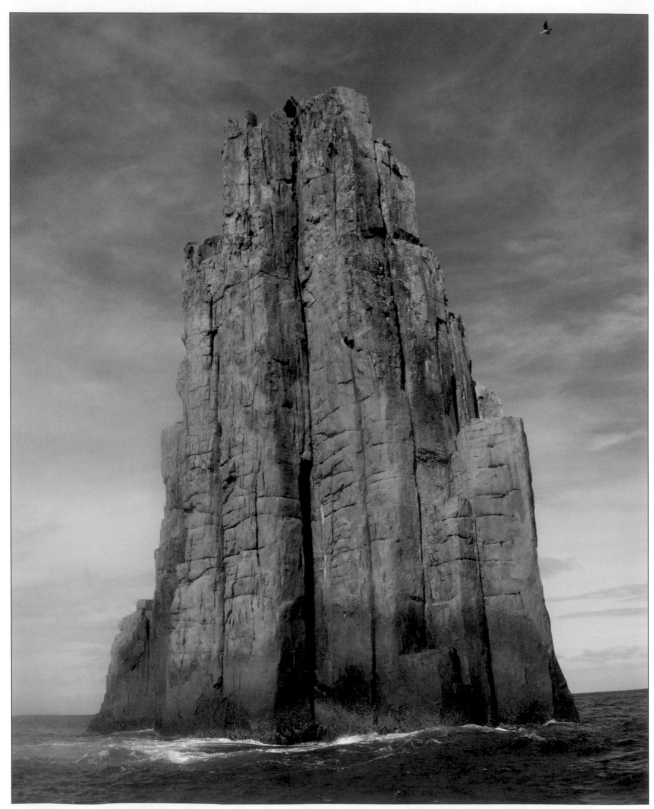

My photo looks OK in color...

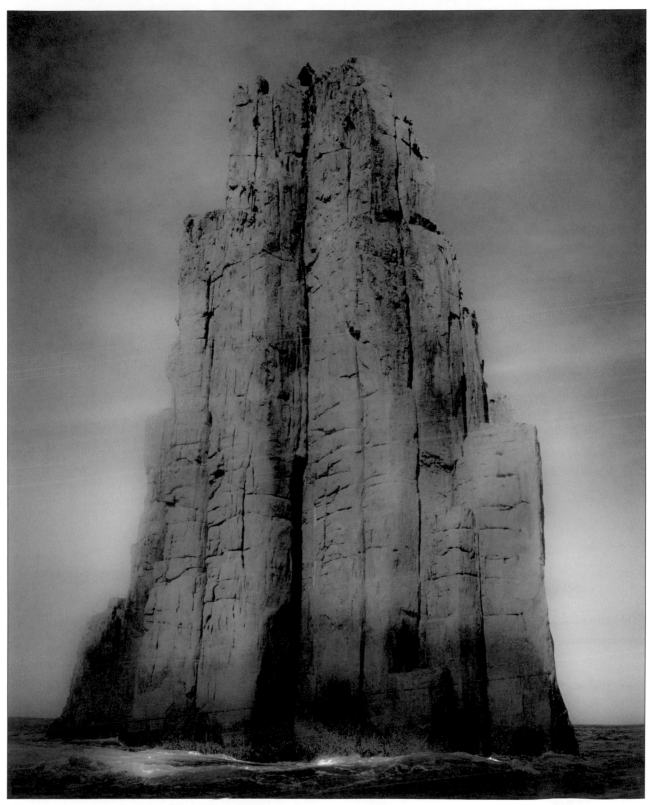

...but it's much more dramatic in black and white.

Basic Black and White Conversion

In Lightroom, black and white conversion is as simple or complex as you like. Let's start with the basic steps of converting an RGB color image into black and white. (In the next section, we'll move on to Lightroom's Grayscale Mix for fine-tuning control that will really give your work a professional look.)

You can quickly convert one or more color images to black and white from any of Lightroom's modules (except the Web module) by simply using an out-of-the-box preset. Here's how.

Using the Contextual Menu to Convert

In any module (except Web), place your cursor on the image display area and right-click. This brings up the contextual menu shown in Figure 7-6, where you can choose Convert to Grayscale from the Develop Settings subgroup. If you're satisfied with the results, you're done. Otherwise, you can go to the Develop module and fine-tune the results there. The contextual menu is also available in the filmstrip. Be sure to place your cursor on the image area, not the frame.

Figure 7-6

Convert from Quick Develop

From the Library module you can convert to black and white via the Quick Develop pane. Select the image (or images) you want to convert from the preview display. Select as many images as you wish. Select Grayscale from the Treatment pop-up menu shown in Figure 7-7. (If Treatment is hidden, reveal it by clicking on the arrow to the far right of Saved Preset.)

NOTE *Press the V key at any time in any module (except Web) and the selected images convert to grayscale. (Press V again to colorize.)*

Figure 7-7

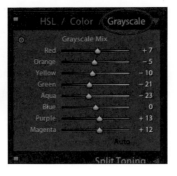

Figure 7-8

Conversion from the Develop Module

You can also convert to black and white from the Basic or HSL/Color/Grayscale panes as shown in Figure 7-8. Selecting Grayscale from either pane produces the same results. Using either of these methods opens up the world of the grayscale mix for the ultimate conversion control. (If you desaturate your image using the Saturation slider in the Basic pane, Grayscale Mix is useless, but you can use Camera Calibration pane controls for fine-tuning.)

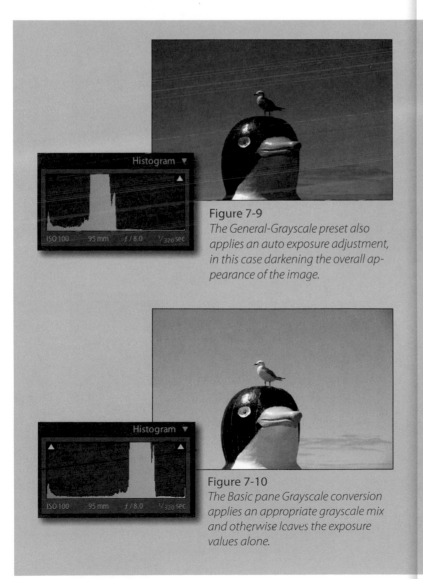

Figure 7-9
The General-Grayscale preset also applies an auto exposure adjustment, in this case darkening the overall appearance of the image.

Figure 7-10
The Basic pane Grayscale conversion applies an appropriate grayscale mix and otherwise leaves the exposure values alone.

Differences in Conversion

Both the General-Grayscale preset and the grayscale conversion in the Basic and HSL/Color/Grayscale panes use a "smart" conversion that automatically creates an auto grayscale mix appropriate for a particular image, as shown in Figures 7-9 and 7-10. This auto mix takes into account the fact that the human eye perceives luminance values differently based on color. For example, we see blue as much darker than green or red, even if it shares the same physical brightness value. When you use Lightroom's General-Grayscale preset, an autoexposure setting is applied as well. Other grayscale conversion presets shipping with Lightroom include Creative-Antique Grayscale and Creative-Sepia. These presets apply a Split Toning—created tint to the grayscale conversion. Note: If you don't want Lightroom to automatically apply an auto grayscale mix to your grayscale conversion, go to the Preferences/Presets tab and uncheck the "Apply auto grayscale mix when converting to grayscale" box.

Using Grayscale Mix for More Control

Lightroom's grayscale mix controls have revolutionized digital black and white conversion. Since using these controls, I've retired several of my more complex and time-consuming conversion techniques. I'll show you how and why I now turn almost exclusively to Lightroom for my black and white conversions.

To start, you need a color image. From a quality point of view, it's preferable to work with a native RAW file, but a JPEG, TIFF, or PSD will do, as long as it is in color, as shown in Figure 7-11.

> NOTE *Many digital cameras now offer a black and white option. Lightroom's grayscale mix controls doesn't have any effect on such images unless they are saved as a RAW file, where the color data is always available. You can, however, "tone" these camera-generated grayscale JPEG or TIFF images with a Develop module preset, the Basic pane Tone sliders, or the Split Tone pane controls.*

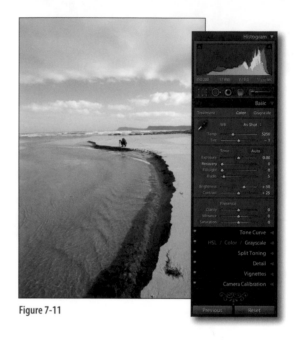

Figure 7-11

Click on the word Grayscale (circled in Figure 7-12) in the HSL/Color/Grayscale pane. Your image will appear unsaturated, but what you see is misleading. The underlying color data is still available, which means that you can use Lightroom's grayscale mix controls to determine how each color is converted. When you export your image as a TIFF, JPEG, or PSD—even though it is saved in RGB—all color data is eliminated. If you export your converted image as a DNG file, the color is retained and can be retrieved, if necessary, in other programs, such as Photoshop.

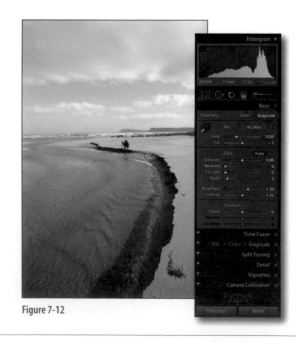

Figure 7-12

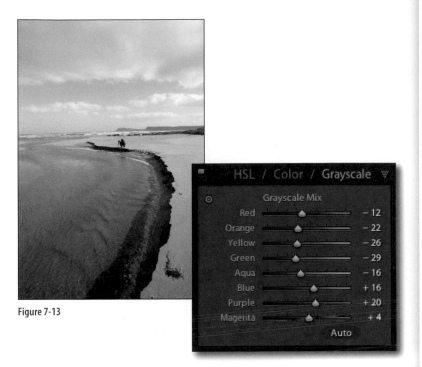

Figure 7-13

If you look closely at the Grayscale Mix sliders shown in Figure 7-13, you can see that they have not all moved the same amount. Lightroom creates a smart custom auto mix (see the sidebar "Differences in Conversion" earlier in this chapter). Although this often produces pretty good results, I find it is mostly just a good starting point.

Often I want to interpret the color conversion differently. Let's say, for this image, that I want to make the blue-purple sky appear darker. I can work specifically on that color in a couple of ways. I'll show you what I mean.

NOTE *Compare Lightroom's basic grayscale conversion with other image editing applications, and I think you will be amazed at the difference. Lightroom does its conversion in the Lab color space at 16 bits per pixel, rather than in RGB at 8 bits per pixel. This effectively reduces or eliminates banding (noticeable stripes) entirely, and subtle transitions between tonal values appear much smoother. (Wikipedia has a great article on the technical reasons why Lab color space is preferable.)*

Using the TAT for Black and White Control

By far my favorite method for this kind of adjustment is to use the targeted adjustment tool (TAT). I can start with the Auto-Adjust mix settings created by default, or I can hold the Option/Alt key and select Reset Grayscale Mix and start from a neutral point, as shown in Figure 7-14.

Figure 7-14

I simply select the TAT icon in the HSL/Color/Grayscale pane (circled in Figure 7-15, lower). Then I place my cursor over the area I wish to work on (in this case, the sky, circled upper) and drag down to darken, or up to lighten. If you look at the Grayscale Mix pane, you can see the beauty of using this method. Even though I wasn't sure which colors were in the sky (remember, I'm looking at a grayscale version of my image), the TAT knew, and the Blue slider—and to a lesser degree, the Aqua slider—moved accordingly.

I can continue using the TAT on different parts of the image to lighten or darken areas based on the color values of the image that are under the tool.

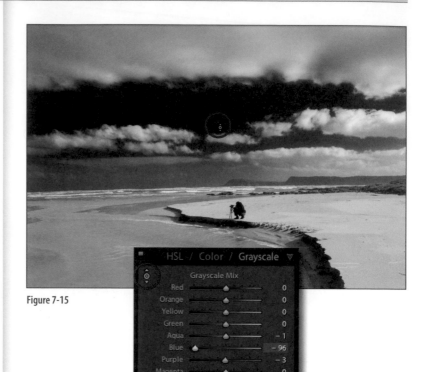

Figure 7-15

Using Before and After for Reference

If you want to work on a color-by-color basis using the grayscale mix sliders, it's difficult, unless you know which colors are where. There is an easy way to do this: use the Before/After mode.

In this example, I physically moved the Orange, Yellow, and Aqua sliders based on the colors in the before view. My adjustments are immediately viewable in the after view. (By the way, to get to the Before/After view, click on the icon in the toolbar at the bottom of the preview window (circled in Figure 7-16).)

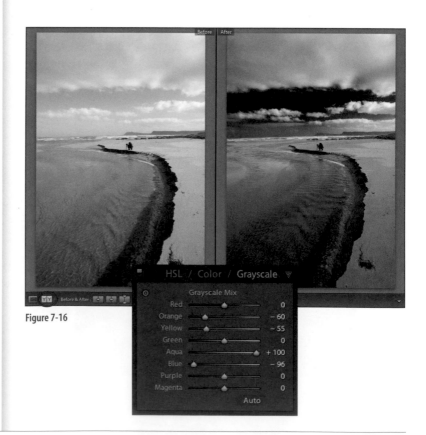

Figure 7-16

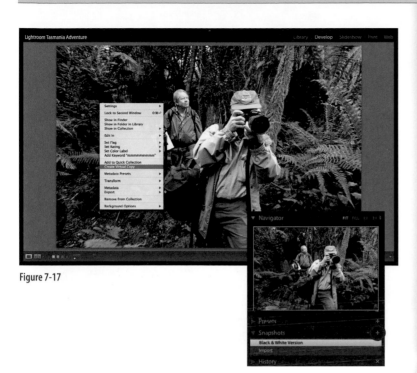

Figure 7-17

Creating Virtual Copies and Snapshots

You can create a virtual copy of your black and white conversion by placing your cursor over the image preview in any module or in the filmstrip. Right-click and select Create Virtual Copy from the contextual menu shown in Figure 7-17. In the Library module, you can group your versions into a stack. Lightroom doesn't actually duplicate the image file; instead, it creates a set of instructions that are saved in the Lightroom database and take up very little space on your hard drive. In the Develop module, you can also create a snapshot to save your settings. Click on the + sign in the Snapshots pane (circled) in the left panel and name your snapshot. It will remain in the Snapshots pane until you delete it by clicking on the – sign.

Figure 7-18
John McDermott took this shot with a Canon EOS 5D and set it to shoot black and white and save as a RAW file. On import into Lightroom, the preview briefly reflected John's settings.

Figure 7-19
Lightroom automatically created its own preview and all the in-camera black and white settings were ignored.

Beware: Camera Black and White Settings Ignored

Many digital SLRs, and some digital point-and-shoots, offer sophisticated control over the way black and white images are converted in the camera (Figures 7-18 and 7-19). If you are planning on using Lightroom, don't spend a lot of time fiddling with these controls or any other camera-based special effects. The settings are often encrypted and unreadable by Lightroom. On import into Lightroom, you will probably get a black and white thumbnail preview that appears to contain your camera settings. However, when Lightroom creates its own standard-size preview, the original camera settings are not applied.

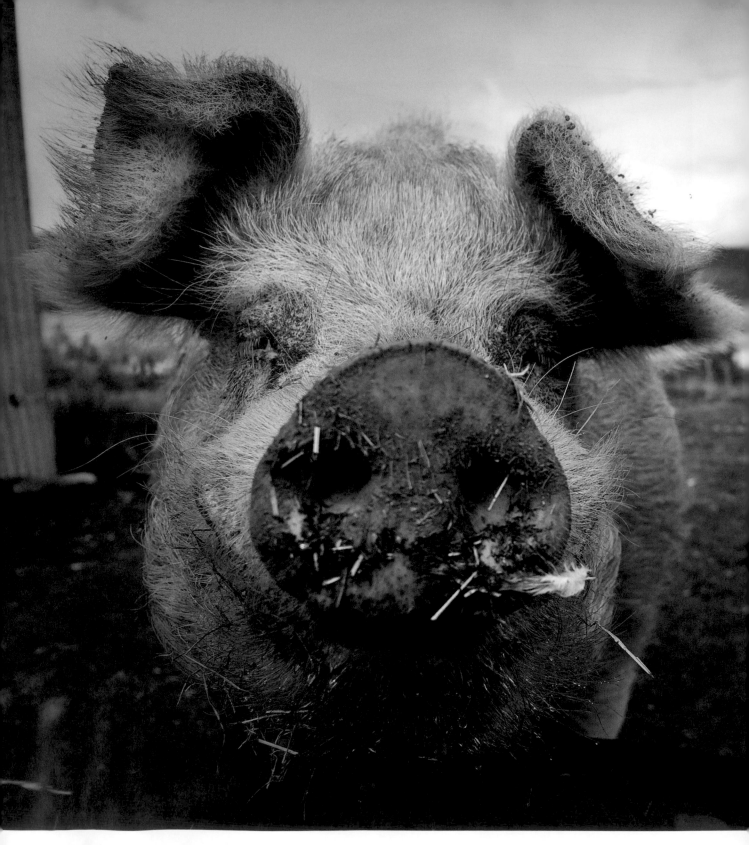

Philip Andrews

Philip, who writes best-selling books on digital photography and is a popular speaker, was one of our Down Under team photographers. Philip took this shot of a massive male hog on a farm on the road between Bicheno and Douglas Apsley National Park. He has another shot, taken from the hog's other end, but because this is a family-friendly book, I decided to run this shot instead.

Adding a Color Tint

Adding a color tint to a black and white photo has long historical precedent in traditional photography. I remember using tea bags to tint my silver halide prints! Who can forget the smell of the chemicals we used to create sepia-color prints? Anyway, it's a lot easier with Lightroom, believe me.

In the spirit of starting with the easiest method, let's turn our attention to the presets that ship with Lightroom, which can be used to color tint either a black and white or color image. The two most obvious ones are called Creative-Sepia and Creative-Antique Grayscale. Another less obvious one is Creative-Cyanotype. These presets are available in the contextual menu, the Library module's Quick Develop pane, and in the Develop module's Lightroom Presets pane, where you can get a preview of the preset by hovering your cursor over it. If you have the Navigator pane open, the preview reflects the changes (as it has done here in Figure 7-20 when I passed my cursor over Creative-Sepia). To apply the preset, simply click on the preset name.

Figure 7-20

Using White Balance Tint Control

Another way to create a color tint from a color image is to simply change the White Balance Tint slider control, found in the Basic pane of the Develop module. Moving the Tint slider to the left shifts the colors to green, and sliding it to the right shifts the colors to magenta, as shown in Figure 7-21. This method definitely works better on some images than others; it all depends on the colors of the image. It doesn't work at all if you have completely desaturated your color image or converted it to grayscale.

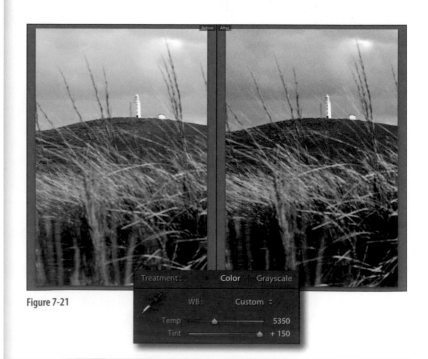

Figure 7-21

Figure 7-22

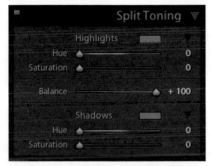

Figure 7-23

Using Split Toning to Single Color Tone

You can also use the Split Toning pane to create a uniform tint to your image. (In the next section, I show you how to create a split-toned look, which distributes the tint to shadows and highlights differently.)

Here's how:

1. Convert your image to grayscale in the Basic or HSL/Color/Grayscale panes, as shown in Figure 7-22. Adjust the grayscale mix as needed. (You can always do this later, after applying a tone.) Open (or go to) the Split Toning pane.

2. Move the Balance slider all the way to the right, to +100, as shown in Figure 7-23. (This effectively pushes the tint values to all tonal values equally, not just to highlights or shadows.)

3. Slide the Hue slider until you get the tint you want, as shown in Figure 7-24. Hold the Option (Alt) key while you do this, to preview the actual tint color. You can control the intensity of the tint with the Saturation slider. In Lightroom 2, you can click on the small color swatch in the Split Toning pane to bring up a larger multicolor swatch with 5 changeable preset colors, shown in Figure 7-25. Change the color of a preset by selecting a color from the swatch, then click and hold over the preset box.

> NOTE *The Develop module's Camera Calibration pane can also be used to tint an image, but it's more hit-or-miss, so I generally don't use it for a single-toned look.*

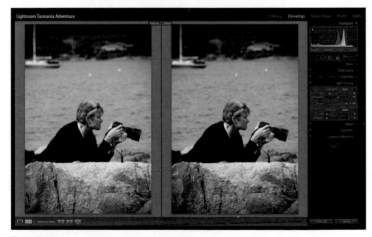

Figure 7-24

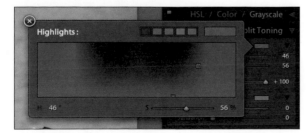

Figure 7-25

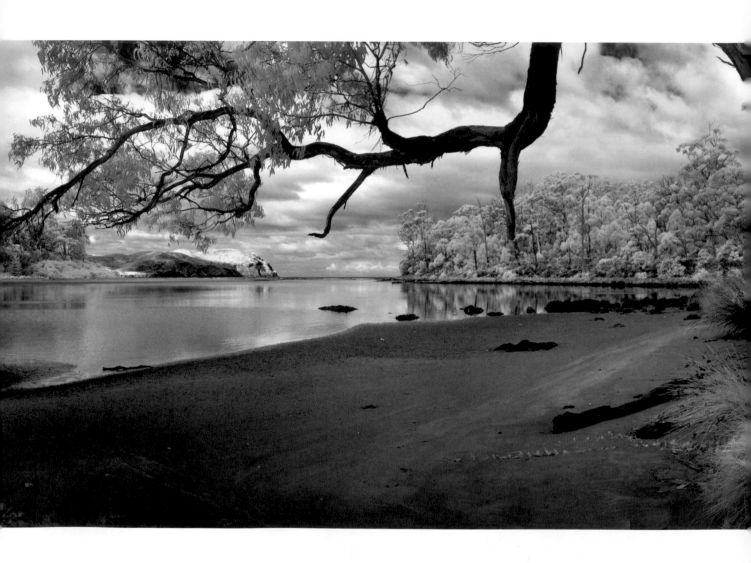

Bruce Dale

Bruce has perfected a combination shooting/Lightroom/Photoshop technique to quickly create panoramas such as the one shown here. This shot was taken with a modified Nikon D-80 sensitive to the infrared spectrum. It was shot on Burny Island, outside of Hobart, and consists of five frames shot in sequence and merged in Photoshop.

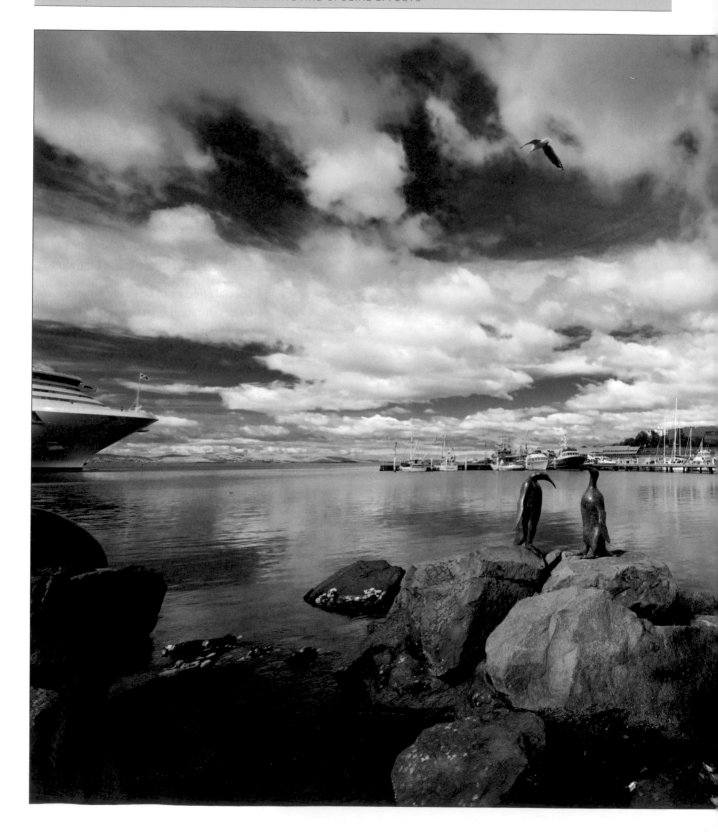

4. However, the red tint spilled beyond the highlights, so I adjusted the Split Toning Balance slider to −100, so the color tint applied only to the brightest highlights. The final image is shown here.

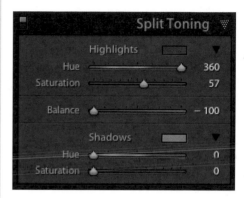

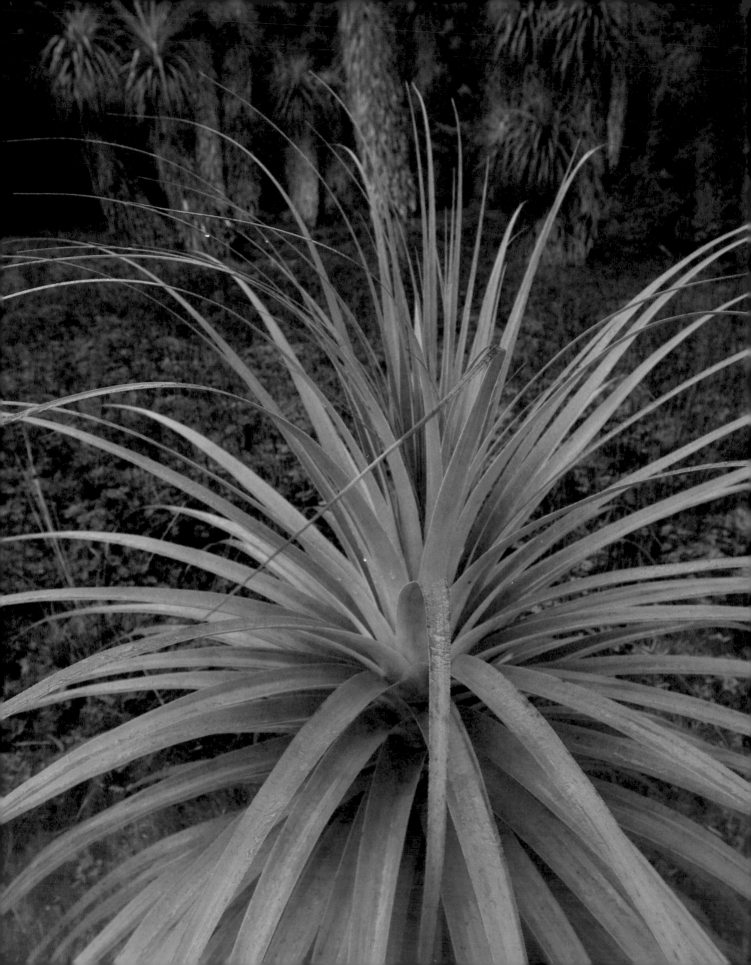

Develop Recipes from Tasmania and Iceland

As you learned in the previous chapters, it's really easy to apply a custom look and feel to your images using Lightroom's Develop module and tonal controls. Several of the Tasmania and Iceland Adventure team members did just that. Let's look at what they came up with, reveal their custom Develop module settings, and give you a chance to try their recipes on your own images. (When necessary, I updated the Iceland recipes for Lightroom 2.)

Chapter Contents

Angela Drury's Antique Look

I call Angela the Adventure recipe queen. She is also the Adobe person responsible for many of the Develop module presets and a mainstay on both the Iceland and Tasmania Adventures. Since everyone loves a sepia-toned image, here is one of Angela's favorite recipes for adding an antique and timeless effect to your images.

Here are the simplified steps of Angela's recipe, as used to sepia tone the Tasmanian sheep head skull shown in before and after enlargements on the next pages. (I say "simplified" because Angela worked through a number of setting configurations until she got what's outlined here. You can always experiment and create your own sepia variations that suit the mood of your images.)

NOTE *Interesting fact: the word sepia comes from the Greek word for cuttlefish, and the origin is the brown pigment from the ink of a cuttlefish.*

1. Angela applies Lightroom's General – Punch preset to the original image, which gives the image more, well, punch, by setting the Clarity slider to +50, as shown in Figure 8-1.

Figure 8-1

2. Angela applies the Creative – Sepia preset to the original color image, as shown in Figure 8-2. (This is a grayscale preset with Split Toning sliders adding the sepia brown tones to the image.) The sepia settings aren't great for this particular image, but they show promise.

Figure 8-2

Figure 8-3

Figure 8-4

Figure 8-5

3. To add drama to the image, Angela adjusts a couple of Basic pane settings. She brings the exposure down to −1.62 and pushes the Blacks slider to +59. Then she sets the Recovery slider to +26 to add cloud detail, as you can see in Figure 8-3.

4. Because of the extreme blacks adjustment, the image is now too dark, and Angela adds light tones back into the image by setting the Fill Light slider to +83. This is the key slider, because it's the contrast between the high level of blacks and the overuse of the fill light that gives this sepia tone the striking "western" glow. To add a bit more punch, Angela sets the Contrast slider to +66 and increases the clarity to +78, as shown in Figure 8-4.

5. When Angela has the tone shades and a tonal contrast that works well, she fine-tunes the image with the Grayscale Mix panel. These sliders let her target specific areas of the underlying monotone values, as shown in Figure 8-5.

6. Finally, Angela adds a small amount of lens vignette (-32) to finish the image.

That's it. With a fairly limited number of adjustments to the Creative – Sepia default preset, Angela was able to add a striking sepia tone to her image. She saved the preset to her preset library, ready to use on other similar images. If this recipe doesn't work exactly as you'd like, go ahead and make additional changes to get the look you want. For instance, you can make changes to the intensity or color of the sepia tone with the Split Toning pane, or adjust the blacks and fill light settings.

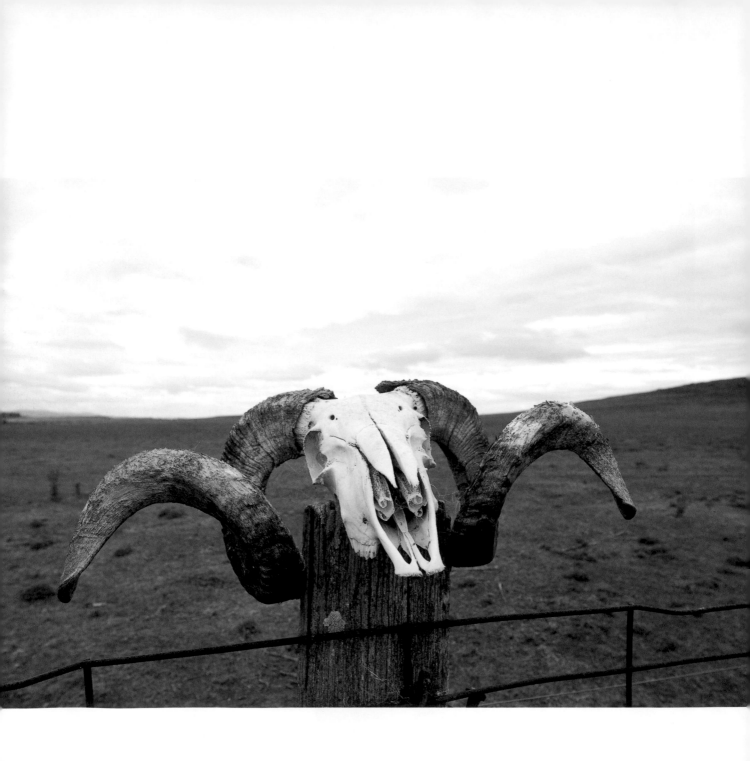

This Angela Drury Tasmania photo is greatly enhanced by...

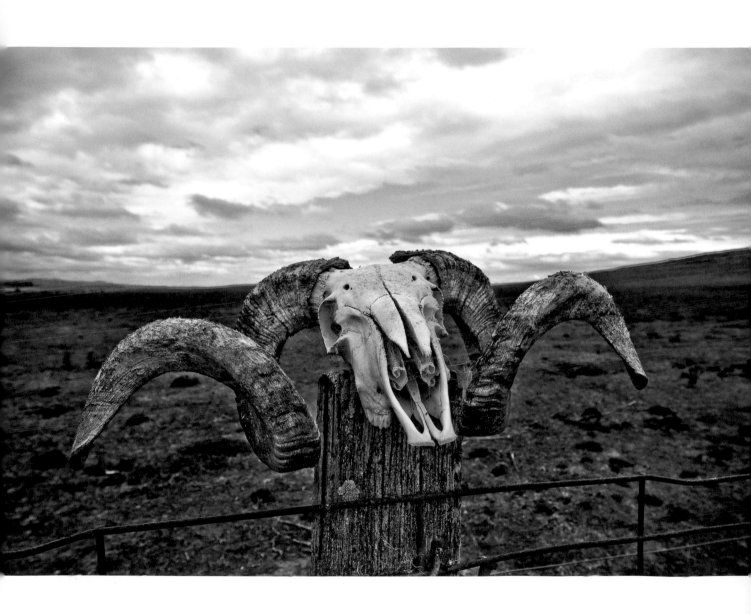

...giving it an old-fashioned tinted look.

Michael Reichmann's Controlled Toning

Readers of Michael Reichmann's immensely popular website The Luminous Landscape (*luminous-landscape.com*) know how Michael feels about Lightroom's grayscale mix controls and split toning controls. He absolutely loves them! He has fine-tuned a toning method that produces great results, especially when viewed as a gallery-quality print.

Michael was a member of the Iceland Adventure, which took place during the summer of 2006 when we were road-testing the first version of Lightroom. The original shot for this example is the beautiful color Icelandic landscape shown in Figure 8-6. When Michael finishes converting the color version into black and white and applies split toning to it, the results are stunning. (By the way, it took very little to update Michael's technique to work with Lightroom 2.)

Figure 8-6

Here is what Michael does to produce his controlled toning effect:

1. In Lightroom's Develop module, he selects Grayscale from the HSL/Color/Grayscale pane. Michael starts with Lightroom's Grayscale Mix Auto settings, as shown in Figure 8-7.

Figure 8-7

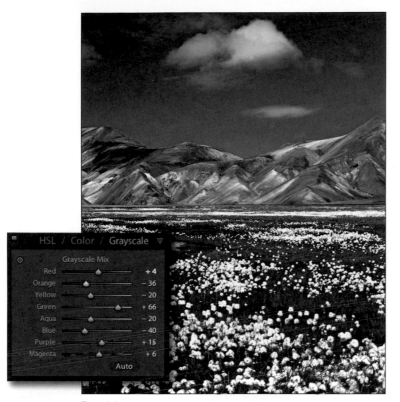

Figure 8-8

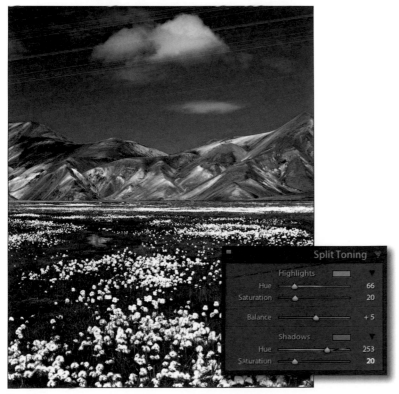

Figure 8-9

2. Michael works the Grayscale Mix color sliders to taste. In this image, he darkens the sky slightly with the Blue slider, uses the Orange slider to build more contrast in the mountains, and increases the Green slider to lighten up the foliage in the foreground, as shown in Figure 8-8.

3. Next, he judges what the monochrome image needs in terms of toning. Sometimes an image needs toning in the highlights, sometimes it needs toning in the shadows, and sometimes it needs toning in both. Sometimes Michael does nothing and just sticks with the monochrome conversion.

Using the Split Toning Controls

Michael's approach to using the Split Toning controls is as follows:

1. Boost the Saturation slider about halfway to 50, so that it's overdone, but obvious what the color is.

2. Choose the tone color by moving the Hue slider. Michael recommends warm tones for highlights and cool for shadows.

3. Slide the Split Toning pane Saturation slider down to a desired level. In this case, he chooses 20.

Michael's eventual Split Toning pane settings for this example are shown in Figure 8-9.

You can see enlarged versions of the before and after images on the following pages.

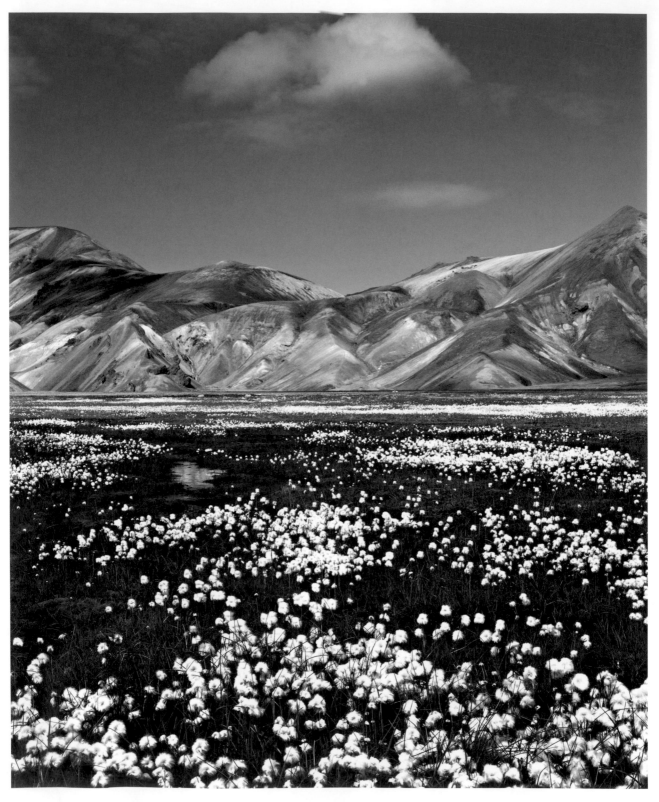

Michael Reichmann started with this color picture of an Icelandic landscape.

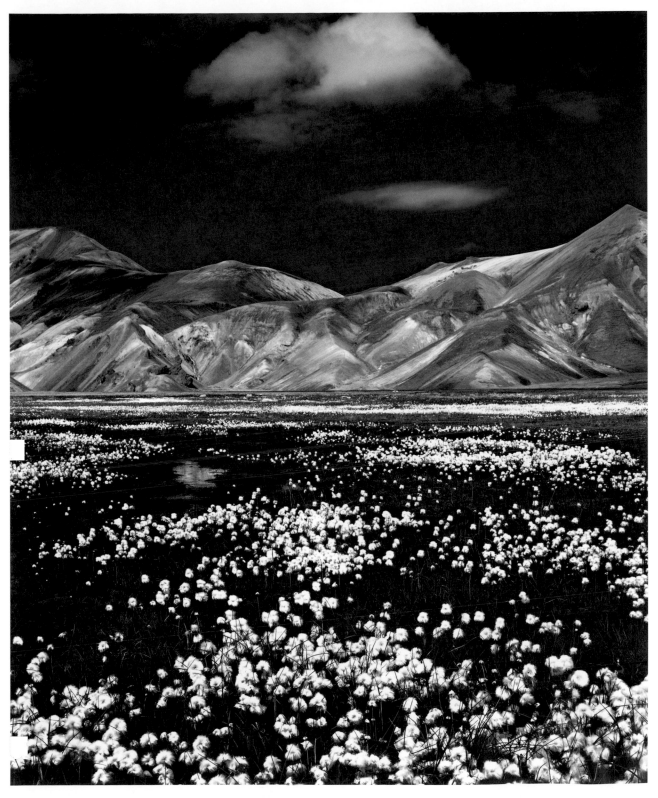

Using Lightroom's Grayscale Mix controls, Michael converted the image to black and white, then used Lightroom's Split Toning controls to warm the highlights and cool the shadow areas.

Mikkel Aaland's Romantic Tasmania

Tasmania is extremely picturesque, but I felt that my out-of-the-camera shots didn't capture what I was feeling. Peter Eastway showed me images he modified with Photoshop and I loved the effect. I realized I could get a similar look to Peter's using Lightroom 2. Here is what I came up with—inspired by Peter, of course.

I'll use one of my shots from a Tasmanian rain forest on the east coast, shown here in Figure 8-10 and enlarged on page 220. I was accompanied by Charlie Cramer and Bruce Dale, and we were led deep into the leech-infested forest by Matt Taylor, our Tourism Tasmania guide. For this shot, I didn't use a tripod, and you can see that I didn't angle the shot correctly, something easily corrected in Lightroom.

Here are the steps.

1. After importing the day's shoot into Lightroom, I make my selection in the Library module and then hit the D key, which brings me immediately to the Develop module.

Figure 8-10

2. Then, I do what I almost always do first with my images—I adjust the black settings as shown circled in Figure 8-11. (Peter Krogh has a recipe, which he shares on page 222, that shows you how to create a preset that applies a very useful auto black setting.)

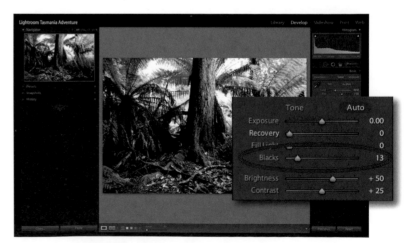

Figure 8-11

Figure 8-12

Next I turn to the Crop overlay tool, which is now located in Lightroom 2 in the tool strip, under the histogram, next to the new localized adjustment tools. When I place my cursor outside the edges of my image and click, the crop overlay icon turns into a curved arrow, and a grid appears over my image. I move my cursor until the tree is aligned at a right angle and release the mouse button, as shown in Figure 8-12. Hitting the Return/Enter key applies the nondestructive crop and takes me out of the crop mode.

Figure 8-13

3. Then I slide the Clarity slider, found with the other Presence sliders in the Basic pane, to –100, as shown in Figure 8-13. I immediately like what I see. The forest glows and comes alive, and now my image is much more evocative of what I actually saw in reality.

4. As a final step, I change my white balance setting from As Shot to Cloudy to warm up the shot. Then I turn to the Vignettes pane and, using the new Post-crop adjustment, I add a slight vignette to give my image more drama, as shown in the final image enlarged on page 221.

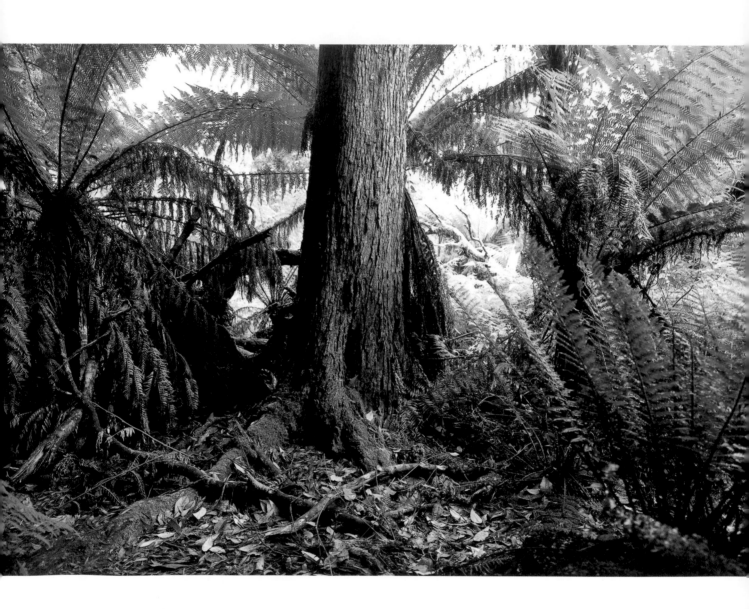

This isn't the rainforest I remember...

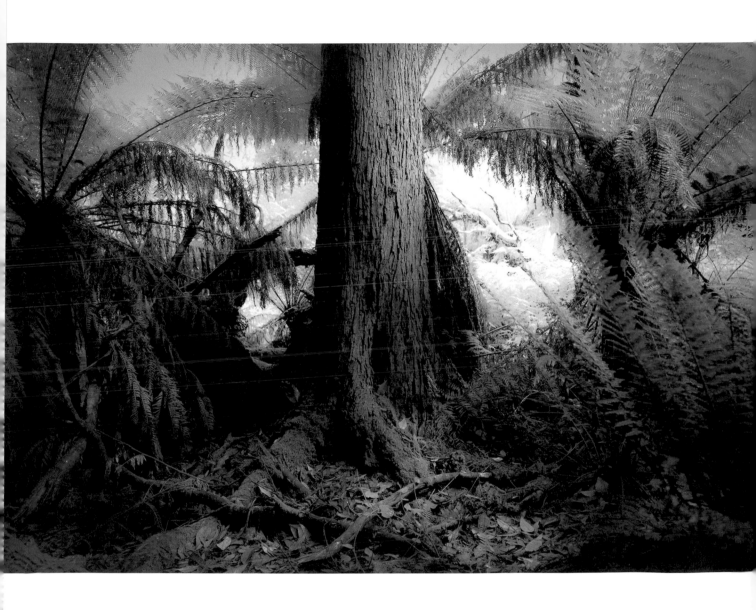

...but with a little negative clarity it looks right.

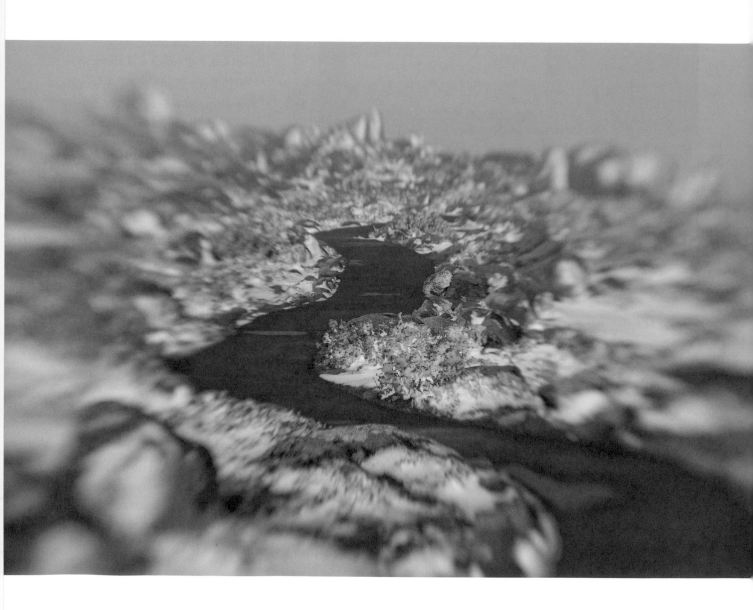

This out-of-the-box-shot by Peter Krogh of snow on a mountain near Hobart...

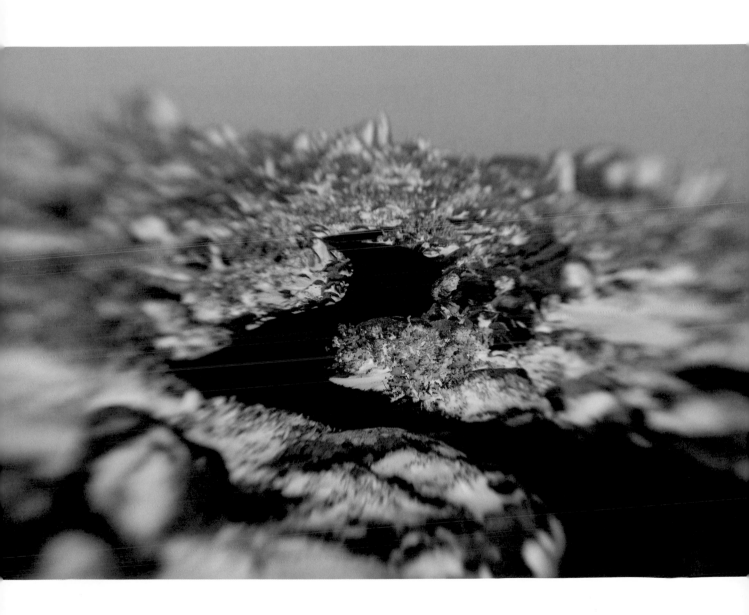

...definitely benefits from Peter's Auto Black recipe.

Charlie Cramer's Secret Sauce

Charlie Cramer doesn't go much for jazzy techniques. He is a straight shooter, and he prints pretty much everything straight out of his camera. There are times, however, with certain types of images, when he applies a secret sauce, which is really just a smart manipulation of the Lightroom tone curve. Let's see how.

In Figure 8-19 you see one of Charlie's Tasmania shots. It's a foggy scene, with most of the important detail in the highlights. (You can see enlarged before and after views on subsequent pages.)

Figure 8-19

If you move the exposure slider in the Basic pane, as shown in Figure 8-20, to try to bring out some of the details in the highlights, you get clipping, as shown by the solid line in the far right of the histogram and the red highlight clipping warning in the preview window. (Clipping means no detail, which is sometimes OK, but certainly not in images like this where the detail is very important.)

To get this right, Charlie turns to Lightroom's Develop module Tone Curve pane, where he gains a lot more control over the distribution of tonal values than is found with simple exposure settings in the Basic pane.

Figure 8-20

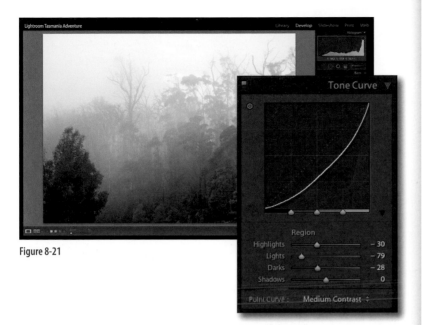

Figure 8-21

As you can see in Figure 8-21, Charlie has come up with a tone curve that is very steep in the highlights and yet achieves a nice separation of highlights and midtones, with a slight increase in saturation as well. Charlie uses a similar steep tone curve on a similar image, shown in Figure 8-22, with good results. Here are the settings:

- Highlights: −30
- Lights: −79
- Darks: −28
- Shadows: 0

Try these values yourself on your own images that are similar in nature to Charlie's. Even if the settings aren't perfect they should make a good starting point.

Figure 8-22

NOTE *Charlie Cramer also has some thoughts on printing with Lightroom. When we were in Tasmania, we worked with an Epson 3800 printer. At first Charlie swore that the printer printed Lightroom-generated files too dark. (And we all agreed.) But then Charlie printed his test target and concluded that everything was as it should be. It goes to show how hard it is to judge things solely from a monitor, Charlie wisely concluded. Often it is a perceptual thing. The monitor glows, and the print doesn't, which leads to the common complaint that things are printing too dark. Charlie believes that there is no replacement for judging from an actual print, and that's why he really likes Lightroom's ability to easily make a big sheet of small prints for proofing.*

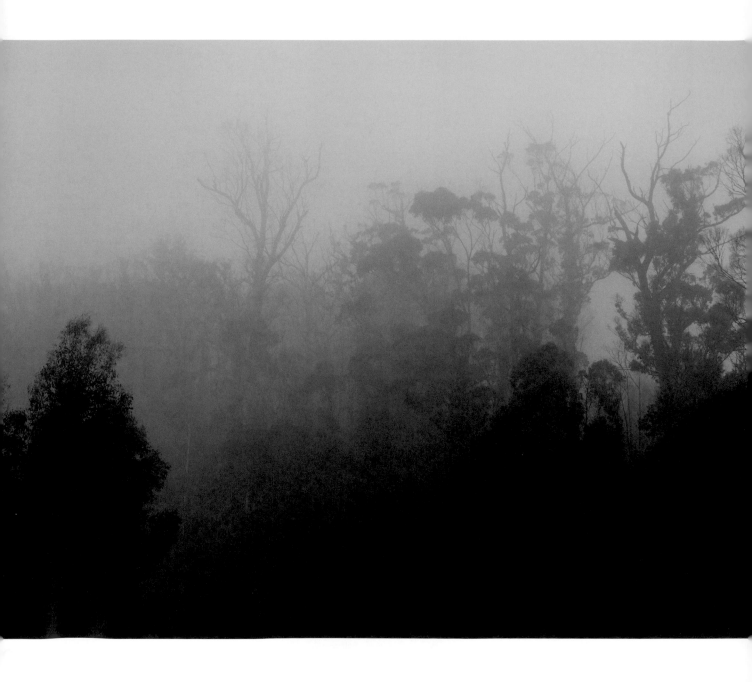

Charlie Cramer's shot needs brightening in the highlights and a simple adjustment with Lightroom's exposure slider makes things worse...

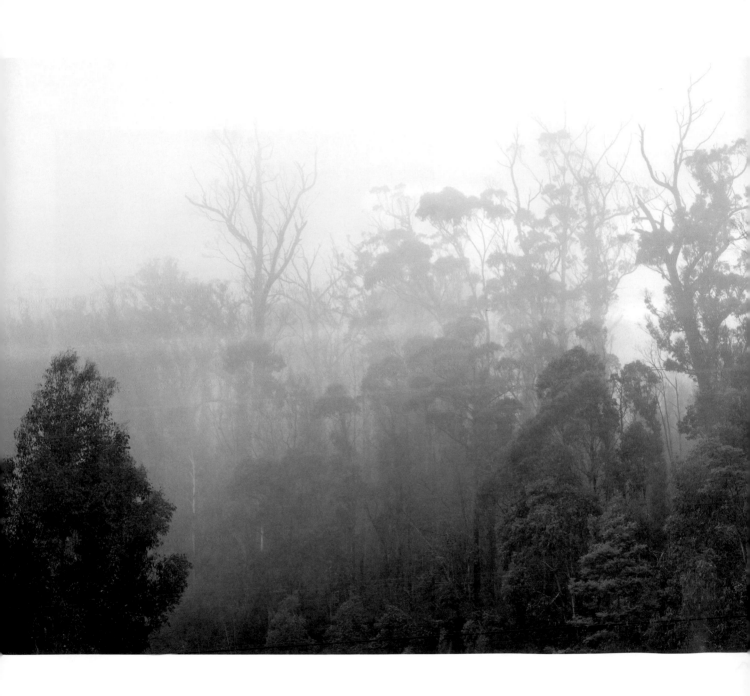

...but with a Tone Curve adjustment, it's just right.

Jeff Pflueger's Graduated Filter

In many photographs there's too much dynamic range between the white clouds and blue skies and the landscape being photographed. Jeff's recipe shows you how to fix this problem without resorting to on-camera neutral density filters.

Often, to expose a landscape correctly, you get an all-white sky, rather than interesting clouds. White skies are a great way to kill an otherwise good image. Graduated neutral density filters have long been used by photographers to bring out sky detail by selectively blocking the light coming in from the sky. Lightroom 2.0 has graduated filters built in, and they aren't just neutral density, they're also graduated filters of any color, contrast, saturation, and even clarity.

Jeff's original image, shown in Figure 8-23 (and enlarged on page 232), was actually shot with a neutral density graduated filter on the lens to block some of the excess light from the sky. But it wasn't enough—and Lightroom can do a better job.

Here is what Jeff does to improve this shot, and shots like this one.

1. In the Lightroom Develop module Jeff selects the new Graduated filter from the tool strip found under the histogram.

2. He starts with the default exposure setting (found by selecting Exposure from the Effect pop-up menu shown in Figure 8-24). The settings are not critical. They can be changed later, at any time.

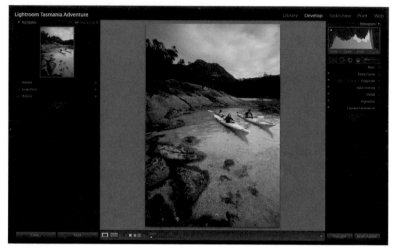

Figure 8-23

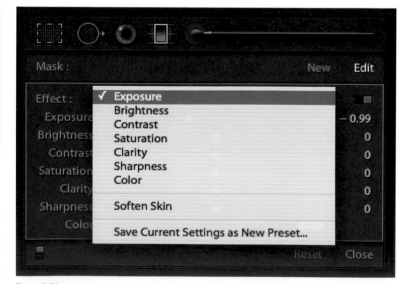

Figure 8-24

Figure 8-25

Figure 8-26

3. Now he uses his cursor to drag down from the top of the image, as shown circled in Figure 8-25. (To restrain the filter to a right angle, hold the Shift key; otherwise, you can angle the filter in any direction you want.)

4. When he releases the mouse button, the Graduated filter goes from new mode to edit mode, and a black pin appears in the white dot, as shown by the arrows in Figure 8-25. (The black dot signifies an active filter. You can have as many Graduated filters on one image as you like, but you can only work on one at a time.)

5. In the edit mode, Jeff fine-tunes the Graduated filter settings. For this image he sets the exposure to –30, increases the contrast to 3, increases the saturation to 43, and boosts the clarity to 90, as shown in Figure 8-26.

When he's finished with the Graduated filter, Jeff uses the M key to deselect it and moves on to other Develop module enhancements to his image. (Pressing the M key in the Develop module also selects the Graduated filter when it is deselected.)

To complete his work on this image, Jeff goes to the Tone Curve pane and boosts the light tones and decreases the dark tones, which gives his image an overall increase in contrast. Then Jeff goes to the HSL/Color/Grayscale pane and uses the Target Assist Tool (TAT) to selectively increase the saturation of the orange rocks and the green seaweed. The final image is shown on page 233.

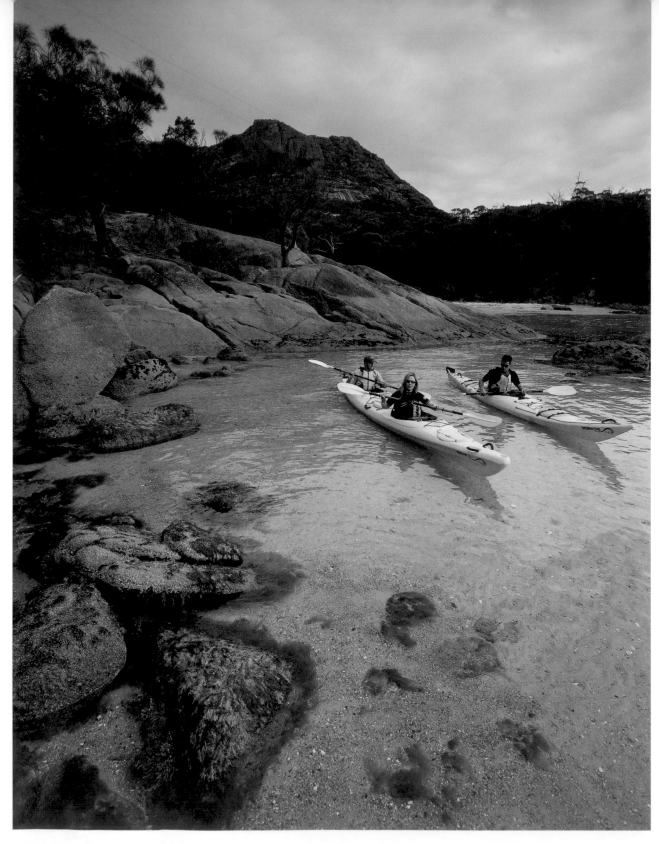

Jeff Pflueger's simple use of the Graduated filter...

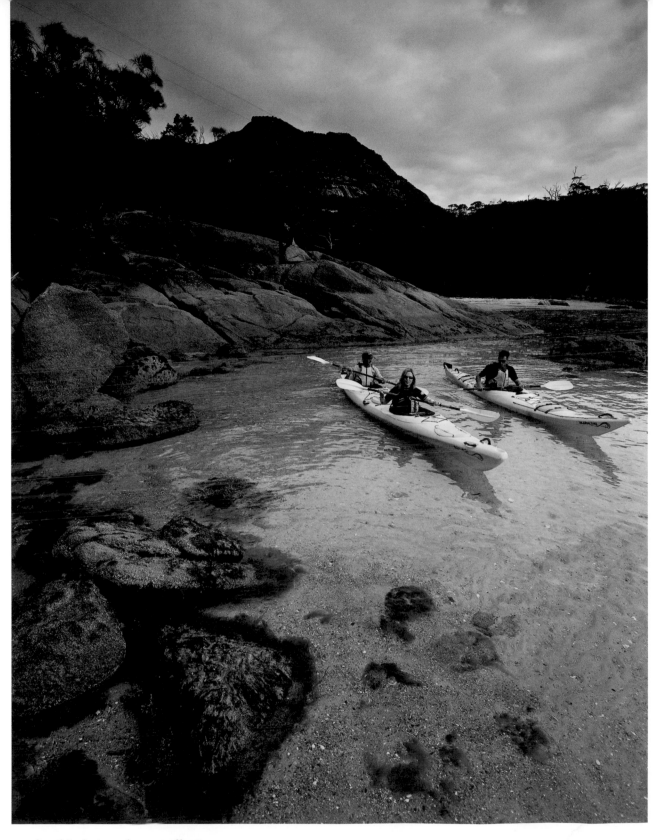

...makes this shot much more effective.

Ian Wallace's Selective Adjustments

Ian Wallace's underwater photographs from Tasmania are stunning. But some of the shots need a little help from Lightroom 2's new adjustment brush. In this recipe, Ian shows you how he separates colors from an object within an image where the object essentially blends into the background.

Look at the shot in Figure 8-27. This is the original image Ian has to work with. (You can see larger before and after versions on subsequent pages.)

Figure 8-27

Here, step by step, is what Ian does to improve the shot.

1. First he adjusts the white balance, which in this case is easy to do because the subject is fairly monotone. He selects the white balance tool (W) and clicks on a neutral area. Figure 8-28 shows the white balance-corrected image.

2. Next he selects Lightroom's new adjustment brush from the tool strip (or use the K key) and sets the exposure to +3. (It doesn't matter if the setting is perfect; you can always go back later and correct it.) Here is what Ian uses for his brush settings for this image:

 • No feather

 • 100% flow

 • Density 100

 • He also makes sure the Auto Mask box is checked

Figure 8-28

Figure 8-29

Figure 8-30

3. Next, in the image window, he uses his cursor (brush) to paint a mask over the object, in this case the stingray. He uses a large brush for the main parts, and a small brush for fine detail. (You can quickly change the size of the brush with the bracket keys). Because Auto Mask is selected, the brush effect automatically stops at edges. (If you accidently include unwanted areas in your brushing, Option/Alt reverses the action of the brush and erases the masked areas.) To see the effect of your brush strokes and the actual mask, press the O key or pass your cursor over the mask pin. If you hold the Shift key while pressing the O key, you can cycle through different mask colors. A red mask color is shown in Figure 8-29.

4. When Ian is finished creating his mask, he turns back to the adjustment brush controls in the tool strip. (At this point you should be in edit mode. The edit will apply to a selected mask, which is designed by a black dot in the middle of a white circle.) For this image, Ian reduces the saturation to 81, slightly changes the exposure (+30), moves the contrast to +50, and sets clarity to +65, as shown in Figure 8-30. Now the stingray (or any foreground object of your choice) is more defined. (Adjust these settings according to the texture and patterns of the object you are adjusting).

As a final step, Ian optimizes the tone curve and applies a vignette from the Vignettes pane, and crops the image to a vertical format.

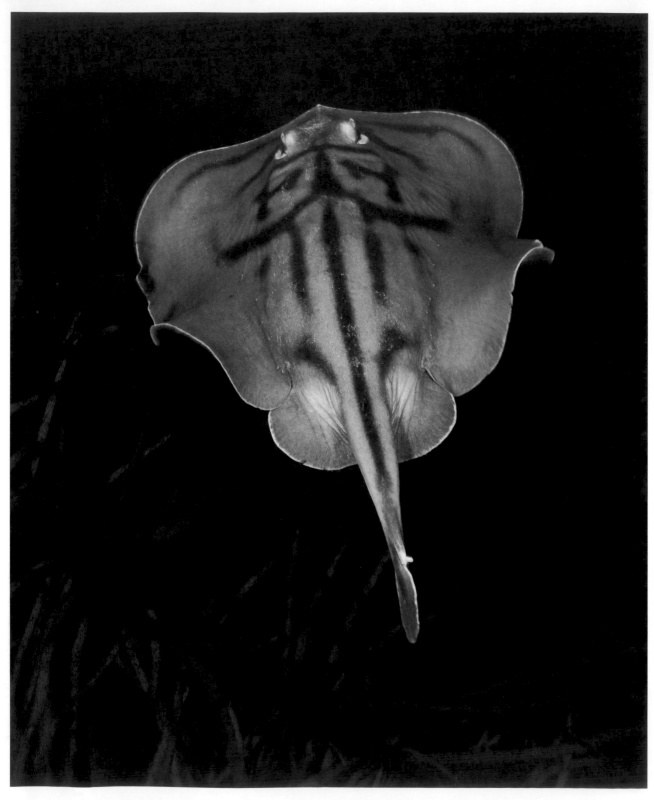

Using Lightroom 2's adjustment brush, Ian Wallace was able to make this stingray, which blends into the background...

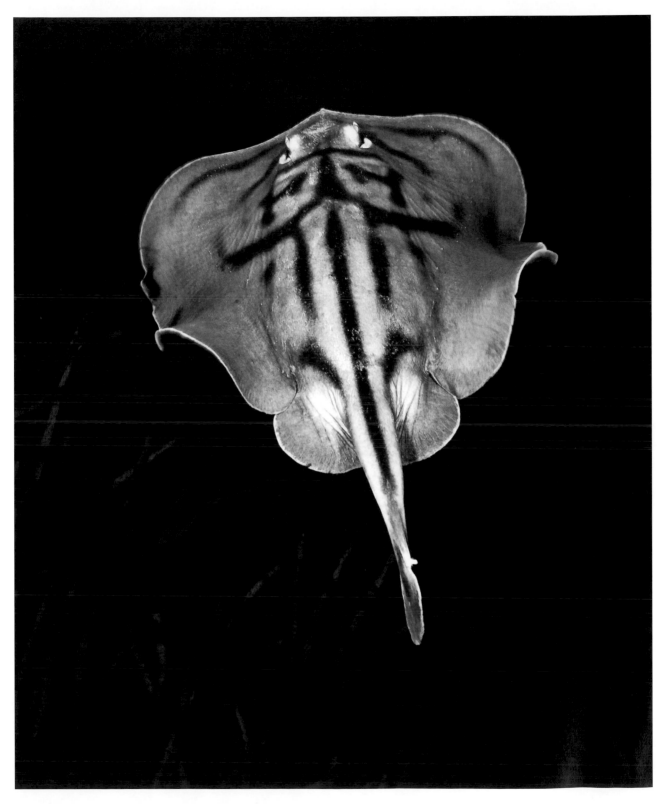

...stand out.

Katrin Eismann

This is another one of Katrin's Hobart garbage dump series, which is really several images she composited together in a grid. Although this isn't exactly a "recipe" per se, I wanted to explain that Katrin actually created the final image using a combination of Lightroom and Photoshop Smart Objects. Smart Objects bring to Photoshop a similar type of non-destructive editing found in Lightroom. They are also a great way to deal with very large files, such as the 128 MB files produced with Katrin's Phase One P25+ back. Why did Katrin need to bring her files into Photoshop in the first place? Every shot you see is a separate image, shot under slightly different lighting. Katrin needed a way to position each image next to each for comparison, and control each background so they matched, something she couldn't do in Lightroom. Because she used Smart Objects in Photoshop, a file that would have been unmanageable became very reasonable in size, and she could size the files up or down without any loss in quality to make a variety of print sizes. The bottom line was she was able to work around a Lightroom limitation and yet create a high-quality and flexible workflow.

Richard Morgenstein's Mixed Light

For this recipe, Iceland Adventurer Richard Morgenstein includes both a shooting and a develop component. In the end, he creates an eerie look that works especially well on landscape shots (like the one used in this example) and portraits.

From a shooting point of view, Richard looks for a scene that contains a mix of natural and artificial ambient light. He sets his camera on a tripod and, in the case of this low-light shot, uses a long exposure (20 seconds at f/9) rather than bumping up the ISO and the camera's sensitivity.

In the case of the example shown here, in Figure 8-31, the result is a photo filled with unnatural colors. Pay particular attention to the tree in the photo. It is receiving light from the sky—which in Iceland in the summer never gets completely dark—*and* the mercury vapor street lights.

Figure 8-31

After Richard imports his RAW photo into Lightroom and the Develop module, he does the following:

1. Pick one of the light sources to correct. In this case, Richard chooses to correct for the mercury vapor lights by placing his white balance tool on the sidewalk, in an area that receives the most light from the lights, and clicking, as shown in Figure 32. (To quickly select the white balance tool, use the W key.)

Figure 8-32

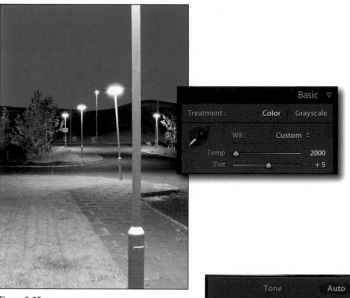

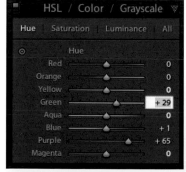

Figure 8-33

Color-correcting for one of the light sources throws the other light source in an interesting and often pleasing direction, as shown in Figure 8-33.

2. Adjust the tonal values. In this case, Richard increases the blacks to +7 and decreases the brightness from +50 to +5 to darken the image overall, as shown in Figure 8-34.

Figure 8-34

Finally, open up the HSL pane and tweak the hue, saturation, and luminance settings to get the desired look. Figure 8-35 shows the settings Richard uses to get the look he's after.

You can see the enlarged before and after images on the following pages.

NOTE *If you apply Richard's recipe to a person, the person can look really awful or very interesting, depending on what kind of effect you're going for. With a landscape shot, you have a lot more leeway with unnatural colors because they add interest and dimension. Also, people are more accepting of a wider range of colors in a landscape shot, especially a landscape shot taken at night.*

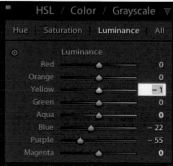

Figure 8-35

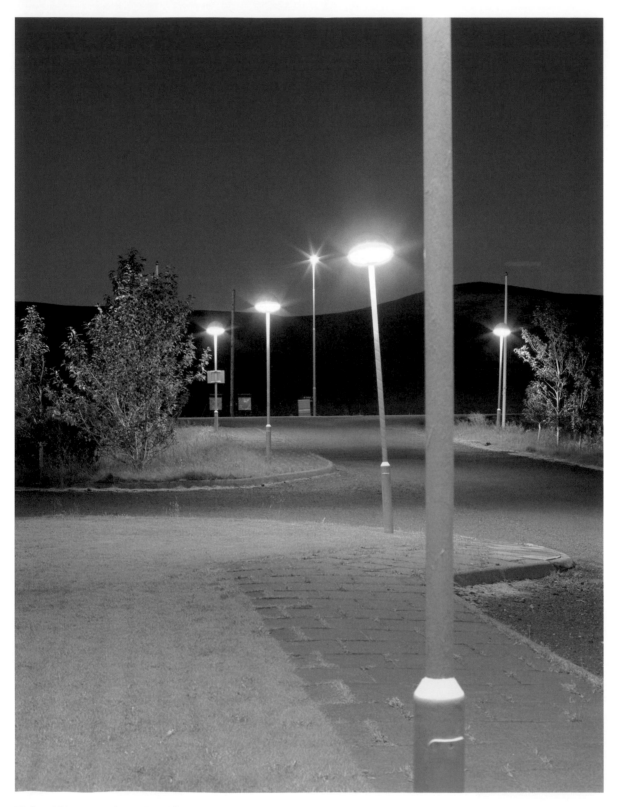

Richard Morgenstein starts with a shot containing a mixture of natural and artificial light...

...and then corrects the white balance setting for one light source, throwing the other light source into an interesting and often pleasing direction.

Exporting Files

As you've learned, within the Lightroom environment, you don't actually save your image files as you might with other applications. As you work on an image, Lightroom automatically saves a set of instructions that are applied to your image whenever you open the application and select that image again. However, as soon as you decide to work outside the Lightroom environment or share your images, you will need to export them or make sure that the Lightroom instructions accompany the image file. This chapter shows you how to do so, as well as how to export selected images as a Lightroom catalog, so they're ready to be imported and incorporated into another Lightroom catalog. Finally, I also cover compatibility between Lightroom and external editors such as Photoshop and Photoshop Elements.

Chapter Contents

Exporting Revealed

With Lightroom, you can export one photo at a time, or many. Most export choices are made in the Export dialog box, where you can enter a name and select the file format, size, color space, and more. If you are exporting a catalog, choices are found in the Export as Catalog dialog box. Let's see how it all works.

You can export images from any Lightroom module by using the filmstrip to make your selection (circled in Figure 9-1). Make your choice, then use the menu command File→Export, as shown in Figure 9-1. Or you can use the keyboard shortcut +Shift+E (Ctrl+Shift+E), which brings up the Export dialog box. You can select and export one batch of images with one set of settings (for instance, save as JPEG), and then, before the export process is complete, start another export with a different set of settings (for instance, save as TIFF). The export progress is noted in Lightroom's Progress bar (or bars, if you have two operations running at once), as shown in Figure 9-2.

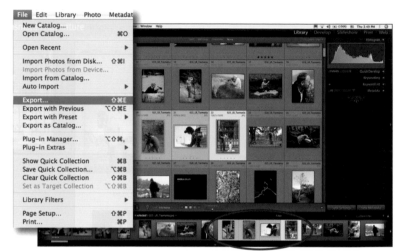

Figure 9-1

Figure 9-2

Export Methods

There are a variety of ways to export:

Export from the Library module To export from Lightroom's Library module, start in the Grid view and select the image you want to export. Select File→Export from the menu, or click on the Export button at the bottom of the left panel, as shown in Figure 9-3.

Some other useful export menu commands are found in all modules:

Export with Previous The menu command File→Export with Previous bypasses the Export dialog box and applies the last Export dialog box settings to your images. It places your images in the previously designated destination folder or location.

Figure 9-3

Figure 9-4

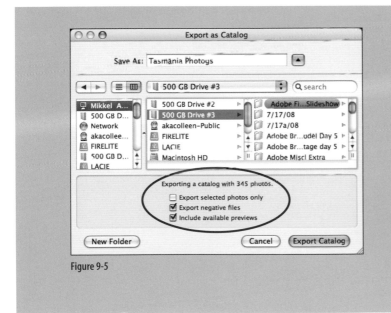

Figure 9-5

NOTE *If you press the Option/Alt key in the Library module, the word Export at the bottom of the left panel becomes Export Catalog. Use this to export a selection of images as a standalone catalog or if you want to incorporate a set of images into another catalog.*

Export with Preset Selecting File→Export with Preset, as shown in Figure 9-4, makes all your export presets (both the default presets and those created in the Export dialog box) available without having to go through the Export dialog box.

Export as Catalog This option is relevant if you want to create a new Lightroom catalog that contains previews and references to selected images. After this selective catalog is created, it can be imported and incorporated into another Lightroom catalog.

Export as Catalog Options

When you select File →Export as Catalog from the menu bar, you get the dialog box shown in Figure 9-5. Name the new catalog and choose a location. Lightroom will automatically add the required *.lrcat* file extension upon export. Deselect Export negative files and Include available previews (circled) if you want a very quick export that doesn't include the original image files or previews. Make sure the version of Lightroom used to import a new catalog is at or above the version number used to export.

Navigating Export Dialog Box

Figure 9-6 shows the Export dialog box that you get when you choose Export from the File menu or at the bottom of the Library module's left panel. Here, you make export choices such as destination, file name, file type, and so on. In Lightroom 2 this dialog box is also a gateway into using and managing Lightroom third-party plug-ins. Let's go through all the options.

Choose a preset

Lightroom ships with some commonly used export presets: Burn Full-Sized JPEGs, Export to DNG, and For E-Mail, as shown in Figure 9-7. These are the same presets you see when you select File→Export Presets from the menu bar. You'll probably want to make some of your own export presets as well. I show you how, later in this section.

Plug-In Manager

At the bottom left of the Export dialog box is a button that reads Plug-in Manager. Click on it to open the Lightroom Plug-in Manager dialog box, shown in Figure 9-8. (You can also get to the Plug-in Manager from the Lightroom menu bar: File→Plug-in Manager). Here it's really easy to add and remove third-party plug-ins and make sure they are working properly by checking their status. If you are online, clicking on the Plug-in Exchange button takes you directly to the Adobe Lightroom Exchange website, which is full of useful plug-ins—some free, some for sale.

"Export [...] selected photos to" menu bar

At the top of the Export dialog box is the "Export [...] selected photos to" menu bar, circled in Figure 9-9. (The number of images selected to export will appear instead of [...].) Here, using the up and down arrows and the subsequent pop-up window, you can choose where your images are exported to. By default Lightroom 2 gives you two export choices: Files on Disc, and Files on CD/DVD (which won't be an option on 64-bit Windows). If you have installed third-party plug-ins, such as the SmugMug or Zenfolio upload plug-ins from Jeff Friedl,

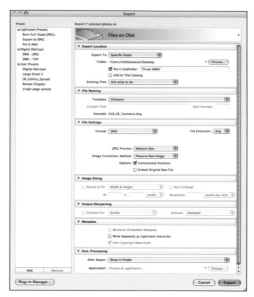

Figure 9-6

Figure 9-7

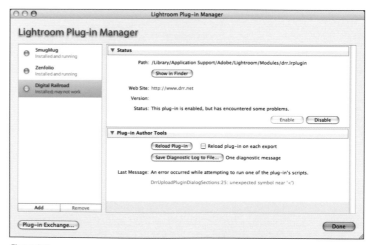

Figure 9-8

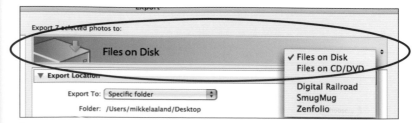

Figure 9-9

or Digital Railroad's plug-in, these will also show up here as an option. Subsequent options in the Export dialog box will vary depending on your Export To choice.

Export location

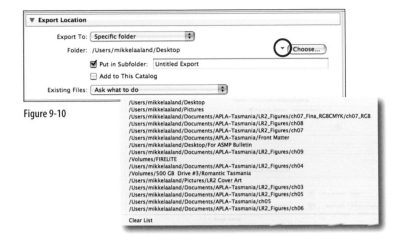

Figure 9-10

Export Location is an option when you select Export to... Files on Disc or Files on CD/DVD. Choose a destination for the exported images by clicking Choose. Click on the triangle next to Choose (circled in Figure 9-10) and you get a pop-up menu with shortcuts to the most recent destinations selected. Check Put in Subfolder, and you can name a new folder that will reside in the selected folder. Select Add to This Catalog to automatically import the exported image data back into the Lightroom catalog. You can also have the exported images reimported and stacked with the original file in Lightroom. From the Existing Files pop-up menu, you can choose how files are handled when Lightroom encounters files with the same name. (I just leave the setting at Ask what to do.)

File naming

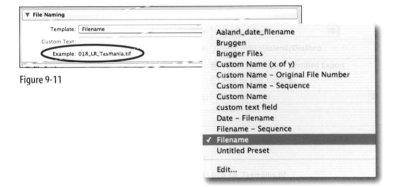

Figure 9-11

You can customize a file name in this field (shown in Figure 9-11) or just leave it as is. A preview of the file name appears in the Export dialog box (circled). Regardless of what you do, Lightroom automatically adds the appropriate file extension based on your file format choice. File naming presets are also available, as shown in the Template pop-up menu. If you select Edit from the Template pop-up menu, you can make a preset of your own. The Filename Template Editor dialog box, shown in Figure 9-12, appears when you select Edit. (I discuss how to use the Filename Template Editor in Chapter 3.) When you are finished, select Save Current

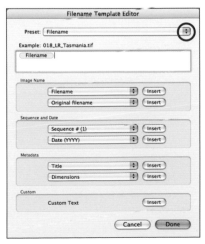

Figure 9-12

Settings as New Preset from the Filename Template Editor's Preset pop-up menu (circled).

File settings

You can choose from the following file formats: JPEG, PSD, TIFF, DNG, and Original, as shown in Figure 9-13. You can export only one file format at a time, but as I said earlier, you can start one export before another is finished, effectively exporting multiple formats nearly simultaneously.

File format Image settings options vary from format to format. When you choose JPEG, for example, you can also choose the amount of compression with the Quality slider (circled in Figure 9-14). If you select TIFF, you can choose between Compression: None, Compression: LZW (which is a lossless compression algorithm and 8-bit only option), and Compression: ZIP (another lossless compression algorithm for both 8-bit and 16-bit). If you choose Original, there are no image-setting options. Original, after all, sends an exact copy of your original image to the destination of your choice. If you choose DNG, there are several important options to choose from, which I cover in detail later in this section.

If you choose JPEG, PSD, or TIFF as a format, you are presented with several Image Settings options, shown circled in Figure 9-15. Here is a summary of your choices:

Color space Choose between sRGB (narrower space, used for the Web and many desktop printers), AdobeRGB (wider space, commonly used in image

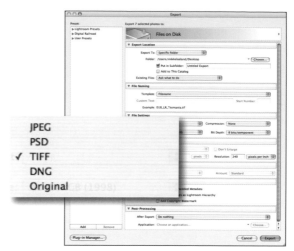

Figure 9-13

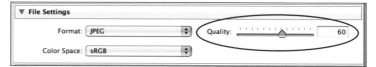

Figure 9-14

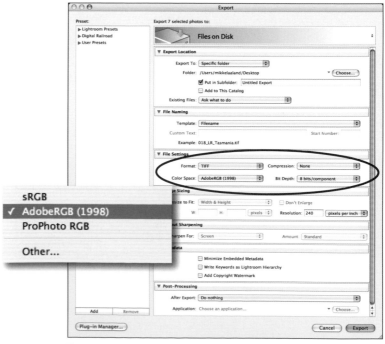

Figure 9-15

editing applications), and ProPhoto RGB (wider color space, but not widely supported). Other brings up user-specific profiles to choose from.

Bit depth If you select the TIFF or PSD file format (but not JPEG), you can choose between 8 or 16 bits/component, as shown in Figure 9-16. It's best to use 8 bits unless you are planning to perform more image processing in another application where the extra bits give you more data to work with.

Figure 9-16

Lightroom Interpolation

When Lightroom resizes for export (or, for that matter, for a print or web gallery) you don't get a choice of interpolation methods as you do with Photoshop or Photoshop Elements, where your choice is based on whether you are sampling up or down. What is Lightroom doing...and is it good? I asked Lightroom's "father," Mark Hamburg, and this is what he said:

"But the really big difference is Lightroom resamples in linear space. Depending on the image, this can create a huge difference. For example, with a Photoshop resampling, if you look closely, you can see a darkening around edges, because Photoshop doesn't generally work in linear.

"Which results one likes for resampling are in part a matter of taste and also depend on the image content. In general, Lightroom should be at least as good as Photoshop and in some cases—such as upsampling—it should be clearly better."

Image sizing

Lightroom 2 offers different ways to determine the dimensions of an image. If you leave Resize to Fit unchecked, the original dimensions of your image are maintained. Select Resize to Fit, and several options are available via the pop-up window, as shown in Figure 9-17:

Width & Height is an absolute constraint.

Dimensions applies the long value to the long edge of the photo regardless of orientation.

Long Edge *and* Short Edge apply the selected value to either the long or short edge of your image. The second value is determined by the aspect ratio of the image and may vary from image to image.

Don't Enlarge is shown circled in Figure 9-18 and when used with Resize to Fit, ensures that no enlargement interpolation is applied and that the copy never contains more pixels than the original.

Enter a resolution as pixels per inch or pixels per centimeter. The default is 240 pixels per inch, as shown in Figure 9-19. (Even if Resize to Fit is deselected, you can enter a new Resolution value.)

Output sharpening

New (and much welcomed) to Lightroom 2 are output sharpening options, shown circled in Figure 9-20. Here, as long as you've haven't chosen Original or DNG, you can select appropriate sharpening based on the final destination of your file. Correct sharpening, as many of you may know, is based on many factors.

Figure 9-17

Figure 9-18

Figure 9-19

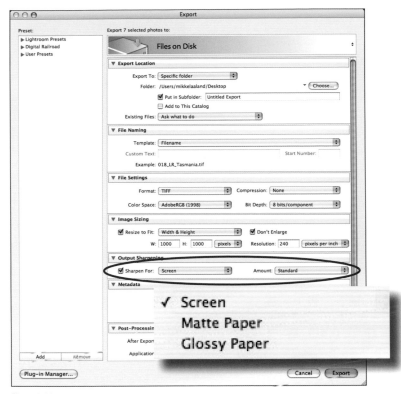

Figure 9-20

Figure 9-21

Sharpening for screen or web viewing, for example, differs from sharpening for a print. And sharpening for a print depends on others factors as well. For example, what kind of paper are you using? Know very well that sharpening is as much a personal preference as a technical issue, and you'll just have to experiment and see if the new Lightroom export sharpening works as well for you as it does for me.

Metadata

Under the heading of Metadata, as shown circled in Figure 9-21, you have three options:

Minimize Embedded Metadata If you don't select this option, Lightroom includes all the metadata entered in the IPTC fields. Select it, and only copyright metadata is included with the exported photos. (Not an option for DNG files.)

Write Keywords as Lightroom Hierarchy Regardless of which file format you choose, you'll have a choice of how keyword metadata is organized. If you check the box to Write Keywords as Lightroom Hierarchy, applications that don't support this option will still display your keywords, albeit without hierarchical structure.

Add Copyright Watermark Check this option, and Lightroom adds the name that's entered in images' IPTC copyright field, at the lower-left corner of every image (circled in Figure 9-22). (Not an option for DNG files.)

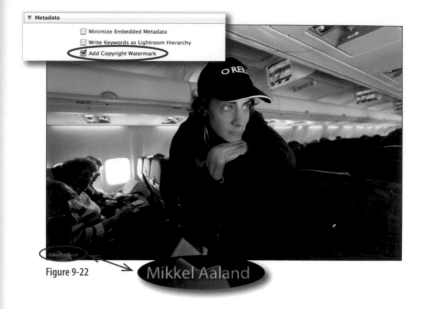

Figure 9-22

Postprocessing

If you choose to Export to Files on Disk from the top menu, post-processing options appear at the bottom of the Export dialog window, as shown in Figure 9-23. Here you can instruct Lightroom to do several things after export is complete.

Figure 9-23

Do nothing If you select this, after export you'll return to the Lightroom module in which you were previously working.

Show in Finder/Explorer If you select this option, shown in Figure 9-24, after export, the files are displayed in an Explorer window (Windows) or Finder (Mac OS) window. I love this export option and use it all the time. It saves me from the "Where the heck did that file go?" frustration.

Figure 9-24

Open in Adobe Photoshop CS3 (or other designated editor) Opens an exported image in the designated external editor set in Lightroom preferences *after* Lightroom applies the parameters (file format, bit depth, size, and so on) set in the Export dialog box or Preferences/External Editing.

Open in Other Application Choose this option and then use Choose (circled in Figure 9-25) to select an application such as Preview (Mac) or Windows Photo Gallery (Windows). When Export is complete, your images open in the designated application.

Go to Export Actions Folder Now This takes you to and opens the Export Actions folder, where you can place any executable application, shortcut, or an alias of an executable application. If you do this, the next time you choose Export, the alias you added to the folder will be listed in the After Export menu of the Export dialog box. You can also add Photoshop droplets or script files to the Export Actions folder.

Figure 9-25

Adding a Custom Preset

New User Presets can be easily added by making your selections in the Export dialog box and then selecting the Add button at the bottom left of the dialog box, circled in Figure 9-26. In the New Presets dialog box, name your preset and designate a folder for it to reside in. To remove a user preset, select the preset and then click Remove at the bottom left of the Export dialog box.

Figure 9-26

DNG Export Options

As promised earlier, here are the choices you have in the Export dialog box when you choose to export a DNG file (circled in Figure 9-27).

JPEG Previews

Choices are None, Medium Size, and Full Size. Larger sizes increase the total file size, but provide a ready-to-print JPEG proof.

File Extension

Choose between an uppercase and a lowercase extension.

Figure 9-27

Image Conversion Method

It's best to use Preserve Raw Image. Select Convert to Linear Image, as shown in Figure 9-28, only if you know that your RAW file contains unusual mosaic patterns not supported by all converters.

Options: Compressed (lossless)

Select this, as shown in Figure 9-29, and your DNG file will be about one-third smaller than the original RAW file with no tradeoff in quality.

Figure 9-28

Figure 9-29

Options: ☑ Compressed (lossless)
☑ Embed Original Raw File

Figure 9-30

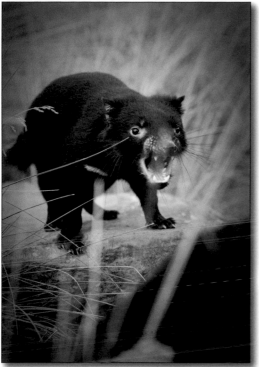

Figure 9-31

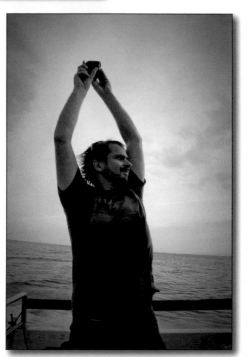

Figure 9-32

Options: Embed Original Raw File

Select this, as also shown in Figure 9-30, and an exact copy of the original RAW file is embedded within the DNG file, which becomes about two-thirds larger than the original file. At this time, you'll need the Adobe DNG converter to retrieve the embedded RAW file from the DNG file.

Figure 9-31 represents a DNG file with the original RAW file embedded, and it weighs in at 25 MB. Figure 9-32 represents a DNG file without the original RAW file embedded, and it weighs in at 10.4 MB. Big difference! (I took the first shot of a Tasmanian devil with a Nikon D3, and Leo Laporte took the second shot of our intrepid guide Joshua with his Canon 5D. The original RAW files for both images are very similar in file size.)

NOTE *DNG stands for digital negative. Use Lightroom to export proprietary RAW data files— or JPEGs or TIFFs—into DNG. (File→Export, or, in the Library module, Library→Convert Photo to DNG.) This archives your photos, accompanying metadata, the original RAW file, and a full-size JPEG preview (if you wish) into an open format that is more likely to be compatible with future software applications.*

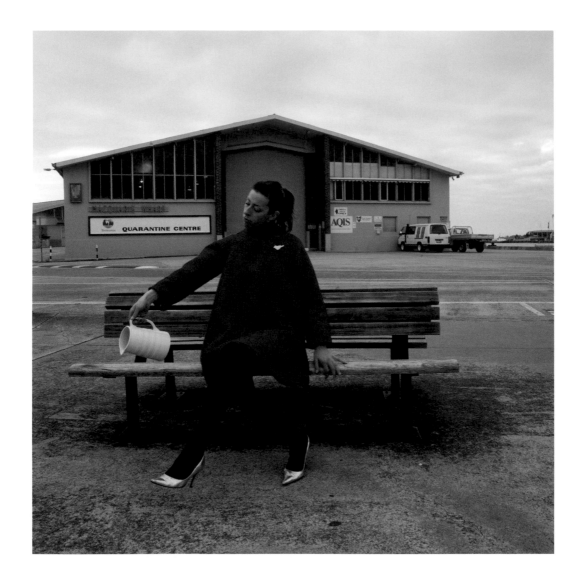

Jackie King

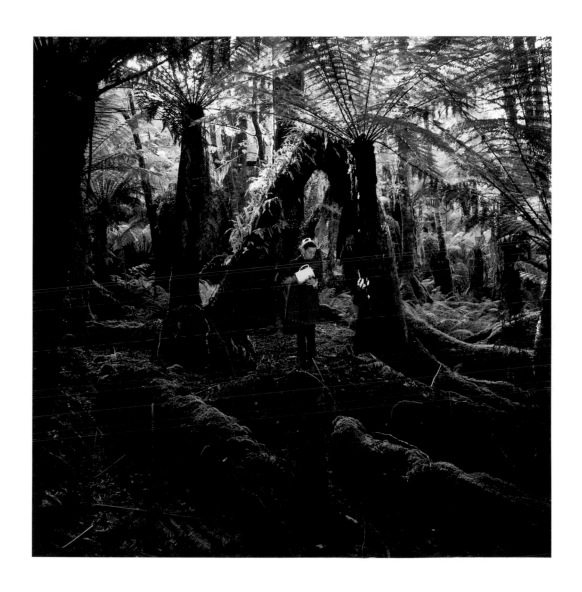

finally....I'm ready to say goodbye

Tasmania invites the unconscious to speak, the unexpected to flourish. Take the story of Jackie King, British Professional Photographer of the Year 2005. She flew halfway around the world with certain expectations about what she was going to photograph. Instead, inspired by several objects she found in Love & Clutter, a small Hobart boutique that specializes in locally made art and fashion, she ended up creating a series of very personal and symbolic images, two of which are shown here. The white jug, she explains, represents the pouring away of life's clutter, the red dress is a color of strength, and a birdcage, which is shown in another image, represents escape and freedom. "[In Tasmania] I was saying good bye and feeling liberated from ties of my past and looking forward to the freedom and excitement of my future."

Editing in Photoshop and Other Applications

For some, Lightroom is an all-in-one solution. For others, however, there will be times when you'll need to leave the Lightroom environment and edit your work in another application, such as Photoshop or Photoshop Elements. Here is what you need to know when you do this.

If you have Photoshop or Photoshop Elements installed on your computer, Lightroom offers these applications for use as an external editor by default, as shown in Figure 9-33. You can choose other additional image editing applications in Lightroom's Preferences under the External Editing tab. (I get into more detail on this later in this section.)

Figure 9-33

Editing Outside Lightroom

Jump to an external editor from the Library, Develop, or Print module by right-clicking on the image in the preview window or filmstrip and selecting Edit in [*External Editor*] from the contextual menu, as shown in Figure 9-34. From the Library and Develop modules, you can also use the File menu command (Photo→ Edit in [*External Editor*]).

Drag and drop to outside editor (Mac)

On a Mac, you can drag and drop a non-RAW file from the Lightroom Library or Develop modules directly into another application such as Microsoft Word or Adobe InDesign. However, your Lightroom settings are not applied. You can also drag and drop an image from Lightroom onto the application icon in the dock or on the desktop, as shown in Figure 9-35. This opens the image in that application, using the parameters set in Lightroom's External Editing Preferences, which I will get to shortly.

Figure 9-34

Figure 9-35

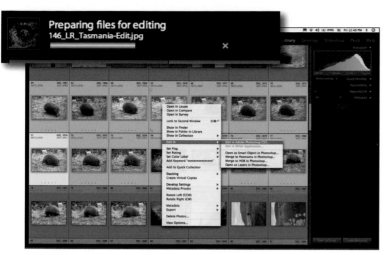

Figure 9-36

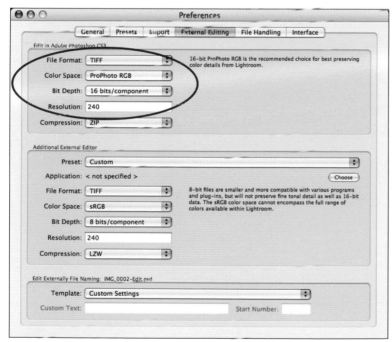

Figure 9-37

Figure 9-38

Edit as many images as you want

You can select and send as many images to an outside editor as you want. However, depending on the number of images you select, and on your edit setting, this can take time. The conversion process for non-RAW files is monitored by the status bar in the upper-left corner of the Lightroom application window, as shown in Figure 9-36.

Setting External Editing Preferences

In Lightroom's Preferences dialog box, shown in Figure 9-37, there are several important preferences relating to external editors. If you use Photoshop or Photoshop Elements you will have the following choices (circled):

File Format PSD or TIFF (if you select TIFF, you get a compression option as well).

Color Space ProPhoto, sRGB, or AdobeRGB (1998).

Bit Depth 16 bits/component or 8 bits/component.

Resolution The default is 240, but you can set any number you want.

Selecting Additional External Editors

Start by selecting Choose (circled) and navigate to the application of choice, as shown in Figure 9-38. When you have done this, you have the same choices as described earlier, but setting recommendations may differ from the ones I mentioned earlier. Eight-bit files, for example, may be desirable because they are smaller and more compatible with various programs and plug-ins, even though they do not preserve fine tonal detail as well as 16-bit data. The sRGB

color space cannot encompass the full range of color available with Lightroom, but is more widely used. Your final choice really depends on the application you choose to use. You can designate as many external editors as you want by selecting Save Current Settings as a Preset from the Presets pop-up menu.

Edit nomenclature

In the external editors preferences you can also control the file nomenclature. To enable the custom text field, select custom text field from the Template pop-up menu. To enable the Start Number field select Filename-Sequence, as shown in Figure 9-39.

Edit Photo Dialog Box

When you send a JPEG, TIF, or PSD file to an external editor, you get this dialog box shown in Figure 9-40. (If you are sending DNG or RAW files to an external editor you won't get this dialog box.)

Let's see what these choices are.

Edit a Copy with Lightroom Adjustments
This option, shown circled in Figure 9-40, sends a copy of the original file, with Lightroom adjustments visible to the external editor.

Edit a Copy This option, shown in Figure 9-41, creates a copy of the original file, without Lightroom adjustments. The newly created file is renamed with "Edit" added to the original folder and automatically placed in the Lightroom Library. (Don't use Save As in Photoshop and rename your file; the new file isn't added to the Lightroom Catalog if you use this method.)

NOTE *To open an original RAW file with another application other than Photoshop and Adobe Camera Raw, you need to know the location of the original RAW file. You can easily find it (or any original file) from within Lightroom by right-clicking on the image preview in Lightroom's Library or Develop module and selecting Show in Finder (Mac) or Show in Explorer (Windows) from the contextual menu. (If you have Photoshop CS 3 or higher, in Lightroom 2 select Photo→Edit In →Open as Smart Object in Photoshop. After the image opens in Photoshop, select Layer→Smart Objects→Edit Contents and you'll be taken to Adobe Camera Raw.)*

Figure 9-39

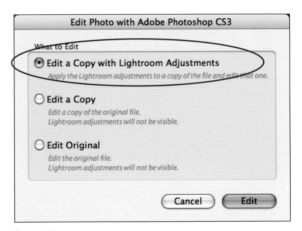

Figure 9-40

Figure 9-41

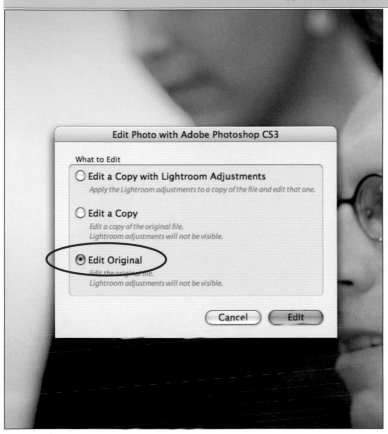

Figure 9-42

Figure 9-43

Edit Original If you select this option, shown circled in Figure 9-42, Lightroom sends the original file to the external editor without Lightroom adjustments. After you work on it in an external editor, you can choose to save the changes and your original file will be overwritten.

NOTE *Before you send a file to an external editor remember to set your editing options—file type, color space, bit depth, resolution, and so on— in Preferences, under the External Editing tab.*

Save in Photoshop

After you finish working with your file in Photoshop, simply select Save and your file is automatically updated and added to the Lightroom catalog. Keep in mind that if you are working with Photoshop 64-bit files, as you might be if you are working with HDR files, Lightroom won't support them. You will need to resample down to a lower bit rate for the file to be imported into Lightroom.

Maximize Compatibility

When you save PSD files in Photoshop or Photoshop Elements, check the Maximize Compatibility check box that may appear, as shown in Figure 9-43. If you don't, the files won't be recognized by Lightroom. Do this either in a warning dialog box (shown) that appears when you save a PSD file, or in Photoshop's Preferences/ File Handling.

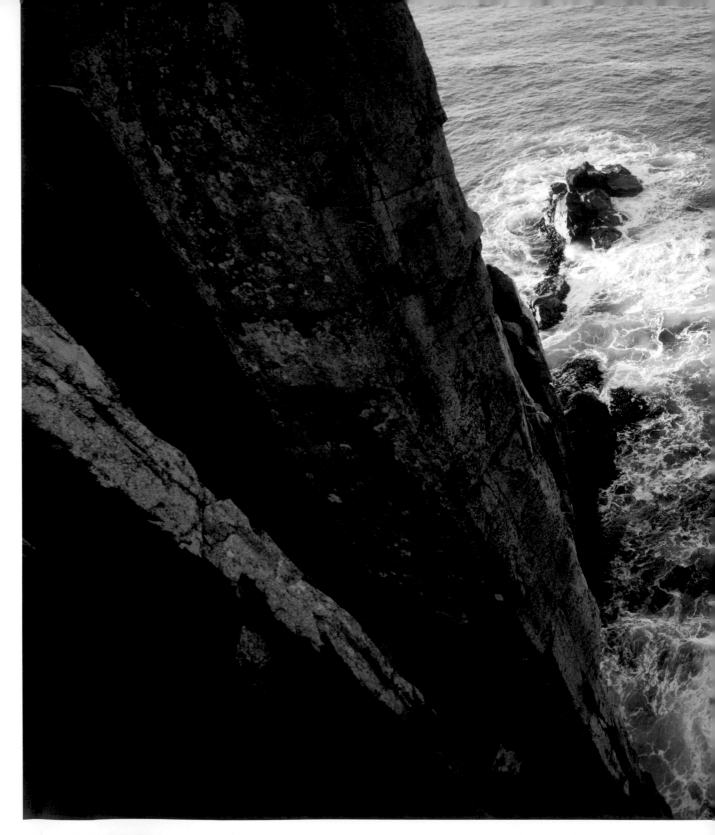

Jeff Pflueger

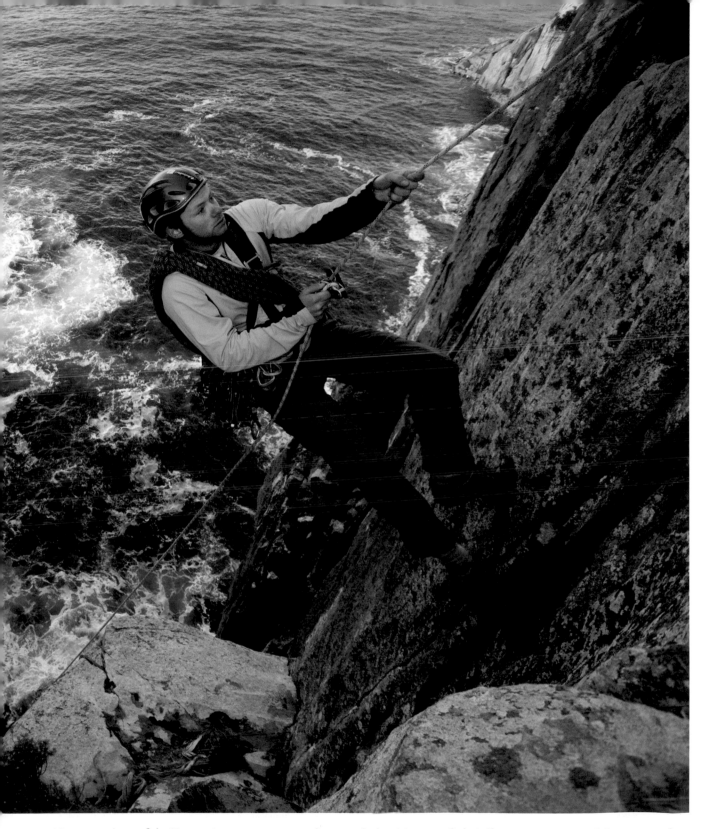

Many members of the Tasmanian team got up early to catch the rising sun. Only Jeff got up at 2 a.m. to join a group of avid Tasmanian climbers for a two-hour drive from Hobart to the Tasman Peninsula. As the sun rose, Jeff anchored himself with a rope and leaned over this treacherous cliff to take photos of Doug McConnell, one of Tasmania's local climbing heroes, rappeling. To the left is the Totem Pole, a dolorite column rising straight out of the sea. Throughout the morning, Jeff, a fearless climber himself, modestly maintained his relatively safe vantage point and made some incredible shots of McConnell and his fellow climbers climbing the pole.

Saving Metadata to the Original File

To properly open or view your Lightroom-adjusted image files in Adobe Camera Raw or Adobe Bridge—or another application that reads Lightroom-generated processing instructions—you'll need to make sure these develop settings travel with the file. In this section, I show you how to do so.

Before I get into the actual how-to of saving your Lightroom-generated metadata to an original file, here is some useful background information.

As long as you remain within the Lightroom environment, your images will look the way you intended. Lightroom keeps a record of the critical information associated with an image in a central catalog database and uses this information in conjunction with the original image to create a proxy (or preview) for you to view in Lightroom. This catalog database resides on your hard drive in a specified location, as shown in Figure 9-44.

Figure 9-44

Pushing Develop Instructions onto the Original Image File

You can push the develop instructions from the Lightroom database onto the original JPEG, TIFF, PSD, or DNG image file, or for RAW files, push the instructions into an XMP sidecar if you want. This is necessary only if you plan to view or work on your images in an application such as Adobe Bridge or Adobe Camera Raw, as shown here in Figure 9-45. If you open your original image in an application that isn't capable of reading this information, the image might open, but you won't see any of your Lightroom adjustments.

If you converted your image to black and white in Lightroom, it will appear in its original color form if you open it in, say,

Figure 9-45

Figure 9-46

> **NOTE** *An easy way to push Lightroom instructions onto an image file, or into a sidecar file, is to select the image or images in the Library module and press Command -S.*

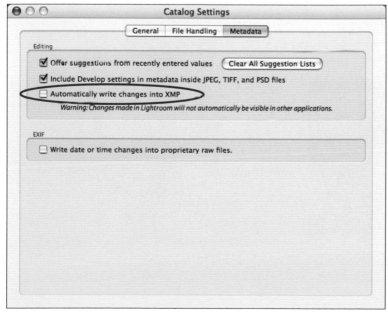

Figure 9-47

other application such as iPhoto, which I have shown here in Figure 9-46. In this case, if you want your image properly viewed, you need to export a copy of the image in a common file format such as JPEG or TIFF, as described earlier in this chapter.

What Is XMP?

To encode the develop instructions, Lightroom uses XMP, which stands for Extensible Metadata Platform, an open standard for embedding information into an image. Although adding XMP metadata to an original image file adds a few kilobytes to the file size, there are reasons not to apply this data indiscriminately. There *is* a downside to applying XMP metadata to an original file. It only takes a brief moment to push this data onto a single image file. However, if you are working with thousands of images, performance speed is affected. There is also the very small, but possible, chance that you may actually corrupt an original image file. Lightroom pushes this data to the original file differently depending on the original file format. RAW files, for example, which generally aren't overwritten, are handled differently from JPEGs, TIFFs, and DNGs, which are. Let's start with RAW files.

XMP metadata to RAW files

Because RAW files from your digital camera are fundamentally untouched, Lightroom instead creates a separate XMP file, often called a *sidecar*, which contains the relevant develop settings and other metadata. By default, Lightroom doesn't automatically generate these XMP sidecars unless you check "Automatically write changes into XMP" in the Catalog Info dialog box, shown in Figure 9-47.

Go to the Metadata tab in the Catalog Info dialog box to find this check box (File→Catalog Settings). You can, if you want, manually tell Lightroom to do this on a case-by-case basis. In the Library module, select your images. Then, from the menu, select Metadata→Save Metadata to File, shown in Figure 9-48. The XMP sidecar files are automatically placed in the same location as the original files. They take up only a few kilobytes of space.

XMP metadata to other files

With PSD, JPEG, and TIFF files, Lightroom writes the XMP develop data directly into the file itself, without the need for a separate sidecar file. (You can view this data if you open your image file in a text editing application, as shown in Figure 9-49. If you want this data automatically updated to your file, select Include Develop settings in metadata inside JPEG, TIFF, and PSD files in the Catalog Settings dialog box (File→Catalog Info/Metadata tab). You can also do this manually in the Library module from the menu bar (Metadata→Save Metadata to File).

XMP metadata to DNG

With a DNG file, Lightroom writes the relevant XMP develop data directly into the file itself, without the need for a separate sidecar file. To have this done automatically, check "Automatically write changes into XMP" in the Catalog Settings preferences dialog box. Or, to do it manually, in the Library module, select Metadata→Update DNG Previews and Metadata from the menu bar, as shown in Figure 9-50, on an image-by-image basis.

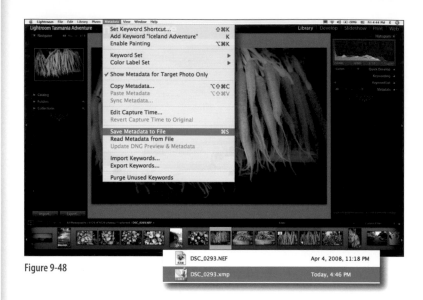

Figure 9-48

Figure 9-49

Figure 9-50

Figure 9-51

Figure 9-52

Figure 9-53

NOTE *If you use earlier versions of Adobe Camera Raw some of Lightroom's Develop adjustments are not read. It's best to update your ACR, which is free from the Adobe site. For the optimal compatibility, upgrade to Photoshop CS3 and ACR v4.5 or higher.*

How do you know you need to update?

There is an easy way to see if the data in Lightroom's database matches the data saved to your original file. Look at the thumbnail shown in Figure 9-51. See the (circled) icon in the upper-right corner? That's what tells you there is a mismatch between the Lightroom database and the XMP metadata attached to the original file.

If you click on the icon, you get the dialog box shown in Figure 9-52. Select Save if you want to update the XMP metadata to the original file.

Import XMP metadata from file

You can also have Lightroom read and apply XMP metadata created by Adobe Bridge or Adobe Camera Raw. Do this manually via the menu bar (Metadata→ Read Metadata from File), shown in Figure 9-53.

What About Informational Metadata?

Up to now, I've been talking about XMP metadata relating to the Lightroom develop instructions. What about other metadata, such as keywords, ratings, and so on? The same holds true for them. You need to push this data onto an original file (or a sidecar file) if you want it to travel with the file outside the Lightroom environment. You can do this on an image-by-image (or selection-by-selection) basis from the Library module menu command Metadata→Save Metadata to File. Or you can set your catalog preferences so it's done automatically to all files and all file types (File→Catalog Settings/Metadata tab, then check Automatically write changes into XMP).

B.Winston Hendrickson

B. Winston, Adobe's senior director of engineering, loves shooting sports, especially his daughter's field sports, of which he has photographed plenty. When Winston heard about an Aussie football semipro match in Devonport, near Cradle Mountain where we were staying, he jumped eagerly at the chance to put his skills to work on a familiar genre. But there was nothing familiar about the Australian sport. It's an amalgam of rugby, soccer, and American football, and the jump ball that B. Winston captured so beautifully in this shot is strangely reminiscent of the jump ball in basketball. It's an exciting, fast-moving sport, and players are allowed to run with the ball or kick it or "handball" it to a fellow player. You've got to see it to believe it, just like almost everything we encountered in Tasmania.

Lightroom Slide Shows

Lightroom is more than an image organizer or image processor. It is a complete environment where you can feel comfortable sharing your images directly with friends or clients. One of the best ways to do this is with a self-running slide show. In this chapter, I'll show you how to use Lightroom's Slideshow module to sequence images, add music and text, and set pacing. I'll highlight the features new to Lightroom 2, such as the ability to add an intro and ending screen. I'll also show you how to export your work as a PDF file and or as sequenced JPEG files ready for use in another slide show application.

Chapter Contents

The Slideshow Module Revealed

Let's start by going over the basics of the Lightroom Slideshow module. Then, in the subsequent section, I'll show you a real-world example that will explain step-by-step how to create a slide show of your own.

Click Slideshow in the Module Picker or use the keyboard shortcut +Option+3 (Ctrl+Alt+3). Images from the Lightroom Library grid viewing area are automatically included in your slide show. New to Lightroom 2 is the ability to select another collection of images from the left panel, the Collections pane, as circled in Figure 10-1. The collections found here mirror the collections found in the Library module. You can also create a slide show from a recently viewed selection without leaving the Slideshow module via the filmstrip pop-up menu; click the arrow icon in the filmstrip toolbar circled at the bottom of Figure 10-1.

You can also make a selection of images in the filmstrip and play only that selection. Do this by making your selection in the filmstrip (circled in Figure 10-2) and then selecting Play→Content→Use Selected Photos from the menu bar. Another option in Lightroom 2 is to play only flagged images. (Choose Play→Content→Use Flagged Photos from the menu bar.) The Lightroom Slideshow module is organized much like the other modules already discussed, and should feel very familiar by now. There is a left and right panel, a viewing area, a toolbar, and the filmstrip.

Figure 10-1

Figure 10-2

NOTE *As you learned in Chapter 1, you can customize the work area by closing panels or by expanding or shrinking the filmstrip.*

Figure 10-3

Figure 10-4

Left Panel of the Slideshow Module

The left panel of Lightroom 2, shown in Figure 10-3, contains the following:

Preview See how your first image will look with overlays but without guidelines or other distractions.

Template Browser Preview one of the existing templates, or one you make yourself, without applying it to all the images by passing your cursor over its name in the Template Browser pane. A preview immediately appears.

Collections Switch to another collection without leaving the Slideshow module by simply selecting the collection in the Collections pane. The new selection appears in the filmstrip, where you can reorder the thumbnails.

Export JPEG/Export PDF New to Lightroom 2 is Export JPEG, which automatically creates a numbered sequence of the slide show images and exports them ready for use in another slide show application. I get into doing this, and using the Export PDF option, later in the chapter.

Main Viewing Area

The main viewing area, shown in Figure 10-4, displays the image, backdrop, guides, and text associated with a specific slide. Control the size of the image in relation to the frame by dragging the guidelines or via the Layout pane in the right panel. Right-click on the canvas outside the slide, as shown, and you get a contextual menu with background choices. These choices impact only the surrounding work area. The slide show backdrop is controlled by the Backdrop pane.

Right Panel of the Slideshow Module

The right panel contains controls for customizing a slide show, as shown in Figure 10-5. New to Lightroom 2 is the Titles pane, which gives you the ability to create an intro and ending screen based on identity plates.

Options pane

The first pane is the Options pane, shown expanded in Figure 10-6. Select Zoom to Fill Frame and the image fills to the guides and crops the image to make it fit, if necessary. (Position the image within the cropped area by dragging it into position.) Select Stroke Border to add a solid border around the perimeter of the image. Control the color of the stroke by clicking on the color patch (circled in Figure 10-6) and choosing from the resulting color picker. Control the thickness of the border with the Width slider. Select Cast Shadow to create a drop shadow that gives your slide depth. Use the sliders to control the opacity, offset, radius, and angle of the drop shadow.

Layout pane

If you select Show Guides, the guides are visible in the screen window, as shown in Figure 10-7. You can control the guides (and thereby the size of the image area) directly from the viewing window by dragging them into position (circled in Figure 10-7). Or you can use the Layout pane sliders. Clicking Link All maintains a constant aspect ratio.

Overlays pane

Add an identity plate to each slide by checking the Identity Plate box as shown in Figure 10-8. You cannot use multiple identity plates at the same time.

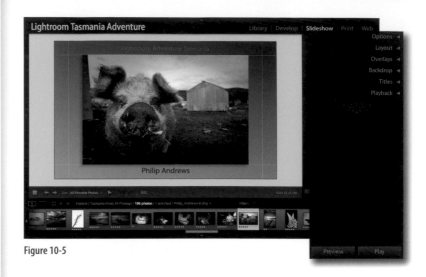

Figure 10-5

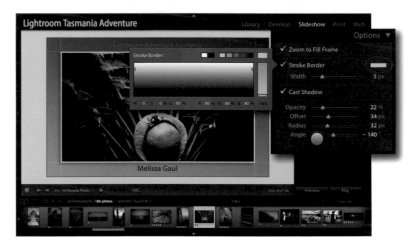

Figure 10-6

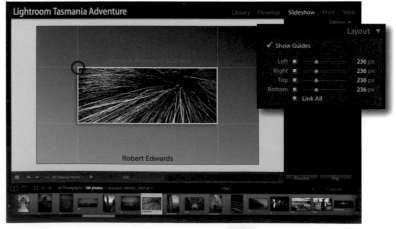

Figure 10-7

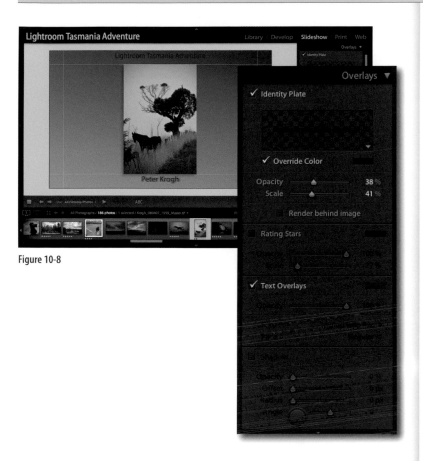

Figure 10-8

(I covered making identity plates in Chapter 1.) Changing identity plates here does not affect your user interface identity plate, it only changes what appears in the slide show. Checking Override Color gives you specific control of the identity plate color via the adjacent color patch. Click on the patch and select a color from the resulting color picker. Control the opacity and scale of the identity plate with the sliders. Checking Render behind image places the identity plate (or part of it) behind the image area.

Checking the Rating Stars box does just that —it adds stars. If an image hasn't been rated, no stars appear. You can control the color of the stars via the adjacent color bar, as well as via the Opacity and Scale sliders. Select the stars in the image window. You can also select Shadow in the Overlays pane (Mac only), controlled by the Opacity, Offset, Radius, and Angle sliders. Check Text Overlays to control any selected text opacity, color (via the color patch), font, and face (style). Text is added via the toolbar, which I cover in a separate section.

Backdrop pane

The Color Wash control lets you create a graduated background that is controlled by the Opacity and Angle sliders. Select a color in the color box. If this color is different from the background color, you'll end up with a multicolor graduated background, as shown in Figure 10-9. For a simple single-color background, select Background Color only and pick a color from the color box.

You can also use an image for a background by checking the Background

NOTE *With the Mac version (but not Windows) you can add drop shadows to the text by selecting the text in the image window and then selecting Shadow in the Overlays pane.*

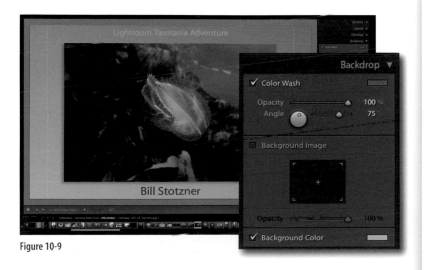

Figure 10-9

Image box, as shown in Figure 10-10. Drag an image from the filmstrip into the box. Control the opacity via the Opacity slider. (Background images don't show up in the intro and ending screens.)

Titles pane

New to Lightroom 2 is the Titles pane, shown in Figure 10-11. Here you can create an intro screen and an ending screen. Basically, you are limited to using an identity plate placed on a color of your choosing. You can't add an image. However, you can use one identity plate for the intro screen and another for the ending screen. You have the same controls over the identity plates as you do in the Overlays pane over color and scale.

Playback pane

In the Playback pane, you can add sound by selecting Soundtrack and then clicking on the arrows next to Library (circled in Figure 10-12). On a Mac, you can choose from your iTunes playlists. In Windows, click on the text that says "Click here to choose a music folder" and select the audio of choice.

Your playback options are very simple. You can control the duration and fades. The only transition is a simple dissolve. Selecting the Color box (circled in Figure 10-12) in Lightroom 2 gives you control over the transition slide color, control I suggest you use judiciously. Checking Random Order does just that: instead of following the selected order, slides display in random order and continue that way until you stop the slide show. If you select Repeat (new to Lightroom 2), the slide show loops continuously. Deselect Repeat, and it stops when all the slides have been shown.

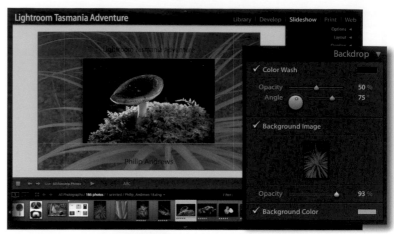

Figure 10-10

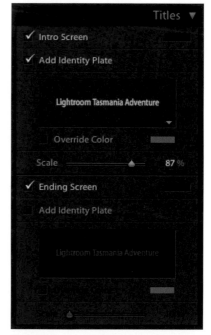

Figure 10-11

Figure 10-12

Figure 10-13

Figure 10-14

Figure 10-15

If you have a second monitor attached, and if you select the number 2 in the upper-left corner of the filmstrip (shown circled in Figure 10-13), you can run a slide show independently, even outside the Slideshow module. As you can see circled in Figure 10-14, Slideshow becomes an option in the second monitor. (It's not an option if you are using the second window within one monitor.)

At the bottom of the window you can choose to run the slide show as programmed in the Slideshow module, or override the Playback pane controls. Click on the word Play in the upper-right corner of the second Window to start the slide show. Hitting the Space bar pauses the slide show, and hitting the Space bar again resumes play. The Esc key stops the slide show and brings you back to the main window.

Preview and Play Buttons

When you are ready, click on Play at the bottom of the right panel, as shown in Figure 10-15. When you do this, your display goes dark and the slide show starts. Each slide fills up the monitor. Stop the show by hitting the Esc key. Clicking Preview starts a preview of the slide show within the Slideshow module, complete with transitions and intro and ending screens, if you have them.

Slideshow Toolbar

The first icon in the Slideshow toolbar is a square (circled in Figure 10-16). When you click it, the first slide is selected. The left and right arrows take you to the previous or next slides, respectively. The pop-up menu next to the word Use gives you your viewing choices: All Filmstrip Photos, Selected Photos, and Flagged Photos. Clicking the triangle starts a preview of the slide show within the Slideshow module, complete with transitions and intro and ending screens, if you have them.

The curved arrows rotate the selected adornment clockwise or counterclockwise (be it a text box, star ratings, or identity plate) but do not rotate the image.

The ABC button is the gateway to some really great features of the Slideshow module. Here you can add custom text and (this is so cool) use metadata to generate captions and overlays. In the next section, I describe how to do this.

Using the Filmstrip to Choose Slides

The filmstrip displays images that can be included in your slide show, as shown in Figure 10-17. Include them all, or make a selection and include only those images. If the images in the filmstrip come from a collection or folder (and not from any of the catalog subpanes or from a Smart Collection), you can change their order. Do this by clicking on the image area of the filmstrip (not the outside border), dragging the thumbnail to its new location, and releasing the mouse.

Figure 10-16

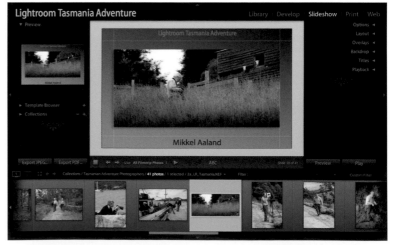

Figure 10-17

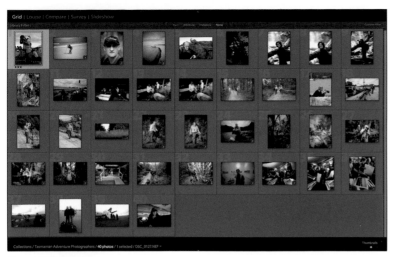

Figure 10-18

Clicking on the 2 in the upper far left of the filmstrip opens a second display. The second display can be used in Grid mode to reorder slides, as shown in Figure 10-18. (Again, you can only reorder slides as long as they don't come from any of the catalog subpanes or from a Smart Collection.)

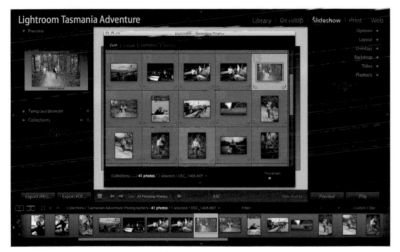

Figure 10-19

If you are using a second monitor, you can also run the slide show separately using the Slideshow mode. If you are not using a second monitor, but only using a second window within a monitor, as shown in Figure 10-19, the Slideshow mode is not an option. In the Slideshow module, you can still access a contextual menu for any image by right-clicking on a thumbnail in the filmstrip or second display.

TIP *While the slide show is previewing or running, you can set or change the image ratings for individual images by using the number keys 1 through 5.*

NOTE *Images do not need to be online for the slide show to work. Lightroom uses whatever preview it can find. If a 1:1 or Standard-size preview has been rendered, the display quality will be excellent. However, if only a thumbnail version exists, the image may appear pixelated when played.*

Katrin Eismann

Katrin captured Tasmania as no one has done before: through a Hobart garbage dump. "Objects tell the story of the people who use them," explains Katrin, who turned her camera to discarded brushes, bathroom scales, tools, paint cans, and as shown here, Ping-Pong paddles. The people of Tasmania love sports—as the well-worn paddles show.

Real World: Creating the Adventure Slide Show

For both the Iceland and Tasmania adventures, the clock was ticking and we had a limited time to put together a slide show for the closing reception. Amazingly, even working with beta versions of Lightroom, we were able to do the job. Here, using Lightroom 2, is a step-by-step procedure that roughly follows what we did in both Tasmania and Iceland.

Starting in the Library Module

Although it's possible to make a selection and arrange the order of images in the Slideshow module, it's a lot easier if you do all that first, in the Library module. Here's what we did after importing a selection of photos (1600 × 1200 pixels each) from the Adventure photographers:

1. We created a collection in the Library module and named it Tasmania Slideshow, as shown in Figure 10-20.

Figure 10-20

2. We dragged and dropped the thumbnails into order. Do this by placing your cursor over the image area of the thumbnail, clicking, then dragging the image into position. A dark line appears between the two existing images, as shown in Figure 10-21. Release the cursor and the image settles in place. Note that you can't sort if you select any of the subpanes in the Catalog pane. You need to be in a folder or collection. You can also sort a folder or collection (but not a Smart Collection) from the filmstrip or in the second window set to Grid mode. After custom sorting, the sort criteria in the toolbar revert to User Order.

Figure 10-21

3. We checked to make sure the Creator field in the Metadata pane (circled in Figure 10-22) was filled in correctly with the photographer's name. (Most of the photographers submitted their work with this field filled in, making our job easier.)

Figure 10-22

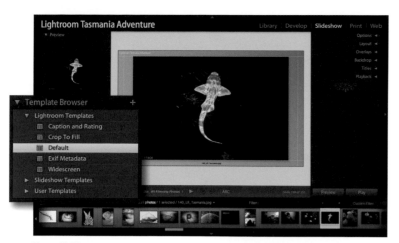

Figure 10-23

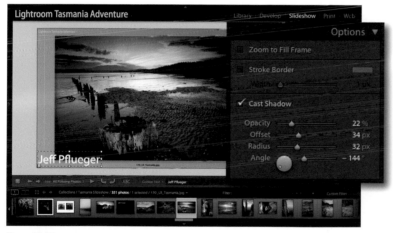

Figure 10-24

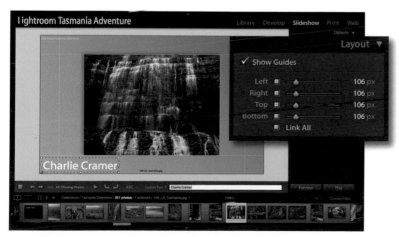

Figure 10-25

Switch to the Slideshow Module

Next, we switched to the Slideshow module. We started with the default template (called Default) shown in Figure 10-23. But then we customized it. (The original Iceland and Tasmania settings were different, but for the sake of simplicity I'll describe them as if they were the same.) The default template contained text boxes based on identity plate and file name. We deleted the file name box by selecting it and choosing delete. We made a custom text box, one based on the Creator field. (I'll show you how to do this in detail in the next section.) We left positioning of the caption and identity plate until last.

Choosing the Righthand Panel Settings

Here are our custom settings for the various panes in the right panel:

Options

These settings, shown in Figure 10-24, gave our slides a hint of depth:

- Cast Shadow: checked

- Opacity: 22%

- Offset: 34 px

- Radius: 32 px

- Angle: −144 degrees

Layout

These layout settings, shown in Figure 10-25, gave us enough room for our captions and framed our images nicely:

- Show Guides: checked

- All sliders: 106 px

Overlays

At first, we tried using a graphic identity plate, shown in Figure 10-26. But it wasn't readable, so we switched to a textual one.

There are a couple of ways to bring up the Identity Plate Editor. In the main viewing window, double-click on the Identity Plate text box. From the Overlays pane, with Identity Plate selected, click on the box and select Edit from the contextual menu, as shown in Figure 10-27.

In the Overlays pane, shown in Figure 10-28, our identity plate settings are as follows:

- Override Color: checked

- Opacity: 38%

- Scale: 41%

We didn't select Rating Stars, shown in Figure 10-29. We were showing our work in a party environment as entertainment, and not to clients who might have found ratings useful.

We selected Text Overlays, shown in Figure 10-30, and used the following settings:

- Font: Myriad Web Pro, which is very readable

- Face: Regular

We didn't add a drop shadow to the text.

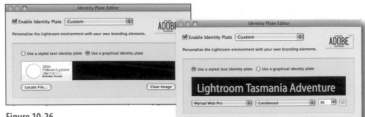

Figure 10-26

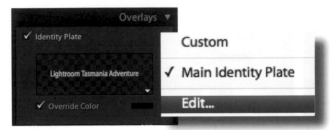

Figure 10-27

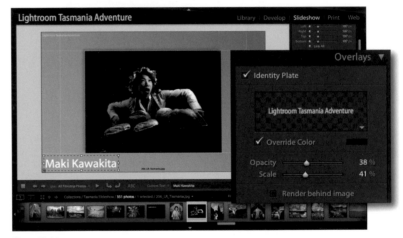

Figure 10-28

Figure 10-29

Figure 10-30

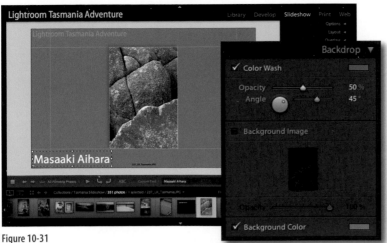

Figure 10-31

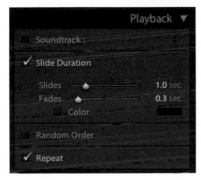

Figure 10-32

NOTE: *After we created the slide show and hit the Play button, the elegant Lightroom interface went away and our images were revealed in all their glory, one by one, as shown in Figure 10-33.*

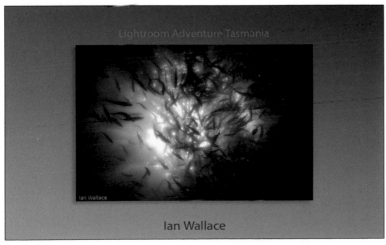

Figure 10-33

Backdrop

We created a backdrop with a slight color wash and a neutral gray color. Our settings, shown in Figure 10-31, were:

- Color Wash: checked
- Opacity: 50%
- Angle: 45 Degrees
- Background Image: deselected
- Background Color: selected

Titles

We didn't use the Titles option to create an intro and ending screen for either slide show. In Tasmania, Katrin created title screens in Photoshop for each photographer with their name and country and imported the screens into Lightroom.

Playback

In the Playback pane, shown in Figure 10-32, for the Iceland Adventure, we opted to use a classic Icelandic soundtrack. In Tasmania we didn't use any soundtrack. We set our slide duration as follows:

- Slides: 1.0 sec
- Fades: 0.3 sec

In Lightroom 1, the slide show repeated by default, which was fine for our purposes in Iceland. In Tasmania, to make a slide show repeat, we needed to make sure the Repeat option was selected.

As a final step, we sized and arranged our text boxes directly from the main viewing area. I show you how to do this in the next section.

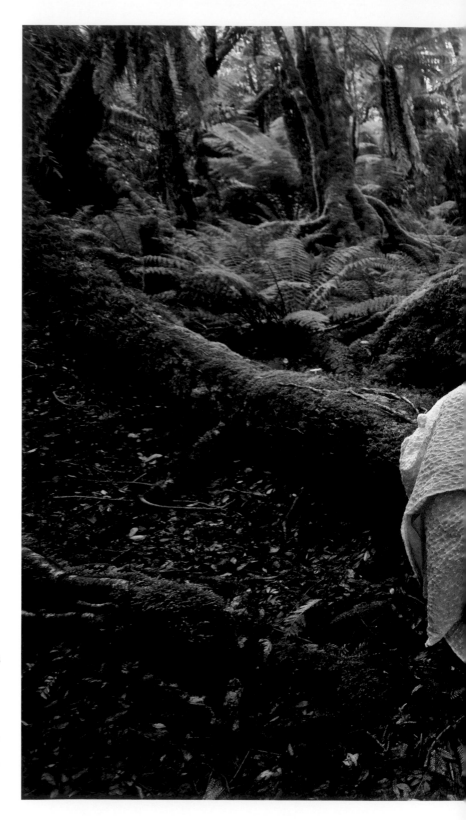

Peter Krogh took this photo of fellow adventurer Maki Kawakita in a rain forest on the east coast of Tasmania. Throughout the Adventure, Maki worked on a series she calls "Makirama," where she put herself in dreamlike situations and made self-portraits. The moss-covered trees and lush undergrowth were perfect for a Sleeping Beauty scene. Peter acted as Maki's assistant for the photo, triggering her camera on command. After each series, Maki examined the results. Maki is shown here in her dual role as photographer and subject.

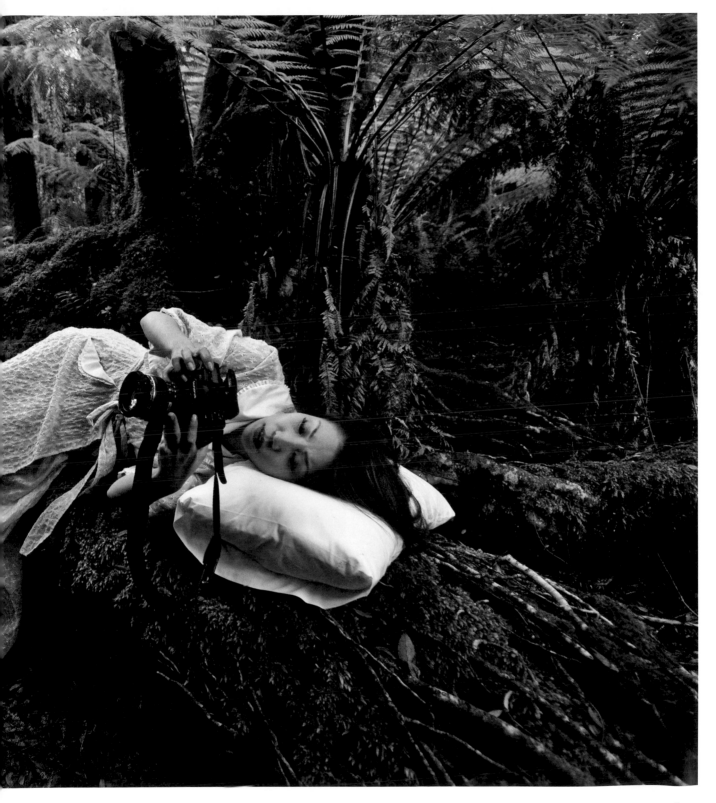

Peter Krogh

Using Metadata and Custom Text for Slide Show Captions

Possibly the single most compelling feature of the Lightroom Slideshow module is the ability to turn metadata associated with an individual image into a slide caption that is totally sizeable and positionable. You can also add custom text that applies as a global caption to all the slides. Here's how.

To create custom text that will appear the same on every slide, click on the ABC icon in the toolbar (circled in Figure 10-34) and in the resulting Custom Text text box, start typing. When you are done, press the Return (Mac) or Enter (Win) key. The text appears in the work area in a bounding box where it can be resized or repositioned.

To use metadata as a slide caption for a specific image, use the presets that appear in the pop-up menu when you click on the up and down arrows next to the text box, as shown in Figure 10-35. If none of these presets are appropriate, select Edit. This opens the Text Template Editor, where you'll have many more options.

Using the Text Template Editor

In the Text Template Editor, shown in Figure 10-36, you can create a new preset that will appear next time you click on the triangle next to the toolbar text box. To create one using the IPTC Creator field, for example, go to the IPTC Data section of the dialog box and choose Creator from the first pop-up menu (circled, bottom), then click Insert. An example appears at the top of the dialog box (circled, top). To save your new preset, select Save Current Settings as New Preset from the Preset pop-up menu, name your Preset and select Create, then click Done.

Figure 10-34

Figure 10-35

Figure 10-36

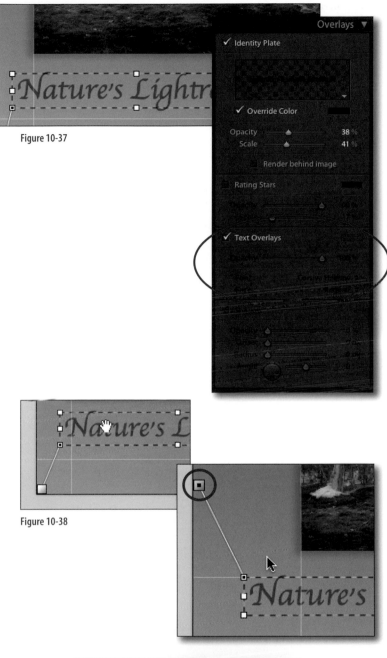

Figure 10-37

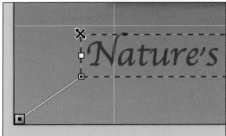

Figure 10-38

Figure 10-39

Adding Multiple Captions

You can add as many text boxes as you want. To add multiple text boxes, click the ABC icon in the toolbar. Make your selection from the pop-up menu, or type in text and hit the Return key. Then, click the ABC again to create another text box.

Working with Text

You can go back at any time and edit, resize, or change the properties of a text box. To change the color or font properties, click on the bounding box containing the text. Go to the Overlays pane in the right panel. The Text Overlays section is automatically selected; make your changes here (circled in Figure 10-37). You can't have different fonts and colors within the same bounding box, but you can change text properties on each box.

Moving and scaling text

Move the bounding box by dragging the box from within. As you do this, the box tethers itself to points on the image's border. The text will now float next to an image or within an image at a consistent distance from the border, regardless of the size or orientation of the image, as shown circled in Figure 10-38. (You can also move the bounding box.) Scale the text by dragging the corners to the desired size, as shown in Figure 10-39.

Changing and deleting text

To delete a text box, click on it in the image view window, then hit the Delete key. To change custom text, select the text box, then change the text in the toolbar's Custom Text box. (To change text based on metadata, go to the Library module and re-enter the text in the Metadata pane.)

Exporting to a PDF Slide Show

If you want to share your slide show outside the Lightroom environment, you have only one ready-to-use choice at this time: saving it as a PDF slide show. I show you how to do this here. (In the next section, I show you how to export a batch of JPEGs that can be used in a more robust presentation application.)

After you're finished making your slide show, select Export PDF from the left pane, as shown circled in Figure 10-40, or from the menu bar (Slideshow→Export PDF Slideshow).

NOTE *Obviously, the PDF slide show has limited capabilities, especially when it comes to transitions. Consider creating a Flash-based "slide show" in Lightroom's Web module. You can share your slide show via the Web with smooth transitions (but not sound), or burn the files to a disc and share it that way.*

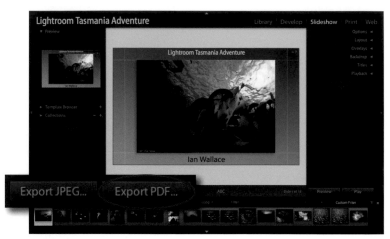

Figure 10-40

After you do this, you will get the dialog box shown here in Figure 10-41.

Your only options are JPEG quality and image size. If you select Automatically show full screen, the slide show is played automatically at the full-screen size.

Note this text in the dialog box: "Adobe Acrobat transitions use a fixed speed." This means that any speed or transitions you set in Lightroom are ignored. Also, any music you added to your slide show is not exported.

For someone to view your PDF slide show, they need Adobe Acrobat Reader (which is free) or Adobe Acrobat (which is not).

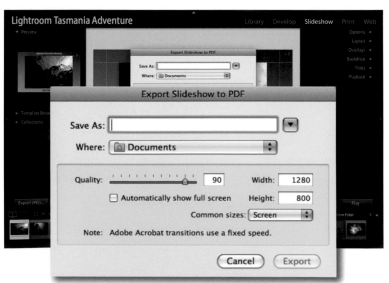

Figure 10-41

The ability to save Lightroom slide shows easily in the Quicktime or Flash format seems, alas, destined for future versions. However, new to Lightroom 2 is the ability to easily export a sequence of JPEGs, which can be then used in other presentation applications with more capabilities.

Exporting JPEGs

Before exporting your slide show as JPEGs:

1. Order your slides in the Library module, or in the Slideshow module's filmstrip. You can also order them in the second window display, in the Grid mode. (Open up the second window display by clicking on the number 2 in the upper-left side of the filmstrip.)

2. In the Slideshow module Options pane (right panel), select or deselect Zoom to Fill Frame as desired.

3. In the Overlays pane, select any information you want to present on the images. Exporting JPEGs will maintain the text as long as it lies within the image area. (Don't bother adding an intro or ending screen in the Titles pane. They won't be exported.)

Figure 10-42

4. When you are finished, click on the Export JPEG button at the bottom of the left panel, as shown circled in Figure 10-42.

5. In the resulting dialog box, shown in Figure 10-43, give your export a name. Lightroom will automatically add that name to every file, and add a number corresponding to the order of the slide as part of the file name as well. Choose from the various size options or create your own custom size.

Now you are ready to use your images in any slide show application you want.

Figure 10-43

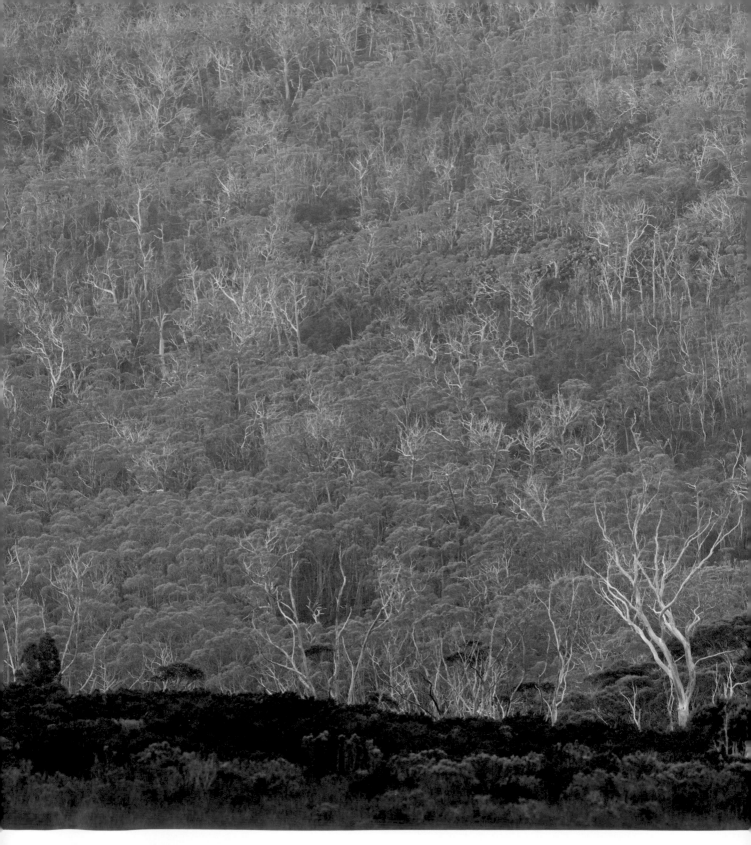

Charlie Cramer

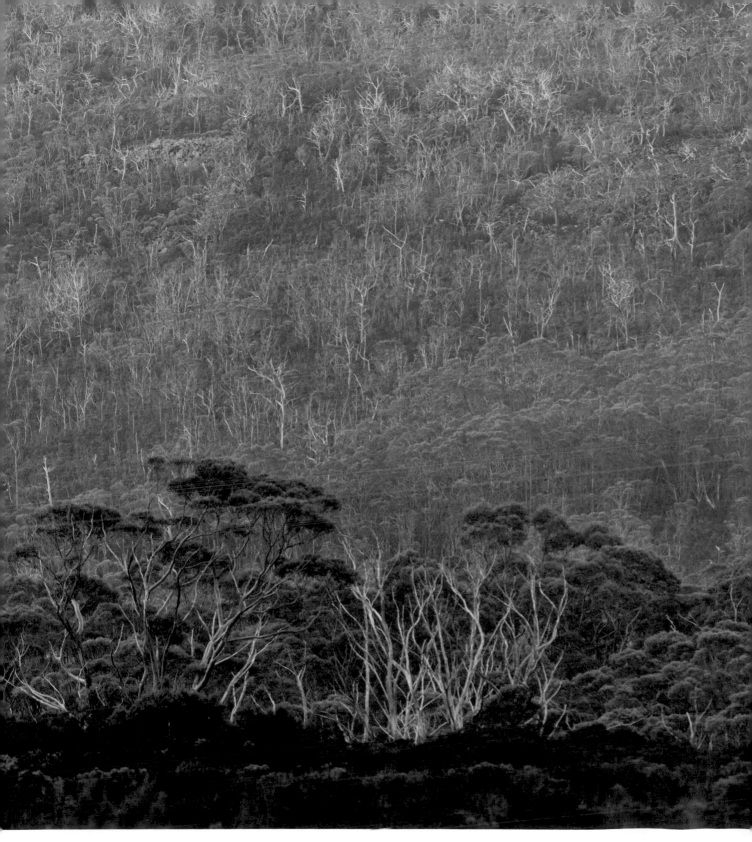

Charlie is a renowned landscape photographer who shoots mostly North American subjects. Tasmania far exceeded Charlie's expectations. On dull, overcast days like the one shown here in Mount Field National Park, Charlie became like a kid in a candy store, since it's his favorite kind of light. The flat light meant that Charlie had more control over the final image, allowing him to selectively paint the light himself, subtly lightening areas he wants to highlight.

Power Printing

At some point in your digital photography workflow, you'll probably want to make a print. With Lightroom's Print module, you are not limited to sending one image at a time to your printer, or one image per page. With a click of the print button you can send an entire collection to the printer with a variety of page configurations. Ready-to-use presets turn your selected images into a variety of sizes, including contact sheet size. You can also create your own custom presets. It's easy to add custom text—or text based on image metadata—to the image border, or place an identity plate anywhere, at any size, on a page. This chapter shows you how to do all of the above, as well as how to use Lightroom 2's awesome new Picture Package layout engine, which was used to create the photo spread shown on the adjacent page.

Chapter Contents

11

The Print Module Revealed

Before you jump in and start printing, let's take the Print module apart and see what it offers. Then, in subsequent sections, I'll show you how to use the new Picture Package layout engine, print single or multiple images, change page layout, add text, and print to file as a JPEG or directly to paper. I'll finish up with a section on color management.

Shown in Figure 11-1 is the full Print module, with left and right panels, workspace, toolbar, and filmstrip visible. You can customize the work area by closing panels or resizing the filmstrip.

Preview Pane

In the Preview pane, found at the top of the left panel and shown enlarged in Figure 11-1, you can view preset page layouts from the Template Browser. Just place your cursor over a template name, and it appears in the preview window. No images appear, just an outline of the selected layout. If you are creating Picture Packages, new Picture Package cells appear as they are added.

Figure 11-1

Template Browser Pane

In the Template Browser pane, Figure 11-2, you can either select page layouts or preview them in the preview window. You can also create custom templates by clicking the plus sign in the Templates Browser pane. To remove User Templates, right-click on the name and select Delete from the pop-up menu. To update a user template to your current settings, right-click on the name and choose Update with Current Settings from the pop-up menu. (You can't do this with Lightroom templates. Instead, you create a new template based on the Lightroom preset by selecting Print→New Template from the menu bar.)

Figure 11-2

Figure 11-3

Figure 11-4

Collections Pane

In Lightroom 2, the Collections pane mirrors the Library module Collections pane, so you can move within collections without leaving the Print module.

Page Setup/Print Settings

Click on Page Setup to set the page attributes for your print job. If you click Print Settings, a dialog box appears that is specific to your operating system and printer. Figure 11-3 shows the Print dialog box for my Mac and an Epson 3800 printer. Here you can set quality and other controls. (Clicking the Print button in the right panel brings up similar controls specific to your computer.) In theory, if you create a custom Lightroom user template after entering these values, you don't need to enter them again, as long as you use that particular user template. However, on a Mac, if you select any preset in the Print dialog box other than Standard, the other settings don't "stick" when you go to print again. This is a Mac issue, and it can be very frustrating if you aren't aware of it.

Display Work Area

The display work area consists of the image layout, the info overlay, and the rulers, grid, and guides. (Figure 11-4 shows the display area with a contact sheet.) You can control the visibility of the info overlay, rulers, grid, and guides from the View menu bar or keyboard commands (circled); or, if you are using the Contact Sheet/Grid layout engine, from the Guides pane in the right panel; or, if you are using the Picture Package engine, from the Rulers, Grid & Guides pane.

Layout Engine Pane

Let's move to the right panel. In Lightroom 2, the Layout Engine pane shows which engine you are using: Contact Sheet/Grid, or Picture Package. The two layout engines function differently—for example, Picture Package, shown in Figure 11-5, offers independently sizable and movable cells, and Contact Sheet/Grid, shown in Figure 11-6, lets you place different images on the same page and add text based on EXIF data. When you select one or the other engine, subsequent panes change to reflect the appropriate controls.

Figure 11-5

Figure 11-6

Image Settings Pane
(Both Layout Engines)

The Image Settings pane contains slightly different options depending on which engine you are using. Figure 11-7 shows both panes. As you can see, both panes provide options for Zoom to Fill and Rotate to Fit, and a controllable colored photo border, which applies to all image cells. When you are using the Contact Sheet/Grid engine you have the option to Repeat One Photo per Page, which duplicates the same image in all the cells.

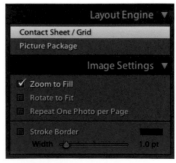

Figure 11-7

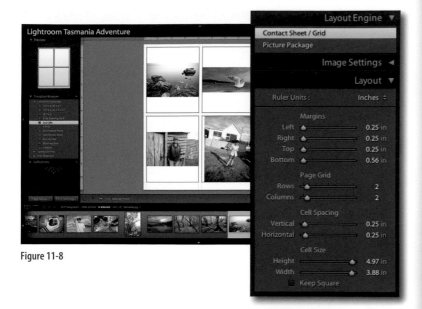

Figure 11-8

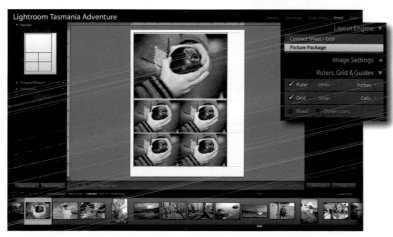

Figure 11-9

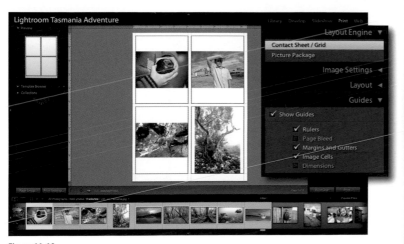

Figure 11-10

Layout Pane (Contact Sheet/Grid)

In the Layout pane that appears when you work with the Contact Sheet/Grid engine, shown in Figure 11-8, you can customize the page layout or simply observe a selected template's settings. Use the Margins sliders to size the individual cells. Use Page Grid to determine how many cells in each row and column. Use Cell Spacing to determine the distance between cells. Use Cell Size to determine the size of the cells. (The size of each cell is determined by the total amount of cells and page size.) Check Keep Square if you want proportionally sized cells.

Rulers, Grid & Guides Pane (Picture Package)

If you are using the Picture Package layout engine, you see a pane that controls the rulers, grid, and guides of the display area, as shown in Figure 11-9. Here you can set the units (inches, centimeters, and so on) and set how cells respond when you move them around the display area. You can have them snap to nearby cells, or to a grid line, or not snap at all. Select Dimensions, and the cell size appears next to a cell. If you select Bleed, an outline of the printable area is shown, which is printer-dependent.

Guides Pane (Contact Sheet/Grid)

If you are using the Contact Sheet/Grid layout engine, you see a Guides pane that controls the visibility of the rulers, page bleed, margin and gutters, image cells, and dimensions of the display area, as shown in Figure 11-10. These same controls are found under View in the menu bar.

Cells Pane (Picture Package)

If you are using the Picture Package layout engine, you see a Cells pane, as shown in Figure 11-11. This is where you can add, subtract, and control the size of the picture cells. Under Add to Package are six buttons with a variety of cell sizes. Clicking on a button adds that cell size to your layout. Although each button creates one cell size, you can change the size by clicking on the triangle in the button and selecting another size from the pop-up menu. If you select Edit, you can create a custom size of your own. Select New Page to create a new blank Picture Package page. You can have up to six pages. Auto layout corrects for overlapping cells and attempts to optimize the distribution of cells for maximum coverage of a page. Clear Page does just that, clears a selected page of cells. You can adjust a selected cells size with the Height and Width sliders found under Adjust Selected Cell. (You can also adjust a cell by physically moving the bounding box edges in the display area.) If you have selected Zoom to Fill in the Image Settings pane, you can move an image around within the cell by holding Option/Ctrl and dragging.

Figure 11-11

Overlays Pane (Both Layout Engines)

The Overlays pane contains slightly different options depending on which engine you are using. In the Overlays pane that appears when you are working with the Contact Sheet/Grid layout engine, shown in Figure 11-12, you control which text and other options (such as page numbers, page info, and crop marks) are printed along with the images. The text can be based either on a identity plate or image metadata.

Figure 11-12

Figure 11-13

Figure 11-14

Custom text is also possible. For text based on metadata, the font sizes are limited, and you can't choose a different font. Larger sizes and different fonts are possible only if you use a custom identity plate.

In the Overlays pane that appears when you are working with the Picture Package layout engine, shown in Figure 11-13, you control the identity plate, as described earlier, and you choose how you want your cut guides to appear in the pop-up menu, as crop marks or lines.

Print Job Pane

Print Job is where you specify whether to print to a printer or to a JPEG file, as circled in Figure 11-14. Options vary depending on your choice. If you choose Print to Printer, you have control over the print resolution, color management, and sharpening, as shown in Figure 11-14. If you check Draft Mode Printing, you can quickly print a screen resolution version of your image. If you leave Print Resolution unchecked, Lightroom uses only the original number of pixels in your image file and does not interpolate. This means that the actual print resolution will differ depending on the print size and the original file size.

Print resolution

With Print Resolution checked, Lightroom uses 240 ppi as the default print resolution, but you can type in higher or lower values between 72 and 480 ppi if you want. For many desktop printers, using values higher than 240 ppi doesn't significantly increase quality, but it does increase printing time.

Print sharpening

There are only three sharpening settings: Low, Standard, and High, as shown in Figure 11-15. You can also choose between Matte and Glossy paper settings with the pop-up menu next to Media Type. However, it's not as simplistic as it sounds. The amount of sharpening is smartly applied relative to the size of the image, which is what you want. Lightroom 2 applies even more sophisticated sharpening behind the scene than earlier versions. Even so, Adobe sums up what to do nicely:

"Sharpening is often a matter of personal taste. Experiment to see what amount produces the results you like. As a starting point, use Low or Medium for prints that are 8.5 × 11 inches and smaller, and use High for prints that are 13 × 19 inches or larger."

16-bit printing (Mac only)

For Mac users using system 10.5 (Leopard) or higher along with a supported printer, you can choose to print your files using16 bits per channel, as circled in Figure 11-16, and theoretically produce a wider gamut of color. The trade-off is speed. It takes much longer to print 16-bit files. Otherwise Lightroom uses 8-bit printing, which is widely supported and perfectly adequate for most color images.

Figure 11-15

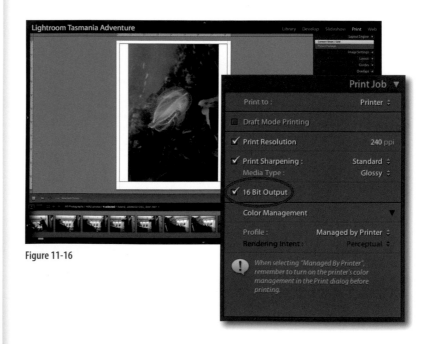

Figure 11-16

Figure 11-17

Figure 11-18

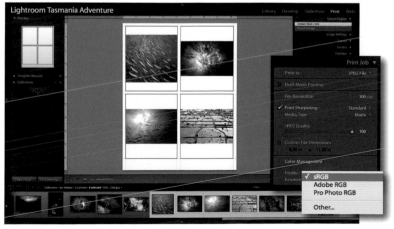

Figure 11-19

Color management

You can choose to have color managed by your printer or by a custom profile, as shown in Figure 11-17.

Choosing between Perceptual and Relative Rendering Intent (shown in Figure 11-18) also gives you control over how your color is managed. I go into more detail on color management later in this chapter.

Print to JPEG

If you choose Print to JPEG you still have the Draft mode, Resolution, Sharpening, and Rendering Intent options, but you also have a choice of JPEG Quality (higher values equal better quality and larger file sizes), Custom File sizes, and Profile. Under Profile you can choose from sRGB, Adobe RGB, and Pro Photo RGB, as well as others, as shown in Figure 11-19. (Choose the profile based on the final destination for your file. For example, if you are sending your files to a service bureau for printing, it might be wise for you to ask them which profile they prefer.)

Print One and Print Buttons

At the bottom of the right pane are the Print One and Print buttons, as shown in Figure 11-20. If you selected Print to JPEG in the Print Job pane, the only choice is Print to File. Select Print One, and Lightroom bypasses the Print dialog box, using the last print settings or the ones set in the user preset. Select Print, and the Print dialog box specific to your operating system and printer appears, with options such as paper quality, color management, and so on. Selecting Print to File, which appears when you select Print to JPEG in the Print Job pane, brings up a Save File dialog box where you can pick a destination for the JPEG files.

Figure 11-20

Print Module Toolbar

The toolbar at the bottom of the display work area, shown in Figure 11-21, has only a few controls that are mostly relevant if you are printing more than one page. The square icon brings you to the first image, and the arrows take you back and forth between pages. (You can also select images to view from the filmstrip.) If you have more than one page, it is also noted in the toolbar (circled). Next to the word Use is a pop-up menu that gives you three selection choices: All Filmstrip Photos, Selected Photos, and Flagged Photos. Pay attention to what is selected. If All Filmstrip Photos is selected, for example, all the photos in the filmstrip are printed, even if you have only selected one.

Figure 11-21

Filmstrip in the Print Module

The Print module filmstrip, shown in Figure 11-22, can be very helpful. Here you select and deselect images to print.

Figure 11-22

Figure 11-23

Figure 11-24

Figure 11-25

You can also, if you want, apply develop presets without leaving the print module by right-clicking on an image and selecting a preset from the contextual menu, as shown in Figure 11-23. (The contextual menu, of course, provides many more options that can be applied to your images without leaving the Print module.)

If the images you want to print aren't showing in the filmstrip, use the pop-up menu (circled in Figure 11-24) and display your entire library of images or a previously viewed collection. You can also navigate to another collection via the Collections pane in the left panel.

Lightroom Sampling

Lightroom automatically samples images up or down to fit a specified print size. (If you leave the resolution box in the Print Job pane unchecked, Lightroom doesn't sample at all.) You don't need to open up an Image Size dialog box and enter dimensions and resampling method as you do in Photoshop, as shown in Figure 11-25. Is this a "convenience" at the cost of quality? As I explain in Chapter 9, Lightroom samples in linear space and—with technical explanations aside—this is a good thing. Obviously, if you radically enlarge a low-resolution image, quality suffers, but no less so than if you use Photoshop.

Using Picture Package

New to Lightroom 2 is Picture Package, a very useful addition that makes it possible to create custom layouts with one photo on up to six pages. (The opening chapter illustration on page 296 was created using Picture Package.) Not only can you now include a variety of sizes on a single page, you can also create custom presets and custom layouts.

The key to the new Picture Package engine is resizable, movable cells, such as the one circled in Figure 11-26. A single page can contain one cell, or many. You can duplicate cells or create new cells from the Cells pane, found in the right panel when Picture Package is selected in the Layout Engine pane. Resize individual cells via the bounding box, or via the Cells pane. Cells with these properties are available only in the Picture Package layout engine, and not in the Contact Sheet/Grid engine. You can tell which engine you are using by looking at the Layout Engine pane at the top of the right panel.

Figure 11-26

Picture Package works with one image at a time and presents that image in a variety of cells, laid out in up to six pages, as shown in Figure 11-27. After you have created a package, you can apply the package to as many images as you want.

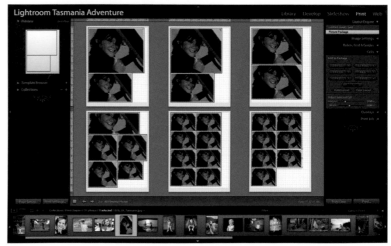

Figure 11-27

Resizing and Customizing Cells

Resize any cell by placing your cursor on the edge or corner of a selected cell, then dragging it, as shown circled in Figure 11-28.

Figure 11-28

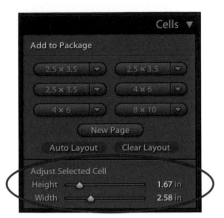

Figure 11-29

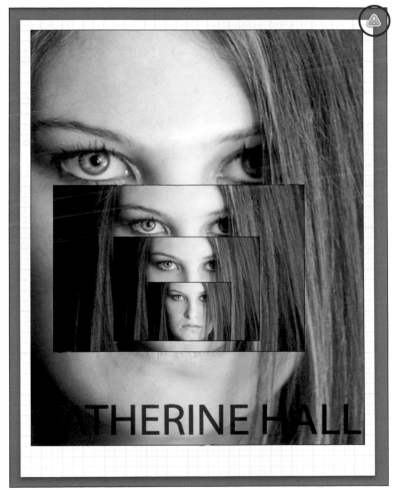

Figure 11-30

Or you can select a cell and use the Height and Width sliders found in the Cells panel (circled in Figure 11-29) to resize. Only one cell can be selected and resized at a time. Right-click on a cell to bring up a contextual menu with Rotate and Delete options.

Moving Cells

To move a Picture Package cell, select it, then drag it to a new location. Use the grid for precise placement. Control the way the cell moves on the grid via the Rulers, Grid & Guides pane, where you can also set the ruler unit of measurement.

Copying Cells

To copy a cell, select it, hold the Option/Alt key, then drag. You can select and copy only one cell at a time. Don't bothering trying the typical copy and paste commands, because they don't work.

Stacking Cells

You can position Picture Package cells on top of each other, which can be used for creative effect, as I have done in Figure 11-30 with one of Catherine Hall's photos of a model in Tasmania. When cells overlap, a warning symbol appears in the upper-right corner of the display window, as circled in the figure. If you see this warning symbol and don't want cells to overlap, go to the Cells pane and select Auto Layout. Lightroom automatically redistributes the images—adding new pages if needed—so they don't overlap.

Positioning Image Within Cell

To position an image whose boundaries extend beyond the cell walls, hold the Command/Ctrl key and drag within the cell. (This is relevant only if you have selected Zoom to Fill in the Image Settings pane.) If you have multiple cells on a page, all nonfull images within other cells respond to the movement.

Zoom Page

If you create several Picture Package pages (you can create up to six), the pages might appear quite small in the display area, as shown in Figure 11-31.

If you select Zoom Page in the Preview pane in the upper-left panel, circled in Figure 11-32, the page containing a selected cell enlarges to fill the display area. Click on Zoom Page again and all the pages appear in the display area. (Clicking on the red X that appears in the upper-left corner of a selected page deletes that page.)

Using an Identity Plate

Select Identity Plate from the Overlays pane, as shown in Figure 11-33, and you can add an identify plate to the first page of a Picture Package. Or, if you select Render on every image, you can add an identity plate to all cells on all pages. The identity plate on the first page is movable and sizable. The other identity plates are sizable, but not movable. They are positioned in the center of all the cells. You can use the opacity slider to create a faint but visible watermarklike effect to protect your images from unauthorized

Figure 11-31

Figure 11-32

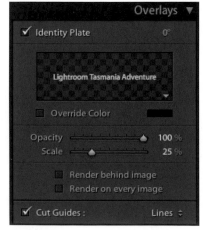

Figure 11-33

Figure 11-34

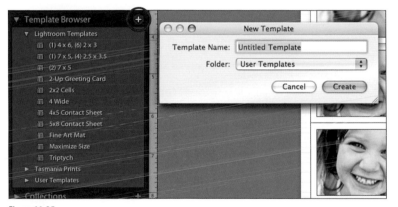

Figure 11-35

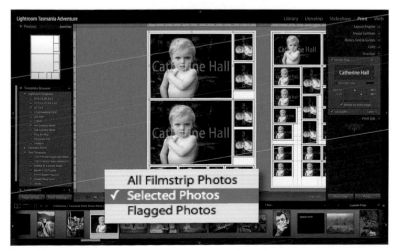

Figure 11-36

use, as shown in Figure 11-34. Control the size with the Scale slider and select Override Color to control color via the color picker box to the right.

Adding Text to Picture Package

Other than what you can add with an identity plate, you can't add text to Picture Packages. (You can add text based on EXIF data to pages created using the Contact Sheet/Grid layout engine. More on this later in the chapter.)

Creating a Custom Picture Package

After you have created a Picture Package that you like, you can turn it into a template that you can apply to other images at any time. To do this, simply click on the plus sign in the Template Browser pane (circled in Figure 11-35). In the resulting dialog box, give your template a name, and locate it in a specific folder, if you want.

When You Are Finished

A Picture Package can be sent to a printer to be printed, or sent as a JPEG and shared as a file. These choices are made in the Print Job pane in the right panel. Before you proceed, be sure to check in the toolbar and see that you have selected the Use choice properly, as shown in Figure 11-36. If All Filmstrip Photos is selected you may inadvertently end up printing all the images in the filmstrip when you only want one selected photo. (I've done this a couple of times; that's why I'm harping on this.)

Selecting and Printing a Single Full-Page Image

OK, now let's turn to the Contact Sheet/Grid layout engine and look at a simple procedure: selecting and printing a single, full-page image with no text. In the following sections, we build complexity by adding text and then learn to print multiple images on the same page or on multiple pages.

Start by clicking an image to select it, as shown in Figure 11-37. You can do this in the Library module, or, if the image is visible, in the Print module filmstrip. You can also use the Collections pane in the Print module to navigate to image collections. To get to the Print module from any other module, click on Print in the module picker. The keyboard shortcut is ⌘+Option+4 (Ctrl+Alt+4).

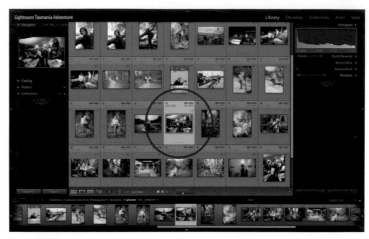

Figure 11-37

Select the Maximize Size Template

In the Print module, select the Maximize Size template from the Template Browser pane as shown in Figure 11-38. A preview of the template appears in the Preview window. (Later, I'll show you how to modify existing templates and make your own.)

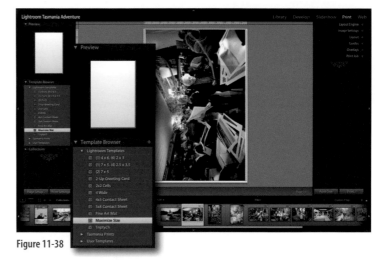

Figure 11-38

Set Page Setup

Select Page Setup from the bottom of the left panel, or from the File menu (File→Page Setup). In the resulting dialog box (which is different for Windows and Mac), select the appropriate printer and page size, as shown in Figure 11-39. The template automatically scales the image to fit. You should see something that

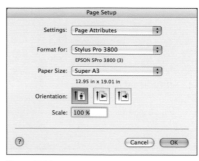

Figure 11-39

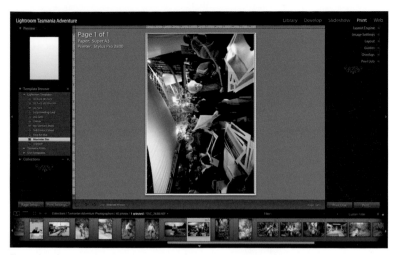

Figure 11-40

looks like what's shown in Figure 11-40. To display the page-related information directly on the work area canvas (circled), select View→Show Info Overlay from the menu bar, or hit the I key. To show the rulers on the sides, select View→Show Rulers, or ⌘+R (Ctrl+R).

Zoom to Fill Frame

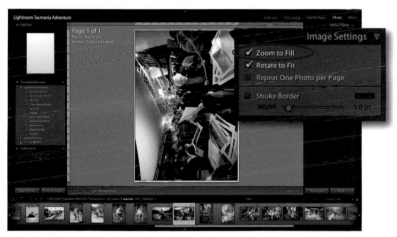

Figure 11-41

If you select Zoom to Fill Frame in the Image Settings pane, circled in Figure 11-41, you'll get even more out of a sheet of paper. The image, however, might be cropped to maximize coverage. Option/ Alt and drag to position the image within a frame.

Add a Border

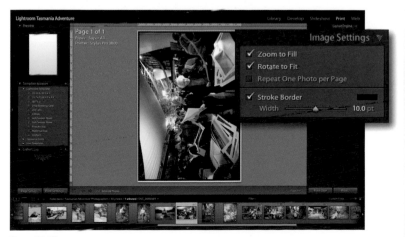

Figure 11-42

Add a simple color border by selecting Stroke Border from the Image Settings pane. The width is determined by the slider, and the color is determined by the color box. The image shown in Figure 11-42 was created with a 10 pt black border.

Modify the Size

We started with the Maximum Size template, which automatically attempts to fill the page. You can manually adjust the image to a different size or position if you want. Do this via the Layout pane, as shown in Figure 11-43, or by hand, using the guides in the image work area. Place your cursor over one of the guides and drag up or down (circled). As you do this, you can see the sliders move correspondingly in the Layout pane.

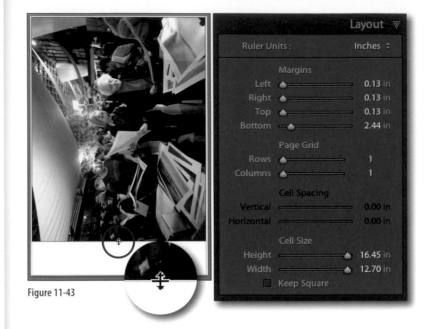

Figure 11-43

Final Settings (Almost)

You are almost ready to print. Make your final settings in the Print Job pane, as shown in Figure 11-44.

Draft Mode Printing Select this only if you want a very quick, screen-resolution-quality image. Lightroom uses cached photo previews. All other print options are dimmed when you choose this option.

Print Resolution In the Print Job pane, check Print Resolution and select a print resolution. The default setting, 240 ppi, works well for most desktop printers. (Generally, the larger the ppi value, the longer it takes to print.) If you leave Print Resolution unchecked, Lightroom doesn't resample the image, and the ppi is determined by the original number of pixels in the image and the print size.

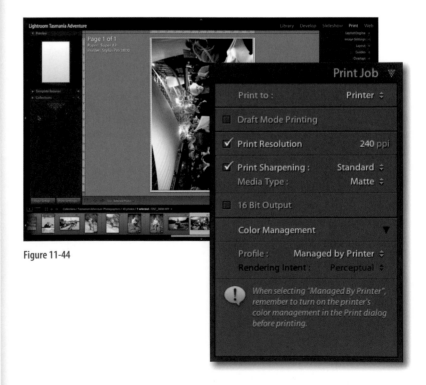

Figure 11-44

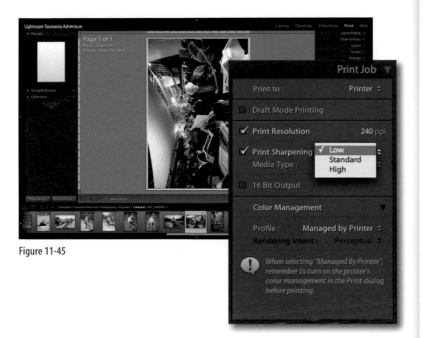

Figure 11-45

Figure 11-46

NOTE *When you are finished, I suggest you make a custom template. Do this by selecting the plus sign from the Template Browser pane. "Untitled..." appears in the New Template dialog box. You can rename the template later by double-clicking on it in the Template Browser and typing in a new name. All your print settings will be saved, including the ones you entered in the Print dialog box.*

Print Sharpening Choose Low if you are satisfied with the Detail settings you set in the Develop module, as shown in Figure 11-45. The other two settings amplify the existing sharpening based on the selected print size and ppi. Many variables determine the correct sharpening setting, including type of printer, type of paper, type of ink, and type of image. The best thing to do is experiment.

Color Management In the Print Job pane, you also need to choose how you want your print color managed. (I cover color management later in this chapter.)

Select Print One or Print

Finally, select either Print One or Print from the bottom of the right panel, as shown in Figure 11-46. Print One bypasses the print dialog box and starts the process of printing based on a previous setting or the settings that you set when you created a user preset. Print brings up your operating system's Print dialog box where, depending on your print driver, you can choose image quality, paper, and so on. (Make sure you are printing only one image, and not your entire collection!) If you choose a custom profile from the Print Job pane's Color Management Profile pop-up window, be sure to turn off the printer's color management, or there will be conflict.

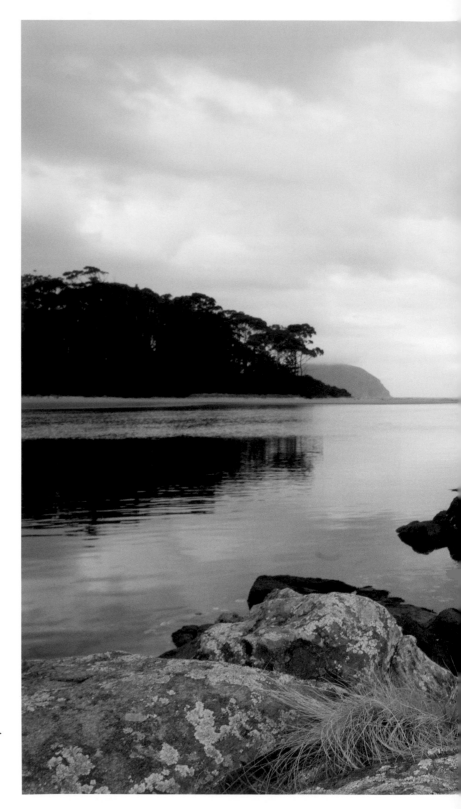

No, this is not a giant live kangaroo. It's stuffed. (The bird on the rock is real, and so is the rest of the scene). German photographer Simone Müller borrowed a set of stuffed animals from the Tasmanian Museum of Natural History that included a kangaroo, a penguin, and a wombat. She purposely placed the animals out of context—the penguin, for example, was shot in the middle of a rain forest—and used strobes to light them. The images seem familiar at first, but then become disturbing and somewhat paradoxical. She was assisted by photographer Katrin Eismann.

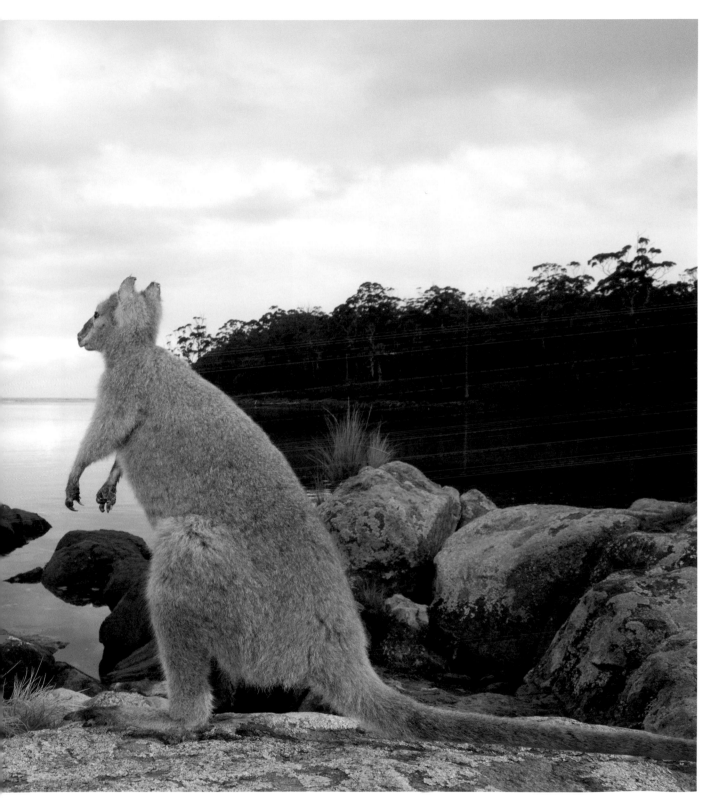

Simone Müller

Adding Text to Prints

You can add text to your prints in a couple of ways. With both the Picture Package and Contact Sheet/Grid layout engines, you can add an existing—or new—identity plate that contains text. Using the Contact Sheet/Grid engine, you can create custom text or use metadata such as file name, title, caption, creator, and keywords attached to your image file. Let's see how.

Let's start by assuming you have an existing identity plate containing text or a graphic. In the Overlays pane for either layout engine, select the Identity Plate check box (circled in Figure 11-47). Your current identity plate appears in the box. It also appears in a bounding box in the display work area. (Using the Picture Package layout engine, it appears only on the first page.)

Identity Plate Placement

You can change the orientation of the bounding box in the Overlays pane by degrees in the upper-right side of the pane. (Clicking on [0 °] degrees brings up a pop-up menu.) Select Override Color and choose another color for the text by clicking on the color selection box. You can also control the opacity and scale of the text (or graphic) with the sliders.

Checking "Render behind image" places the identity plate, or part of the plate, behind the image. Choosing "Render on every image" places the content of the identity plate directly in the middle of every image in your layout, as shown in Figure 11-48. Use the Opacity and Scale sliders in the Overlays pane to control the content of the box.

If you haven't checked Render on every image, you can also work directly in the bounding box in the work area window. Click inside the bounding box and drag it to your desired location, as shown in

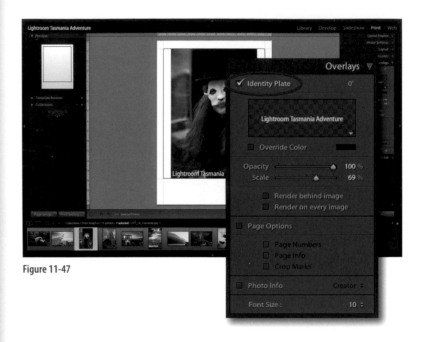

Figure 11-47

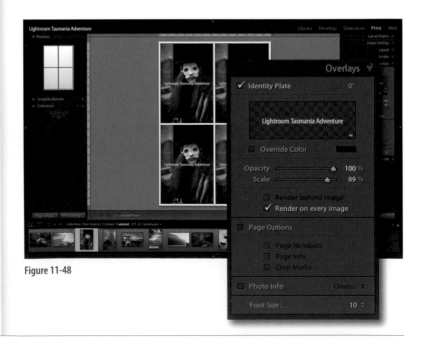

Figure 11-48

Figure 11-49

Figure 11-50

Figure 11-51

NOTE *If you select Sequence from the Photo Info pop-up menu in the Overlays pane, Lightroom applies sequential numbers to the photos based on how many you're printing (for example, 1/10, 2/10, and so on, for a 10-image set).*

Figure 11-49. The text fills only one line and can be enlarged only to the width or length of the page.

Creating custom text

To create a custom text identity plate, double-click on the bounding box in the work area window, or, in the Overlays pane, select Edit from the pop-up menu, as shown in Figure 11-50. Either action brings up the Identity Plate Editor dialog box, where you can edit text and choose another font or style.

Adding page numbers, and so on (Contact Sheet/Grid engine only)

Select Page Options in the Contact Sheet/Grid layout engine's Overlays pane, and you can selectively add page numbers, page info, or crop marks to the print, as shown in Figure 11-51. You can't control the size or position of the options; page numbers and page info appear at the bottom of each page. You can choose to include page info or crop marks around each photo (to use as cutting guides after printing).

Using metadata for page info option (Contact Sheet/Grid engine only)

If you select Photo Info in the Overlays pane of the Contact Sheet/Grid layout engine, you can add text based on available image metadata to your photo, or create your own custom text. (This is not an option in the Picture Package layout engine.) The text always appears at the bottom of the image, with limited choice of font size and no choice of font style or color. Select from one of the presets or choose Edit, which brings up the Text Template Editor, where you can create your own template based on one of the image data fields or add custom text of any length.

Printing Multiple Images

With Lightroom's Contact Sheet/Grid layout engine you can print multiple images on single or multiple pages, and you can print multiple copies of the same image on the same page. You can also crop images to fit a particular layout. And it's all really easy! Let's see how.

I'll start by making a contact sheet, and then move on to other layouts.

Creating a Contact Sheet

To create a contact sheet, start by selecting the images you want to include. You can do this in the Library module, or in the Print module via the filmstrip, or by selecting a Collection from the Collections pane in the left panel. For this example, I started in the Library module. I selected my Adventure slide show collection and then used ⌘+A (Ctrl+A) to select all the images, as shown in Figure 11-52.

When you are in the Print module, you can also use ⌘+A (Ctrl+A) to select all the images in the filmstrip. ⌘+D (Ctrl+D) deselects all the images. You can also go to the toolbar in the Print module and next to the word Use select All Filmstrip Photos from the pop-up menu.

In the Print module, confirm that the images you want are all selected by observing the number in the info overlay (circled, top) or lower-right side (circled, bottom), as shown in Figure 11-53.

Choose one of the default contact sheet templates from the Lightroom Templates folder or select one of your own from the User Template folder. In this example, I selected 4 × 5 Contact Sheet, as shown in Figure 11-54. If you have chosen Use: Selected Photos from the toolbar, deselecting an image or images from the filmstrip removes them from the contact

Figure 11-52

Figure 11-53

Figure 11-54

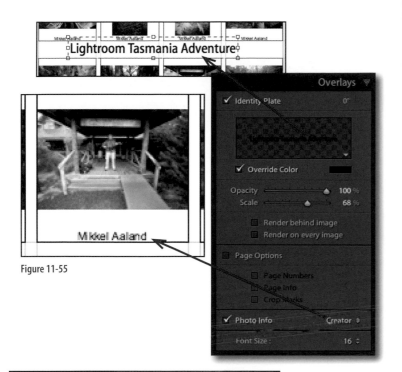

Figure 11-55

Figure 11-56

sheet. To deselect one image at a time, hold the key (Ctrl key) while clicking on the thumbnail of the image you want to remove in the filmstrip.

From the Overlays pane in the right panel, decide on the text you want to include. For this example, I included a textual-based identity plate that reads "Lightroom Tasmania Adventure" and positioned it near the middle of the page. I also selected the metadata Creator field. This placed the individual photographer's name under each image, as shown in Figure 11-55. (Another useful bit of information for a contact sheet might be the file name.)

You can customize the contact sheet layout in the Image Settings and Layout panes. When you are finished, select Print from the bottom of the right panel. Save your custom layout as a template by clicking the plus button in the Template Browser pane.

One Image per Page, Multiple Pages

Let's say you are done printing a contact sheet, as in the previous example. Now you want enlargements of several images from the same collection. All you do is select another template from the Template Browser. For this example, I've chosen Fine Art Mat, as shown in Figure 11-56. As you can see from the info overlay (circled, top), all 40 of my images are ready to print using the new layout. I don't want to print all 40 images, though, so I use the filmstrip to deselect the ones I don't want. (Remember, +click [Ctrl-click] on the thumbnail in the filmstrip to deselect.) Now I'm down to 30 (circled, bottom). As you can see, I also added an identity plate and a Creator field from the Overlays pane. The identity plate

will print on all 22 pages, exactly as you see here, and the creator field will reflect the name that appears in each image's Creator IPTC metadata field.

One Image, Multiple Times on a Page

If I want, I can also repeat the same image multiple times on the same page. For this example, I selected the 2 × 2 template from the Lightroom Templates folder in the Template Browser, as shown in Figure 11-57. In the Image Settings pane, I selected Repeat One Photo per Page. (You can also do this using the Picture Package layout engine.)

Because the image is horizontally oriented, it doesn't fill the cells. However, if I check Auto-Rotate to Fit in the Image Settings pane, as I did in Figure 11-58, the image fills the cells.

Positioning Images

In this example, I choose the 4 Wide template from the Lightroom Templates folder in the Template Browser, as shown in Figure 11-59. As you can see, the images are cropped because they are a different aspect ratio from the cells, and the Zoom to Fill Frame option is selected (by default) in the Image Settings pane.

Figure 11-57

Figure 11-58

Figure 11-59

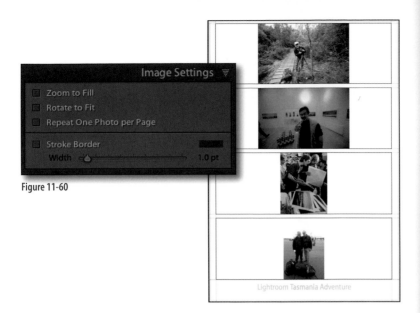

Figure 11-60

If I deselect Fill to Frame, the images are now uncropped, as shown in Figure 11-60, but this still isn't the effect I want.

What I can do is reselect Fill to Frame in the Image Settings pane, and then move the individual images within the cells to position them so that only the parts I want to show are viewable. To do this, drag an image around in the cell until the area you wish to see is revealed. Do this with each cell, as shown in Figure 11-61.

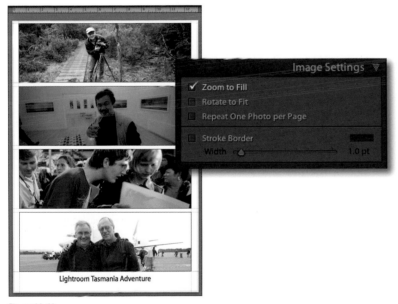

Figure 11-61

NOTE *When using the Contact Sheet/Grid layout engine you can change the size of cells in the Layout pane, but you can't have a variety of cell sizes on the same page; all the cells are the same size. If what you want is a variety of cell sizes, use the Picture Package layout engine, where you can resize individual cells.*

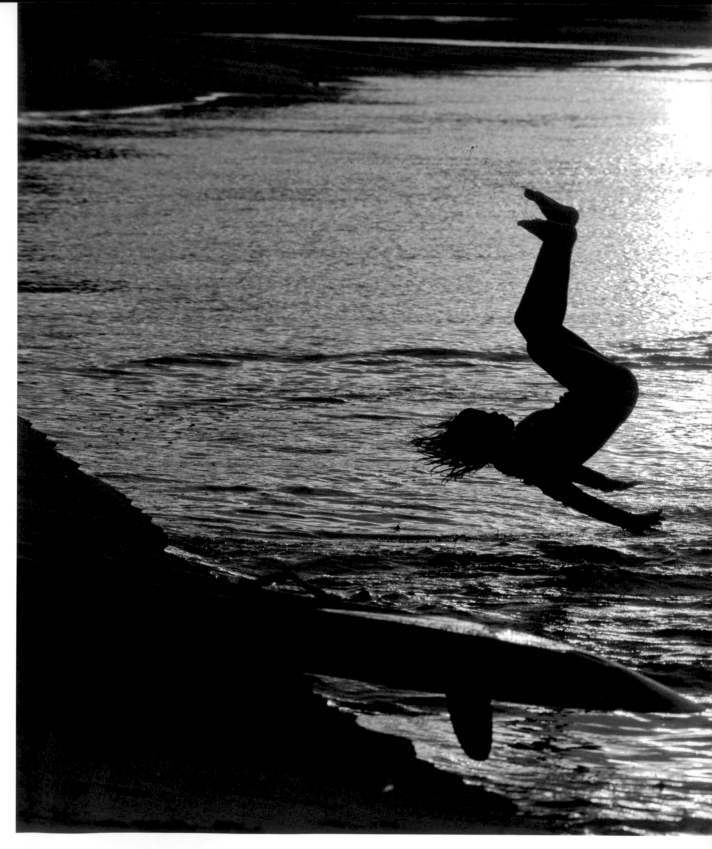

Bruce Dale

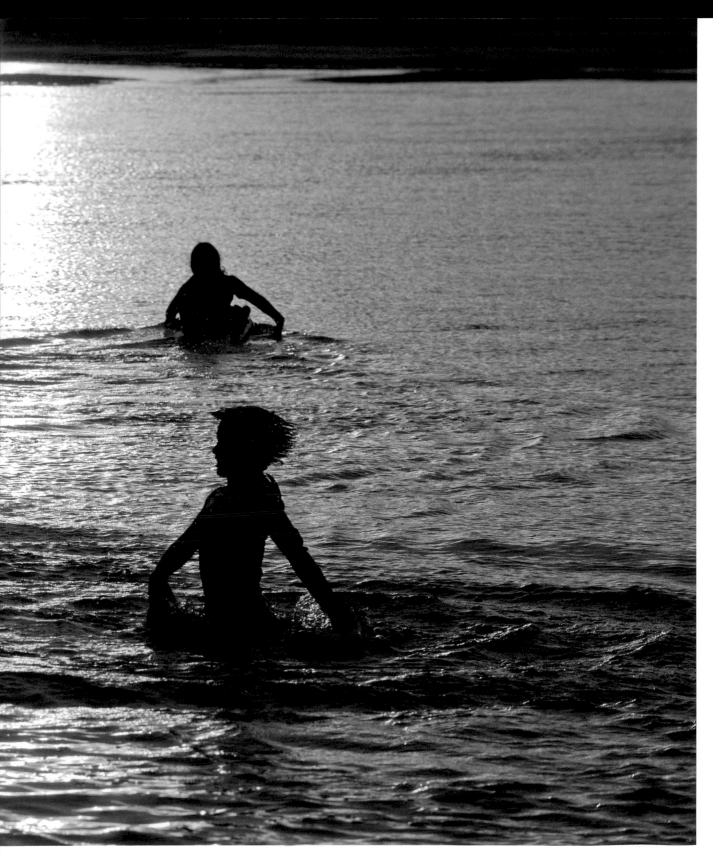

I was with the legendary Bruce Dale when he took this photo, and I had the good luck to watch the master at work. We got out of our car and Bruce made a beeline to the beach, where we could see kids fearlessly diving into the cold sea. Bruce quickly found the perfect vantage spot, with the setting sun in front, radiating the last few drops of warmth on the fall day. Within minutes, Bruce gained the trust of the skeptical parents who wondered what he was up to, showing them the shots on his camera's LCD and promising to email copies. My shots were dull in comparison.

Lightroom Color Management

You have two choices when it comes to color management in Lightroom's Print module. You can use a custom printer profile, or you can turn the color management over to your printer software. You also have a choice of how Lightroom converts the image into a printing color space. Here you'll learn how.

Color Management Profiles

By default, there are two choices in the Profiles pop-up of the Print Job pane, as shown in Figure 11-62.

Managed by Printer option

If you select this option, you hand over control of how the color is handled to the printer driver software that came with your printer. Before you print, you must open the printer driver and select the appropriate settings. Every printer driver is different, but I use an Epson Stylus Pro 3800, and Figure 11-63 shows what I get when I click on the Print Settings box at the bottom of the left panel. The critical thing here is, under Printer Color Management, to select Colorsync (Mac) or ICM Color Management (Windows) as a color correction option. You also need to choose the appropriate print settings and media (which you need to do regardless of which method you use).

Other... option

If you select Other, a dialog box appears, as shown in Figure 11-64. This is a list of printer profiles that came with your printer or that you have loaded yourself. (If no profiles are loaded, this dialog box is empty. If a profile is for CMYK it doesn't show up either.) These profiles take many factors into account, including the printer, color space, and type of paper. Check the box or boxes next to the profile or profiles that you want to use (circled).

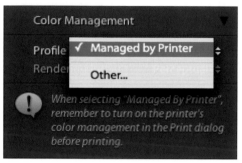

Figure 11-62

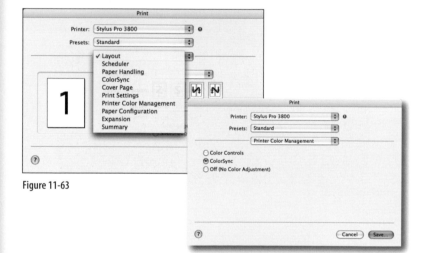

Figure 11-63

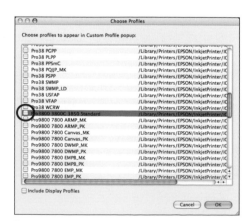

Figure 11-64

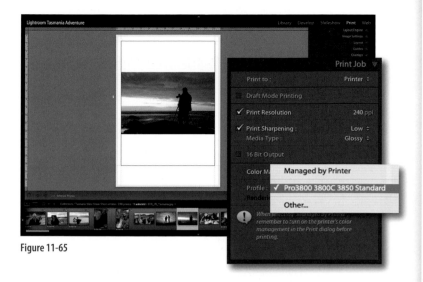

Figure 11-65

Figure 11-66

Perceptual rendering attempts to preserve the visual relationship between colors and is generally the best choice when printing color images. However, colors that are in gamut might change as out-of-gamut colors are shifted to reproducible colors.

Relative rendering, on the other hand, preserves all in-gamut colors and shifts out-of-gamut colors to the closest reproducible color. The Relative option preserves more of the original color and may be desirable if you have few out-of-gamut colors. The only way to know for sure which method to use is to try both and compare the results.

The chosen profile appears as a choice in the pop-up menu, as shown in Figure 11-65. To remove it, select Other again and deselect your choice. To add custom printer profiles, place the profile in your computer's Colorsync (Mac) or Color (Win) folder. (On the Mac, this folder is found in the Library folder. In Windows, the Color folder is a bit hidden, so I suggest searching for the *.icm* extension to find it.) After placing the new profile in the folder, restart Lightroom, and the next time you select Other, the profile should appear in the list. Let me amplify the warning found in the Print module Color Management pane: if you use a custom profile, it's very important to turn off the color management in your printer driver dialog box. You don't want the custom and printer management to *both* manage your colors.

Choosing Rendering Intent

One last option for color management via the Lightroom Print module is to choose the rendering intent. You have two choices, Perceptual and Relative, as shown in Figure 11-66. Suffer with me a moment for a brief explanation of how Lightroom handles color space. Lightroom's working color space, ProPhoto RGB, is an extremely wide and accommodating color space. If you edit your photo in the Develop module, and, say, supersaturate it, this color space is large enough to handle the expanded colors. However, when you go to print, your computer—and often the printer—isn't set up to handle the expanded range of colors. Choosing Perceptual or Relative determines how any out-of-gamut colors are handled. The box to the left sums up which to use when.

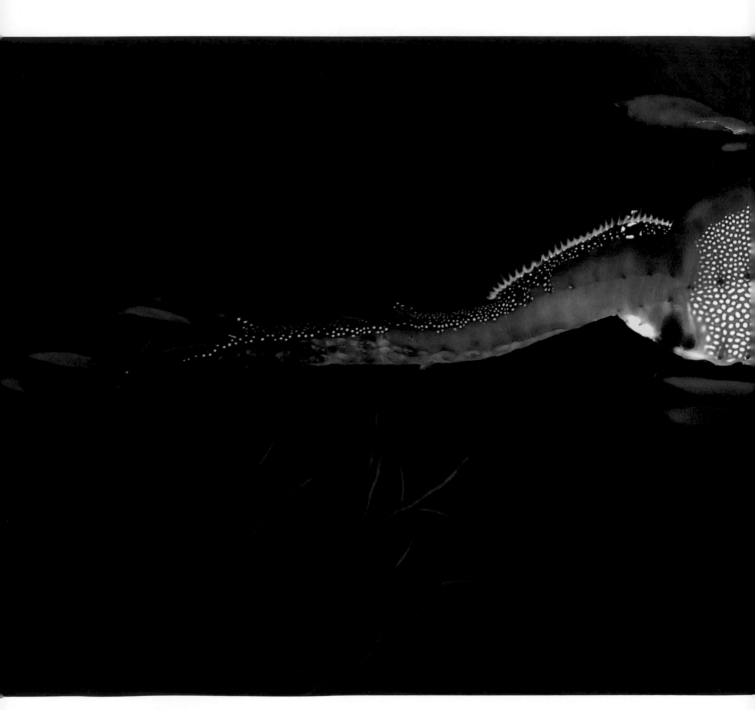

Bill Stotzner

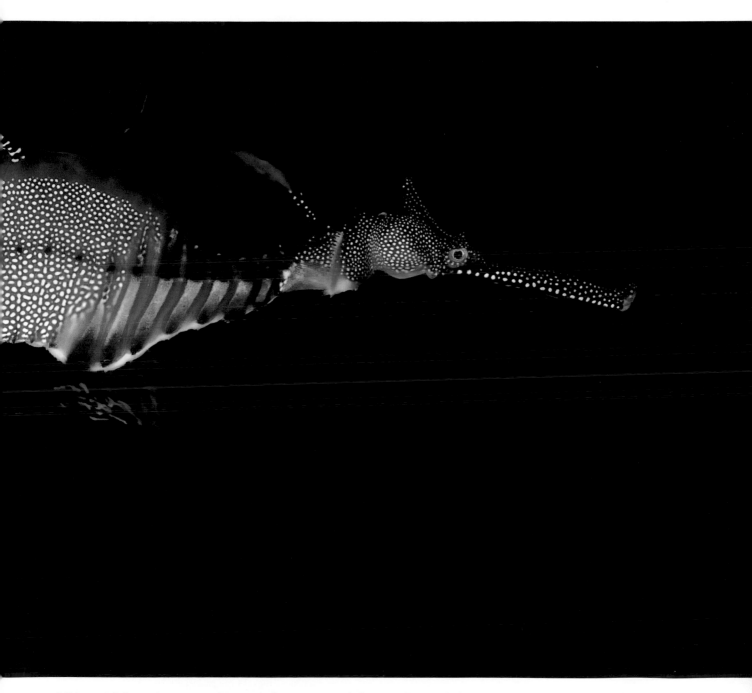

Bill is an Adobe Lightroom quality control engineer, and also a professional photographer by training. Bill's the one who first told me that Tasmania is considered a Mecca for underwater diving. This surreal Weedy Sea Dragon (as opposed to a Leafy Sea Dragon) is unique to Tasmania, and Bill photographed it at a diving site called Dragon City, on the coast not far from Hobart. The dragons are generally 12 inches long and are actually hard to spot. When I showed this photo to my younger daughter she gasped and said "Can I have it as a pet?"

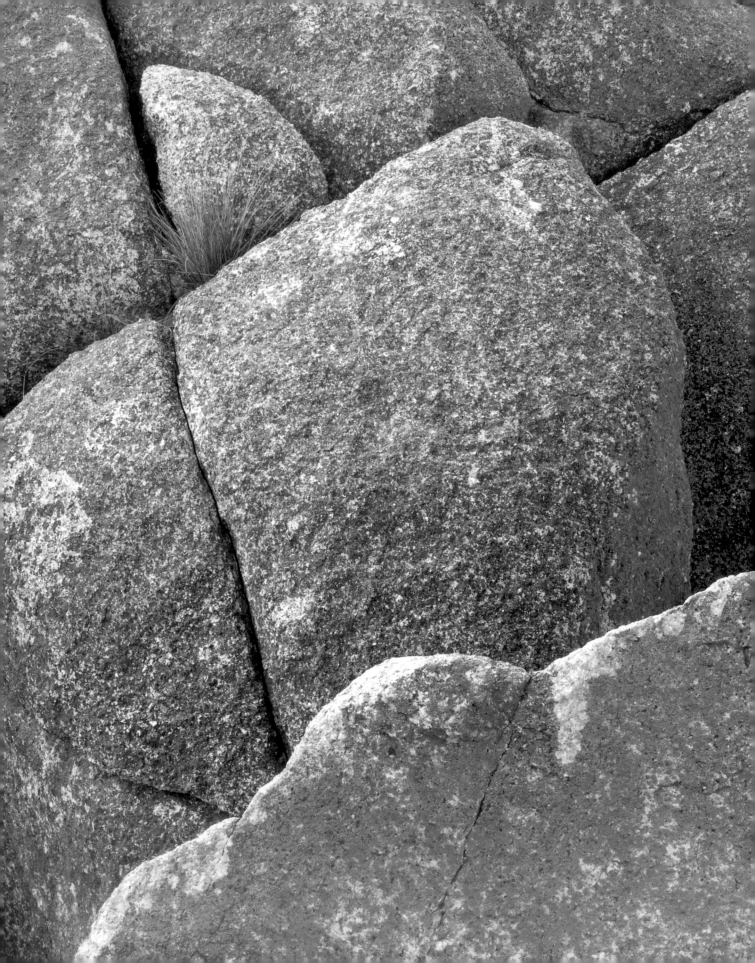

Creating a Web Gallery

Selecting a series of photos and creating a unique web photo gallery can be accomplished quickly and easily from within Lightroom's Web module. Lightroom generates all the components you'll need for your website, from thumbnail images, to larger preview versions of the photos, to the necessary code that binds everything together. You can choose either standard HTML or the more flashy Flash style. Lightroom will even upload your ready-to-go web gallery directly, if you choose. This chapter shows you how to use the ready-made presets or customize one of your own.

Chapter Contents

12

The Web Module Revealed

Web galleries are created in Lightroom's Web module, which is stating the obvious, right? OK, let's break the Web module down to its specific components and describe it that way. Then, in subsequent sections, we'll see how to put the Web module to practical use.

Here, in Figure 12-1, is the Web module, shown in full with left and right panels, workspace, toolbar, and filmstrip visible. As is true with all the Lightroom modules, you can customize the work area by closing or resizing panels and by expanding or shrinking the filmstrip.

NOTE *If you create a Lightroom Web Gallery using HTML, it will be viewable on all web browsers. Preview images will be viewed at the size you set in the Lightroom Web module. If you create the gallery using Flash, the viewer will require a widely available browser plug-in for Flash. Flash Web galleries produce online slide shows with smooth transitions and auto-resizing based on the size of the viewer's browser window.*

Web Preview Pane

In the Preview window, you can view template page layouts from the Template Browser. Just hold your cursor over a template name and it appears in the Preview window, as shown in Figure 12-2. You can tell if you're creating an HTML- or a Flash-based gallery by looking at the icon in the lower-left corner of the Preview window (circled).

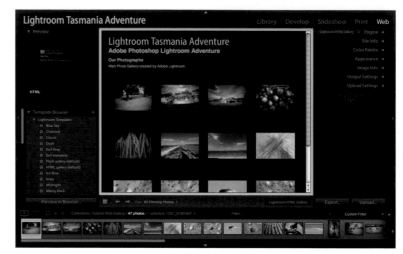

Figure 12-1

Figure 12-2

Figure 12-3

Web Module Template Browser

Here in the Template Browser, you can either select a gallery style, or, as I mentioned earlier, preview a style in the Preview window. When you select a template, Lightroom immediately begins generating the new style, which can take some time, depending on how many images are selected and the template style in use. You can also save custom user templates by clicking the plus sign at the right of the Template Browser pane (circled in Figure 12-3). To remove a user template, select the template and then click on the minus sign. (To remove a template from the Lightroom Templates list, you need to find the actual file on your hard drive and trash it from there.)

Figure 12-4

If you right-click on one of the user templates, as shown in Figure 12-4, you have the option via the contextual menu to Update with Current Settings, which basically means "Change template from here on out to reflect the adjustments I just made." This is not an option with templates in the Lightroom Templates folder. To achieve basically the same thing, customize the template, and then select Web→New Template from the menu bar and give the template a name. The new template with the updated settings then appears in the User Templates folder or a new subfolder of your choice.

Collections Pane

New to Lightroom 2's Web module is the addition of the Collections pane, shown in Figure 12-5, which mirrors the Collections pane found in the Library, Slideshow, and Print modules. From here you can navigate to other collections without leaving the Web module.

Preview in Browser

Click on Preview in Browser at the bottom of the left panel to open your gallery in your default Web browser. (This can take time depending on your choices; Lightroom generates all the necessary information and saves it before the preview can occur.)

Display Work Area

The display work area displays the Web gallery pages almost exactly as they will appear in a browser, as shown in Figure 12-6. The gallery is fully operable, and you can click on thumbnails and active links and preview the effect. You can also view the slide show (Flash only). Operability of the gallery might take some time while Lightroom generates all the necessary thumbnails, large images, and code. (Consider starting with a small subset of your images, and then apply the style to all your images when you're ready.) A status bar at the upper-left corner of the Lightroom window indicates the progress. You can stop the progress at any time by clicking on the X at the end of the progress bar (circled in Figure 12-7).

Figure 12-5

Figure 12-6

Figure 12-7

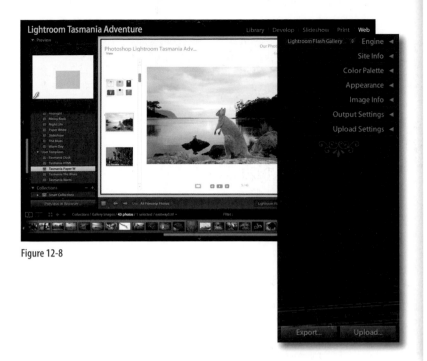

Figure 12-8

Figure 12-9

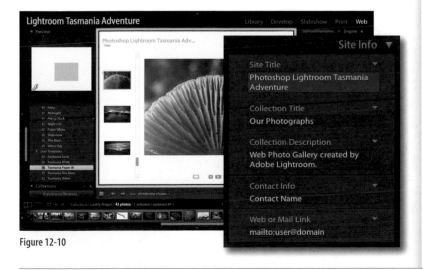

Figure 12-10

Web Module Right Panel

The right panel, shown in Figure 12-8, is where you can add descriptive text, customize colors, and set image sizes. It's also where you go to export your gallery files or upload your finished gallery directly to a server.

Engine pane

In the right panel, starting at the top, is the Engine pane, which indicates what type of gallery you are working with, HTML or Flash. Also available here is a list of user-added third-party plug-ins. (By default, Lightroom includes interactive Flash Web galleries created by Felix Turner of Airtight Interactive. Felix offers pro versions of his galleries at www. airtightinteractive.com.) If you choose a template using HTML, Lightroom HTML Gallery appears (shown left in Figure 12-9). If you choose a gallery using Flash, Lightroom Flash Gallery appears (right). Because Flash and HTML galleries are fundamentally different, the customizing choices you see in subsequent panes may differ substantially. The choices will also change if you use third-party plug-ins such as Felix's Airtight Postcard Viewer.

Site Info pane

In the Site Info pane, shown in Figure 12-10, you can add fixed titles and a description, your contact information, and email address. Type size, font style, and location are set by the template. HTML and Flash panes are basically the same, but in the HTML pane you also have the option to add an identity plate. (For Flash Gallery styles, the Identity Plate option is found in the Appearance pane.)

Color Palette pane

In the Color Palette pane, you set the text, background, and other web component colors. Just click on a color swatch box to bring up a color picker. As you can see in Figure 12-11, there are different choices in the HTML (left) and Flash (right) Color Palette panes.

Appearance pane

In the HTML Appearance pane, shown in Figure 12-12, you can choose to include a drop shadow, add section borders and choose a color for them, and add photo borders with a specified width and size. You can set how many thumbnails appear on each page by clicking on the grid. You can control the size of the full-size image pages—from 300 to 2071 pixels—but not the size of the index pages. If an index page is showing in the display window, a warning [!] (circled) instructs you to click on an index thumbnail to open a page with a large image, and see the effects of moving the Size slider. More pixels means a larger page and a larger image, which is fine if you know that your viewers have a large screen. But it also means a large file size (which you can reduce somewhat by setting a higher JPEG compression in the Output Settings pane).

In the Flash Appearance pane shown in Figure 12-13, you can determine where the thumbnails appear on the page with the Layout pop-up menu (circled). You can select an identity plate. You can also control the size of the large images and thumbnail images via the size pop-up menu options: Extra Large, Large, Medium, and Small. Lightroom actually creates three versions of each photo to accommodate different-size browser windows.

Figure 12-11

Figure 12-12

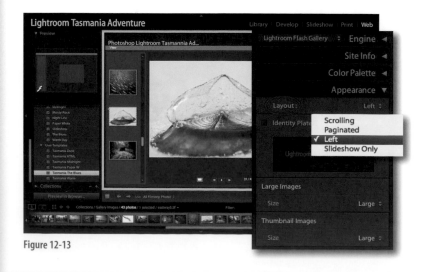

Figure 12-13

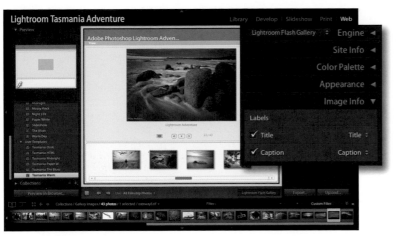

Figure 12-14

Image Info pane

The Image Info pane, shown in Figure 12-14, is the same for HTML and Flash. This is where you choose a subtitle and captions based on EXIF metadata. I get into this in more detail later in the chapter.

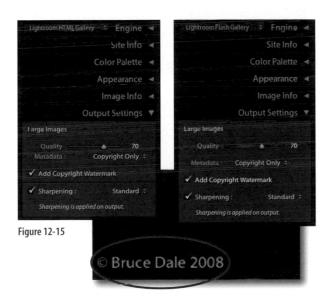

Figure 12-15

Output Settings pane

The Output Settings pane for both HTML and Flash styles are basically the same, as shown in Figure 12-15. The Quality slider controls JPEG compression for large images. Larger numbers indicate higher quality, lower compression, and a larger file size. Smaller numbers indicate lower quality, higher compression, and a smaller file size. A metadata option lets you embed either only the copyright information or all the informational metadata associated with an image. There is also a Copyright Watermark check box. When you select it, a name based on the copyright EXIF field appears in the lower-left corner of each image (circled). You can't change the position or size of the text.

Upload Settings pane

The Upload Settings pane is the same for both HTML and Flash, as shown in Figure 12-16. Start by selecting Edit from the Custom Settings pop-up menu (circled). In the Configure FTP File Transfer dialog box that appears, enter the appropriate settings and password for your server so Lightroom can automatically upload your gallery.

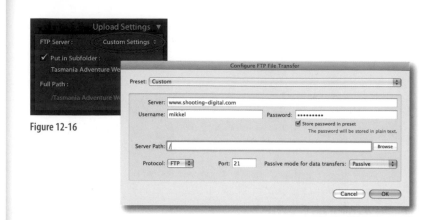

Figure 12-16

Export and Upload buttons

Click the Export button shown in Figure 12-17 to save your files to another location. You can load them onto a server or open the files and further customize the code. Click the Upload button, and Lightroom automatically places your gallery on a server, based on the information entered in the Output pane. You need to be online and have an Internet service provider (ISP) for this to work, obviously!

Figure 12-17

Web Module Toolbar

There are just a few controls in the Web module toolbar: The square icon (circled in Figure 12-18) brings you to the first image in the filmstrip, and the arrows take you back and forth between images in the filmstrip. In the Use pop-up menu you can control which photos to use. To the far right of the toolbar, you can see at a glance which style you are working with, HTML or Flash.

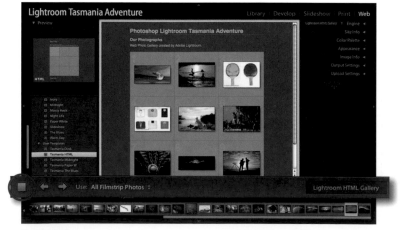

Figure 12-18

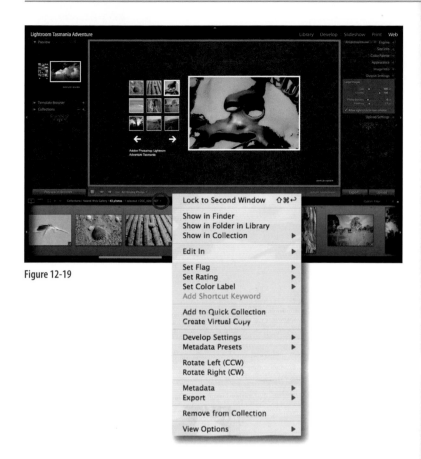

Figure 12-19

The Filmstrip in the Web Module

In the filmstrip, you can apply develop presets without leaving the Web module by right-clicking on an image and selecting a preset from the contextual menu, as shown in Figure 12-19.

To switch to another collection or folder, use the pop-up menu (circled), which displays your entire library of images or a previously viewed collection. You can directly select or deselect individual images for the Web gallery from the filmstrip. Do this, and then select Content →Use Selected Photos from the menu bar.

Figure 12-20

NOTE *It is possible, if you are knowledgeable, to go under the hood and do even more customizing of the Lightroom Web gallery. You need to know something about HTML or Flash coding and you also need to know exactly what parameters you can change or alter. For more on this, and for a list of third-party Web module galleries go to: http://learn. adobe.com/wiki/display/LR/Lightroo m+presets,+galleries,+and+plug-ins. A page from the web site is shown in Figure 12-20.*

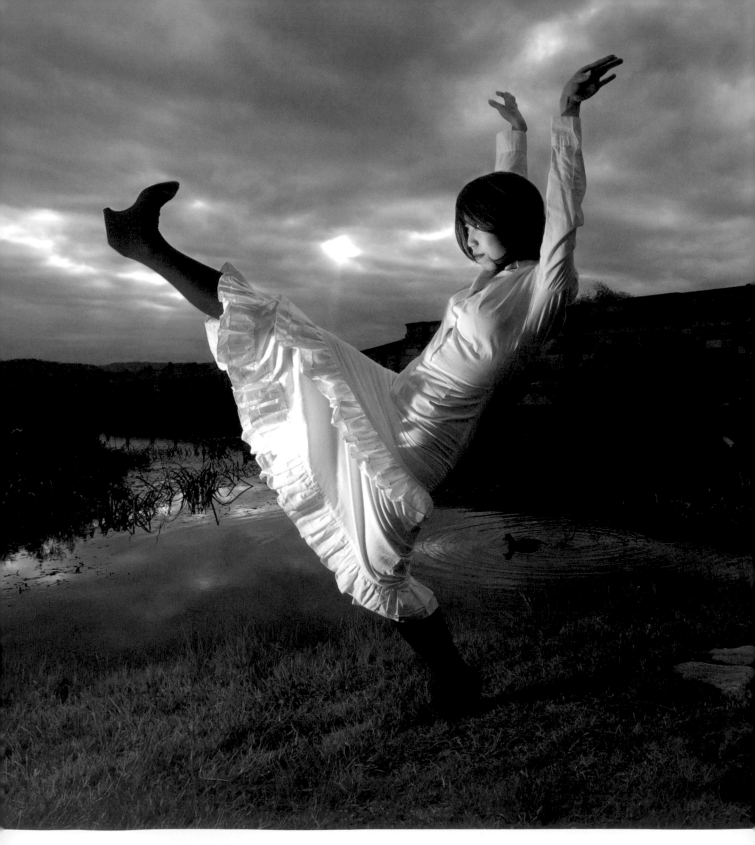

Maki Kawakita

This is another of Maki's Makirama series. When I asked Maki how she defines a Makirama, this is what she wrote: "Makirama is the never-ending evolution of self. It is an autobiographical project. It is a visual diary depicting my emotions through life. The title, Makirama, comes from my name, Maki, representing the fundamental part of me. Rama represents the dimensions of the self, whether it's my alter ego, my surroundings, or the impact of cultural differences. Makirama is inspired by Kabuki (Japanese traditional opera) and its theatrical aesthetics, possessing its striking colors, contrasts, dynamic compositions and dramatic stories. The characters that I create in this body of work are to illustrate the alter ego. Just like opera or motion pictures, I give myself roles to play so different personalities within myself can be expressed in a particular visual setting. By creating such images, however, I like to think of Makirama not only as a way to analyze myself as I go through life but also as an invitation to my audience to undertake a similar journey of self-discovery through my imagery. As a result I can learn new visual observations of the self and self-discovery simultaneously. For that reason, Makirama is meant to be a never-ending project of self-evolution."

Customizing a Web Gallery

Lightroom ships with several Web gallery templates, and some third-party plug-ins. Change these templates and plug-in settings, save your own version, then choose between building an HTML or Flash gallery. Finally, export all the necessary files and place them on a server yourself or let Lightroom do it for you. Let's see how.

To start, you must first select the images you want to include in your Web gallery. Start with a small subset of images; otherwise, Lightroom slows down considerably as it generates a gallery based on an entire collection. Apply the settings to all the images when you are done.

Selecting Images

In the Library module, select a folder, collection, or keyword, as shown in Figure 12-21. If you are not in the Library module, press the G key, and you're taken to the Library module's grid view. If your Web gallery Use setting is set to All Filmstrip Photos, images appearing in the grid display work area are included in the Web gallery. I usually create a unique collection for each Web gallery. That way, I can preserve my image order, and it also makes it easier for me to update my Web gallery at a later date. You can also make your choice in the Web gallery Collections pane or in the Web gallery filmstrip, and then, in the toolbar Use pop-up menu, choose Selected Photos. (You can also use this pop-up menu to select All Filmstrip Photos or Flagged Photos.)

Select the Web Module

Now—if you are not there already—go to the Web module. Get there by clicking Web in the module picker or use the

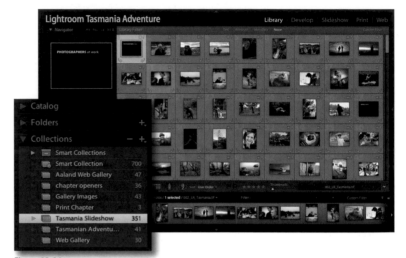

Figure 12-21

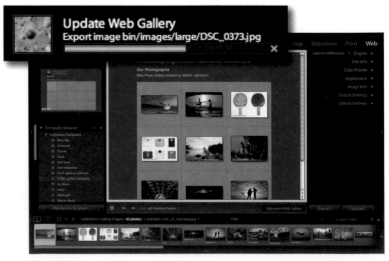

Figure 12-22

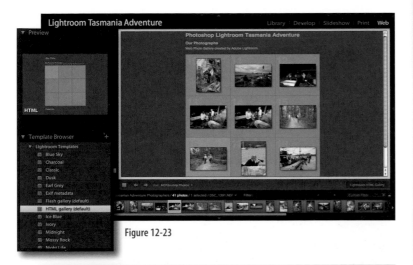

Figure 12-23

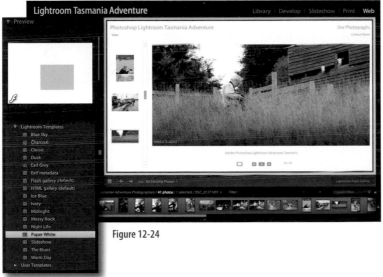

Figure 12-24

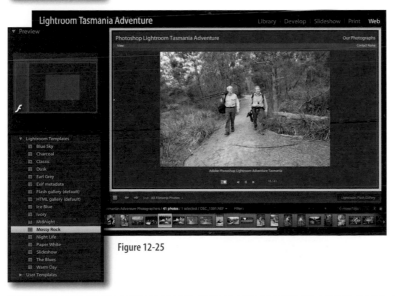

Figure 12-25

keyboard ⌘+Option+5 (Ctrl+Alt+5). As soon as you enter the Web module, Lightroom begins generating or updating the gallery. You'll see the status of this operation in the status bar shown in Figure 12-22. You can modify the order of images in the filmstrip.

Select a Web Template or Plug-in

Select a Lightroom template from the Template Browser or select a plug-in from the Engine pane in the right panel. You can see a preview of the template or plug-in layout in the Preview window. In the lower left of the Preview window, a graphic indicates whether the style is HTML or Flash (circled in each example). Here—taking into account variations in color, type, and captions—are your basic Lightroom template and plug-in gallery choices:

- Galleries with separate windows of thumbnail images that lead to windows of full-size images. This basic style can be either HTML or Flash, as shown in Figure 12-23.

- Galleries with a single window containing thumbnail images that, when clicked on, display an adjacent full-size image or enlarge, as they do with the Airtight Postcard Viewer plug-in. This is available only as a Flash style, as shown in Figure 12-24.

- Galleries that consist of a user-controlled slide show with no thumbnails. This is available only as a Flash style, as shown in Figure 12-25.

Create a Title and Description

After you select a template, go to the Site Info pane to add all the pertinent information about your gallery, as shown in Figure 12-26. The Site Info pane for HTML-based and Flash-based galleries is pretty much the same, except that identity plate settings are in the Site Info pane for HTML and in the Appearance pane for Flash. If you click on the triangle near a text field (circled), you get a pop-up menu of previously used text. You can't change the size of the text or the font.

> NOTE *Lightroom uses sRGB as its color space (and embeds it) for Web-destined photos. You can't change this, nor would you likely want to.*

Control the Color

In the Color Palette pane, shown in Figure 12-27, you can change the text colors, background, and so on. You'll see a difference between the HTML and Flash versions. Flash galleries tend to be more complex; therefore, there are more choices in the Flash version. To change colors in either pane, click on the color swatch. This brings up a color picker where you can make your color selection.

Change and Control Thumbnails

Both HTML and Flash thumbnails are controlled from the Appearance pane. You cannot change the size of the HTML thumbnails, but you can control how many appear on an index page via Grid Pages. Click on the grid shown in Figure 12-28 to reduce or expand the number of cells.

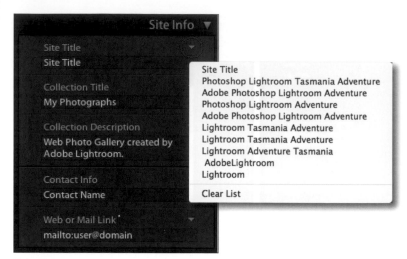

Figure 12-26

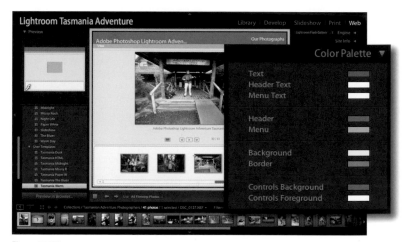

Figure 12-27

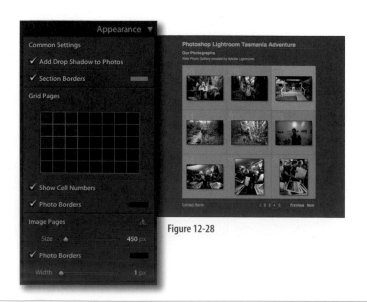

Figure 12-28

Figure 12-29

If you select Show Cell Numbers, each cell contains a sequential number (circled in Figure 12-29), the visibility of which is dependent on the particular template or your color choices in the Color Palette pane.

In the Flash Appearance pane, you can choose where the thumbnails appear, how they are displayed, and their size. Click on the triangle to the right of Layout (circled in Figure 12-30), and a pop-up menu appears with choices. Selecting Slideshow Only removes the thumbnails entirely.

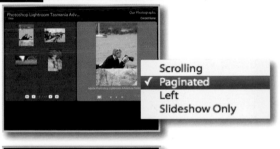

Figure 12-30

You can set the thumbnails on the left (top screen shot), use a paginated option (center screen shot), or have them set for scrolling (bottom screen shot).

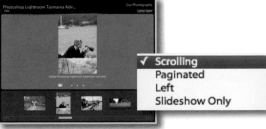

You have a choice of four thumbnail sizes from the Size pop-up menu: Extra Large, Large, Medium, and Small.

Change Large Image Sizes and Quality

You also control HTML and Flash large image sizes from the Appearance pane. There are fundamental differences between the HTML and the Flash panes. HTML large image sizes are controlled by pixels to a fixed size, using the Image Pages Size slider shown in Figure 12-31, regardless of the size of the viewer's browser window.

Figure 12-31

Flash large images can be Extra Large, Large, Medium, or Small, as shown in Figure 12-32. In reality, Lightroom creates more sizes than that—in fact, it generates three sizes for each category. That way, when viewers resize their browser window, the thumbnails and previews adjust accordingly.

You can set the JPEG quality of large images for both HTML and Flash styles in the Output Settings pane, as shown in Figure 12-31. The higher the quality number, the better the quality (less compression). Higher quality numbers also create larger file sizes and potentially a slower download speed on the viewer side.

Add Copyright Notice and Metadata

The Output pane for either HTML or Flash styles is also where you can add a copyright notice to the images (circled in Figure 12-33). Lightroom places the copyright information, which is based on EXIF metadata, in the lower-left corner of each image. You have no control over where the information is placed, or over font type, size, or style. (Some plug-ins, such as the Airtight Postcard Viewer, don't offer copyright notices.)

Add Info Text and Identity Plate

Both the HTML and Flash gallery styles give you the option to add a title or caption based on EXIF data. This is done from the Image Info pane, shown in Figure 12-34. You can also use an identity plate to add custom text or graphic. I show you more on this in the next section.

Figure 12-32

Figure 12-33

Figure 12-34

Figure 12-35

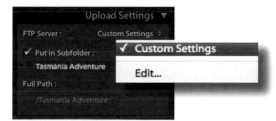

Figure 12-36

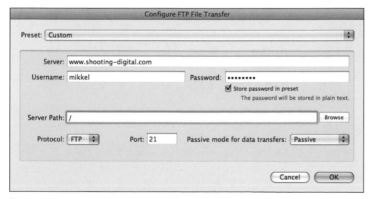

Figure 12-37

NOTE *In the Web module Site Info pane, for both HTML and Flash Galleries, you can enter your email address. Do this knowing that by including your email address on your site you are now susceptible to web bots that automatically harvest web sites for email addresses and sell the addresses to spammers.*

Preview and Create a Custom Preset

When you are finished, you can preview your Web gallery in a browser by clicking the Preview in Browser button at the bottom of the left panel. Your gallery eventually opens in your default Web browser, as shown in Figure 12-35. If you are satisfied with the results, make a user template by selecting Web→New Template from the menu bar. Name your template, and if you want, create a user subfolder. After you select Create, the template appears under User Templates in the left panel.

Publish Your Work Online

Lightroom will place your finished Web gallery directly onto a server of your choice. In the Upload Settings pane (HTML and Flash are the same), select Edit from the pop-up menu (circled in Figure 12-36). In the Configure FTP File Transfer dialog box, fill out the appropriate address, password, and so on, as shown in Figure 12-37. Select Browse to make sure that your configuration is online and working. Pay particular attention to the fact that Lightroom saves your password in plain text, which can be readable by anyone with access to your computer. Also note that many servers require the passive mode for data transfers, but not all. I had to turn this option off to successfully upload a gallery to my shooting-digital.com site.

Click the Upload button at the bottom of the right panel, and as long as you are online, Lightroom will do the rest. Click on the Export button to export the files to a location of your choice and then place them manually on your site, or view them locally, or burn them to a DVD.

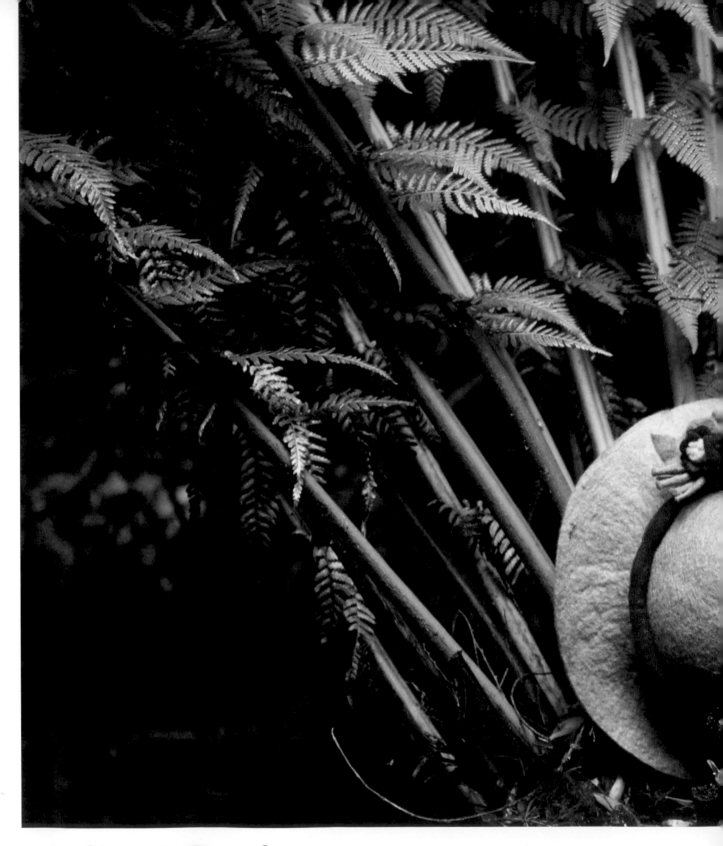

Melissa Gaul

Melissa found this lovely handcrafted hat at the Salamanca Market in Hobart early in the trip and was inspired to use it as the unifying element of a set of outdoor shots—giving the hat a taste for the outdoors that proved its undoing. Unfortunately, soon after this picture was taken, the hat decided its destiny lay outdoors, and went to live with the penguins.

Adding Text to Web Galleries

Lightroom creates Web pages that emphasize your images. But text is important, too. Not only will you want to credit your work so everyone can see, it's also sometimes useful to include other information about where, when, and how your images were made. Let's see how.

You can add text from the Site Info pane in the right panel or directly in the image work area by clicking in the text field circled in Figure 12-38. Click on the triangle to the right of a text field, and a list of previously used text appears for you to choose from. You can't control the size or font without going under the hood and rewriting code yourself, but on a Mac you can spell check by Ctrl-clicking on the text field and using the contextual menu. This is not an option with Windows.

Figure 12-38

You can type up to 162 characters in the Collection Description field (circled in Figure 12-39), and Lightroom automatically adds the line returns when necessary. If you are using an HTML style, the collection description text appears below the Site Title and Collection Title text on the thumbnail pages (circled).

Figure 12-39

If you are using a Flash style, the collection description text appears in a separate window when a viewer selects View→About These Photos (circled in Figure 12-40).

Figure 12-40

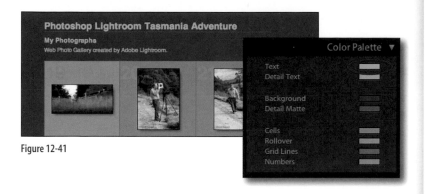

Figure 12-41

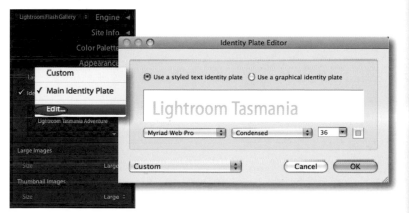

Figure 12-42

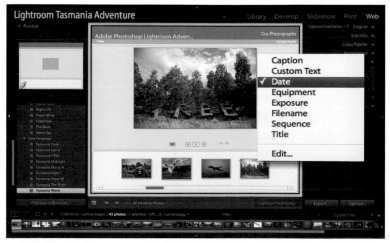

Figure 12-43

Changing Type Color

Change the color of type in the Color Palette pane. Click on the color swatch box (circled in Figure 12-41) and select a readable color from your operating system's color picker.

Using an Identity Plate

You can also add text (or a graphic) to your Web page via the Site Info (HTML) or Appearance (Flash) pane. To add custom type, select Edit from the pop-up menu (circled in Figure 12-42). Then, in the Identity Plate Editor, which appears when you select Edit, type the text you want to include. You can select a font, style, and size. If you are using a Flash template, the identity plate replaces the site title and your font size will never appear larger than approximately 36 pt, regardless of what you set. With HTML, you can select just about any font size you want, although the type might not fit on the page.

Subtitles and Captions

You can add subtitles and captions, based on EXIF metadata or custom text, in the Image Info pane, as shown in Figure 12-43. When selected, both Title and Caption offer various options via the pop-up menu. Choose Edit to bring up the Text Template Editor to further customize the options. (I explain how to use the Text Template Editor in Chapter 10, in the section "Using the Text Template Editor.")

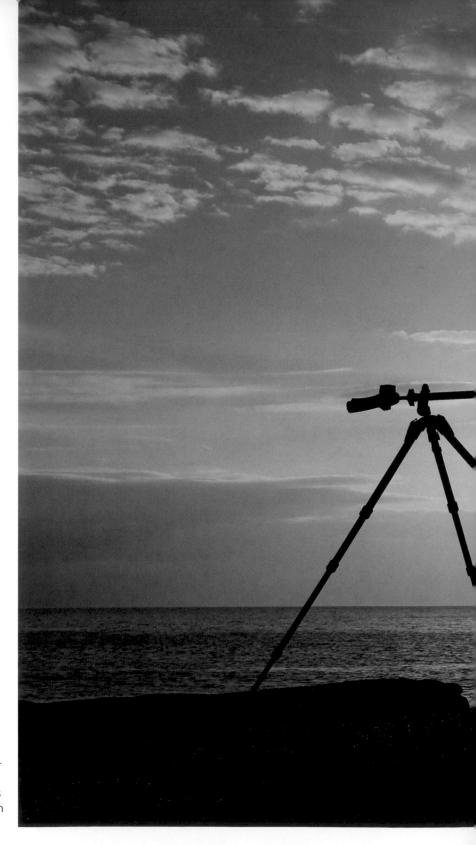

Australian Darran Leal captured his coun-
trymen Philip Andrews and Mark Cokes sil-
houetted against the setting sun at Coles
Bay, on the east coast of Tasmania. Philip is
trying to figure out where to put the film in
his camera and Mark is equally as baffled.

Darran Leal

Index

Symbols

About the Author

Mikkel Aaland is an award-winning photographer, popular workshop leader, and author of 11 books, including *Photoshop Lightroom Adventure(Iceland)* and *Photoshop CS3 RAW* (O'Reilly), *Shooting Digital: Pro Tips for Taking Great Pictures with Your Digital Camera*, 2nd edition (Sybex), and *The Sword of Heaven (Traveler's Tales)*. Visit his website at *www.shooting-digital. com.*

Colophon

The cover image is an original photograph by Mikkel Aaland. The small photos are original photographs by Mikkel Aaland, Philip Andrews, Ian Wallace. The cover font is Frutiger. The text and heading font is Myriad Pro.

Join the conversation.
digitalmedia.oreilly.com

comprehensive tutorials informative podcasts technical articles
shortcuts recipes forums

O'REILLY®